JULIAN SCHNABEL

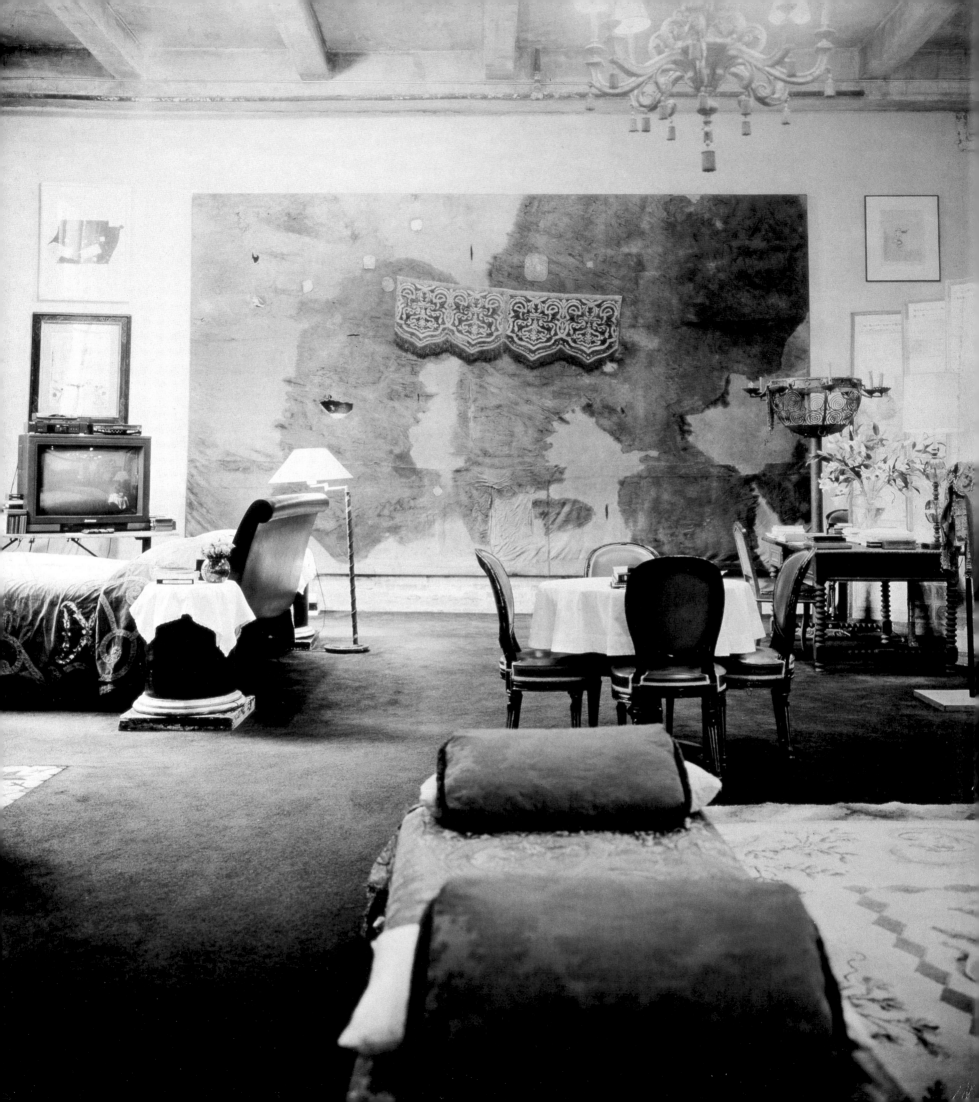

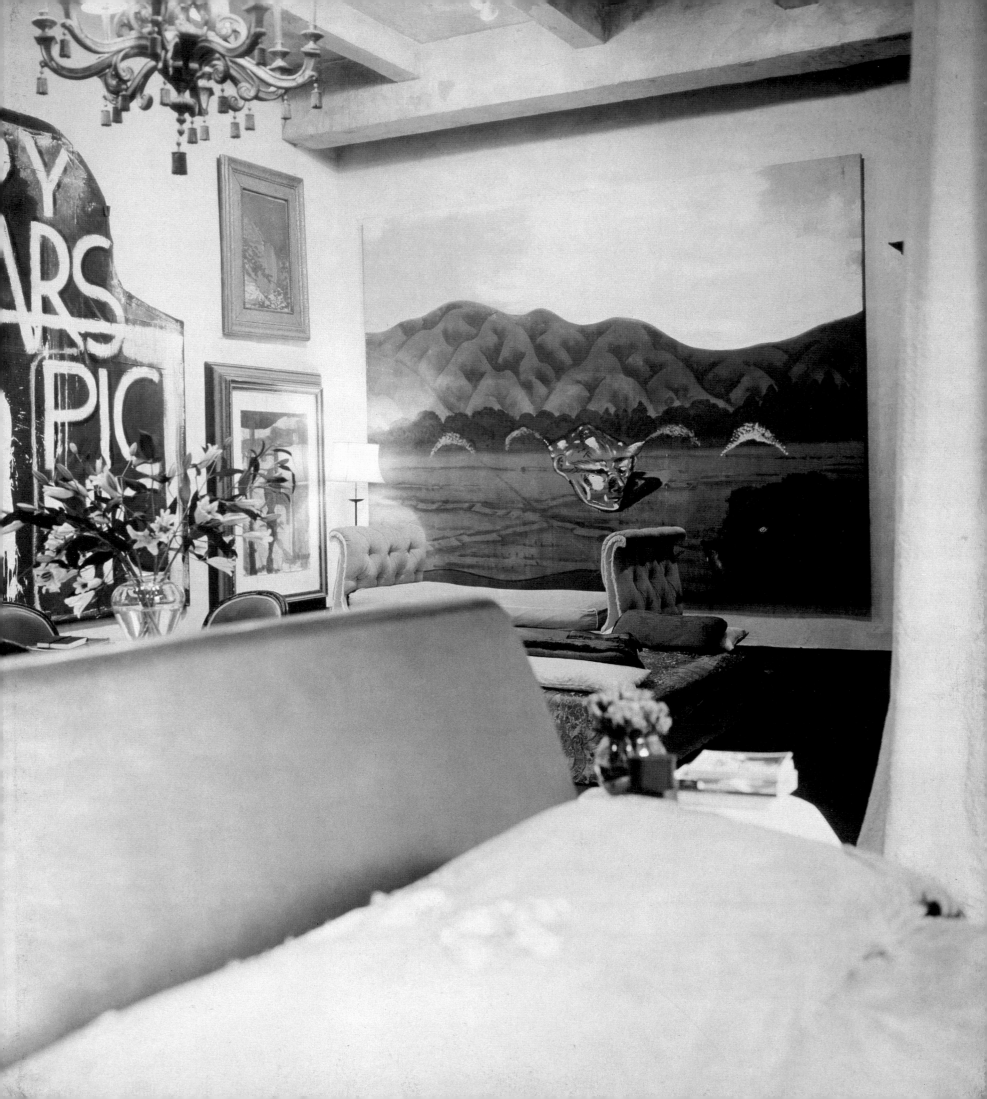

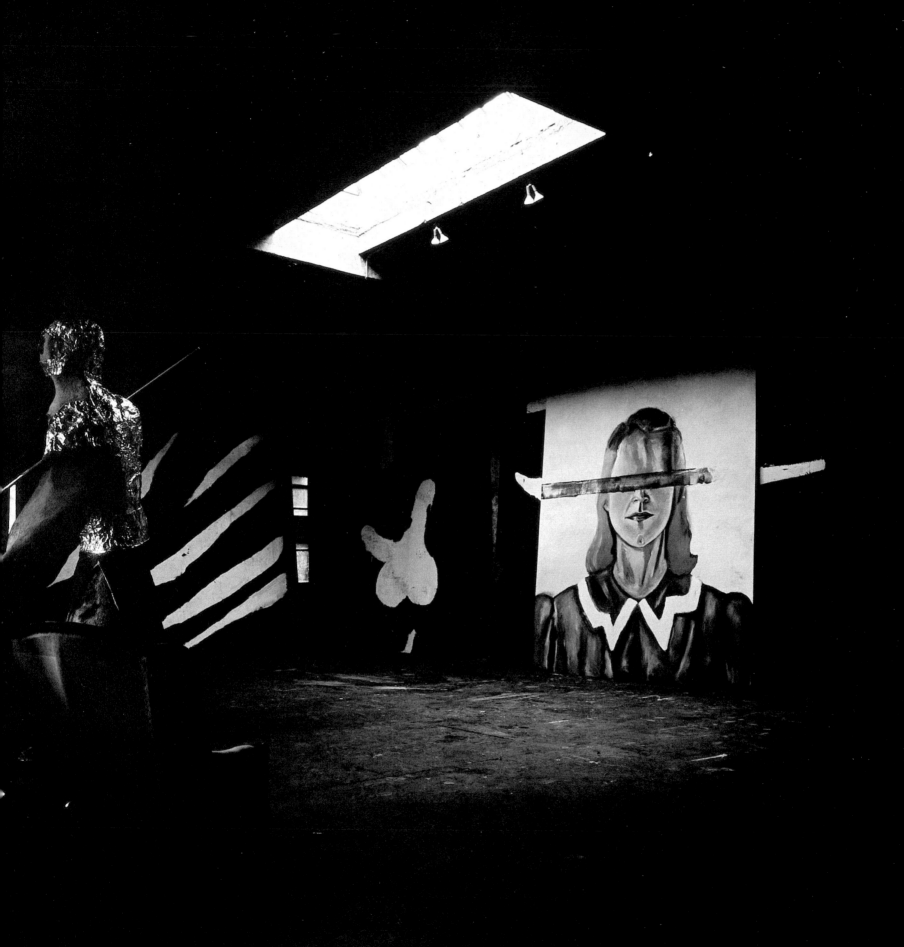

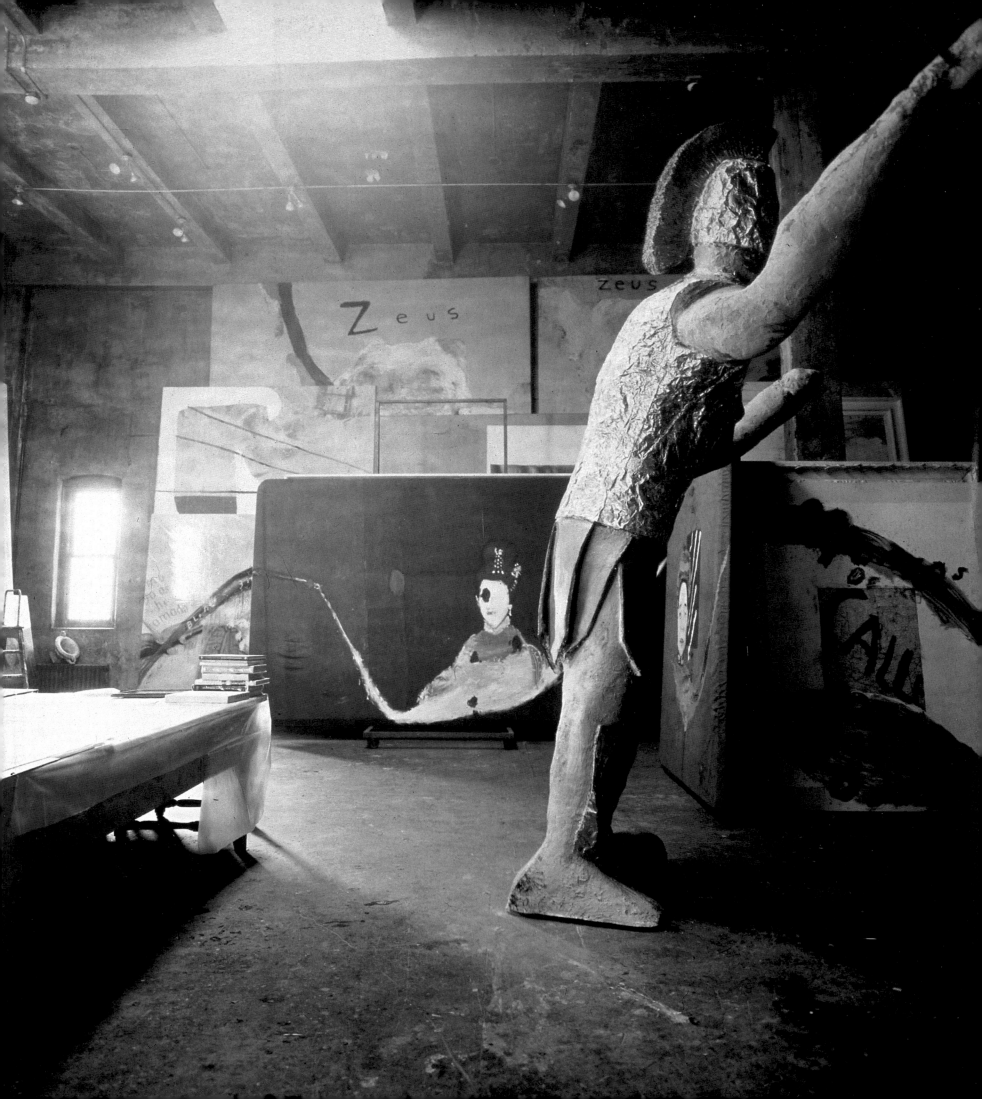

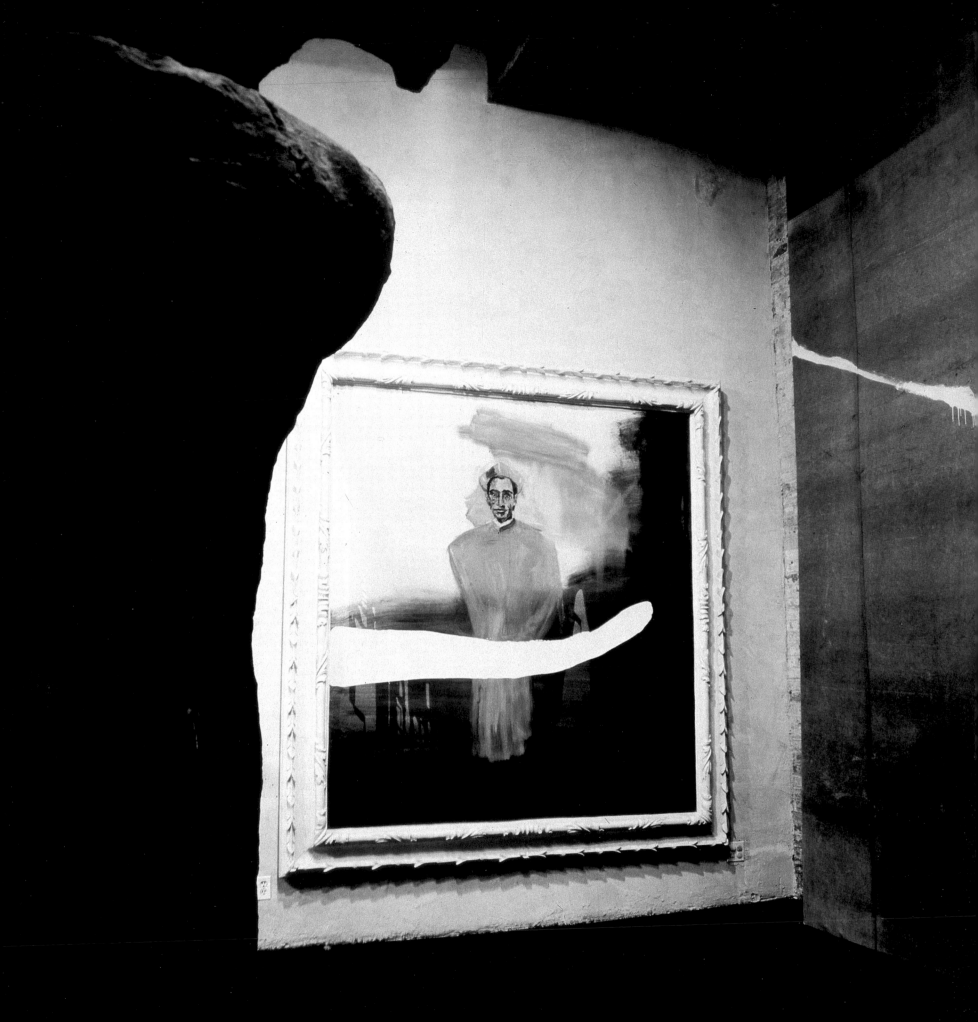

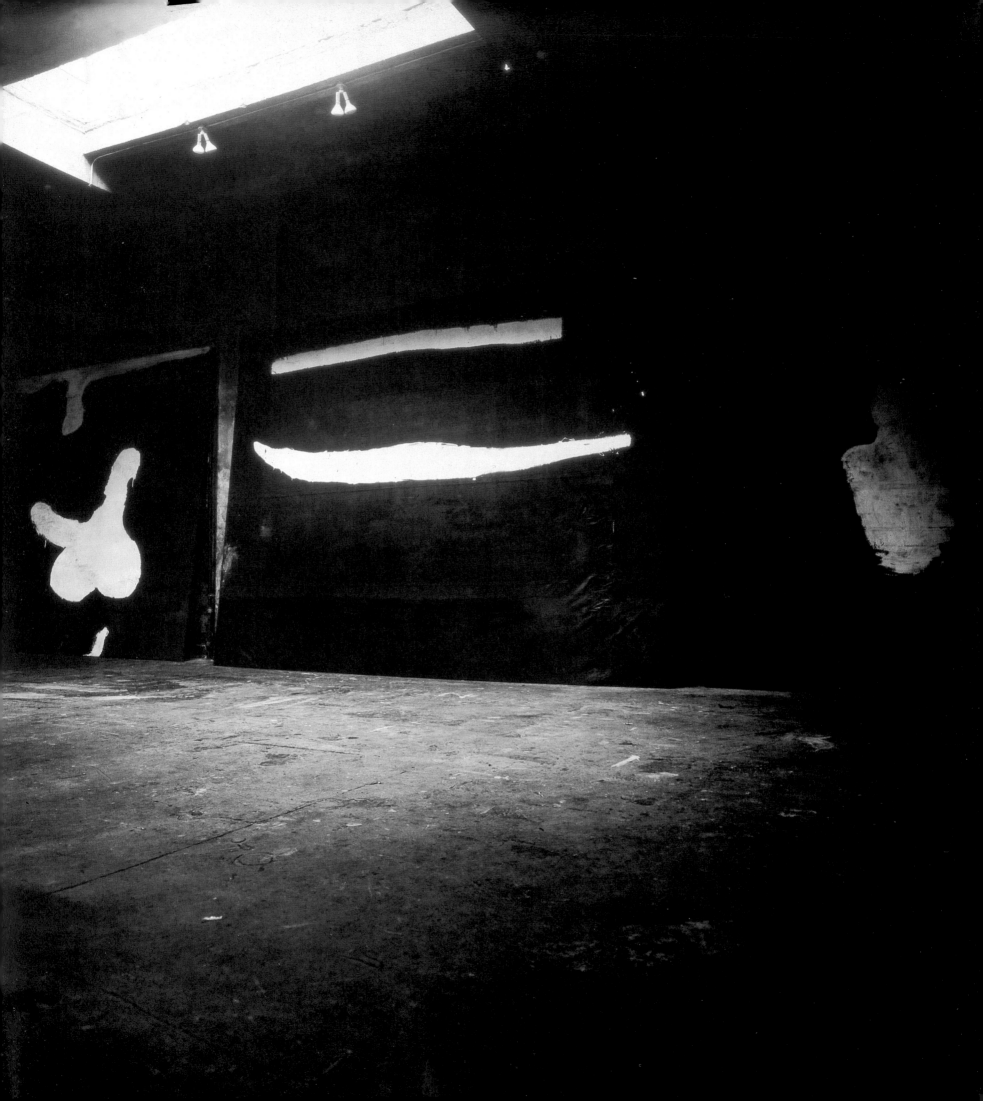

JULIAN SCHNABEL
MALEREI / PAINTINGS 1978–2003

Herausgegeben von / edited by MAX HOLLEIN

Mit Beiträgen von / with contributions by MARIA DE CORRAL

ROBERT FLECK

MAX HOLLEIN

INGRID PFEIFFER

KEVIN POWER

HATJE CANTZ

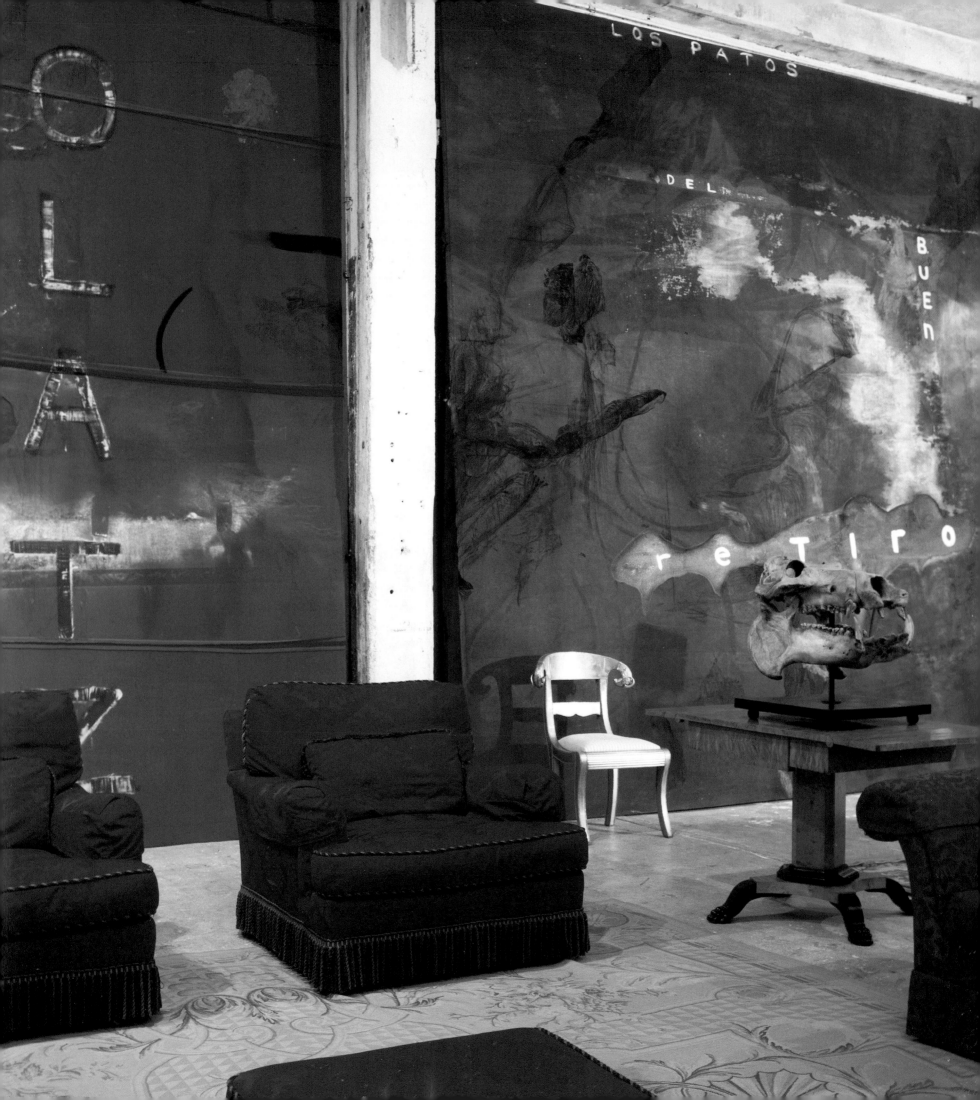

Contents / Inhalt

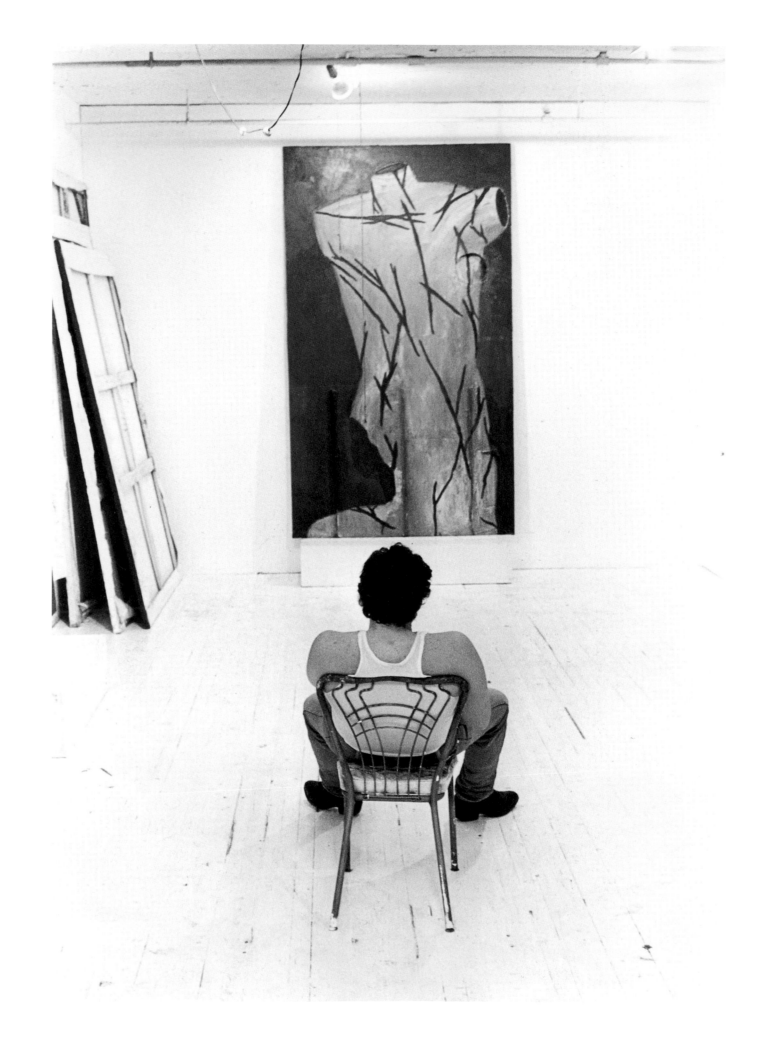

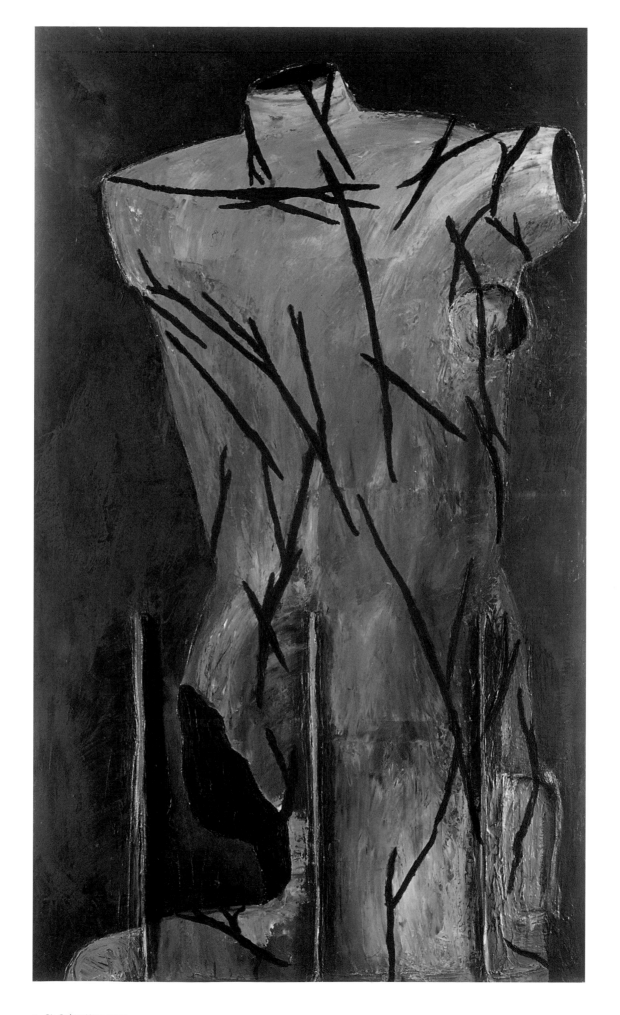

3 St. Sebastian, 1979

MAX HOLLEIN **Foreword**

Vorwort

I did not personally experience the spectacular ascent of the young Julian Schnabel in the late seventies and early eighties, the hysterical excitement surrounding his first exhibitions at the Mary Boone Gallery in 1979, or the even more legendary double exhibition there and at the Leo Castelli Gallery in 1981; I was simply too young at that time. But I was all the more aware of the late eighties and the shift of people's enthusiasm into a harsh, heated, and particularly critical debate about art of the previous decade in light of the waning boom in the art market. Even then, I was highly interested in the art first publicly presented at that time, and attempted to view these works not in the context of an emotionally charged protest against them, but instead to consider the works themselves in an unbiased manner.

The figure of Julian Schnabel naturally plays as fascinating a role here as Schnabel the painter. Due to his outstanding international success, his particular perspective as a painter, and his worldwide omnipresence, Schnabel was forced, willingly or not, to serve as a symbol for an entire artistic scene in the eighties. He was the central figure around whom criticism polarized. This led to a treatment of Schnabel's work which was as intense as it was superficial: a debate that at times revolved more around aspects of his person and his position in the art market than serious artistic criticism of his work itself.

In the past year, the Schirn Kunsthalle in conjunction with the Centre Pompidou in Paris and the Kunsthalle in Vienna featured the exhibition "Dear Painter, Paint Me," addressing a new generation of painters as well as the timelessness of the medium of painting, especially in the context of our multimedia society. Many of these artists studied in the eighties, and inevitably Julian Schnabel was for them, in one way or another, a benchmark, an archetype, a counter-position, or a giant to be toppled in the changing of the generational guard. I am constantly surprised how intensely a range of young artists have examined his work. Not only in this context is it more than essential, seventeen years after the last large Schnabel presentation in Germany, to reconsider Schnabel's work—from a new, contemporary perspective and with a fresh, unbiased view. One should concentrate on the painting itself in this process and disregard the nu-

Den kometenhaften Aufstieg des jungen Julian Schnabel Ende der siebziger, Anfang der achtziger Jahre, die hysterische Begeisterung rund um seine ersten Ausstellungen in der Mary Boone Gallery 1979 und die noch legendärere Doppelausstellung ebendort gemeinsam mit der Leo Castelli Gallery 1981 habe ich persönlich nicht miterlebt. Dafür war ich damals einfach noch zu jung. Das Ende der achtziger Jahre, der Wandel der Begeisterung in eine sehr harsch geführte, leidenschaftliche und vornehmlich kritische Debatte über Kunst des gerade erst ausgeklungenen Jahrzehnts angesichts des abflauenden Kunstmarktbooms ist aber umso präsenter. Schon damals habe ich mich intensiv mit der Kunst, die in dieser Zeit erstmals an die Öffentlichkeit trat, auseinander gesetzt und versucht, diese Arbeiten nicht im Kontext einer emotional aufgeladenen Gegenstimmung zu sehen, sondern unvoreingenommen das Werk selbst zu betrachten.

Die Figur Julian Schnabel spielt hier natürlich eine ebenso faszinierende Rolle wie der Maler Schnabel. Wohl aufgrund seines herausragenden internationalen Erfolgs, seiner besonderen Position als Maler und seiner weltumspannenden Omnipräsenz musste Schnabel, willentlich oder nicht, als Symbol für eine ganze Generation, für eine ganze Kunstszene in den achtziger Jahren herhalten. Er war die Leitfigur und an ihm polarisierte sich die Kritik. Dies führte zu einer ebenso heftigen wie oberflächlichen Auseinandersetzung mit Schnabels Werk, die sich gelegentlich mehr in Aspekte rund um seine Person und seine Position am Kunstmarkt verrannte als seriöse Kunstkritik an den Arbeiten selbst zu betreiben.

Im letzten Jahr zeigte die Schirn Kunsthalle gemeinsam mit dem Centre Pompidou und der Kunsthalle Wien die Ausstellung *Lieber Maler, male mir* und thematisierte damit eine neue Generation von Malern sowie die zeitlose Aktualität des Mediums Malerei gerade im Kontext unserer multimedialen Gesellschaft. Viele dieser Künstler studierten in den achtziger Jahren, und Julian Schnabel war für sie unweigerlich auf die eine oder andere Weise ein Bezugspunkt, ein Vorbild, eine Gegenposition oder eine Größe, die es im Sinne einer Generationsablösung zu stürzen galt. Immer wieder bin ich überrascht, wie intensiv sich eine Reihe von jungen Künstlern mit dem Werk von Julian Schnabel auseinandergesetzt hat. Nicht nur in diesem Zusammenhang ist es nun,

merous—undoubtedly attractive—stories related to Schnabel as a star of the art market and a dazzling icon of the artistic scene—along with the fact that as a director he has in the meantime generated great enthusiasm for his movies *Basquiat* (1996) and especially *Before Night Falls* (2000), despite being a self-taught newcomer to the medium of film. Based on a selective range of works, this exhibition shall—and must—focus on Schnabel's paintings of the past twenty-five years.

In this context, the artist himself naturally deserves my most sincere gratitude. This project was an absolute pleasure. One really should not make such a simple statement regarding the preparation of a solo exhibition of a contemporary artist, especially not in a catalogue, due to the risk of either being accused of lying hypocritically or being identified as the curatorial puppet of the artist himself. But especially in working with Julian Schnabel, such a statement is completely appropriate, important even. He has the reputation of being not only difficult, but also a notorious egomaniac. When we met in his New York studio two years ago to discuss the general idea of putting on a comprehensive retrospective—the pieces for which I alone wanted to personally select from his meanwhile enormous collection of works—it was in fact surprising that Julian Schnabel quickly agreed. After touring the premises together, we decided on the Schirn Kunsthalle in Frankfurt not only as the perfect site for the most comprehensive exhibition of Julian Schnabel's painting up to now, but also as the starting point for a large traveling show. Characteristic traits of Schnabel, ones which also emerge in his work, are his charming and relaxed manner of dealing with his environment and the generosity he displays, both towards other artists and his own work. Just as there is no clear path in the progression of his work, he himself is less interested in continuity, and much more in exploring boundaries and others' opinions, especially of course of the younger generation; for this I cannot thank him enough. I am also grateful to his wife Olatz, who not only agreed to yet another project within an already eventful and intense family and professional life, but who also has to endure that many pieces from their private collection are on loan for the duration of this exhibition.

17 Jahre nach der letzten großen Schnabel-Präsentation in Deutschland, mehr als notwendig, das Werk von Schnabel zu betrachten – aus einer neuen, aktuellen Perspektive, mit einem frischen, vorurteilslosen Blick. Dabei sollte man sich auf die Malerei selber konzentrieren und die vielen, sicherlich attraktiven Geschichten rund um die Figur Schnabel als Kunstmarktstar und schillernde Gestalt der Szene außer acht lassen – ebenso auch die Tatsache, dass er mittlerweile auch als Regisseur mit seinen Filmen *Basquiat* (1996) und insbesondere *Before Night Falls* (2000) als vollkommener Neuling und Autodidakt in diesem Medium große Begeisterung hervorgerufen hat. In dieser Ausstellung soll und muss anhand einer selektiven Auswahl Schnabels Malerei der letzten 25 Jahre im Vordergrund stehen.

Mein größter Dank in diesem Zusammenhang gilt natürlich dem Künstler selbst. Dieses Projekt war ein absolutes Vergnügen. An sich sollte man eine solche simple Feststellung in Zusammenhang mit der Vorbereitung einer Einzelausstellung eines aktuellen Künstlers nicht äußern, schon gar nicht in einem Katalog. Läuft man doch sofort Gefahr, entweder der heuchlerischen Lüge bezichtigt oder als vermeintliche kuratorische Marionette des Künstlers identifiziert zu werden. Doch gerade wenn man mit Julian Schnabel zusammenarbeitet, ist eine solche Feststellung durchaus angebracht, ja sogar wichtig. Ihm eilt bisweilen der Ruf voraus, nicht nur schwierig, sondern auch ein berüchtigter Egomane zu sein. Als wir vor zwei Jahren in seinem New Yorker Studio über die grundsätzliche Idee sprachen, eine umfassende Retrospektive zu zeigen – wobei ich aus seinem mittlerweile enorm großen Werk alleine und sehr persönlich auswählen wollte –, war es doch überraschend, dass Julian Schnabel sehr rasch einwilligte und wir nach einer gemeinsamen Besichtigung der Räumlichkeiten in Frankfurt die Schirn nicht nur als perfekten Ort der bisher wohl umfassendsten Ausstellung zur Malerei von Julian Schnabel bestimmen, sondern auch als Ausgangspunkt für eine große Ausstellungstournee fixieren konnten. Ein Wesenszug von Schnabel, der sich wohl auch in seinen Werken zeigt, ist der charmante und lockere Umgang mit seiner Umgebung und die Großzügigkeit, die er an den Tag legt, sowohl in Bezug auf andere Künstler als auch in Bezug auf sein Werk selbst. So wie es in

It would have been nearly impossible to realize both the exhibition and the catalogue without the great help and support of Dan Parker and Bianca Turetsky from Julian Schnabel's studio in New York; I owe them my heartfelt thanks.

In the context of reexamining Schnabel's work, we were able to acquire Robert Fleck, the new director of the Deichtorhallen Hamburg, as catalogue author, as well as Kevin Power, the new associate director of the Museo Nacional Centro de Arte Reina Sofia in Madrid (our cooperation partner and second location of the traveling exhibition), and María de Corral, the guest curator there of the Schnabel exhibition. Ingrid Pfeiffer, curator at the Schirn, developed a biography based on quotes from Julian Schnabel and long discussions with the artist regarding central themes in the development of his work. I wish to extend warm thanks to all the authors for their contributions.

I am especially grateful to the various lenders, without whose generous support important main pieces would be missing in the exhibition. They include Bruno Bischofberger and Caratsch, de Pury & Luxembourg in Zurich, as well as various private collectors who wish to remain anonymous.

We are especially delighted that after its presentation in Frankfurt, this exhibition will be shown in the Palacio Velázquez at Reina Sofia in Madrid, and subsequently at the Mostra d'Oltramare in Naples. I would like to thank our cooperation partners at Reina Sofia, especially Director Juan Manuel Bonet, Subdirector Kevin Power, visiting curator María de Corral, and the staff at Reina Sofia, Mónica Ruiz Bremón and Osbel Suarez, for their assistance. My warmest thanks also to Eduardo Cicelyn, director for cultural affairs of the Campania region, and Antonio Bassolino, the president of the Campania region, in Naples for their cooperation.

As a Kunsthalle, only the partnership with internationally operating companies and the support of our friends and patrons offer us the opportunity of realizing such a sophisticated and complex project. We were able to attract Lehman Brothers International, and the Friends of the Schirn Kunsthalle as sponsors. We would especially like to thank Karl Dannenbaum of Lehman Brothers for the financial support of and enthusiastic interest in this project. We would also like to

der Abfolge seiner Arbeiten keinen klaren Weg gibt, so interessiert ihn selbst auch weniger die Kontinuität, sondern vielmehr das Testen und die Meinung anderer, insbesondere natürlich die einer jüngeren Generation. Dafür möchte ich mich bei ihm mehr als bedanken. Ebenso gilt mein Dank seiner Frau Olatz, der diese Ausstellung nicht nur ein weiteres Projekt innerhalb eines bereits sehr ereignisreichen und intensiven Familien- und Arbeitslebens beschert hat, sondern die auch erdulden muss, dass große Teile der privaten Sammlung für die Dauer der Ausstellung ihre normalen Orte der Präsentation verlassen.

Ohne die große Hilfe und Unterstützung von Dan Parker und Bianca Turetsky in Julian Schnabels Atelier in New York hätten sich die Ausstellung und der Katalog kaum verwirklichen lassen, ihnen danke ich sehr herzlich dafür.

Im Sinne einer Neubetrachtung des Werks haben wir als Katalogautoren Robert Fleck, den neuen Direktor der Deichtorhallen in Hamburg sowie auf der Seite unserer Kooperationspartner und der zweiten Station der Ausstellung im Museo Nacional Centro de Arte Reina Sofia in Madrid den neuen Vize-Direktor Kevin Power und die dortige Gastkuratorin der Schnabel-Ausstellung María de Corral gewinnen können. Die Schirn-Kuratorin Ingrid Pfeiffer hat eine Biografie anhand von Zitaten und nach langen Gesprächen mit dem Künstler rund um zentrale Themen seiner Werkentwicklung erarbeitet. Allen Autoren sei hiermit für ihre Beiträge herzlich gedankt.

Besonders dankbar bin ich allen Leihgebern, ohne deren großzügige Unterstützung zentrale Hauptwerke in der Ausstellung fehlen würden, darunter Bruno Bischofberger und Caratsch, de Pury & Luxembourg in Zürich, sowie einer Reihe von privaten Sammlern, die nicht namentlich genannt werden wollen.

Es ist für uns eine besondere Freude, dass diese Ausstellung nach ihrer Präsentation in Frankfurt im Palacio Velázquez der Reina Sofia in Madrid und danach auch im Mostra d'Oltramare in Neapel gezeigt wird. Hierfür und für ihre Hilfe möchte ich unseren Kooperationspartnern von Seiten der Reina Sofia, insbesondere Juan Manuel Bonet, Direktor, Kevin Power, Gastkuratorin María de Corral sowie den Mitarbeitern

express our gratitude to the members of our association of Friends, chaired by Christian Strenger, for their ongoing support, particularly of this project. We would also like to thank the Georg und Franziska Speyer'sche Hochschulstiftung for making this publication possible. For their personal support we would like to thank Peggy and Karl Dannenbaum.

As with every exhibition, we are again indebted to the city of Frankfurt and, on behalf of all decision-makers, Mayor Petra Roth and the head of the city's Department of Culture, Hans-Bernhard Nordhoff, who make our work possible in the first place.

In designing the advertising campaign, Holger Lutz and especially Dieter Romatka, Sandra Voit, Wilhelm Dehmel, and their team from the advertising agency Saatchi & Saatchi have again demonstrated their outstanding creative efforts and untiring enthusiasm. We would also like to thank our media partners at the newspaper Die Welt/Welt am Sonntag, the German edition of Vogue magazine, and especially our corporate partner CineStar Metropolis, specifically Elke Beeck and Kai Lauterbach, who through their unconventional and enthusiastic efforts have enabled us to show the trailer developed by Julian Schnabel for the exhibition.

I would especially like to thank the team at the Schirn Kunsthalle Frankfurt for their great enthusiasm and commitment during all phases of the exhibition's development:

Ingrid Pfeiffer has accompanied this project with me from the very beginning and always maintained control over the innumerable aspects of an exhibition that is truly complex and large, not merely in its number of works. I am very grateful to her for the professional realization of the exhibition and for her enthusiastic and imaginative curatorial contributions to the exhibition and the catalogue.

I am also indebted to Carla Orthen, who provided important assistance in editing the catalogue and preparing the exhibition, as well as to Ronald Kammer for the technical direction, Karin Grüning and Elke Walter for organizing the works on loan, Andreas Gundermann and the installation team along with Stefanie Gundermann for conservational assistance, Inka Drögemüller and Lena Ludwig for marketing and attending to sponsors and partners, Dorothea Apovnik and Jürgen Budis for managing the press office, as well as

der Reina Sofia Mónica Ruiz Bremón und Osbel Suarez danken. In Neapel danke ich für die Kooperation Eduardo Cicelyn, Direktor des Führungsstabs für kulturelle Angelegenheiten der Regione Campania und Antonio Bassolino, dem Präsidenten der Regione Campania, sehr herzlich.

Nur die Partnerschaft mit international agierenden Unternehmen sowie die Unterstützung von unseren Freunden und Förderern bietet uns als Kunsthalle die Möglichkeit, ein solch anspruchsvolles und aufwändiges Projekt zu realisieren. Als Sponsoren konnten wir Lehman Brothers International und den Verein der Freunde der Schirn Kunsthalle gewinnen. Wir danken hier insbesondere Karl Dannenbaum von Lehman Brothers für das finanzielle Engagement und das enthusiastische Interesse für dieses Projekt. Unser großer Dank geht auch an die Mitglieder unseres Freundeskreises unter dem Vorsitz von Christian Strenger für die finanzielle Unterstützung insbesondere dieses Projekts und an die Georg und Franziska Speyer'sche Hochschulstiftung, die die Publikation zur Ausstellung ermöglicht hat. Für ihr persönliches Engagement danken wir Peggy und Karl Dannenbaum.

Grundsätzlich gilt unser Dank wie bei jeder Ausstellung der Stadt Frankfurt und stellvertretend für alle Entscheidungsträger der Oberbürgermeisterin Petra Roth und dem Kulturdezernenten Hans-Bernhard Nordhoff, durch die unsere Arbeit überhaupt erst ermöglicht wird.

Holger Lutz und insbesondere Dieter Romatka, Sandra Voit, Wilhelm Dehmel und ihr Team von der Werbeagentur Saatchi & Saatchi haben bei der Gestaltung der Werbekampagne wieder einmal ihren herausragenden kreativen Einsatz und ihr unermüdliches Engagement gezeigt. Unser großer Dank gilt auch unseren Medienpartnern Die Welt/Welt am Sonntag, der deutschen Vogue und insbesondere unserem Corporate Partner CineStar Metropolis, namentlich Elke Beeck und Kai Lauterbach, die uns einmal mehr durch ihren unkonventionellen und enthusiastischen Einsatz ermöglicht haben, den von Julian Schnabel entwickelten Kinospot zur Ausstellung zu zeigen.

Für ihr hohes Engagement in allen Phasen der Entstehung danke ich vor allem dem Team der Schirn Kunsthalle Frankfurt: Ingrid Pfeiffer hat dieses Projekt von Anfang an gemeinsam mit mir begleitet und die unzähligen Aspekte ei-

Simone Boscheinen, who together with Irmi Rauber developed the educational program, and all other staff who played a role in the organization and complicated technical and logistic realization of the exhibition.

Finally, I would especially like to thank Hatje Cantz Publishers, in particular Karin Osbahr and Tas Skorupa for their—as always—reliable editing and Andreas Platzgummer for designing the catalogue.

Max Hollein
Director
Schirn Kunsthalle Frankfurt

ner nicht nur in der Dimension seiner Werke wahrlich großen und komplexen Ausstellung jederzeit unter Kontrolle gehabt. Für diese professionelle Umsetzung und auch für ihre engagierte und ideenreiche kuratorische Beteiligung an der Ausstellung und am Katalog möchte ich ihr herzlich danken. Gedankt sei auch Carla Orthen, die eine wichtige Unterstützung bei der Katalogredaktion und bei der Vorbereitung der Ausstellung war, ebenso Ronald Kammer für die technische Leitung, Karin Grüning und Elke Walter für die Organisation der Leihgaben, Andreas Gundermann und dem Hängeteam sowie Stefanie Gundermann für die restauratorische Betreuung, Inka Drögemüller und Lena Ludwig für das Marketing und die Betreuung der Sponsoren und Partner, Dorothea Apovnik und Jürgen Budis für die Pressearbeit ebenso Simone Boscheinen, die mit Irmi Rauber das pädagogische Programm entwickelt hat, und allen übrigen Mitarbeitern, die am Aufbau und an der komplizierten technischen und logistischen Realisierung der Ausstellung beteiligt waren.

Besonderer Dank gilt auch dem Hatje Cantz Verlag, hier ganz besonders Karin Osbahr und Tas Skorupa für das wie immer zuverlässige Lektorat sowie Andreas Platzgummer für die Gestaltung des Kataloges.

Max Hollein
Direktor
Schirn Kunsthalle Frankfurt

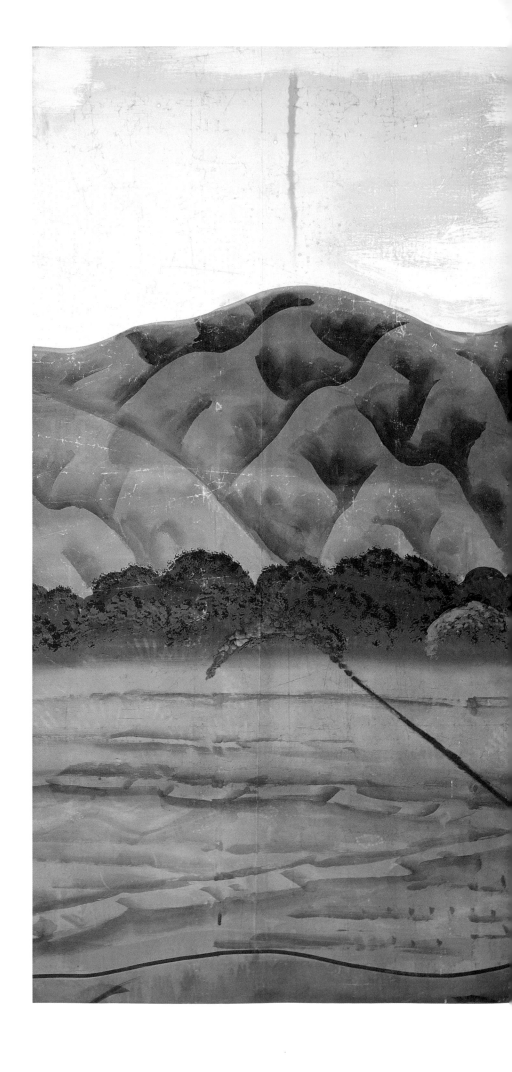

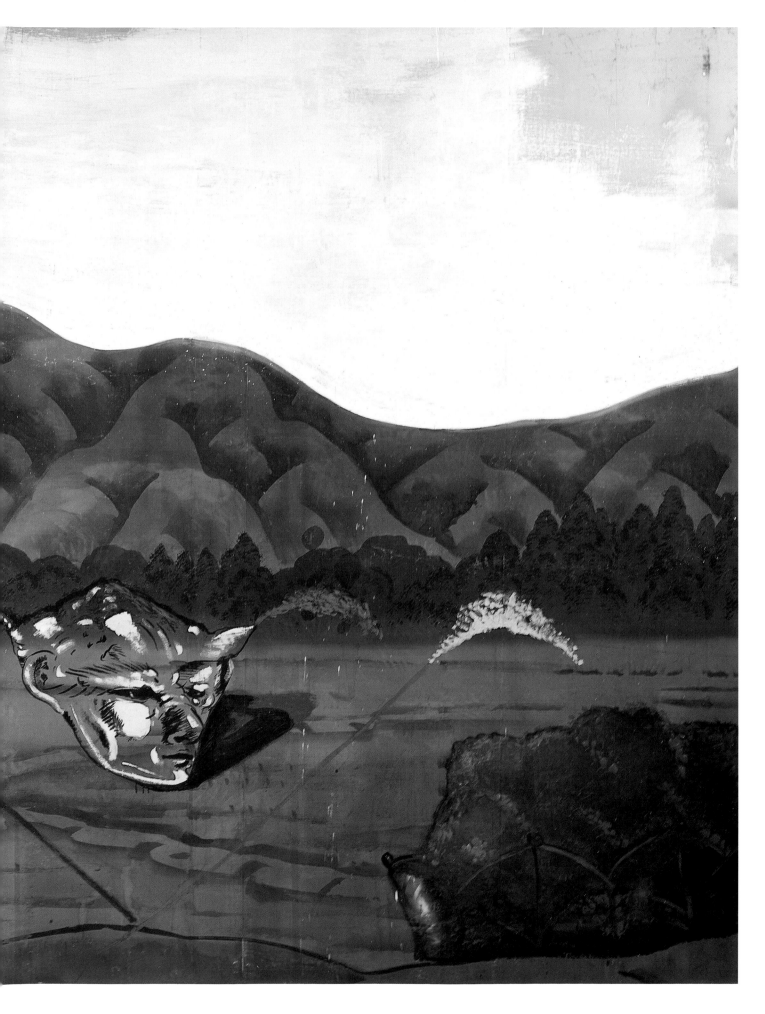

15　Eulalio Epiclantos after Seeing St. Jean Vianney on the Plains of the Cure d'Ars, 1986

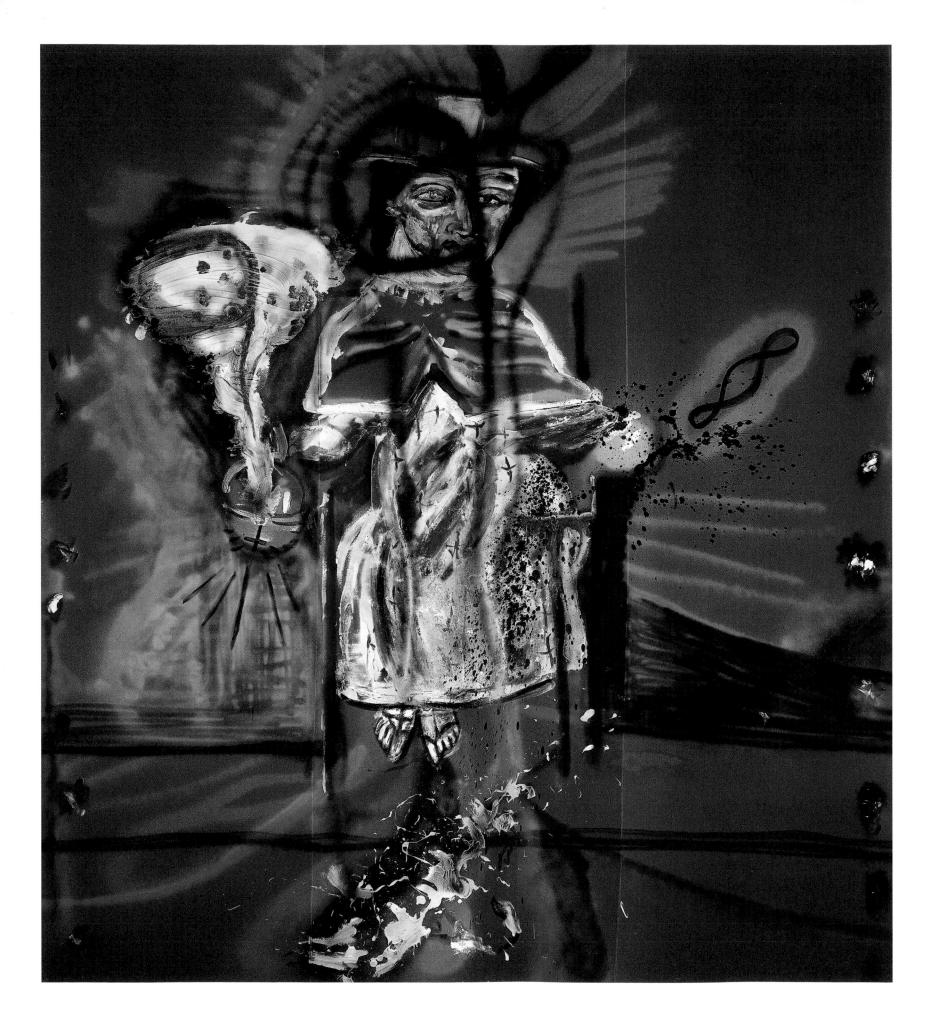

13 Resurrection: Albert Finney Meets Malcolm Lowry, 1984

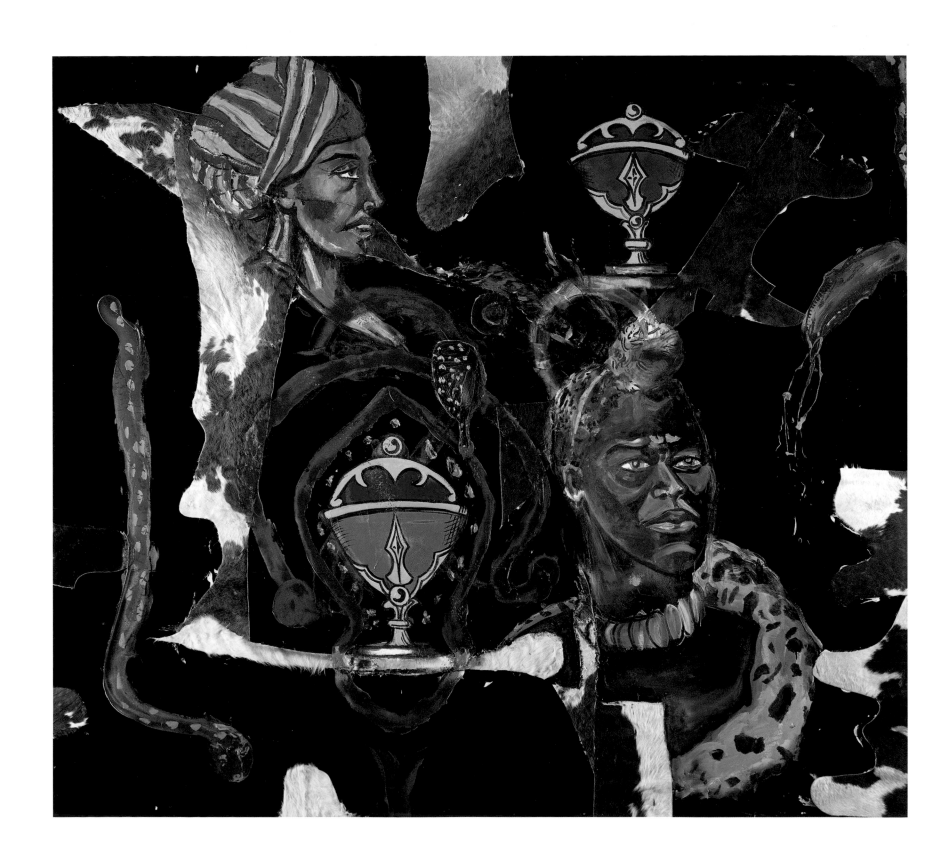

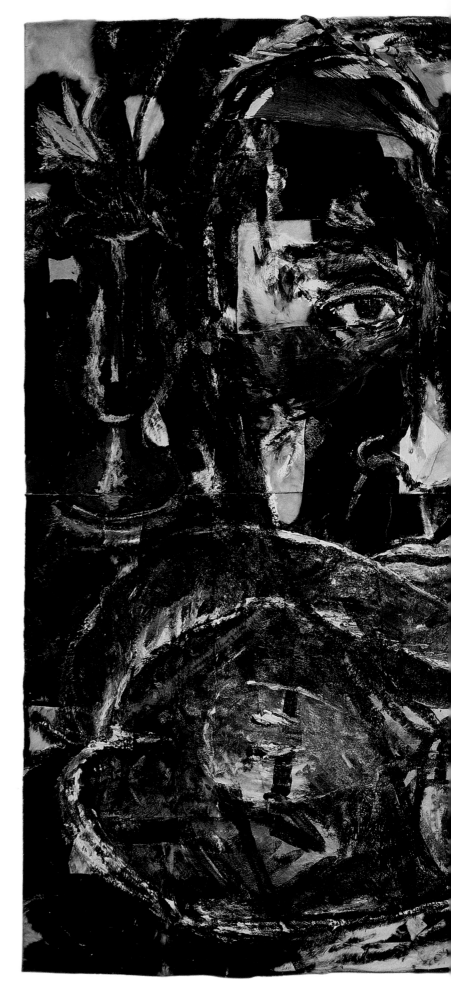

6 Prehistory: Glory, Honor, Privilege and Poverty, 1981

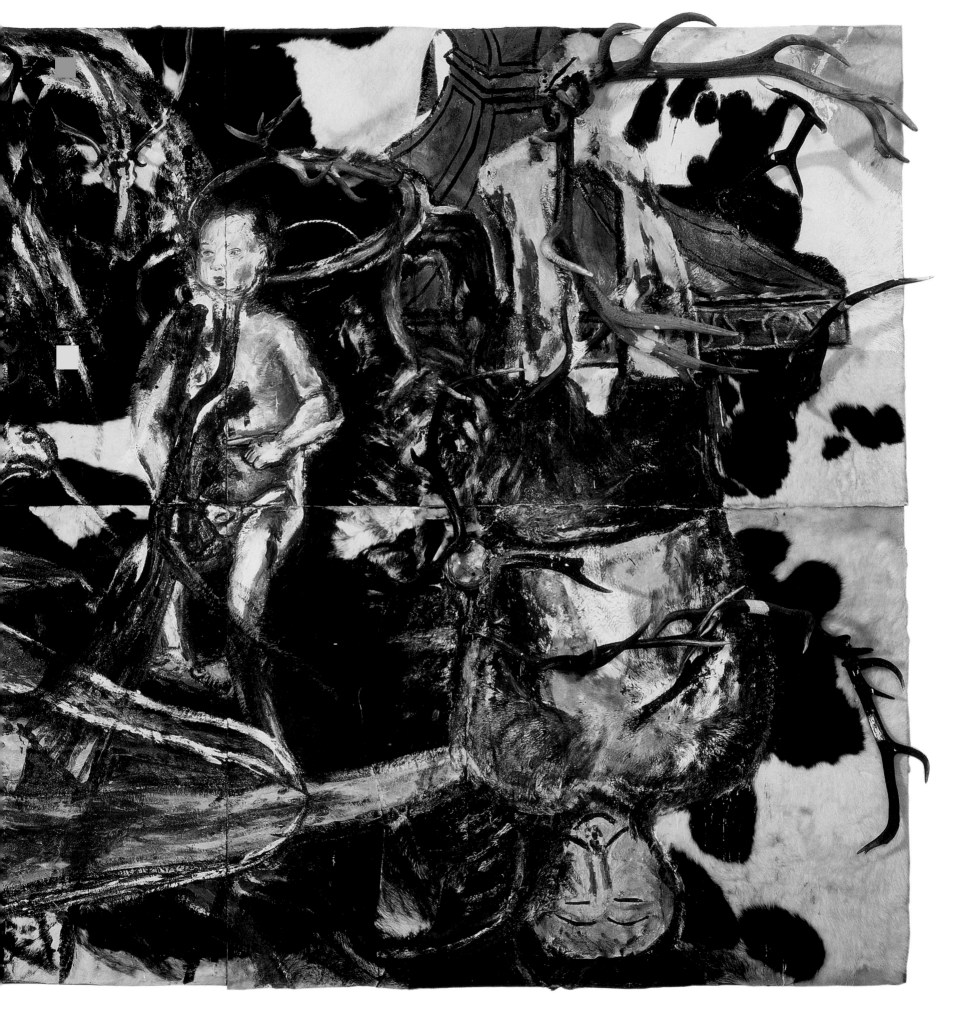

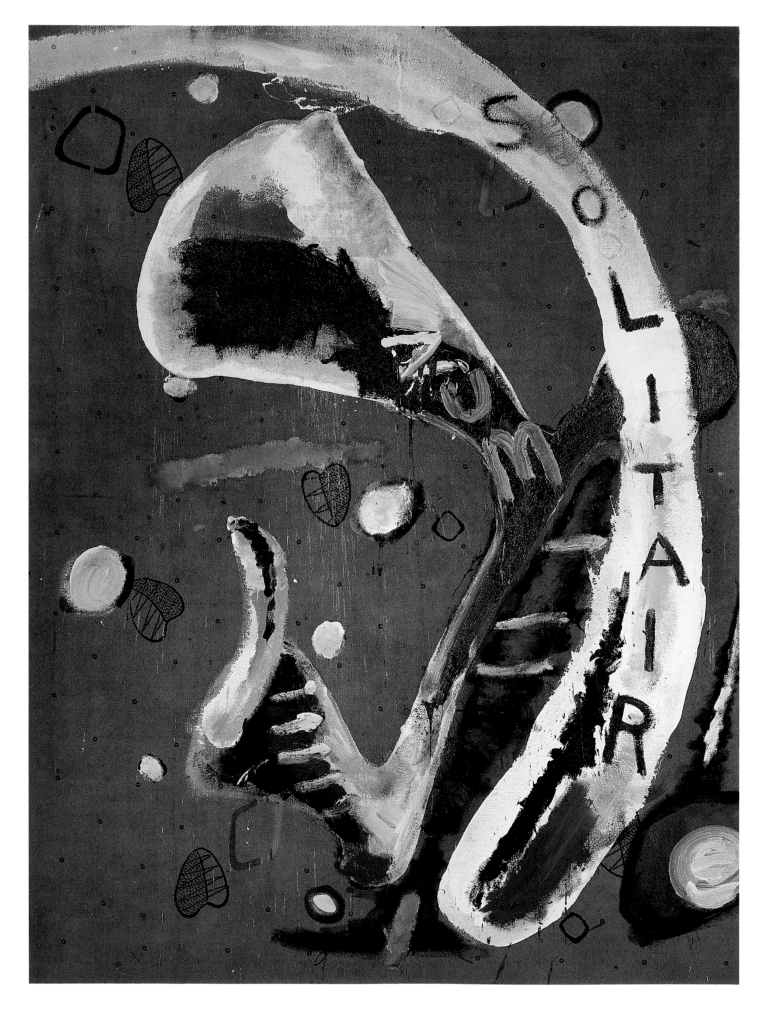

22 Zum Solitaire, 1988

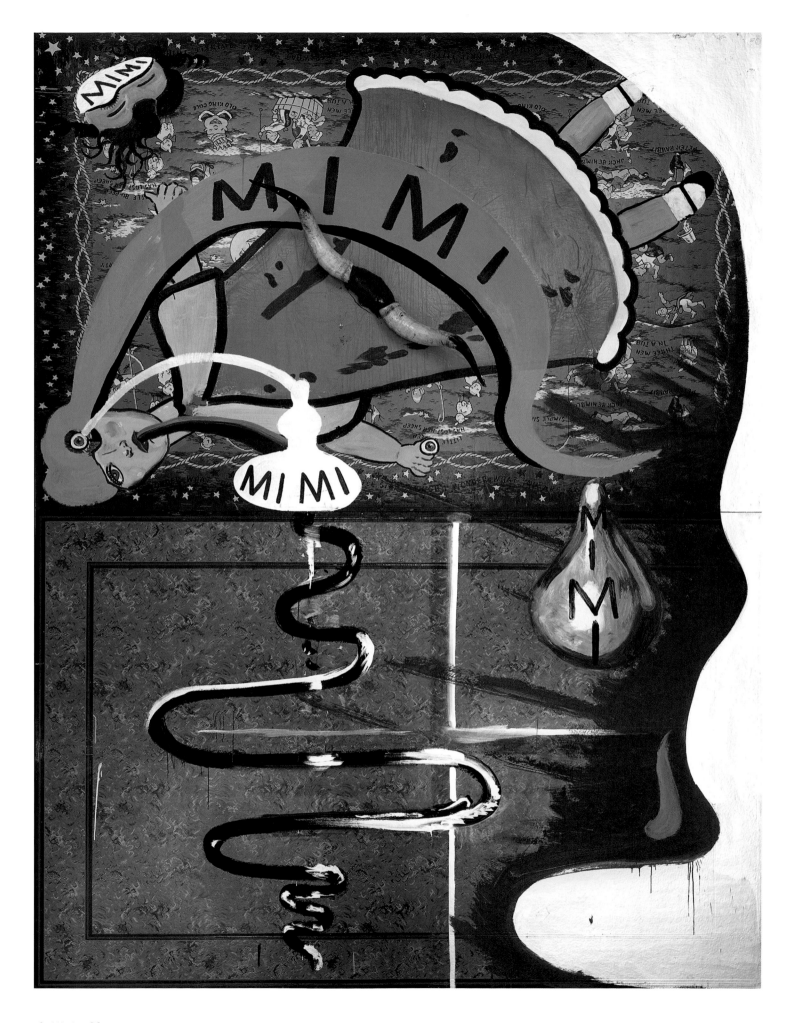

16 Mimi, 1986

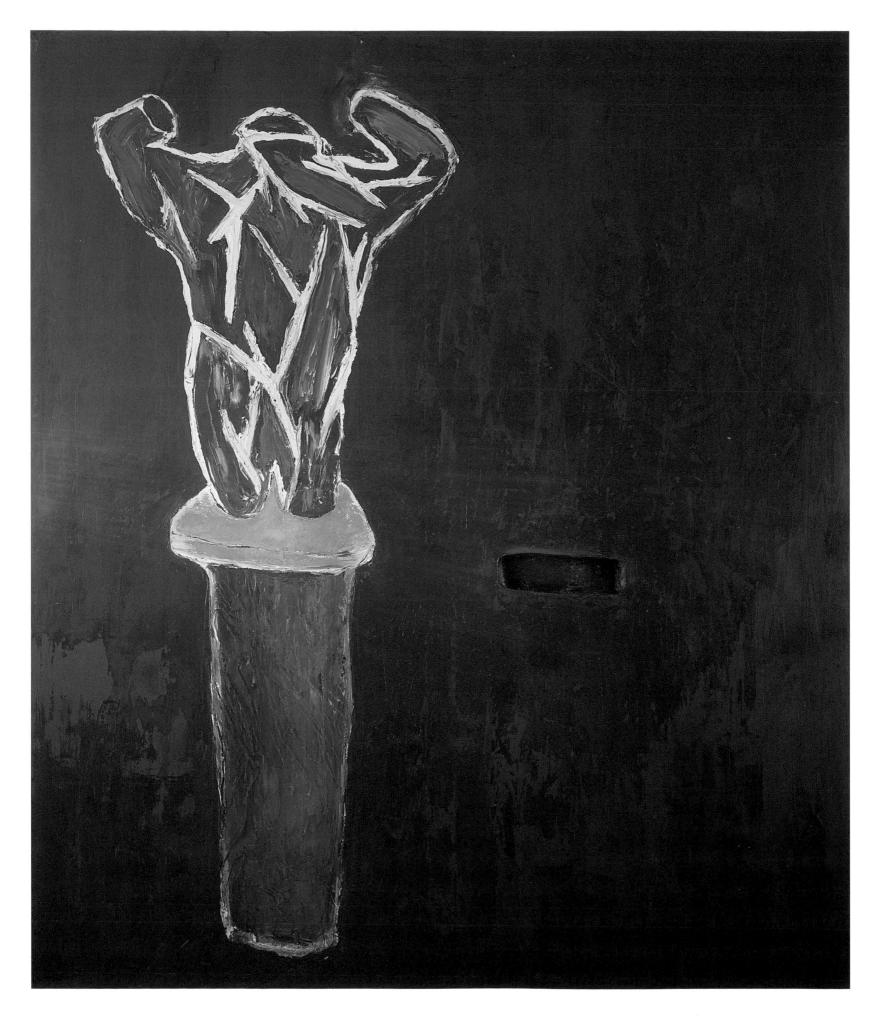

1 Accattone, 1978

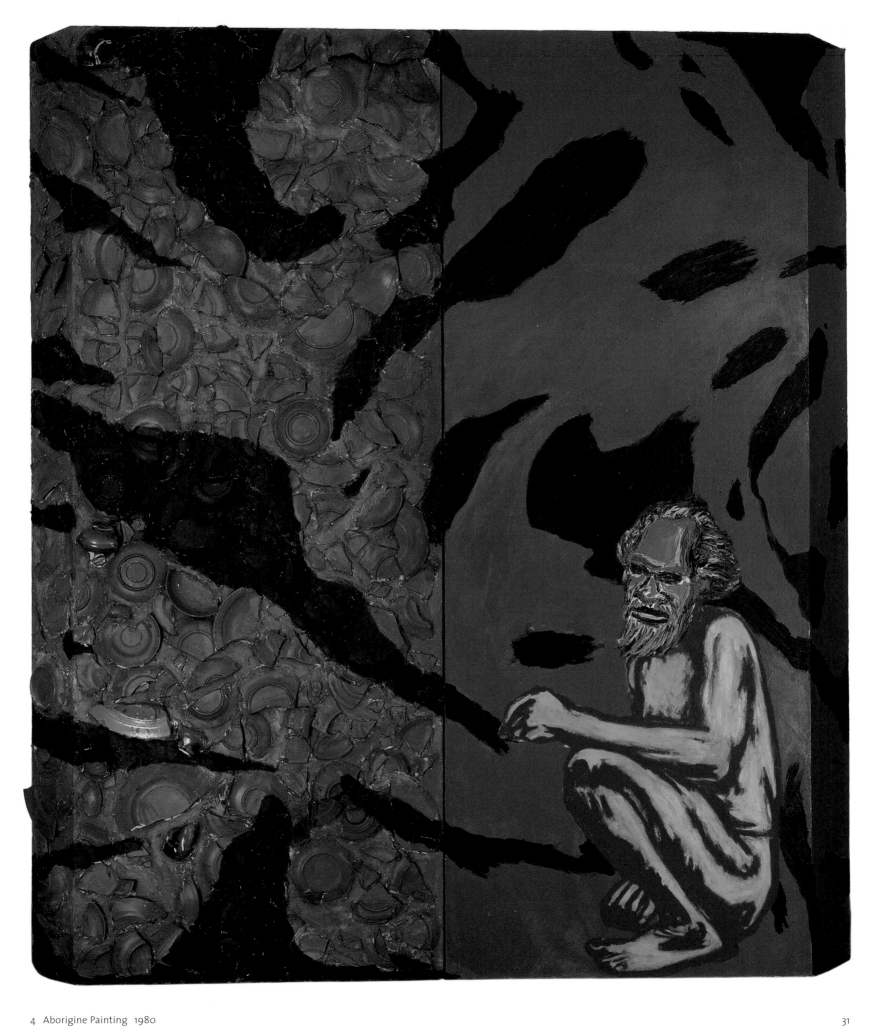

4 Aborigine Painting 1980

The Works and Their Viewers **Werk und Betrachter**

Demanding absolute artistic freedom, swimming against the stream of expectations, and constantly coming up with surprises—all of these are important elements of Julian Schnabel's personal and creative credo. He approaches each new group of works—and they are numerous, indeed—with a new spectrum of contents, stylistic elements, materials, and symbols. He does so tirelessly and with boundless enthusiasm, yet he does not simply drift along. As an artist, Schnabel knows exactly what he wants; once it is achieved, he then turns quickly to something new. He does not satisfy the public's longing for an all-encompassing framework, a definitive style. Thus what ultimately holds his oeuvre together is the fact that he is—and steadfastly remains—a painter. And this should not be taken for granted, since painting would seem at first glance to offer a very limited range of options, especially for an artist like Schnabel. We are surprised that Schnabel the painter still finds ways to expand the spectrum of artistic resources and usable materials again and again. Yet he remains true to the medium of painting. This restriction to "traditional" artistic means is important. Even in spite of his highly successful excursions into film and sculpture, painting remains the medium that lends responsibility, stability, and concentration to his creative process—precisely the qualities he needs in order to channel his creative energy.

Critics would only too gladly have categorized Schnabel as the Neo-Expressionist creator of the *Plate Paintings* (pp. 44–51). Many of those who hail him above all as the superstar of the eighties and focus exclusively on the *Plate Paintings* fail to credit this perhaps most eclectic of all American painters with any kind of parallel or progressive artistic development. And that is not the only reason why art historians schooled in convention find it difficult to feel comfortable with Julian Schnabel's works. Unpredictable as a painter, he may even be an art dealer's nightmare, despite his supposed status as an art-market celebrity. For no sooner have the public, critics, and collectors come to terms with one style and its characteristic features, he produces a completely different group of paintings that does not appear to have evolved from its predecessor. The artist himself has occasionally expressed surprise on his own part: "I do not know if it

Für sich absolute künstlerische Freiheit zu beanspruchen, gegen den Strom der Erwartungen zu schwimmen und dabei immer wieder zu überraschen, ist Teil des persönlichen und kreativen Selbstverständnisses von Julian Schnabel. Bei jeder neuen Werkgruppe – und davon gibt es wahrlich viele – arbeitet er mit einem neuen Spektrum von Inhalten, Stilmitteln, Materialien und Symbolen. Er tut dies unermüdlich mit einer uneingeschränkten Begeisterungsfähigkeit, lässt sich dann aber nicht treiben. Schnabel weiß als Künstler sehr genau, was er will, erreicht es und wendet sich dann mit rasantem Tempo Neuem zu. Die Sehnsucht des Publikums nach einer alles umfassenden Klammer, einem prägenden Stil wird von ihm nicht befriedigt. Der Gesamtzusammenhalt seines Schaffens entsteht insofern zuallererst dadurch, dass er Maler ist und bleibt. Dies ist durchaus nicht vorauszusetzen, denn gerade bei einem Künstler wie ihm stellt die Malerei auf den ersten Blick ein durchaus limitiertes Handwerkszeug dar. Es ist überraschend, dass es dem Maler Schnabel weiterhin gelingt, das Spektrum der künstlerischen Mittel und der einsetzbaren Materialien permanent zu erweitern. Dabei bleibt er aber prinzipiell der Malerei als Medium treu. Die Einengung auf diese – wenn man will, traditionelle – künstlerische Ausdrucksform ist wichtig. Auch unter Berücksichtigung seiner sehr erfolgreichen Exkursionen in den Film oder in die Skulptur ist es die Malerei, welche seinem Schaffensprozess die Verantwortung, Stabilität und Konzentration verschafft, die notwendig sind, um eben diesen zu kanalisieren.

Nur zu gerne hätte man Schnabel als neoexpressionistischen Maler der *Plate Paintings* (S. 44–51) wegkategorisiert. Viele, die ihn zuallererst als Superstar der achtziger Jahre bezeichnen und sich ausschließlich auf die *Plate Paintings* beziehen wollen, sprechen so gerade dem amerikanischen Maler mit dem vielleicht eklektischsten Stil jegliche Parallel- und Weiterentwicklung ab. Nicht nur deswegen scheint sich das herkömmlich geschulte Auge des Kunsthistorikers an Julian Schnabels Arbeiten schwer gewöhnen zu können. Als Maler unberechenbar, ist er trotz seines vermeintlichen Status als Kunstmarktstar vielleicht sogar der Albtraum eines jeden Kunsthändlers. Denn haben sich Publikum, Kritik und Sammler einmal auf einen Stil und seine Merkmale eingelassen, dann kommt bereits die nächste, vollkommen andersge-

was a conscious decision, but I never seemed to be able to make work that went with the painting that came just before it."[1] He does not regard style as a formal matter but part of a fundamental artistic attitude. Early on, Schnabel had an inkling of what has since become a reality of his oeuvre: "I suggest that style is the effect or character, armed with intensity, a sense of purpose, a method, a syntax that reveals the will and need to make something. Style is the fringe benefit of intention and action completed."[2] Thus Schnabel progresses from one painting to the next in a chain of associations and with an evolving style whose history perhaps only he himself could accurately trace. He works with a wide range of materials, including oil, wax, emulsion, and plaster. He paints on canvas, wood, Masonite, shards, rags, velvet, muslin, and tarpaulins, and has not shied away from using even surfboards as a painting surface.

Pursuing this fascination with the material characteristics of surface and his love of *objets trouvés,* which he incorporates into his paintings, Schnabel introduced a new, playful material quality into contemporary painting in the late seventies—and it stands in stark contrast to the Minimalist reduction of that time. A found painting surface, such as an old tarpaulin, a dark-colored velvet, or a panel from a stage set, already has its own structure and history. Such surfaces are not neutral; they are not passive, but instead already have a voice of their own and the power to evoke a mood.[3] Inevitably, a new and totally autonomous architecture and structure of the painting emerges from such a surface. Historical elements (such as clay shards or art prints) as well as everyday objects (photographs, pieces of leather, antlers, etc.) become part of the work. Schnabel uses the past histories of these objects as points of reference, for "using already existing materials establishes a level of ethnographicness in the work; I mean it brings a real place and time into the aesthetic reality. Its selection can locate a place and time into the aesthetic reality. Its selection can locate a place, a cultural familiar or exotic, self-made or procured. This is the platform for the mental and physical structure within the painting."[4]

Schnabel's paintings take getting used to, each and every one of them. It is not that they are less accessible than oth-

artete Bildgruppe, ohne sich im Grunde evolutionär aus der vorherigen zu ergeben. Auch der Künstler selbst wirkt bisweilen darüber durchaus erstaunt: »Ich weiß nicht, ob es eine bewusste Entscheidung ist, aber ich scheine nicht in der Lage zu sein, Werke zu schaffen, die etwas mit den vorherigen zu tun haben.«[1] Stil ist für ihn nicht eine Frage des Formalen, sondern der grundsätzlichen künstlerischen Haltung. Schon sehr früh ahnte Schnabel, was für sein Œuvre Wirklichkeit wurde: »Ich vermute, dass Stil der Effekt oder Charakter, ausgestattet mit Intensität, ist, eine Art Zweck, Methode, Syntax, die den Willen und die Notwendigkeit, etwas zu tun, enthüllen. Stil ist der Nebeneffekt von Intention und ausgeführter Handlung.«[2] Schnabel entwickelt sich so von einem Bild zum nächsten in einer Assoziationskette und mit einer stilistischen Evolutionsgeschichte, die wohl nur er selbst in eine Reihe bringen könnte. Dabei arbeitet er mit den unterschiedlichsten Materialien wie Öl, Wachs, Emulsion oder Gips. Als Malgrund verwendet er Leinwand, Holz, Masonit, Scherben, Lumpen, Samt, Musselin, Abdeckplanen und macht sogar vor Surfbrettern nicht halt.

Schnabel führt mit diesem Hang zur materialbestimmten Oberfläche und seiner Vorliebe für Objets trouvés, die er in seine Bilder inkorporiert, Ende der siebziger Jahre wieder eine neue, spielerische Materialität in die zeitgenössische Malerei ein, die im deutlichen Gegensatz zur Reduktion des Minimalismus steht. Dabei besitzt ein gefundener Maluntergrund, wie etwa eine alte Abdeckplane, ein dunkelfarbiger Samtstoff oder ein Panel aus einer Theaterkulisse, bereits Struktur und Geschichte. Eine solche Oberfläche ist nicht neutral, ihre Beschaffenheit nicht passiv, sondern hat bereits eine eigene Stimme und kann per se eine Stimmung evozieren.[3] Jeweils eine vollkommen eigenständige, immer wieder neuartige Architektur und Struktur des Bildes muss sich unweigerlich darauf aufbauen. Ebenso werden historische Elemente (etwa alte Tonscherben oder Kunstdrucke) als auch alltägliche Dinge (Fotografien, Lederfetzen, Geweihe etc.) Teil der Arbeit. Schnabel nutzt die Vergangenheit dieser Objekte als Referenzpunkte, denn »bereits existierendes Material zu verwenden, bringt etwas Ethnographisches in die Arbeit; ich meine, damit werden ein realer Ort und eine reale Zeit in der ästhetischen Wirklichkeit angesiedelt. Mit der

ers but that they are more difficult to grasp, particularly for those who approach them from a standardized point of view and with preconceived expectations. This is surely not attributable to their enormous size alone. The individual work, the composition, appears to have been woven together, forming a web that may fall apart at any time. The linking of different strands and the juxtaposition of essentially incompatible elements at the levels of color, material, and even content give each work a dissonant quality. Schnabel does not make things easy for the viewer—his often extremely fragmentary combinations exert a kind of psychological pressure. The viewer must wrestle with Schnabel's painting, constantly being pulled forward and thrown back again. The artist achieves this effect again and again, in the fragile combination of hundreds of individual parts in the *Plate Paintings*, in the use of different materials, as in *Ethnic Types No. 15 and No. 72* (p. 25), by incorporating a huge number of figurative, narrative elements, as in *Prehistory* (pp. 26–27), or in the rough color confrontations of such paintings as *Untitled (View of Dawn in the Tropics)* (p. 122). In the midst of these deliberate collisions, the viewer is compelled by the work itself to submit to this powerful synthesis. Some may attempt to resist, but the effort will have been in vain. Schnabel's paintings do not strive for eternal balance; instead, they tip in many ways—both in composition and content. This erratic, sometimes destructive quality has a very interesting effect on our recollection of the works themselves. In attempting to reconstruct a mental picture of a painting by Julian Schnabel, one realizes that often only rudimentary details and abstract images have remained imprinted in one's memory. More so than with the works of many other painters, one actually has to stand in front of such a painting in order to grasp and respond to it. Even when he uses a reduced range of colors and focuses essentially on a single, central motif (something he achieves most strikingly in the so-called *Recognitions* series [pp. 68–72]), giving the paintings a more conceptual look, it is not the result of a deliberate strategic restriction of formal possibilities but rather a highly intuitive, associative approach. The selection, style, execution, and compositional embedding of the typographical elements in these works are surely worlds apart from the word elements in Ed Ruscha's

Auswahl wird ein bestimmter Standort festgelegt, sei er kulturell vertrauter oder exotischer Art, selbst entworfen oder vorgefunden. Dies ist die geistige und psychische Struktur im Bild.«[4]

Schnabels Arbeiten sind gewöhnungsbedürftig, jede einzelne von ihnen. Nicht, dass sie sich schwerer erschließen als andere, aber sie sind nicht leicht zu erfassen, falls man sich ihnen mit einem standardisierten Blick und einer vorgefestigten Erwartung nähert. Das hat sicherlich nicht nur mit ihrer oft enormen Größe zu tun. Das einzelne Werk, die Komposition, wirkt wie zusammengewebt in einem Netz, das jederzeit aufreißen kann. Das Verbinden unterschiedlichster Stränge und das Zusammenführen sich im Grunde abstoßender Elemente sowohl im Farblichen und Materiellen als auch im Inhaltlichen gibt den jeweiligen Arbeiten eine dissonante Qualität. Schnabel macht es dem Betrachter nicht leicht. Seine bisweilen extrem fragmentarischen Zusammenstellungen üben einen physischen Druck aus. Als Betrachter in das Bild hineingezogen und wieder zurückgeworfen, muss man mit Schnabels Werken ringen. Diesen Effekt erzeugt er immer und immer wieder, sei es durch die labile Kombination von Hunderten an Einzelteilen bei den *Plate Paintings*, sei es durch unterschiedlichste Materialien wie zum Beispiel bei *Ethnic Types No. 15 and No. 72* (S. 25) oder durch eine Unzahl von figurativ-narrativen Elementen wie etwa bei *Prehistory* (S. 26/27) ebenso wie in den rohen Farbkollisionen von Bildern wie *Untitled (View of Dawn in the Tropics)* (S. 122). Inmitten dieser bewussten Kollision wird der Betrachter von der Arbeit selbst gezwungen, sich der gewaltsamen Synthese auszusetzen. Vielleicht versucht man sich dagegen sogar zu wehren, aber ohne Erfolg. Schnabels Gemälde suchen nicht die ewige Balance, sie kippen mannigfach – sowohl kompositorisch als auch inhaltlich. Diese flirrende, fragmentarische bisweilen auch zerstörerische Qualität hat auch einen sehr interessanten Effekt auf unsere Erinnerung an die Arbeiten selbst. Bei dem Versuch, ein Bild von Julian Schnabel im Nachhinein im Kopf zu rekonstruieren, wird man bemerken, dass sich oft nur rudimentäre Details und Abstraktionen in die Erinnerung eingeprägt haben. Noch mehr als bei vielen anderen Malern muss man tatsächlich selbst vor dem Werk stehen, um es erfassen und rezipieren zu können.

paintings, in which the letters are chiseled into the supposedly only possible place on the pictorial surface as if in perpetuity.

Julian Schnabel's next works are always unpredictable, as are their position within his oeuvre as a whole. There are indeed inconsistencies of a highly productive artist. An artist who does not rely on an established, confirmed signature style perfected over the course of decades exposes himself again and again to the risk of gradual failure—and draws new impulses from it. This goes hand in hand with an attitude of courageous curiosity and a controlled form of letting-go. Anything can serve as a source and a point of departure. It is surely also a matter of testing one's own capabilities and the discipline itself, making new discoveries, staying "fresh," in an almost athletic sense. Schnabel appears to thrive on the ecstatic energy of the moment and a strong sense of his ability to create something new and meaningful at any time in his paintings. His oeuvre probably now encompasses more than 1,200 paintings, although no definite count has been made—and that in itself is a sign of the difficulty involved in keeping track of things in the face of such stupendous productivity; it is also an indication that such a question is ultimately beside the point. Only the next, completely new painting is important. It need not be evaluated, classified, and assigned to a group until much later.

Schnabel's paintings are large, yet their proportions still remain "human." The dimensions of his pictures, which are rarely smaller than seven feet in height and width, permit him to depict reality, and especially the human figure, without reduction. Thus Schnabel's compositions are neither "inflated" nor are they scaled-down versions of reality. They appear in full, true-to-life size—"one-on-one" with the viewer. And that is why viewing these paintings is a physical experience. The artist refuses to accept limitations on the dimensions of the painted surface and pursues this attitude to the extreme. Looking at the artist standing next to such works as *War, MG (Untitled)*, or *Apathy* (p. 164), each of which is considerably larger than one hundred and twenty square feet, it might seem as if he has created his own Tyrannosaurus rex, yet the viewer realizes that, while this may be true, it is also the reason why the relationship to the human figure is pre-

Selbst dort, wo er die Farbpalette in seinen Bildern zurücknimmt und sich im Grunde auf ein zentrales Motiv konzentriert – am eindrucksvollsten gelingt dies wohl in den so genannten *Recognitions*-Bildern (S. 68–72) – und diese dadurch konzeptueller wirken, zeugen sie nicht von einer bewussten, formalstrategischen Limitierung der Möglichkeiten, sondern von einer sehr intuitiven, assoziativen Vorgangsweise. Auswahl, Stil, Ausführung und kompositorische Einbettung der Schriftzüge in diesen Arbeiten sind zum Beispiel meilenweit von den wie für alle Ewigkeit und nur an den vermeintlich einzig möglichen Ort innerhalb der Bildfläche eingemeißelten Worten in Ed Ruschas Werken entfernt.

Die nächste Arbeiten von Julian Schnabel sind immer unvorhersehbar, auch ihr Stellenwert innerhalb des Gesamtœuvres. Es gibt sie, diese Schwankungen im Œuvre eines hochaktiven Künstlers. Wenn man sich nicht auf einen einmal gefundenen, abgesicherten und dann über Jahrzehnte perfektionierten »signature style« verlässt, setzt man sich auch immer wieder dem Risiko des graduellen Scheiterns aus – um daraus dann wieder neue Impulse zu erhalten. Dies geht einher mit einer Haltung des neugierigen Muts und des kontrollierten Sich-gehen-Lassens. Alles kann als Vorlage und Ausgangspunkt dienen. Es ist sicherlich auch immer ein Testen der eigenen Fähigkeiten und die Disziplin, weitere Entdeckungen machen zu wollen, fast im sportlichen Sinne »frisch« zu bleiben: Schnabel braucht wohl den Rausch des Moments, verbunden mit dem ausgeprägten Selbstbewusstsein, immer wieder etwas Neues, Wesentliches schaffen zu können, um seine Bilder entstehen zu lassen. Mittlerweile umfasst sein Werk wohl über 1200 Gemälde – genaue Angaben gibt es nicht, dies einerseits ein Zeichen für die Schwierigkeit, bei einer solchen Produktivität den Überblick zu behalten, und auf der anderen Seite auch ein Indiz für die Unwesentlichkeit einer solchen Frage. Nur das nächste, vollkommen neue Bild ist wichtig, beurteilt, eingereiht und gruppiert werden soll es erst viel später.

Schnabels Werke sind groß und dabei trotzdem »menschlich« in ihren Proportionen. Die Dimension der Bilder, welche in der Regel das Breiten- und Längenmaß von zwei Metern nicht unterschreitet, erlaubt eine unreduzierte Wiedergabe der Wirklichkeit, insbesondere der menschlichen Figur.

cisely correct. Of course, the monumental scale of these paintings and the resulting altered relationship to the viewer reflect an American tradition, and the gesture is not the only reason why Jackson Pollock is often cited as a source of inspiration in this context. Equally important is the work of the muralists in Mexico, and perhaps what Schnabel himself often cites as a major influence—something some critics have criticized automatically as a presumptuousness—is actually the most important inspiration of all: his personal impressions gained during early travels in Europe, particularly in the churches of Italy, of which not only Giotto's Capella della Scrovegni in Padua and Fra Angelico's fresco cycle in the Dominican monastery San Marco in Florence have remained indelibly etched in his memory.

Schnabel's paintings captivate us in the sense that they dominate everything around them. They are overpowering, occupy the center of every spatial situation, and immediately take possession of their surroundings. The scale and the gravity which emanate from them and which actually exist are integral parts of each work. The artist loves the weightiness of these paintings, although he insists upon keeping it under control—even in a direct, physical sense. When he has guests in his studio, Schnabel seems to enjoy nothing better than moving his enormous canvases from one corner to the other as his visitors watch. His large-scale works are altered significantly by changes in the distance between the viewer and the painting, as the result of which a work either condenses into a whole or falls apart entirely. His paintings demand both—distance from the viewer in the sense of an integrated, sometimes eye-catching composition and the intimacy of proximity to the observer, who must immerse himself in them and follow the eddies and rhythms of their individual components.

The scale and the weight of these paintings is dramatic, but not artificial. Schnabel strives to achieve physical presence—which is thus always a psychological presence as well—and total embrace of the viewer. The most successful of his works are perhaps those in which he had a specific (or imaginary) location in mind as he painted them. It is not that they ultimately need to be set in that place but rather that the mood of the surroundings can be imparted to the paint-

Schnabels Kompositionen sind insofern nicht »aufgeblasen« gegenüber dem Maßstab der Wirklichkeit, aber ebenso auch nicht reduziert. Sie stehen da, in voller, realer Größe – »one on one« mit dem Betrachter. Gerade deswegen sind die Bilder eine physische Erfahrung. Der Künstler verweigert die Einschränkung der Malfläche und treibt diese Haltung bis zum Extrem. Sieht man Schnabel neben seinen deutlich über 40 m² großen Arbeiten wie *War, MG (Untitled)* oder *Apathy* (S. 164) könnte man meinen, er habe seinen eigenen Tyrannosaurus Rex erschaffen, um dann doch zu erkennen, dass dies einerseits vielleicht richtig ist und gerade darum das genau richtige Ausmaß in Bezug auf die menschliche Figur darstellt. Natürlich steht diese Größe der Bilder und die daraus resultierende neue Relation zum Betrachter in einer amerikanischen Tradition, und nicht nur wegen dieser Geste wurde in diesem Zusammenhang oft Jackson Pollock als Inspiration angeführt. Doch sind dabei genauso die Entwicklungen der Muralisten in Mexiko von Bedeutung und vielleicht tatsächlich primär das, was Schnabel selbst immer wieder als signifikanten Einfluss angibt und was ihm reflexhaft immer wieder als Anmaßung von manchen Kritikern vorgeworfen wird: die persönlichen Eindrücke bei seinen frühen Europaaufenthalten, insbesondere in den Sakralbauten Italiens, von denen ihm nicht nur Giottos Capella della Scrovegni in Padua oder Fra Angelicos Freskenzyklus im Dominikanerkloster San Marco in Florenz unvergesslich blieben.

Schnabels Arbeiten fangen uns ein, indem sie alles um sich beherrschen. Sie sind überwältigend, das Zentrum jeder räumlichen Situation, von ihrer Umgebung kurzerhand Besitz ergreifend. Die Dimension, die Schwere, die sie ausstrahlen und die auch tatsächlich existieren, sind Teil des Werks. Der Künstler liebt die Schwere dieser Arbeiten, legt aber großen Wert darauf, diese bewältigen zu können – auch im ganz direkten, physischen Sinne. Nichts scheint Schnabel bei einem Atelierbesuch lieber zu machen, als seine gigantischen Leinwände vor dem Besucher eigenhändig von einer Ecke in die andere zu bewegen. Seine großformatigen Arbeiten wandeln sich deutlich durch die Veränderung der Distanz zwischen Bild und Betrachter, je nachdem formt sich das Werk zu einem Ganzen oder fällt auseinander. Die Arbeiten verlangen beides, die Entfernung vom Betrachter im Sinne einer

ing and that the work itself takes on this spatial and atmospheric quality from the very first moment and absorbs the identity of the place. Schnabel is fond of exposing his paintings to different surroundings. The three different work areas in which his paintings are executed speak for themselves—a gigantic studio that occupies an entire floor of a warehouse in Manhattan, a tennis-court-sized open-air arena in Montauk, and a small, dark, dank hole of a garage in San Sebastián. Again and again, Schnabel seeks to escape the nameless and faceless white cube gallery rooms as exhibition settings. Schnabel accomplished this to an extreme and absolute perfection in his installations for the Cuartel del Carmen in Seville in 1988 (p. 165) and the CAPC Musée d'art contemporain in Bordeaux in 1989 (p. 74). The moods and histories of these spaces posed very specific demands on the works to be exhibited there and required the artist to create an installation that would blend into the site in perfect harmony. In this sense, Schnabel's works are closely interwoven with their surroundings, and they also intensify the entire spatial situation and spatial psychology.

But Schnabel's paintings are the direct opposite of decorative. Indeed, they have a raw, instinctive quality. Schnabel, a master of staging in his own personal environment, an artist who has keen sense of material and atmospheric arrangement, is basically anti-aesthetic in his paintings. And that gives his works a rare intensity and aura. Schnabel's paintings, in which tones of morbid melancholy are often present, are works of powerful emotive force. However, the proverbial agony and ecstasy of the painting and the artist are controlled, thus heightening their effect even more.

Schnabel's paintings are objects that have sculptural presence, by virtue of their size, their frame, their weight, their three-dimensionality, or the different materials used in composing them. Like a piece of furniture, the painting's proportions are directly related to its surroundings. As sculpture, it assumes an object-like quality. Schnabel's works nearly always contain both abstract and figurative elements, which means that distinction or specification on the basis of such terms is bound to fail with respect to his works, as they oscillate between the two poles. Thus they are always both at once—narrative painting and abstract object.

ganzheitlichen, manchmal auch plakativen Komposition und dann die Nähe und Intimität des Gegenübers, der in sie eindringen und sich dem Strudel und Rhythmus der einzelnen Komponenten ergeben muss.

Die Dimension der Arbeiten und die Wucht der Bilder ist dramatisch, aber nicht artifiziell. Es geht sowohl um eine physische Präsenz – die dadurch auch immer eine psychische ist – und zugleich um die absolute Umarmung des Betrachters. Es sind dabei vielleicht gerade jene Arbeiten von Schnabel, die zu den gelungensten zählen, bei denen er eine konkrete (oder imaginäre) Umgebung für diese Bilder bei der Entstehung im Kopf hat. Nicht, dass sie am Ende genau diesen Ort zur Aufstellung brauchen, aber die Stimmung dieser Umgebung vermag er auf das Bild zu übertragen, und von diesem Moment an nimmt das Werk selbst diese räumliche und atmosphärische Qualität an und die Identität dieses Ortes in sich auf. Nur zu gerne setzt Schnabel seine Arbeiten unterschiedlichen Umgebungen aus, schon seine drei verschiedenen Arbeitsräume, in denen seine Bilder entstehen, sprechen hier für sich – ein riesiger, ein gesamtes Stockwerk eines Lagerhauses umfassender Atelierraum in Manhattan, eine tennisplatzgroße Freilichtarena in Montauk und ein kleines, düsteres, feuchtes Garagenloch in San Sebastián. Immer wieder versucht Schnabel, dem identitäts- und geschichtslosen White Cube der Galerienräume als Ausstellungsort zu entfliehen. Zu einem Extrem und zu absoluter Perfektion hat Schnabel dies wohl bei seinen Installationen im Kloster Cuartel del Carmen in Sevilla 1988 (S. 165) und für das CAPC Musée d'art Contemporain in Bordeaux 1989 (S. 74) gebracht. Diese Räume hatten in ihrer Stimmung und ihrer Historie ganz spezifische Anforderungen an die Arbeiten, die sie aufnehmen sollten, und verlangten vom Künstler eine Installation, die in perfekter Harmonie mit dem Ort selbst aufgehen musste. Die Arbeiten Schnabels sind insofern vollkommen mit der Umgebung verwoben, gleichzeitig verstärken sie die gesamte Raumsituation und Raumpsyche.

Die Gemälde sind dabei das Gegenteil von dekorativ. Stattdessen wird eine rohe, instinktive Qualität deutlich. Schnabel, der in seiner privaten Umgebung einer der eindrucksvollsten Inszenatoren ist, der ein herausragendes Gefühl für Material und stimmungsvolles Arrangement hat, ist

Symbols, objects, and sequences of words are integral parts of his works. These elements already have a history of their own, an existence and an identity, before they become a part of a painting. Schnabel recognizes in everything a motif quality and thus a potential for abstraction—a quotation, a déja-vu, a color contrast, a commonplace material, a half-sentence still buzzing in one's ear on the fringe of aware-ness. In essence, such elements are registered *en passant,* without concentration, sometimes through a totally inade-quate medium (such as a handwritten sentence on a bank-note), along with the lack of perfection naturally associated with this kind of impromptu reception. The motifs them-selves have no hierarchic order. They are props drawn from his perceived surroundings, and they come together as com-ponents of the composition without commenting upon the value of specific images from reality or respecting them as such. The artist is not concerned with their deeper meaning but instead with the potential of these elements as catalysts for feelings and aspects of a history. Far removed from the actual content they become content in their own right, in the same way that a certain melody, an unfamiliar phrase, a frag-ment of an overheard conversation, a spontaneous but strik-ing visual impression remains fixed in our mind and we—knowing that it has or must have a certain meaning—nevertheless usually assign the experience an entirely differ-ent meaning that is no less intense. Names of familiar or un-familiar people, sometimes totally isolated from their con-text, torsos of phrases consisting of words or series of letters thus become intrinsically meaningless yet powerful icons and ideal projection screens for our own emotions and recol-lections. These physically tangible elements contain an ener-gy and expression that can be used. The titles and the texts incorporated into the paintings serve essentially as an ex-tremely sketchy diary of the artist who makes no distinction between ordinary everyday happenings and important events. And so a work like *Ozymandias* (pp. 112–113) can forge an au-tobiographical link to the poem of the same title by the Ro-mantic poet Percy Bysshe Shelley, and a painting like *The Mud in Mudanza* (pp. 50–51) can elevate the mundane word "Mudanza" printed on the sides of Spanish trucks, which refers simply to moving, to the status of a title.

in seinen Arbeiten im Grunde anti-ästhetisch. Gerade da-durch stellen sie Inszenierungen von selten gesehener Inten-sität und Aura dar. Schnabels Bilder, in denen sehr oft ein Gefühl des Melancholisch-Morbiden mitschwingt, sind Ar-beiten von kraftvoller Emotionalität. Die sprichwörtliche Agonie und Ekstase des Bildes als auch des Künstlers sind aber durchaus kontrolliert und gerade dadurch umso effekt-voller.

Schnabels Gemälde sind Objekte von skulpturaler Prä-senz, sei es durch ihre Größe, ihren Rahmen, ihr Gewicht, die Dreidimensionalität der Oberfläche oder ihre Zusammenset-zung aus verschiedensten Materialien. Wie ein Möbelstück steht das Bild in direkter Proportion zu seiner Umgebung. Als Skulptur nimmt es eine objekthafte Qualität an. Schnabels Werke, die nahezu immer neben abstrakten auch gewisse figurative Elemente beinhalten, sodass eine Unterscheidung oder Spezifizierung anhand solcher Termini bei seinen zwi-schen diesen beiden Polen oszillierenden Werken vollkom-men ins Leere läuft, sind insofern immer beides zugleich, narratives Bild und abstraktes Objekt.

Symbole, Objekte, Wortfolgen sind integrale Bestandteile seiner Arbeiten. Diese Elemente hatten bereits eine Ge-schichte, sie hatten bereits eine Existenz und Identität, bevor sie Teil des Werks wurden. Alles hat für Schnabel eine motivi-sche Qualität und damit auch ein Abstraktionspotenzial – ein Zitat, ein Déjà-vu, ein Farbkontrast, ein alltägliches Mate-rial, ein noch im Ohr summender Halbsatz am Rande der Wahrnehmungsfähigkeit. Es sind im Grunde Elemente, die en passant, ohne Konzentration, bisweilen über ein vollkom-men inadäquates Trägermedium (wie etwa ein handge-schriebener Satz auf einem Geldschein) aufgenommen wer-den mitsamt der fehlenden Perfektion, die bei einer solchen Impromptu-Aufnahme einhergeht. Die Motive selbst haben keine hierarchische Anordnung, sie sind Versatzstücke aus seiner sensorischen Umgebung, die sich als Komponenten der Komposition zusammenfügen, ohne eine Aussage über die Wertigkeit der einzelnen Abbildungen aus der Wirklich-keit zu machen oder sie in diesem Sinne zu respektieren. Es geht dem Künstler dabei nicht um den tieferen Inhalt, son-dern vielmehr um ihr Potenzial als Katalysator von Empfin-dungen und Elemente einer Historie. Weit vom tatsächlichen

Print plays a dominant role and becomes a key element of the painting. In abstract works, this is essentially an inevitable process, since the viewer relies initially on these printed elements when looking at them, he has a certain degree of trust in their narrative character. The viewer expects some explanation from every integrated word or sequence of letters, but is bound to be frustrated in Schnabel's case. Nowhere is this more clearly evident than in the paintings in the outstanding *Recognitions* series (pp. 68–72), in which printed names are incorporated into the painting from top to bottom and from left to right, practically filling the entire surface of the painting, and thus represent an apparent, because initially legible, means of access that may soon turn out to be a mute wall for the viewer if he is unable to project himself through the formal level of the print image.

Print is both the content and a formal element of composition. Although these works are clearly based on Schnabel's personal insight that it is enough to paint a word on the pictorial surface in order to create a work that is as profound in content as other works of his, the difference between this approach and the strategy of dissolving painting pursued by Conceptual artists is evident. The materiality of the painting, the atmospheric identity of the tarpaulins as surface, the reduced yet still very gestural application of paint identify the work, as do the content, title, and theme of the work, above all as original, classical painting.

The fragmentary quality of these paintings, regardless of whether it is achieved by breaking apart the pictorial surface as in the *Plate Paintings* (pp. 44–51), in which pieces of porcelain plates are affixed to the canvas, presenting their concave or convex surfaces or rising from the canvas at an oblique angle, or by applying different materials, colors, or elements, imbues Schnabel's paintings with an inherently enigmatic, enchanted quality. Bound up within these paintings is a fate, a story that lies beyond the realm of the artist's personal experience and feelings. Yet despite all of the gravity and emotion of these works, and despite the artist's boundless energy, one ultimately discovers a component that may come as a surprise to many: the lighthearted humor that sparkles both in Schnabel and his art. That humor is evident even in the *Plate Paintings*, specifically in the selection of materials. Ac-

Inhalt entfernt werden sie selbst zum Inhalt, so wie uns eine gewisse Melodie, ein Fremdwort, ein aufgeschnappter Gesprächsfetzen, ein spontaner, aber einprägsamer visueller Eindruck nicht aus dem Kopf gehen und wir – wissend, dass dies eine gewisse Bedeutung hat oder haben muss – dieser Erfahrung nichtsdestotrotz meist eine ganz andere, aber um nichts weniger intensive Bedeutung zumessen. Namen bekannter oder unbekannter Personen, manchmal vollkommen aus dem Zusammenhang herausgelöste, torsohafte Satzteile aus Wörtern und Buchstabensequenzen werden so zu inhaltsleeren, aber kraftvollen Ikonen und damit zu idealen Projektionsflächen unserer eigenen Emotionen und Erinnerungen. Diese physisch spürbaren Elemente beinhalten bereits eine Energie, einen Ausdruck, der benutzt wird. Die Bildtitel und Texte in den Arbeiten funktionieren dann im Grunde auch wie ein extrem notizenhaftes Tagebuch des Künstlers, der zwischen profanem Alltagserlebnis und bedeutungsvollem Ereignis keinen Unterschied macht. Da kann ein Werk wie *Ozymandias* (S. 112/113) einen autobiografischen Bezug zum gleichnamigen Gedicht des englischen Romantikers Percy Bysshe Shelley herstellen und eine Arbeit wie *The Mud in Mudanza* (S. 50/51) einen profanen Umzug ankündigenden Schriftzug »Mudanza« auf spanischen LKWs zum Titel erheben.

Die Verwendung von Schrift ist dabei durchaus dominant und wird zum zentralen Element des Bildes. Dies ist im Grunde bei abstrakten Arbeiten ein unausweichlicher Vorgang, denn der Betrachter hält sich bei einem solchen Bild zuallererst an eben diesen schriftlichen Elementen an. Er bringt ihnen ein gewisses Vertrauen in Bezug auf ihre narrative Qualität entgegen. Bei jedem integrierten Wort oder jeder Buchstabenfolge hat man eine inhaltlich-erklärende Erwartung – um dann bei Schnabel wieder vor der nächsten irritierenden Hürde zu stehen. Nirgendwo ist dies deutlicher als bei den Arbeiten der herausragenden *Recognitions*-Serie (S. 68–72), wo Namensschriftzüge geradezu bildfüllend von oben nach unten und von links nach rechts eingespannt sind und so einen vermeintlichen, weil vorerst lesbaren Zugang darstellen, der sich aber auch sehr bald als stumme Wand gegenüber dem Betrachter herausstellen kann, wenn sich dieser nicht durch die formale Ebene des Schriftbildes hin-

tually, these plain plates, some of which still bear a price label, are meaningful only in a historical sense, as they are broken and have already experienced history. As fragments, they take on a new value and potential for meaning they could never have attained as simple, unaltered plates on canvas. We respond to these fragments of a commonplace product with an entirely new set of expectations and immediately begin to look for the inherent historical quality, the act that preceded their final existence as shards. In our longing for history and meaning, we project precisely such values onto the object. Schnabel's selection of this particular object of our private everyday culture, which essentially has no identity, for a special destiny of meaning is a gesture which, despite the earnestness of his approach to content in all of his works, also betrays a playful attitude towards his surroundings even in his earliest paintings. Art critics have often divided the New York art scene during the decade of the eighties into two camps: Schnabel on the one side and—as a supposed counterreaction—Jeff Koons, Ashley Bickerton, Peter Halley, and others who were grouped together under the meaningless umbrella of "Neo-Geo." Yet it is becoming increasingly clear that this direct opposition is a myth. In the case of Koons, in particular, whom Schnabel promoted actively early in his career,[5] one recognizes affinities of attitude with respect to the transformation of the objects in terms of their meaning, their history, and our expectations about them. In much the same way that Schnabel converts plates into historical, yet essentially meaningless documents of the times, Koons turned an inflatable plastic rabbit (*Rabbit,* 1986) into a contemporary, universal object of love and desire cast in stainless steel.

"Painting is dead"—this ominous prophecy has been a presence in the art world for some time and has accompanied Schnabel the artist in cycles throughout his career. During the seventies painting was regularly denied all justification for existence, and thus that was probably the best possible moment in which to concentrate on the medium and develop it further. Schnabel was instrumental in moving painting back into the focus of attention in the New York art world—a shock for some art critics who, in the American art landscape left behind after Minimal and Conceptual Art, sud-

durchprojizieren kann. Der Schriftzug ist sowohl Inhalt der Arbeit als auch formales Mittel der Bildgestaltung. Obwohl diese Arbeiten deutlich auf Schnabels persönlicher Erkenntnis beruhen, dass es ausreicht, ein Wort auf die Bildfläche zu malen, um ein Werk zu schaffen, das einen ebenso tiefen Inhalt hat wie andere seiner Arbeiten, ist der Unterschied zu einer bildauflösenden Strategie der Konzeptkunst evident. Die Materialität des Bildes, die stimmungsvolle Identität der Abdeckplanen als Oberfläche, der reduzierte, aber immer noch sehr gestische Farbauftrag identifizieren die Arbeit genauso wie Inhalt, Titel und Thema des Werks noch immer zuallererst als originäre Malerei im klassischen Sinne.

Das Fragmentarische der Arbeiten, sei es durch das Aufbrechen der Bildfläche wie bei den *Plate Paintings* (S. 44–51), wo Porzellanscherben konkav oder konvex liegend oder in einem schrägen Winkel abstehend auf die Leinwand befestigt werden, oder durch die Applikation unterschiedlichster Materialien, Farben oder Elemente, gibt Schnabels Werken einen inhärenten enigmatischen, verwunschenen Charakter. Die Bilder tragen ein Schicksal, eine Geschichte, die jenseits der persönlichen Erfahrungen und Empfindungen des Künstlers liegen. Allerdings, bei aller Schwere und Melancholie der Arbeiten muss man auch eine – für manche vielleicht unerwartete – Komponente erkennen. Die Leichtigkeit des Humors, die man sowohl bei der Person als auch bei der Arbeit von Schnabel immer wieder hervorblinzeln sieht. Schon bei den *Plate Paintings* erkennt man eine solche Haltung anhand der Auswahl des Materials. Im Grunde bekommen die alltäglichen Teller, von denen bisweilen nicht einmal die Preisetiketten entfernt wurden, nur eine historische Bedeutung, weil sie zerbrochen sind und damit bereits Geschichte erfahren haben. In ihrer Fragmentierung erreichen sie eine neue Wertigkeit und ein Bedeutungspotenzial, das sie als simple, unberührte Tellerflächen auf der Leinwand nie haben konnten. Wir reagieren auf diese Fragmente eines Alltagsprodukts mit einer ganz neuen Erwartungshaltung und suchen sofort die inhärente historische Qualität, die als Akt vor der Endexistenz dieser Scherben lag. In unserer Sehnsucht nach Geschichte und Bedeutung projizieren wir genau solche Werte in das Objekt hinein. Dass Schnabel gerade dieses, im Grunde identitätslose Objekt unserer privaten Alltagskultur

denly found themselves confronted with figurative crucifixion scenes and expressive abstractions. As the figurehead of this supposedly regressive tendency, as the artist responsible for restoring a medium that had been declared dead to prominence, Schnabel soon polarized the community of critics. An unbiased look at his works was virtually impossible. Surprisingly, Schnabel himself, as a person and a symbolic figure, became the primary focus of debate, while critical analysis of his art receded more and more into the background. The art world witnessed at least another two "deaths of painting" in the two decades that followed. Yet the truth is that painting was never dead, and never will be. It is always there, sometimes closer to, sometimes farther from the center of media interest. Schnabel himself knows this only too well: "The conversation about painting being dead has gone on for about one hundred years. People have been talking about the death of painting for so many years that most of the people are dead now."[6]

Now, of all times, as we—yet again—experience a widely propagated Renaissance in contemporary painting and witness a young generation of artists asserting itself through the medium in the contest of a multimedia society, is the right time to take a new, unprejudiced look at Julian Schnabel's complete works to date. More than a few people will make a completely new discovery. Schnabel is not only an outstanding painter but also a role model who has pursued his own course in complete freedom for decades. It is a course that has opened doors, and not only for painting—a classic course.

zu einem besonderen Bedeutungsschicksal auserwählt, ist eine Geste, die bei all der Schwere der inhaltlichen Orientierung seiner Arbeiten schon sehr früh auch einen spielerischen Umgang mit unserer Umgebung verrät. Sehr oft sind die achtziger Jahre in New York von der Kunstkritik in zwei Teile aufgebrochen worden: Auf der einen Seite Schnabel und auf der anderen – als vermeintliche Gegenreaktion – Jeff Koons, Ashley Bickerton, Peter Halley und andere, die in der bedeutungslosen Hülle »Neo Geo-Gruppe« zusammengefasst wurden. Gerade diese direkte Kontrastellung scheint sich aber immer mehr als ein Mythos zu entpuppen. Insbesondere auch bei Koons, der von Schnabel am Beginn seiner Karriere sehr gefördert wurde,[5] erkennt man eine Nähe der Haltung in Bezug auf die Transformation von Objekten im Hinblick auf ihre Bedeutung, ihre Geschichte und unsere Erwartungshaltung ihnen gegenüber. So wie Schnabel aus Tellern historische, aber im Grunde inhaltsleere Zeitzeugen macht, so hat Koons mit *Rabbit* (1986) aus einem aufblasbaren Plastikhasen ein in Edelstahl gegossenes Universalobjekt der Liebe und Begierde unserer Zeit gemacht.

Die Malerei sei tot – diese ominöse Prophezeiung begleitet die Kunstwelt schon reichlich lange und den Künstler Schnabel in Zyklen seit dem Beginn seiner Tätigkeit. In den siebziger Jahren wurde dem Medium gerne jegliche Daseinsberechtigung aberkannt, wahrscheinlich der beste Moment, um sich auf dieses Medium zu konzentrieren und es weiterzuentwickeln. Mit Schnabel war die Malerei wieder ins Zentrum des Interesses der New Yorker Kunstwelt gerückt. Ein Schock für so manchen Kritiker, der sich in der amerikanischen Kunstlandschaft nach Minimalismus und Konzeptkunst plötzlich mit figurativen Kreuzigungsszenen oder expressiven Abstraktionen konfrontiert sah. Als Leitfigur für diese vermeintlich regressive Tendenz, als Verantwortlicher für die wiedererstarkte Prominenz eines totgesagten Mediums polarisierte Schnabel sehr bald die Kritiker. Ein unvoreingenommener Blick auf seine Arbeiten war kaum mehr möglich, die Person und Symbolfigur Schnabel wurde überraschenderweise das primäre Thema der Auseinandersetzung, während eine kritische Analyse des Werks selbst immer mehr in den Hintergrund rückte. Mindestens zwei weitere »Tode der Malerei« hat es in den darauffolgenden

1 Julian Schnabel, in conversation with the author, New York 2003.
2 *Julian Schnabel: Paintings 1975–1987*, ed. Nicholas Serota and Joanna Skipwith, exh. cat. Whitechapel Art Gallery, London, 1987, p. 101.
3 See also Thomas McEvilley, "The Case of Julian Schnabel," in ibid., p. 17.
4 Schnabel, July 11, 1986, in ibid., p. 105.
5 See also "Jeff Koons Talks to Katy Siegel," in *Artforum* 41, no. 7 (March 2003), p. 252.
6 "Julian Schnabel Talks to Max Hollein," in ibid., p. 58.

zwei Jahrzehnten gegeben. Die Wahrheit aber ist, das Malerei nie tot war und auch nie tot sein wird. Sie ist immer da, manchmal stärker, manchmal schwächer im Zentrum des medialen Interesses. Schnabel selbst weiß dies nur zu gut: »Seit über hundert Jahren geht dieses Gerede darüber, dass Malerei tot ist. Die Leute haben so lange über den Tod der Malerei geredet, nun sind die meisten von denen selbst tot.«[6]

Gerade jetzt, wo wir wieder einmal eine weitpropagierte Renaissance der zeitgenössischen Malerei erleben, wo sich eine junge Künstlergeneration mit diesem Medium vor den Kulissen einer multimedialen Gesellschaft behauptet, ist der richtige Zeitpunkt, um einen neuen, vorurteilsfreien Blick auf das bisherige Gesamtwerk von Julian Schnabel werfen. Nicht wenige werden eine vollkommen neue Entdeckung machen. Schnabel ist nicht nur ein herausragender Maler, sondern auch eine Identifikationsfigur, die seit Jahrzehnten mit absoluter Freiheit seinen Weg geht. Ein Weg, der nicht nur der Malerei neue Türen geöffnet hat. Ein zeitloser Weg.

1 Julian Schnabel im Gespräch mit dem
 Verfasser, New York 2003.
2 *Julian Schnabel Paintings 1975 – 1987*,
 hrsg. von Nicholas Serota, Joanna Skip-
 with, Ausst.Kat. Whitechapel Art Gallery,
 London, Musée National d'Art Moderne,
 Centre Georges Pompidou, Paris,
 Städtische Kunsthalle Düsseldorf, 1987,
 S. 99.

3 Siehe dazu auch Thomas McEvilley,
 »The Case of Julian Schnabel«, in: ebd.,
 S. 17.
4 Schnabel, 11. Juli 1986, in: ebd., S. 103.
5 Vgl. dazu auch: »Jeff Koons Talks to
 Katy Siegel«, in: *Artforum*, Bd. 41, Nr. 7,
 März 2003, S. 252.
6 »Julian Schnabel Talks to Max Hollein«,
 in: ebd., S. 58.

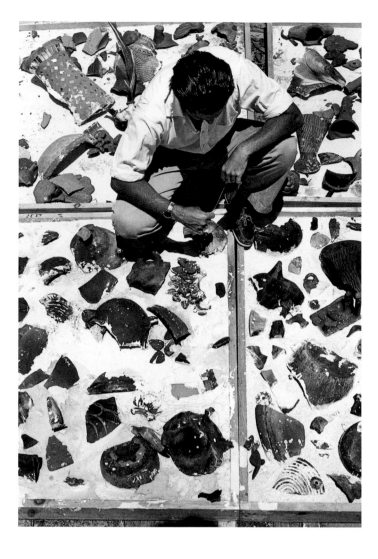

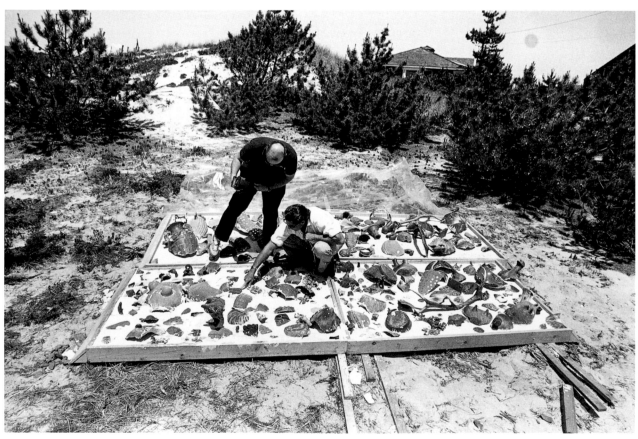

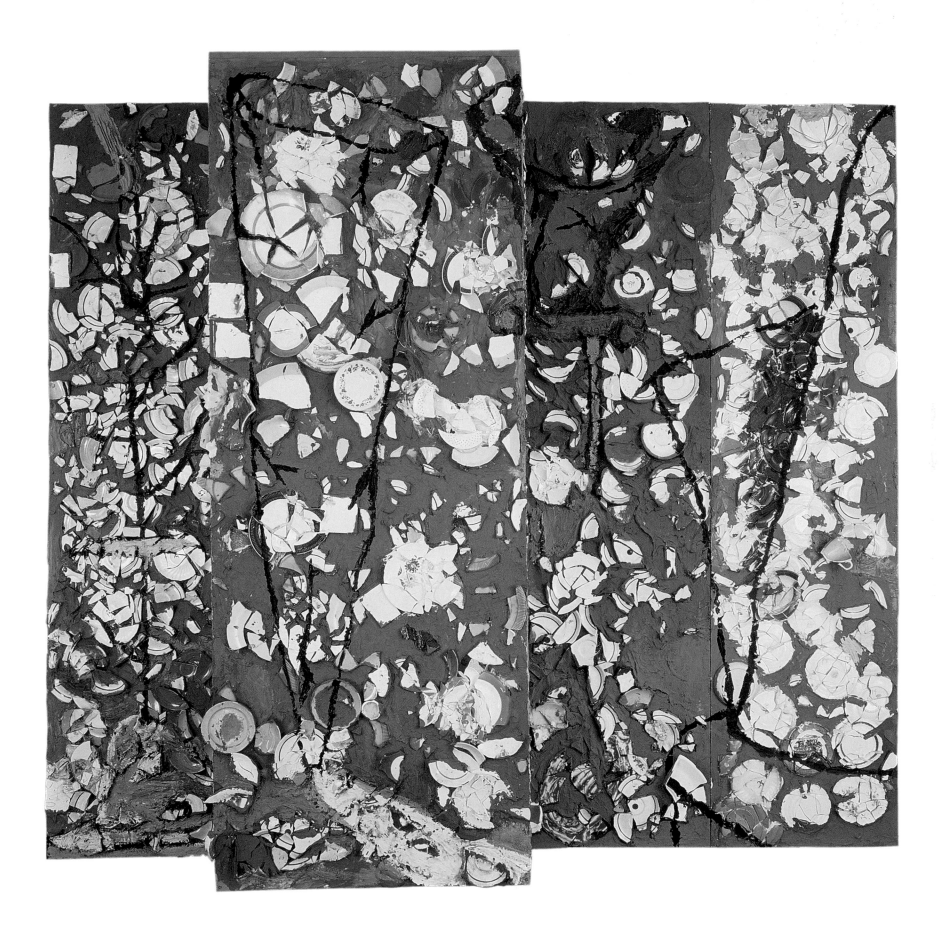

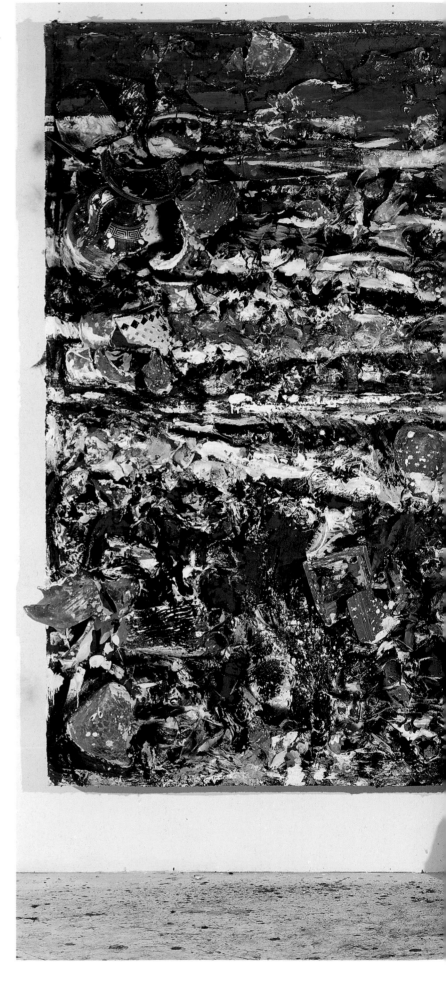

5 The Sea, 1981

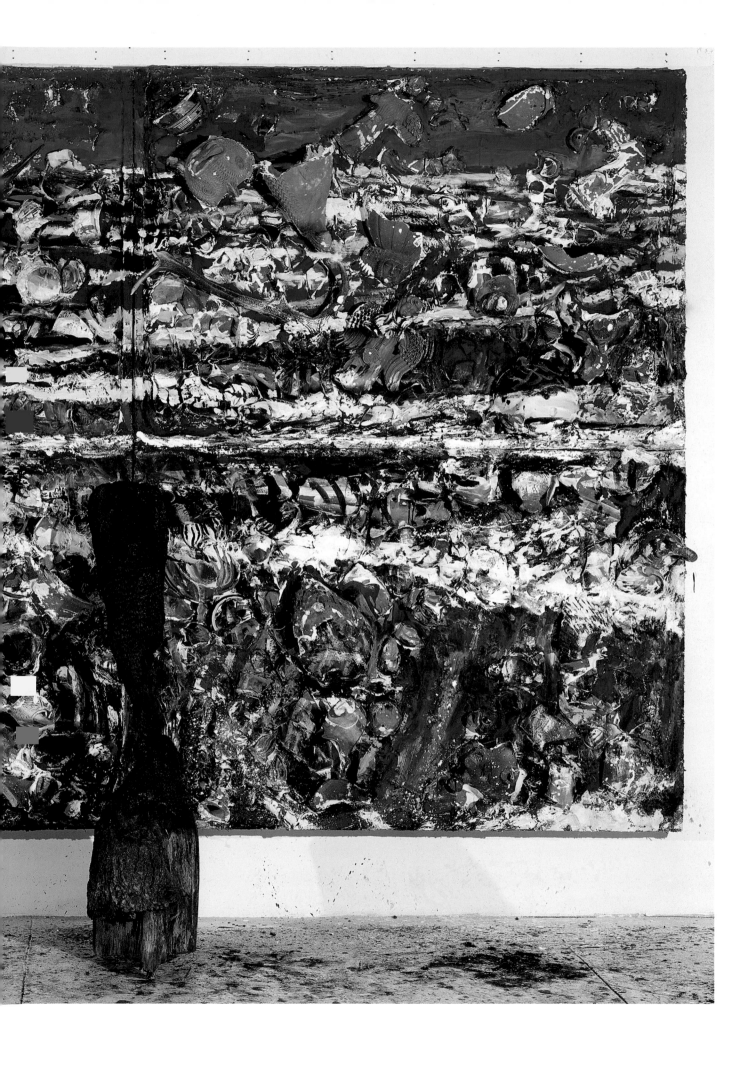

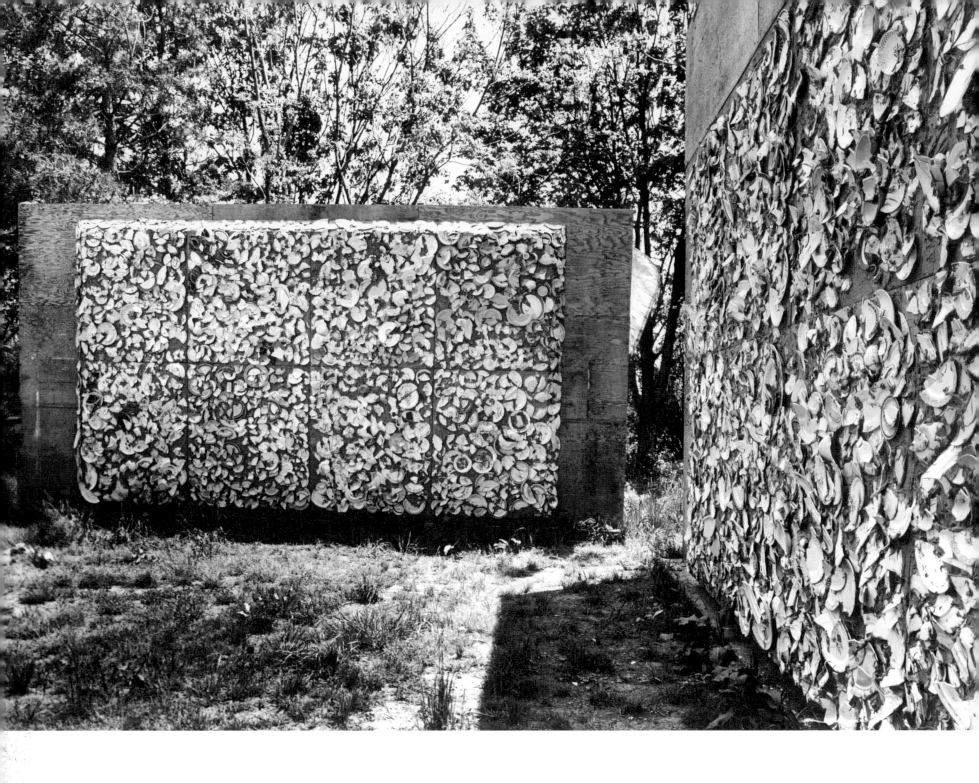

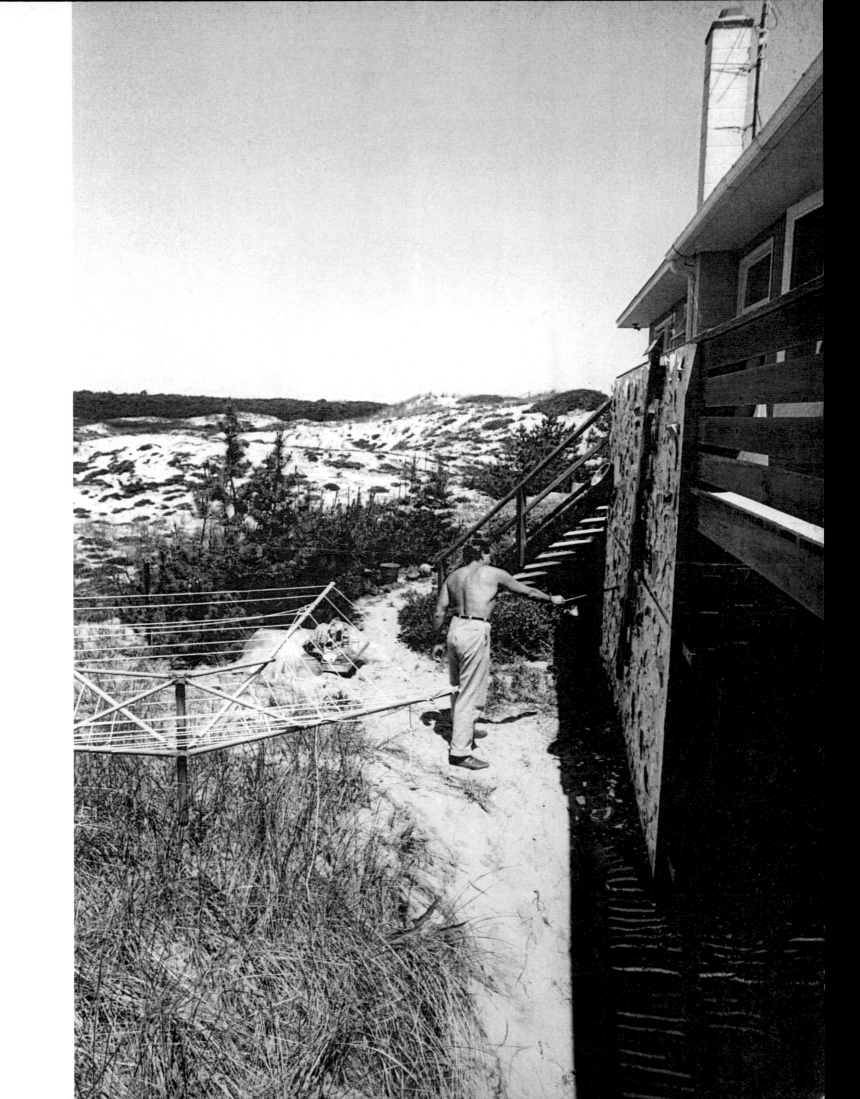

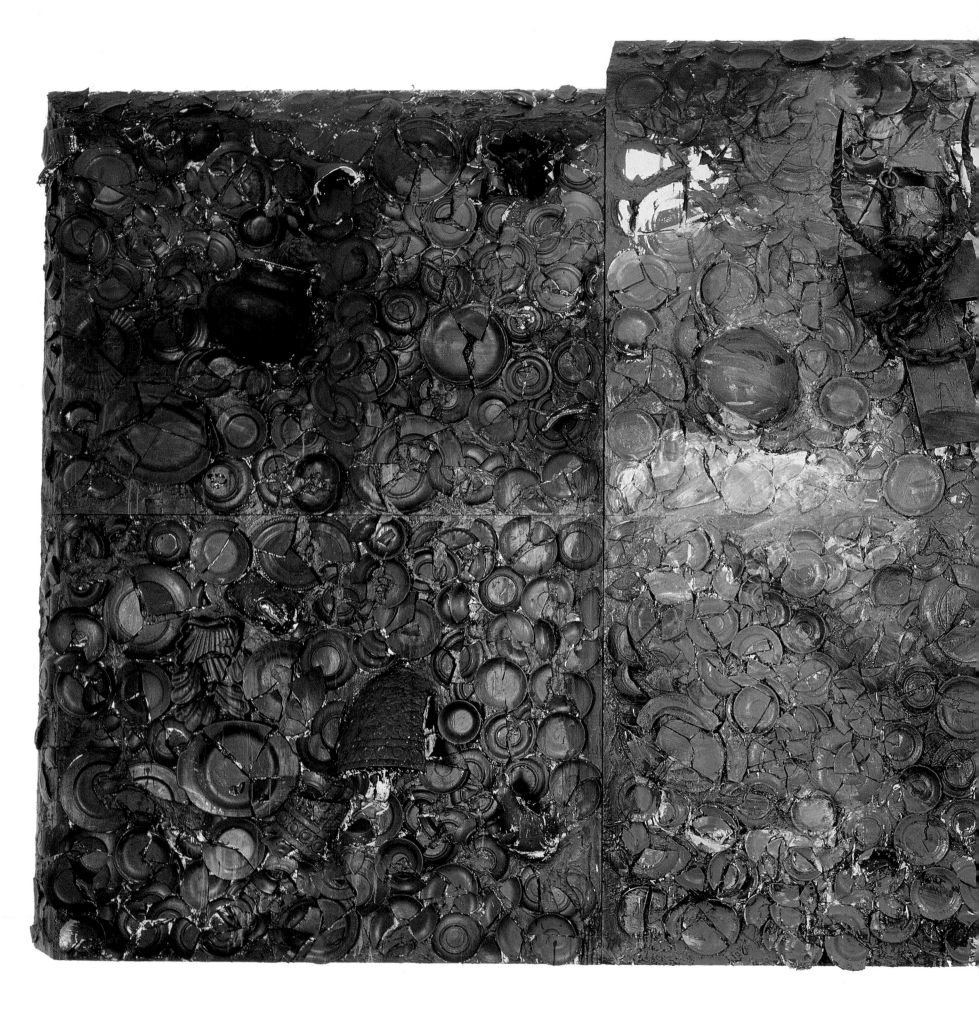

50 9 The Mud in Mudanza, 1982

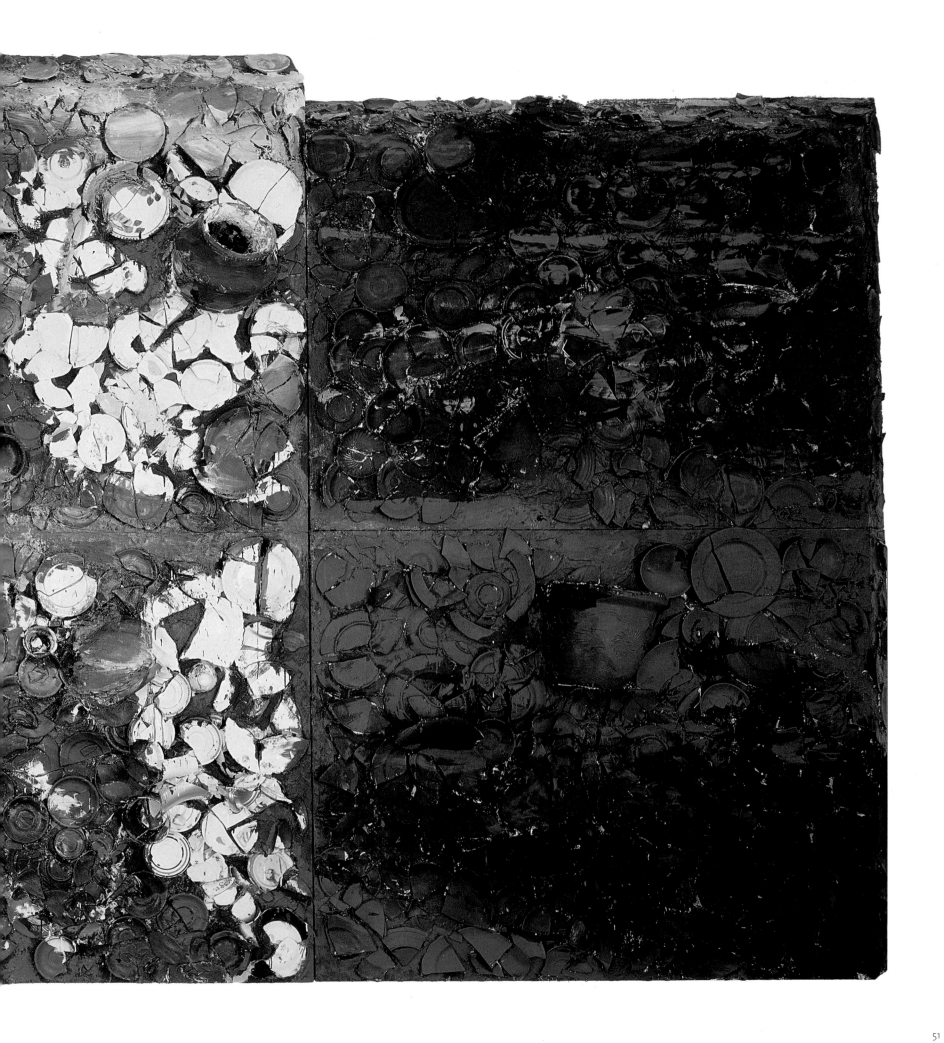

"a painter's response to these times"

»a painter's response to these times«

A canvas sewn together from U.S. Army surplus material. The surface of the painting is raw and inhospitable. A patchwork of faded strips of khaki material is only seldom to be seen in a museum. The painting itself is just as unusual. The figure, applied in thick impasto strokes of paint, appears to float on the tent material. A long, concave, curved line forms the abstract element of the painting's composition. It resembles an ark or a torrent of water, carrying a Chinese dignitary. The artistic vocabulary in this painting is unusual for contemporary art. The piece seems out of balance; no conventional rules of composition are respected. The painting is nonetheless monumental and stable at the same time. It bears longer scrutiny and leaves behind a sustained visual impression in the viewer's memory. Then there is the force of the picture; it involves a physical kind of painting that extends itself toward the viewer. Reason enough to explore in more detail the artist who produced this unusual object.

Upon closer inspection, it becomes clear that the seemingly unfinished, spontaneous painting is rationally constructed from four elements. The dingy surface, in principle completely inappropriate for painting, plays a primary role. The white, curved strip of paint and, slightly offset from it, the hieratic head portrait, vertically oriented and painted in a different style, are additional components. A highly colorful zone at the neck of the person portrayed lends the painting a colorist center. Surprisingly, the head and the remainder of the painting appear to originate from two different concepts for the picture. The four elements are gently brought into balance so that the viewer hardly notices this initially. Despite its contradictory parts, the painting does not disintegrate, but gains strength through its disparity. The painting is anchored on the army fabric through a virtual line consisting of five black dots. These dots are amorphous areas that the painter superimposed on the already finished painting. They form a second curved, horizontal link. One of these fields of black paint hides the eye of the portrait's head, which otherwise would have gazed directly at the viewer.

The painting from the year 2003 is called *Chinese Painting* (pp. 148–149). It is just as extraordinary as its creator, the American painter Julian Schnabel. The dimension of the canvas surprises even experienced exhibition visitors. Hardly

Eine zusammengenähte Leinwand aus Reststücken der US-Army. Die Bildoberfläche ist rau und unwirtlich. Ein Patchwork aus ausgewaschenen Stoffbahnen in Kaki ist nur selten in einem Museum zu sehen. Ebenso ungewöhnlich ist das Gemälde. Die Figur, mit dicken, pastosen Farbaufträgen gemalt, scheint auf dem Zeltgewebe zu schweben. Eine lange, konkave Bogenlinie stellt das abstrakte Element des Bildgeflechts dar. Sie gleicht einer Arche oder einem Wasserschwall, eine chinesische Hoheit tragend. Das malerische Vokabular ist für die heutige Kunst ungewöhnlich. Das Bild scheint aus der Balance geraten. Keine herkömmliche Kompositionsregel wird respektiert. Dennoch ist das Gemälde monumental und stabil zugleich. Es hält auch einer langen Betrachtung stand und hinterlässt einen nachhaltigen Eindruck auf das visuelle Erinnerungsvermögen des Betrachters. Dazu kommt die Wucht des Bildes. Es handelt sich um physische Malerei, die aus dem Gemälde auf den Betrachter zukommt. Grund genug, sich eingehender mit dem Künstler zu beschäftigen, der das ungewöhnliche Objekt hervorgebracht hat.

Bei näherem Hinsehen wird deutlich, dass das unfertig, spontan erscheinende Bild aus vier Elementen in rationaler Weise aufgebaut ist. Der verschmutzte, für Malerei im Prinzip völlig ungeeignete Bildgrund spielt eine zentrale Rolle. Dazu kommen der weiße, geschwungene Farbstrom sowie das davon abgesetzte, anders gemalte hieratische Kopfporträt vertikaler Ausrichtung. Eine buntfarbige Zone am Hals der porträtierten Person gibt dem Bild ein koloristisches Zentrum. Überraschenderweise scheinen der Kopf und der Rest des Gemäldes zwei verschiedenen Bildgedanken zu entstammen. Die vier Elemente sind in sanfter Weise in Balance gebracht, sodass es der Betrachter zunächst kaum bemerkt. Trotz seiner widersprüchlichen Teile fällt das Bild nicht auseinander, sondern gewinnt aus der Disparatheit an Kraft. Seinen Halt findet das Gemälde auf einem Armeestoff durch eine virtuelle Linie, die aus fünf schwarzen Punkten besteht. Es handelt sich um amorphe Abdeckflächen, die der Maler in das bereits fertig gestellte Gemälde gesetzt hat. Sie stellen eine zweite geschwungene, horizontale Verbindung dar. Eines dieser schwarzen Farbfelder verdeckt das Auge des Porträtkopfes, das den Betrachter vor diesem Eingriff direkt angeblickt hatte.

anyone dares attempt such formats today. One is at best familiar with them from the painting of Abstract Expressionism and from Minimalism. In contrast to these archetypes, however, the painting has an unorthodox development. It lacks any kind of systematic approach, as characterizes most important contemporary works of painting. One could believe that several artists had worked on the painting at the same time. The picture nonetheless features wonderful colorist sweeps that also lend it presence, independent of the figural area. The lines have been applied to the painting surface by hand, that is, without a paintbrush. This is where the painting derives its directness, which can hardly be conveyed by a reproduction in a catalogue. The head of the depicted woman strikingly contrasts with its environment; it represents an intentional foreign body. While the painting overall may be characterized by a "Chinese" mood, this depiction proves to be a "European portrait" reminiscent of classical style. The power of the fragment comes from the fact that it indeed involves a real portrait. The intended portrayal is related to a concrete person whom the painter knows quite well. The Chinese figure is an image that has been painted on a mirror. The tarp substitutes its dark spotty surface for the disintegrating aluminum of the mirror. The figure floats in front of the canvas, and the observer participates in this tension. In this structure consisting of nothing but foreign bodies, the giant piece of fabric develops a physical and iconographic strength that cannot so easily be forgotten.

For Julian Schnabel, this likewise represents a key painting in his more recent work. The piece is visually significant, but also biographical. The person depicted is his mother, whom he attempted to paint in the last months of her life. The worn-out, green-blue army supply material, nine by sixteen feet in format, served as a canvas. It was the second painting that derived from a dream that his daughter told him two days before. The image of the Chinese woman and the black eye with red and green tones was created in late 2002, when his mother died. It was through the painting of the mirror that Schnabel first became aware of how his mother's wheelchair had become a second dwelling for her. The painting addresses this realization, as well as how a

Das Bild von 2003 heißt *Chinese Painting* (S. 148/149). Es ist ebenso ungewöhnlich wie sein Autor, der amerikanische Maler Julian Schnabel. Die Dimension der Leinwand überrascht selbst erfahrene Ausstellungsbesucher. An solche Formate wagt sich heute fast niemand heran. Man kennt sie allenfalls aus der Malerei des Abstrakten Expressionismus und aus der Minimal Art. Entgegen diesen Vorbildern ist das Gemälde jedoch unorthodox entwickelt. Es fehlt jeder systematische Ansatz, wie er die meisten bedeutenden Malereiwerke der Gegenwart kennzeichnet. Man meint, mehrere Künstler gleichzeitig hätten an dem Gemälde gewirkt. Dennoch weist das Bild wunderbare koloristische Schwünge auf, die ihm auch unabhängig von der figurativen Zone Eindrücklichkeit verleihen. Die Linien sind mit den Händen auf den Malgrund aufgetragen, ohne Pinsel also. Daraus bezieht das Gemälde eine Direktheit, die auch die Reproduktion in einem Katalog nicht zu vermitteln vermag. Das Haupt der dargestellten Frau setzt sich markant vom Umfeld ab. Es bildet einen bewussten Fremdkörper. Wenn das Bild insgesamt von einer »chinesischen« Stimmung geprägt ist, so erweist sich diese Darstellung als »europäisches Porträt« klassischer Reminiszenz. Die Kraft des Fragments kommt daher, dass es sich um ein tatsächliches Porträt handelt. Der Darstellungswille bezieht sich auf eine ganz bestimmte Person, die der Maler bestens kennt. Die chinesische Figur war ursprünglich ein auf einen Spiegel gemaltes Bild. Die dunkle, fleckige Oberfläche der Persenning ersetzt hier das abblätternde Aluminium des Spiegels. Die Figur treibt vor dem Malgrund, und der Betrachter nimmt an dieser Spannung teil. Die riesige Stofffläche entwickelt in dieser Struktur aus lauter Fremdkörpern eine physische und ikonografische Kraft, die man so schnell nicht wieder vergisst.

Für Julian Schnabel handelt es sich gleichfalls um ein Schlüsselbild seines neueren Werks. Das Gemälde ist bildnerisch bedeutsam, aber auch biografisch. Bei der dargestellten Person handelt es sich um seine Mutter, die er in ihren letzten Lebensmonaten zu malen versuchte. Als Leinwand dienten die abgenützten, grünblauen Stoffe aus Armeebeständen im Format 274×485 cm. Es war das zweite Bild, das er nach einem Traum malte, den ihm seine Tochter zwei Tage zuvor erzählt hatte. Das Bild mit der chinesischen Frau und dem

painter deals with such an event. The *Chinese Painting* (pp. 148–151) series of large-format tarpaulin panels from U.S. army surplus has never been exhibited until now.

"It just glues together," replies Julian Schnabel to the comment that he works with disparate elements.[1] As in all of the artist's important works, seemingly incongruent elements somehow mesh together wonderfully in the end, resulting in iconographically surprising painting, which is at the same time highly physical. With his famous *Plate Paintings* (pp. 44–51) from the late seventies and early eighties (he later limited the *Plate Paintings* for the most part to single large-format portraits), he deliberately challenged the status quo of the late sixties and seventies, which was based on predictable painting codes. The *Plate Paintings* made Julian Schnabel a superstar of contemporary painting and a synonym for a patchwork of styles that also maintains a physical concept of the painted picture.

Numerous painters and postmodern object artists have since profited from the schism Schnabel created in artistic discourse of the time as the heyday of Conceptual art wound down. Schnabel himself however suddenly became a bone of contention in a long-standing polemic about contemporary painting, in the wake of which fifteen years ago he positioned himself on the margin, beyond the pressure to "keep up" with the exhibition business. Since then, he has established one of the most important collections of paintings one could possibly visit, as if it involved the work of a new painter creating risky art. At the beginning of the twenty-first century, several highly talented painters from the early fifties-generation are proving to be especially exciting. They are filled with a personal strength that painting has not sought to affirm ever since.[2] This is true for Albert Oehlen and Martin Kippenberger just as for Julian Schnabel, Georg Jiri Dokoupil, Francesco Clemente, and Cucchi. (Incidentally: these painters have always thought highly of one another and collected each others' work.) These painters define one of the important bridges from the twentieth to the twenty-first century.

The work of Julian Schnabel is of great importance for the contemporary genre of painting. His work is oriented first of all towards dimension, more precisely towards the definition

schwarzen Auge mit roten und grünen Tönen entstand Ende 2002, als seine Mutter starb. Schnabel wurde erst durch das Bild auf dem Spiegel gewahr, wie sehr der Rollstuhl für seine Mutter zu einer zweiten Behausung geworden war. Davon handelt das Gemälde und auch davon, wie ein Maler mit einem solchen Ereignis umgeht. Die *Chinese Painting*-Serie (S. 148–151) auf großformatigen Persenningbahnen aus Beständen der US-Army war bislang noch nie zu sehen.

»It just glues together«, entgegnet Julian Schnabel der Bemerkung, dass er mit disparaten Elementen arbeite.[1] Wie bei allen wichtigen Arbeiten des Künstlers kommen scheinbar nicht vereinbare Elemente irgendwie wundersam doch zusammen und ergeben eine ikonografisch überraschende und zugleich physische Malerei. Mit seinen berühmten *Tellerbildern* (S. 44–51) der späten siebziger und frühen achtziger Jahre (später hat er die *Tellerbilder* weitgehend auf großformatige Einzelporträts beschränkt) zerschlug er ganz bewusst die auf durchschaubare Bildkonzepte angelegte Situation der Malerei der späten sechziger und der siebziger Jahre. Mit den *Tellerbildern* wurde Julian Schnabel zu einem Superstar der Neuen Malerei und zum Synonym für ein Patchwork der Stile, das zugleich ein physisches Konzept des gemalten Bildes bewahrt. Unzählige Maler und postmoderne Objektkünstler haben seither von der Bresche profitiert, die Julian Schnabel damals in die Kunstdiskurse der auslaufenden Blütezeit der Concept Art schlug. Schnabel selbst dagegen wurde unversehens zum Streitobjekt einer langjährigen Polemik über die Neue Malerei, in deren Gefolge er vor fünfzehn Jahren eine Randposition jenseits des Aktualitätsdrucks des Ausstellungsbetriebs bezog. Seither hat er eines der wichtigsten malerischen Werke hingelegt, das man heute besichtigen kann, als handle es sich um das Werk eines neuen Malers, der mit Risikobildern umgeht. In der Situation des beginnenden 21. Jahrhunderts erweisen sich mehrere große Talente der Malergeneration der frühen achtziger Jahre als besonders spannend. Sie sind von einer persönlichen Kraft erfüllt, die Malerei seither nicht mehr zu affirmieren suchte.[2] Das gilt für Albert Oehlen und Martin Kippenberger ebenso wie für Julian Schnabel, Georg Jiri Dokoupil, Francesco Clemente und Cucchi. (Übrigens haben diese Maler einander stets gegenseitig geschätzt und gesammelt.) Diese Maler

of scale, which in Schnabel's understanding carries the painting. The canvas does not subordinate itself to the architecture, but contests its legitimacy. This also applies to *Chinese Painting*. Most of the space has been left free; the painting nonetheless possesses an incomparable tension. With the help of unorthodox methods, a spontaneously inserted theme—the portrait of an elderly woman—is balanced in the scene. Everything is seemingly "impossible" or "forbidden" in this painting: the realistic figure, the rough surface, the colorist shapes composed of amorphous conglomerates of lines and planes. But at the same time, the picture is amazingly powerful. It is one of the great paintings representing the new contemporary attitude toward life.

Julian Schnabel consistently employs painting surfaces that don't really allow the painting of a coherent picture: velvet, tent fabric, truck tarpaulins, surfaces of broken crockery, Chinese landscape paintings, Japanese cartoons, and so on. Sometimes he "complicates" his task by using resin or limiting himself to painting with his hands. Each painting is a tour de force. He is a highly talented painter, and the artificial obstacles are a means for him to avoid making things simple for himself and to fight against easy solutions. He puts himself in predicaments that compel visual inventiveness to achieve the final painting.

The name Julian Schnabel is well known. With his pieces from the early eighties, he significantly shaped the artistic world. Nearly all art students in painting today claim to have been partially influenced by Julian Schnabel, although they often have never seen one of his paintings in the original and add that they are unfamiliar with Schnabel's work in recent years. This is all the more remarkable in light of the fact that art students are only interested in the work of four or five contemporary painters, on average. That Julian Schnabel is among them, although his work has rarely been exhibited publicly in recent years, shows what a great impression his most famous pieces from the eighties had on the collective consciousness.

Although Schnabel, through various circumstances, has withdrawn from the pressure of the zeitgeist for the past fifteen years, he has established outstanding working conditions for himself and regularly received positive response to

definieren eine der wichtigen Brücken vom 20. ins 21. Jahrhundert.

Das Gesamtwerk von Julian Schnabel ist von großer Bedeutung für den zeitgenössischen Begriff von Malerei. Dieses Werk orientiert sich zuallererst an der Dimension, genauer am Begriff des Maßstabs (»scale«), der Schnabels Auffassung vom Gemälde trägt. Die Leinwand ordnet sich der Architektur nicht unter, sondern bestreitet ihr die Legitimität. Das gilt auch für *Chinese Painting*. Der meiste Raum ist freigelassen. Dennoch hat das Bild eine unvergleichliche Spannung. Ein spontan hingeworfenes Motiv – das Porträt einer alten Frau – ist dank unorthodoxer Mittel auf der Bildfläche ausbalanciert. Alles ist scheinbar »unmöglich« oder »verboten« in diesem Gemälde: die realistische Figur, die raue Oberfläche, die koloristischen Gebilde aus amorphen Konglomeraten von Linien und Flächen. Aber das Bild ist zugleich verblüffend kraftvoll. Es handelt sich um eines der großen Bilder des neuen Lebensgefühls dieser Gegenwart.

Julian Schnabel verwendet durchweg Bildträger, die es eigentlich nicht erlauben, ein kohärentes Bild zu malen: Samt, Zeltbahnen, Lastwagenplanen, Scherbenflächen, chinesische Landschaftsgemälde, japanische Comic-Bilder usw. Bisweilen »erschwert« er sich die Aufgabe durch die Verwendung von Kunstharzen oder die Beschränkung auf das Malen mit den Händen. Jedes Bild ist eine Tour de force. Er ist ein großes Malertalent, und die künstlichen Hindernisse sind für ihn ein Mittel, es sich nicht einfach zu machen und gegen die leichten Lösungen anzukämpfen. Er stellt sich Zwangslagen, die zur Bilderfindung zwingen, wenn man das Gemälde hinbekommen will.

Der Name Julian Schnabel ist sehr bekannt. Er hat mit seinem Werk der frühen achtziger Jahre die Vorstellungswelt nachhaltig geformt. Heutige Kunststudenten, die mit Malerei umgehen, sagen fast durchweg, von Julian Schnabel mitgeprägt zu sein, obwohl sie oft noch nie eines seiner Gemälde im Original gesehen haben, und fügen hinzu, sie wüssten nicht, wie Schnabels Werk aus den letzten Jahren aussehe. Dies ist umso bemerkenswerter, als Kunststudenten im Durchschnitt nur Interesse für das Werk von vier oder fünf Malern der Gegenwart haben. Dass Julian Schnabel unter ihnen figuriert, obgleich das Werk zuletzt vergleichsweise wenig öffentlich ausgestellt wurde, zeigt, wie groß

his work largely outside of international exhibition events. This is also an unusual paradox. Never before has the development of art been more characterized by exhibitions, which in the course of the past century have ascended to a prominent medium. There are incomparably more exhibitions of contemporary art than ever before, and they attract more visitors than thirty or forty years ago. But Julian Schnabel is a living example of the fact that pivotal collections of work can thrive just as well outside of the exhibition industry.

Julian Schnabel has developed a diverse and, at first glance, seemingly uncategorizable iconography, unique in the context of painting after 1975. His imagery hardly has anything to do with the artistic discourses in painting in recent years. Often, two works in progress are consolidated into the same painting. Non-objective and figurative elements, abstract forms of expression and classical representation with rendering of the visible can be found in the same painting. Nearly every painting by Julian Schnabel possesses such a paradoxical visual status. These combinations are "forbidden" for serious painters, strictly speaking. They are also dangerous, because as soon as they establish themselves as a style or method, they represent treacherous traps for artists. And vice-versa: every painting can fail if one constantly treats these conditions differently. This risk can always be sensed with Julian Schnabel; it accords the paintings their strength. Each piece is a tightrope walk from which a daring composition emerges. This position "on the brink of disaster" lends the painting of Julian Schnabel its excitement.

This risk has a very precise purpose: the compulsion towards iconographic invention. The legendary paintings from the early eighties also originate from this "painter's battle against painting as a technique." Surfaces that in principle cannot be painted on lead to new visual effects, new artistic spaces, and new iconographic contents. Since the mid eighties, Julian Schnabel has been more concerned with directly working on the iconography and inventing a new vocabulary, and less with combining predefined forms of painting.

Describing Schnabel's work as "painting against the rules of painting," as a confrontation of contradictory materials and creative approaches in the same piece, may suggest an Expressionist interpretation of his painting. At the beginning

der Eindruck seiner bekanntesten Bilder der achtziger Jahre auf das kollektive Bewusstsein ausfiel.

Zweitens hat sich der Maler durch verschiedene Umstände seit etwa fünfzehn Jahren aus dem Druck des Zeitgeistes herausgenommen, sich aber hervorragende Arbeitsbedingungen und ein regelmäßiges Echo auf seine Arbeit weitgehend außerhalb des internationalen Ausstellungsgeschehens bewahrt. Auch das ist ein seltenes Paradoxon. Die Entwicklung der Kunst ist wie nie zuvor durch Ausstellungen geprägt, die im Verlauf des letzten Jahrhunderts zu einem führenden Medium aufstiegen. Es gibt ungleich mehr Ausstellungen zeitgenössischer Kunst als zuvor, und sie ziehen mehr Publikum an als vor dreißig oder vierzig Jahren. Doch Julian Schnabel ist ein lebendes Beispiel dafür, dass zentrale Gesamtwerke ebenso so gut abseits des Ausstellungsbetriebs gedeihen.

Julian Schnabel hat sich eine vielfältige und auf den ersten Blick kaum einordbare Ikonografie erarbeitet, die im Kontext der Malerei ab 1975 einzigartig dasteht. Seine Bildsprache hat mit den malerischen Diskursen der letzten Jahre kaum etwas zu tun. Oft sind zwei Bildentwürfe im gleichen Gemälde zusammengeführt. Ungegenständliche und figurative Elemente, abstrakte Ausdrucksformen und klassische Repräsentation mit Wiedergabe des Sichtbaren finden sich im gleichen Bild. Fast jedes Gemälde von Julian Schnabel hat einen solchen paradoxalen Bildstatus. Eigentlich sind diese Kombinationen für seriöse Maler »verboten«. Sie sind auch gefährlich, da sie, sobald sie zum Stil oder zur Methode ausarten, dem Künstler heimtückische Fallen stellen. Umgekehrt kann jedes Gemälde scheitern, wenn man mit diesen Voraussetzungen stets wieder neu umgeht. Dieses Risiko ist bei Julian Schnabel immer spürbar. Es gibt den Gemälden ihre Kraft. Jedes Bild ist eine Gratwanderung, aus der eine gewagte Setzung hervorgeht. Dieses »Stehen am Abgrund« gibt der Malerei von Julian Schnabel ihre Spannung.

Das Risiko besitzt einen präzisen Zweck, nämlich den Zwang zur ikonografischen Erfindung. Auch die legendären Bilder aus den frühen achtziger Jahren entstammen diesem »malerischen Ankämpfen gegen die Malerei als Technik«. Oberflächen, die es im Prinzip nicht ermöglichen, auf ihnen zu malen, führen zu neuen Bildwirkungen, neuen Bildräu-

of his career, Julian Schnabel was in fact categorized by art critics as the main representative of Neo-Expressionism. This definition was related to the premise that Julian Schnabel was inspired by the work of the first Neo-Expressionists, German painters such as Georg Baselitz and Anselm Kiefer. Several authors propagated this line of reasoning in the eighties, in an attempt to put the steep ascent of the shooting star into perspective. This had serious consequences for Schnabel's image in the discourses of contemporary art at the time. Schnabel finds "ridiculous" the idea, widespread in the U.S., that he supposedly copied German examples.

Nothing could be more incorrect than to interpret Julian Schnabel's painting as Expressionist or Neo-Expressionist. Apart from the fact that this is only even partially true for Baselitz and Kiefer, since they did not use German Expressionism as a starting point for their visual structures but were influenced rather by American Abstract Expressionists like Jackson Pollock and Willem de Kooning, Julian Schnabel doesn't have the least bit in common with the intention or visual vocabulary of these painters. Julian Schnabel's artistic freedom and the scale of the *Plate Paintings* from the years 1979 and 1980 in fact encouraged the generation of painters fifteen years older to free the formats and methods of their own painting from existing constraints.[3]

Schnabel is a well-trained painter, highly aware of his own references and preferences.[4] In terms of German art from the past century, he feels a true kinship with Max Beckmann, Joseph Beuys, and Blinky Palermo.[5] If one wishes to pinpoint the Expressionist direction in his work, it more involves Beckmann's non-subjective realistic approach. He on the other hand influenced the anti-subjective Abstract Expressionists in the U.S. in the fifties, who resisted Pollock's subjective intention and the idea of painting as a "psychogram of the artist." Similarly, Julian Schnabel implemented a varied but clear "signature": the picture is created at the edge of iconographic implosion. This represents an expressive tendency, but one which does not require expressionistic self-manifestation.

From this perspective, Schnabel's intention can be more closely identified. Broadly speaking, he is Post-Minimalist. His work has its roots in the late sixties and early seventies,

men und neuen ikonografischen Gehalten. Seit Mitte der achtziger Jahre geht es Julian Schnabel mehr um direktes Arbeiten an der Ikonografie, weniger um das Kombinieren vorgefundener Bildformen, mehr um das Erfinden eines neuen Vokabulars.

Die Beschreibung der Malerei von Julian Schnabel als »Anmalen gegen die Malerei«, als Konfrontation widersprüchlicher Materialien und bildnerischer Ansätze im gleichen Gemälde kann auf eine expressionistische Interpretation dieser Malerei hindeuten. Tatsächlich wurde Julian Schnabel zu Beginn seiner Laufbahn von der Kunstkritik als Hauptvertreter des Neo-Expressionismus eingeordnet. Dieser Begriff bezieht sich auf die These, Julian Schnabel knüpfe an die ersten Neo-Expressionisten an, an deutsche Maler wie Georg Baselitz und Anselm Kiefer. Dieses Argument wurde in den achtziger Jahren von mehreren Autoren mit dem Hintergedanken vorgetragen, den kometenhaften Aufstieg von Julian Schnabel zu relativieren. Für Schnabels Image in den aktuellen Diskursen der zeitgenössischen Kunst hatte dies schwerwiegende Folgen. Die in den USA weitverbreitete Idee, Schnabel kopiere deutsche Vorbilder, empfindet der Maler als »lächerlich«.

Nichts aber ist falscher, als die Malerei von Julian Schnabel als expressionistisch oder neo-expressionistisch zu deuten. Abgesehen davon, dass dies auch für Baselitz und Kiefer nur beschränkt zutrifft, da sie in ihren Bildstrukturen nicht an den deutschen Expressionismus anknüpfen, sondern an den Abstrakten Expressionismus der Amerikaner, von Jackson Pollock bis Willem de Kooning, hat Julian Schnabel mit dem Ausdruckswillen und dem bildnerischen Vokabular dieser Maler nicht das Mindeste gemein. Umgekehrt dagegen haben die malerische Freiheit und der Maßstab der *Tellerbilder* von Julian Schnabel aus den Jahren 1979 und 1980 die um fünfzehn Jahre ältere Malergeneration darin bestärkt, Formate und Malweisen ihrer eigenen Malerei aus bisherigen Zwängen zu befreien.[3]

Schnabel ist ein überaus gebildeter Maler, und er ist sich seiner Bezüge und Vorlieben sehr bewusst.[4] Eine echte Beziehung empfindet er, was die deutsche Kunst des vergangenen Jahrhunderts anbelangt, zu Max Beckmann, Joseph Beuys und Blinky Palermo.[5] Wenn man das expressive Ausdrucks-

when the new aesthetic paradigm formulated by Minimal art was being explored. That which today may be interpreted as Expressionist resulted as a variation within the Minimalist painting discourse. Even today, Julian Schnabel's work features Post-Minimalist painting structure: the width of the canvas, which embraces the observer; the flat visual space; the rejection of a principle of composition; the treatment of a wide range of different image elements and areas of color as specific objects; the radical juxtaposition of the picture elements; the fascination with the topic of time. Julian Schnabel however turned the aesthetic paradigm of Minimalism into a highly expressive art, which today addresses the entire emotional palette of existence in symbolic compositions. This recovering of the expressive within the Minimalist paradigm is the historic achievement of Julian Schnabel.

The artist's career has proceeded differently than one might initially expect. After studying art at the University of Houston, Julian Schnabel received a scholarship in 1973 to the Whitney Program in New York. This postgraduate program was the premier training center for post-Conceptual artists and museum curators. It has had a stronger influence than any other institution on the development of contemporary art in the last thirty years. For Julian Schnabel, acceptance to the Whitney Program initially meant simply the opportunity to leave Houston behind him and return to New York. But the scholarship generated the decisive developmental impetus in his work. His painting didn't "fit in" with others' work. As the "Texas painter," he remained an outsider, but one whose personal dynamism made an immense impression—a position that he still occupies in the New York art world. Sherrie Levine had completed the Whitney Program a year earlier. The Conceptual artist Ron Clark, a pioneer of the new relationship to the formal heritage of Classical Modernism, was a tutor. Schnabel became friends with his fellow scholarship recipient Tom Otterness, who in turn had contact with the avant-garde legend Vito Acconci. In this way, he met all the important artists in the New York art scene of the time, including Richard Serra, Brice Marden, Donald Judd, Richard Artschwager, and Malcolm Morley. He sublet for a time from the girlfriend of Gordon Matta-Clark,

moment dieser Malerei benennen will, so geht es eher um die nichtsubjektive, realistische Variante Beckmanns. Dieser wiederum hat die antisubjektiven Abstrakten Expressionisten der fünfziger Jahre in den USA beeinflusst, die sich gegen den subjektiven Ausdruckswillen Pollocks und gegen die Idee vom Gemälde als einem »Psychogramm des Künstlers« zur Wehr setzten. Ebenso praktiziert Julian Schnabel eine vielfältige, aber klare »Handschrift«: das Bild entsteht am Rand der ikonografischen Implosion. Diese stellt ein expressives Moment dar, das aber nicht des expressionistischen Selbstausdrucks bedarf.

Von da aus lässt sich der Ausdruckswille Schnabels näher bestimmen. Er ist in wesentlichen Zügen post-minimalistisch. Sein Werk wurzelt in den späten sechziger und frühen siebziger Jahren, als es darum ging, das neue ästhetische Paradigma auszuloten, das die Minimal Art formuliert hatte. Was sich heute als expressiv deuten lässt, entstand als Variante innerhalb der minimalistischen Malereidiskurse. Mit diesen teilt Julian Schnabel bis heute die post-minimalistische Bildstruktur – die Weite der Leinwand, die den Betrachter umfängt, der flache Bildraum, die Ablehnung eines Kompositionprinzips, die Behandlung unterschiedlichster Bildelemente und Farbteile als spezifische Objekte, das radikale Nebeneinander der Bildteile, die Faszination am Thema »Zeit«. Allerdings hat Julian Schnabel das ästhetische Paradigma der Minimal Art in eine hochexpressive Kunst gewendet, die neuerlich die gesamte Emotionspalette der Existenz in symbolischen Setzungen anzusprechen vermag. Diese Wiedergewinnung des Expressiven innerhalb des minimalistischen Paradigmas ist die historische Leistung von Julian Schnabel.

Der Werdegang des Künstlers ist denn auch ganz anders gelagert, als man zunächst glauben würde. Nach dem Studium an der Kunsthochschule in Houston war Julian Schnabel 1973 Stipendiat des Whitney Program in New York. Dieses Post-graduate-Programm ist die einflussreichste Kaderschmiede für postkonzeptuelle Künstler und Museumskuratoren gewesen. Es hat die Entwicklung der zeitgenössischen Kunst in den letzten dreißig Jahren stärker beeinflusst als jede andere Institution. Für Julian Schnabel bedeutete die Aufnahme in das Whitney Program zunächst nur die Möglich-

Susan Ensley. This context is a key to understanding the origins and the significance of his work.

Julian Schnabel's early work can even be interpreted as the consequential application of the school of thought encouraged in the Whitney Program; it includes direct references to several contemporary painters of Minimalist origin.

Another characteristic of Julian Schnabel is also related to the Whitney Program. Fifteen young art historians and artists had guest ateliers housed at the Immigrant Savings Bank building and were confronted each week with an experienced art critic. Since that time, Julian Schnabel is in the habit of using an especially articulate manner of expression. His spoken remarks on his own work are always well thought out and polished. His language indicates a deliberate, historically and theoretically well-founded artistic vocabulary. The precise coordinates of his way of thinking, which came into being in the seventies in the context of the Whitney Program in New York, accompany Julian Schnabel even today.

The second important influence in Schnabel's work resulted from a decision that had much to do with the Middle European culture with which Schnabel grew up. His father comes from Prague, is Slovakian by birth, and in 1926 emigrated to the U.S. during the economic crisis following the dissolution of the Habsburg monarchy. In 1976, Julian Schnabel undertook an extended trip through Europe to study pre-Modernist paintings, which he mainly knew at the time only though books, to see "how they really look." He traveled to Paris and Italy. Even today, he still remembers minute details of the paintings he saw. "The scale and the specific gravity" of these paintings especially impressed him, says the artist today. Both aspects germinated a few months later in the *Plate Paintings*, which attacked Post-Minimalist painting. "On such a trip, you slowly realize the different techniques of the various painters," adds Julian Schnabel. The field excursion into European culture, with which he was already familiar from his father's stories, is the second reference point in his work.

The memory of the scale of Renaissance paintings moved Julian Schnabel to now begin painting largely outdoors. This allows the pieces to develop a particular sovereignty in the indoor spaces of museums and art collections. At the same

keit, nach New York zurückkehren und Houston hinter sich lassen zu können. Doch das Stipendium bewirkte den entscheidenden Entwicklungsschub in seiner Arbeit. Seine Malerei passte nicht zum Rest. Als »Maler aus Texas« blieb er ein Außenseiter, dessen persönliche Dynamik aber großen Eindruck machte – eine Position, die er bis heute in der Kunstwelt New Yorks einnimmt. Sherrie Levine hatte das Whitney-Programm ein Jahr vorher bestritten. Der Konzeptkünstler Ron Clark, ein Vordenker des neuen Verhältnisses zum formalen Erbe der Klassischen Moderne, war der Tutor. Schnabel freundete sich mit dem Stipendiatenkollegen Tom Otterness an, der wiederum Kontakt zur Avantgarde-Legende Vito Acconci hatte. Dabei lernte er alle wichtigen Künstler der damaligen Szene New Yorks kennen, Richard Serra etwa und Brice Marden, Donald Judd, Richard Artschwager und Malcolm Morley. Eine Zeitlang wohnte er zur Untermiete bei der Freundin von Gordon Matta-Clark, Susan Ensley. Dieser Kontext ein Schlüssel zum Verständnis der Wurzeln und der Tragweite seines Werkes.

Das Frühwerk von Julian Schnabel kann sogar als folgerichtige Anwendung des Denkens gelesen werden, das im Whitney Program geprägt wurde; es verbindet unmittelbare Zitate mehrerer zeitgenössischer Maler minimalistischer Provenienz.

Eine weitere Eigenschaft von Julian Schnabel steht mit dem Whitney Programm in Verbindung. Fünfzehn junge Kunsthistoriker und Künstler hatten Gastateliers im Gebäude der Immigrant Savings Bank und wurden jede Woche mit einem erfahrenen Kunstkritiker konfrontiert. Seither pflegt Julian Schnabel eine besonders artikulierte Ausdrucksweise. Seine mündliche Äußerungen zur eigenen Arbeit sind stets druckreif. Das Vokabular verrät einen bewussten, historisch und theoretisch abgesicherten Malereibegriff. Die präzisen Koordinaten des Denkens, das in den siebziger Jahren rund um das Whitney Program in New York entstand, begleiten Julian Schnabel bis heute.

Der zweite wichtige Einfluss für das Werk ergab sich durch eine Entscheidung, die viel mit der mitteleuropäischen Kultur zu tun hat, unter deren Eindruck Schnabel aufwuchs. Sein Vater stammt aus Prag, ist gebürtiger Slowake und war 1926, während der Wirtschaftskrise nach der Auflösung der

time, his experiences in Italy led to the question of whether one couldn't again use picture formats such as Deposition from the Cross or Pietà, paintings which had remained impressive since the Renaissance.

"For that I would need a surface that could bear the composition without being Mannerist like Richard Lindner or Francis Bacon." [6] An atelier experiment resulted in the first *Plate Paintings*. Dishes were thrown at the canvas and fixed in their respective state, sometimes broken, not in an intentional reference to Daniel Spoerri's *tableaux pièges* (trap pictures) from the Nouveau Réalisme movement of the sixties, but certainly aware of that work. Painting powerful and expressive images of figures on such a surface, and sometimes integrating collages to portray classical themes, captivated observers and the art world. At the first exhibitions of the *Plate Paintings* in New York in 1979 and in Europe in 1980, observers were amazed by the paintings' simultaneous physical strength, dimension, and lasting impression. Certainly no painter had attacked the aesthetic consensus of an epoch in such a decided and deliberate manner since Yves Klein's blue monochromes in 1958. "Nobody else had ever painted like that," felt Julian Schnabel when he created the first *Plate Paintings*. "I always had wanted to make a painting I had never seen before."

Within a few months, the artistic climate shifted as a result. In spring 1982, the large exhibitions "A New Spirit in Painting" at the Royal Academy of London and "Zeitgeist" at the Martin-Gropius-Bau in Berlin celebrated the reinstatement of figural painting, from Francis Bacon to Andy Warhol, while the older generation from the sixties and seventies, including Georg Baselitz and Gerhard Richter, returned to large-format painting with signature traces in an abandonment of the Post-Minimalist aesthetic of the seventies.

At "documenta 7" in Kassel, Germany in 1982, the ostracization of Julian Schnabel, the most-discussed painter of the times, became a public dispute. The artistic director Rudi Fuchs staged a brilliant and historically significant retrospective of those artists from the Minimalist approach who remained important within the new "Neo-Expressionist" paradigm of the 1980s—from Gilbert and George, Georg Baselitz, and Gerhard Richter to Richard Artschwager, Daniel Buren,

österreich-ungarischen Monarchie in die USA ausgewandert. 1976 unternahm Julian Schnabel eine ausgedehnte Europa-Reise, um die Bilder der Malerei vor der Moderne, die er bislang vorwiegend aus Büchern kannte, dahingehend zu studieren, »wie sie wirklich aussehen«. Er fuhr nach Paris und Italien. Noch heute kennt er die gesehenen Gemälde bis in die Details. »Der Maßstab und das spezifische Gewicht dieser Gemälde« hätten ihn besonders beeindruckt, meint er heute. Beide Aspekte gingen wenige Monate später in den *Tellerbildern* auf, die die post-minimalistische Malerei damit attackierten. »Langsam begreift man auf einer solchen Reise die unterschiedliche Technik der verschiedenen Maler«, fügt Julian Schnabel hinzu. Die Studienfahrt in die europäische Kultur, die ihm zuvor aus den Erzählungen seines Vaters vertraut war, ist der zweite Bezugspunkt des Werks.

Die Erinnerung an den Maßstab der Gemälde in der Renaissance bewog Julian Schnabel, von nun an die Gemälde zumeist im Freien zu beginnen. Die Leinwände entwickeln damit in den Innenräumen der Museen und Kunstsammlungen eine besondere Souveränität. Zugleich führte die Italien-Erfahrung zur Frage, ob man Bildschemen wie »Kreuzabnahme« oder »Pieta«, die seit der Renaissance konstant eindrücklich geblieben waren, nicht wieder einsetzen könnte. »Dazu aber benötigte ich eine Oberfläche, die die Figuration wieder aushielte, ohne manieristisch zu sein wie bei Richard Lindner und Francis Bacon.« [6] Aus einem Atelierexperiment heraus entstanden die ersten *Tellerbilder*. Geschirr wurde auf die Leinwand geworfen und im jeweiligen Zustand – teilweise zerbrochen – darauf fixiert, nicht in einer bewussten Bezugnahme auf die *Fallenbilder* von Daniel Spoerri des Nouveau Réalisme der sechziger Jahre, aber in dem Wissen um sie. Auf einer solchen Oberfläche kraftvoll und expressiv Figurenbilder zu malen, die bisweilen kollagenhaft mit klassischen Themen umgehen, schlug Betrachter und Kunstwelt in den Bann. Bei den ersten Ausstellungen der *Tellerbilder* 1979 in New York und 1980 in Europa stand man verblüfft vor den Gemälden, die zugleich mit physischer Kraft, Dimension und Erinnerungswirkung beeindruckten. Seit Yves Kleins blauen Monochromen von 1958 hatte wohl kein Maler derart dezidiert und bewusst den ästhetischen Konsens einer Epoche angegriffen. »Niemand hat je so ge-

and Katharina Sieverding. Side rooms and the exhibition at the Neue Galerie were dedicated to the young artists who for the past two years had publicly asserted expressive forms again, from the painters of the Mülheimer Freiheit group and the Berliner Gruppe at Pariser Platz to Jonathan Borofsky and Martin Disler. Julian Schnabel was only indirectly represented, through the most monumental painting at "documenta 7," a *Bücherbild* (book picture) by Georg Jiri Dokoupil, in which the German-Czech painter and instigator of the Mülheimer Freiheit group used a canvas filled with glued-on books to deliver a brilliant commentary on the aesthetic revolution that Schnabel represented. Julian Schnabel's *Plate Paintings* were so omnipresent in the art public at that time that numerous exhibition visitors mistook Dokoupil's painting for one by Julian Schnabel. A lifelong artistic friendship grew between Julian Schnabel and Georg Jiri Dokoupil, Martin Kippenberger, and Albert Oehlen from this experience. However, the statement ascribed to Rudi Fuchs that Julian Schnabel was "a product of the American art market" had short and medium-term consequences. Schnabel continued painting, but in the medium range withdrew from the spotlight of current artistic events.

From his American background, Julian Schnabel has acquired a practical nature. This is reflected in particular in his decision to make an international feature film about Jean-Michel Basquiat. A filmmaker who interviewed Schnabel in 1988, soon after Basquiat's death, wrote a screenplay based on the late painter's life. Schnabel found it to be so removed from reality that he decided, "I've got to do this job myself." Without knowing it at the time, Julian Schnabel for the second time carried out a decisive act in the development of American art. With the stylistic means of biographical film, he created a nationally and internationally successful tribute to his painter colleagues in the New York art scene, which within three years was shaken by the deaths of Andy Warhol, Keith Haring, and Jean-Michel Basquiat. Schnabel's first feature film found its place in the reversal of trend of the early nineties when coping with the AIDS epidemic in New York brought about, a new aesthetic of documentary-based political and social awareness. Even today, Julian Schnabel's two feature films are shown regularly around the globe. In histo-

malt«, empfand Julian Schnabel, als er die ersten Tellerbilder malte. »Ich habe immer Bilder machen wollen, wie ich sie noch nie zuvor gesehen habe.«

Binnen weniger Monate wandelte sich in der Folge das künstlerische Klima. Im Frühjahr 1982 zelebrierten die Großausstellungen *A New Spirit in Painting* und *Zeitgeist* in der Londoner Royal Academy beziehungsweise im Berliner Martin-Gropius-Bau die Rehabilitierung figuraler Malerei, von Francis Bacon bis Andy Warhol, während die ältere Generation der sechziger und siebziger Jahre, mit Georg Baselitz und Gerhard Richter, wieder großformatige Malerei mit handschriftlichen Spuren in Abkehrung von der post-minimalistischen Ästhetik der siebziger Jahre praktizierte.

Bei der *documenta 7*, die 1982 in Kassel stattfand, wurde die Ausgrenzung von Julian Schnabel, dem meistdiskutierten Maler dieser Jahre, zum öffentlichen Disput. Der künstlerischer Leiter Rudi Fuchs inszenierte eine brillante und historisch bedeutsame Retrospektive derjenigen Künstler, die aus dem minimalistischen Kunstansatz heraus innerhalb des neuen »neo-expressionistischen« Paradigmas der achtziger Jahre bedeutend blieben – von Gilbert and George über Georg Baselitz und Gerhard Richter bis zu Richard Artschwager, Daniel Buren und Katharina Sieverding. Seitenräume und die Ausstellung in der Neuen Galerie waren den jungen Künstlern gewidmet, die seit zwei Jahren expressive Ausdrucksformen erneut öffentlich durchgesetzt hatten, von den Malern der Mülheimer Freiheit und der Berliner Gruppe am Pariser Platz bis zu Jonathan Borofsky und Martin Disler. Julian Schnabel war bloß indirekt vertreten, durch das monumentalste Gemälde der *documenta 7*, ein *Bücherbild* von Georg Jiri Dokoupil, auf dem der deutsch-tschechische Maler und damalige Motor der Gruppe Mülheimer Freiheit auf einer mit Büchern vollgeklebten Leinwand einen brillanten Kommentar zur ästhetischen Revolution vorführte, die Schnabel repräsentierte. Die *Tellerbilder* von Julian Schnabel waren zu diesem Zeitpunkt in solchem Maße in der Kunstöffentlichkeit gegenwärtig, dass zahlreiche Ausstellungsbesucher Dokoupils Gemälde für »das Bild von Julian Schnabel« hielten. Aus dieser Erfahrung erwuchs eine lebenslange Künstlerfreundschaft mit Georg Jiri Dokoupil, Martin Kippenberger und Albert Oehlen. Das Rudi Fuchs zugeschriebene Wort,

ry and in the personal economy of artists, the manner in which Julian Schnabel escaped the pressure of the artistic environment remains an important example.

From this extraordinary biography, a collection of works has resulted that can today be viewed as if it were the testimonial of a new painter who is just being discovered; painting without a direct antecedent, almost. Julian Schnabel has maintained a physical and architectonic strength in his paintings, a strength which re-emerges on the canvas in a collision of inhospitable surface and atypical treatment. Many of Schnabel's pictures have been painted with his hands, protected by thin rubber gloves. The picture is allowed to "crash." In terms of their specific artistic position, the pictures are high-risk paintings. Schnabel paints nearly all of his pieces outdoors, like Edvard Munch when he withdrew to Norway after similar experiences in the art world. The expansive power of forms is much stronger in Julian Schnabel's work today than in early pieces. The visual after-effect of the paintings remains intense. Their repertoire of forms evades the conventional dogmatic canon of the past fifteen years of painting. In short: even a quarter of a century after beginning his career, Julian Schnabel has not lost his artistic energy. After examining his paintings in detail, Schnabel concludes: "I guess that's it: a painter's response to these times."

Julian Schnabel sei »ein Produkt des amerikanischen Kunstmarkts«, zeitigte jedoch kurz- und mittelfristige Folgen. Während er sein malerisches Werk fortführte, zog sich Julian Schnabel mittelfristig aus dem Rampenlicht der künstlerischen Aktualität zurück.

Aus seiner amerikanischen Lebensgeschichte bezieht Julian Schnabel einen pragmatischen Wesenszug. Dieser kommt vornehmlich in seiner Entscheidung zum Ausdruck, einen internationalen Spielfilm über Jean-Michel Basquiat zu machen. Ein Filmemacher, der Schnabel 1988 kurz nach Basquiats Tod interviewte, schrieb ein Drehbuch über das Leben des verstorbenen Malers. Schnabel war es zu weit von der Realität entfernt, sodass er entschied: »Ich muss den Job selbst machen.« Ohne es zunächst zu ahnen, setzte Julian Schnabel damit zum zweiten Mal einen entscheidenden Akt in der amerikanischen Kunstentwicklung, indem er mit biografischen Stilmitteln eine landesweit und international erfolgreiche Zeugenschaft für die Malerkollegen der New Yorker Kunstszene schuf, die binnen dreier Jahre mit dem Ableben von Andy Warhol, Keith Haring und Jean-Michel Basquiat ein Trauma erlebte. Schnabels erster Spielfilm hat seinen Platz in der Trendwende der frühen neunziger Jahre, als aus der Verarbeitung des Aids-Traumas von New York nochmals eine neue Ästhetik politischer und sozialer Bewusstheit auf dokumentarischer Grundlage ausging. Noch heute werden die beiden Spielfilme, für die Julian Schnabel als Regisseur zeichnet, regelmäßig überall auf der Welt gezeigt. In der Geschichte der persönlichen Ökonomie der Künstler ist die Art und Weise, in der sich Julian Schnabel vom Druck der künstlerischen Umwelt freispielt, ein wichtiges Beispiel.

Aus dieser ungewöhnlichen Biografie ergibt sich ein Werk, das man heute betrachten kann, als handle es sich um das Zeugnis eines neuen Malers, der gerade erst entdeckt wird, ja fast um Malerei ohne unmittelbare Vorgeschichte. Julian Schnabel hat sich eine physische und architektonische Kraft der Bilder bewahrt, die auf der Leinwand im Zusammenprall von unwirtlicher Oberfläche und unmalerischer Behandlung neu entsteht. Viele Bilder sind mit den Händen gemalt, die durch feine Gummihandschuhe geschützt sind. Das Bild kann »abstürzen«. Die Gemälde sind

1 The quotes from Julian Schnabel come from a discussion with the author in July 2003 in San Sebastián.
2 Comment from Hans Ulrich Obrist, Paris.
3 At "Aperto" section of the 1980 Venice Biennale, curated by Harald Szeemann, one of Julian Schnabel's historic *Plate Paintings* was featured, while Georg Baselitz decided to exhibit one of his first large wooden sculptures, instead of showing paintings (which later increased in dynamism and format), in the German Pavilion.

4 During the tour of his vacation home above the bay of San Sebastián, Julian Schnabel exclaims, "Look, this view is the same as Max Beckmann's above Nice." The similarity is actually quite remarkable.
5 Sigmar Polke came to the U.S. in 1974; Julian Schnabel and Blinky Palermo drove with him to Philadelphia in a car belonging to Schnabel's father.
6 Schnabel appreciated Francis Bacon as a teenager, "especially his *Van Gogh Going to Work*, where it's so untypical."

Risikobilder, was ihre spezifische malerische Position kennzeichnet. Nahezu alle Bilder malt Schnabel unter freiem Himmel wie Edvard Munch, nachdem er sich in einer kunstsoziologisch vergleichbaren Situation nach Norwegen zurückgezogen hatte. Die Expansionskraft der Formen ist bei Julian Schnabel heute noch stärker ausgeprägt als im Frühwerk. Die visuelle Nachwirkung der Bilder bleibt intensiv. Ihr Formenrepertoire entzieht sich den geläufigen Kanons der Malerei der letzten fünfzehn Jahre. Kurzum: Julian Schnabel hat auch ein Vierteljahrhundert nach Beginn seiner Laufbahn seine künstlerische Energie nicht verloren. Am Schluss einer ausführlichen Betrachtung seiner Gemälde meinte er: »I guess that's it: a painter's response to these times.«

1 Die Zitate von Julian Schnabel stammen aus einem Gespräch mit dem Autor, das im Juli 2003 in San Sebastian stattfand.

2 Hinweis von Hans Ulrich Obrist, Paris.

3 Auf der Biennale von Venedig 1980 gab es bei Aperto, kuratiert von Harald Szeemann, eines der heute historischen *Tellerbilder* von Julian Schnabel zu sehen, während Georg Baselitz sich entschlossen hatte, im Pavillon der Bundesrepublik Deutschland nicht die eigene Malerei zu zeigen (die in der Folge an Dynamik und Format hinzugewann), sondern eine wuchtige, erste Holzskulptur.

4 Bei der Führung durch sein Ferienhaus über der Bucht von San Sebastián meint Julian Schnabel: »Schau, diese Aussicht entspricht Max Beckmanns Sicht über Nizza.« Die Ähnlichkeit ist tatsächlich frappant.

5 1974 kam Sigmar Polke in die USA, Julian Schnabel und Blinky Palermo fuhren ihn im Auto seines Vaters nach Philadelphia.

6 Schnabel schätzte Francis Bacon als Teenager, »besonders sein *Van Gogh geht zur Arbeit*, wo es aus dem Rahmen fällt«.

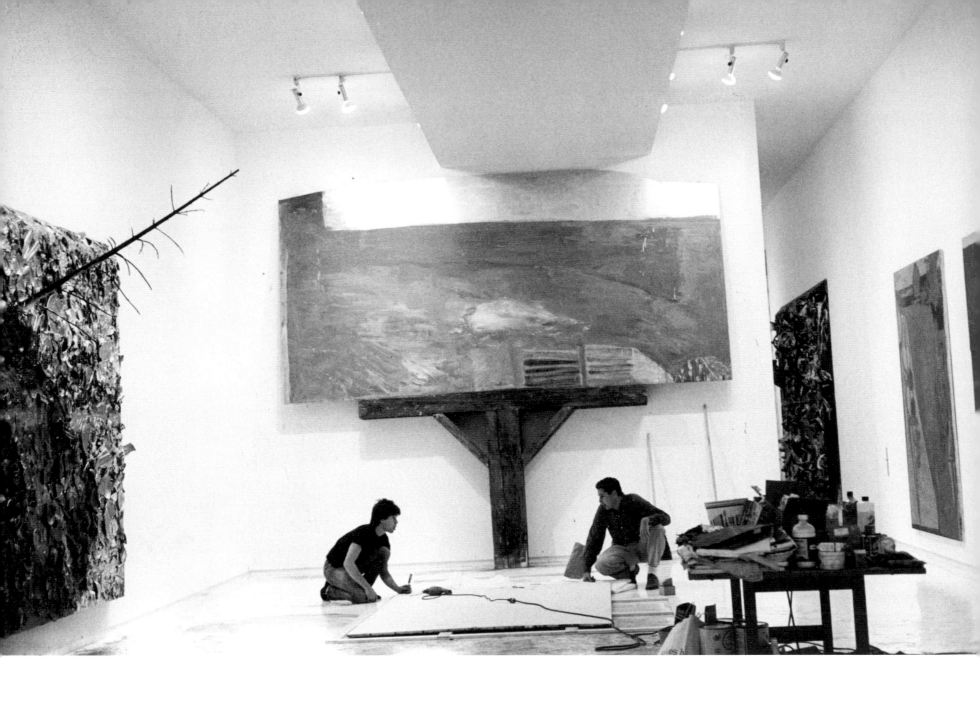

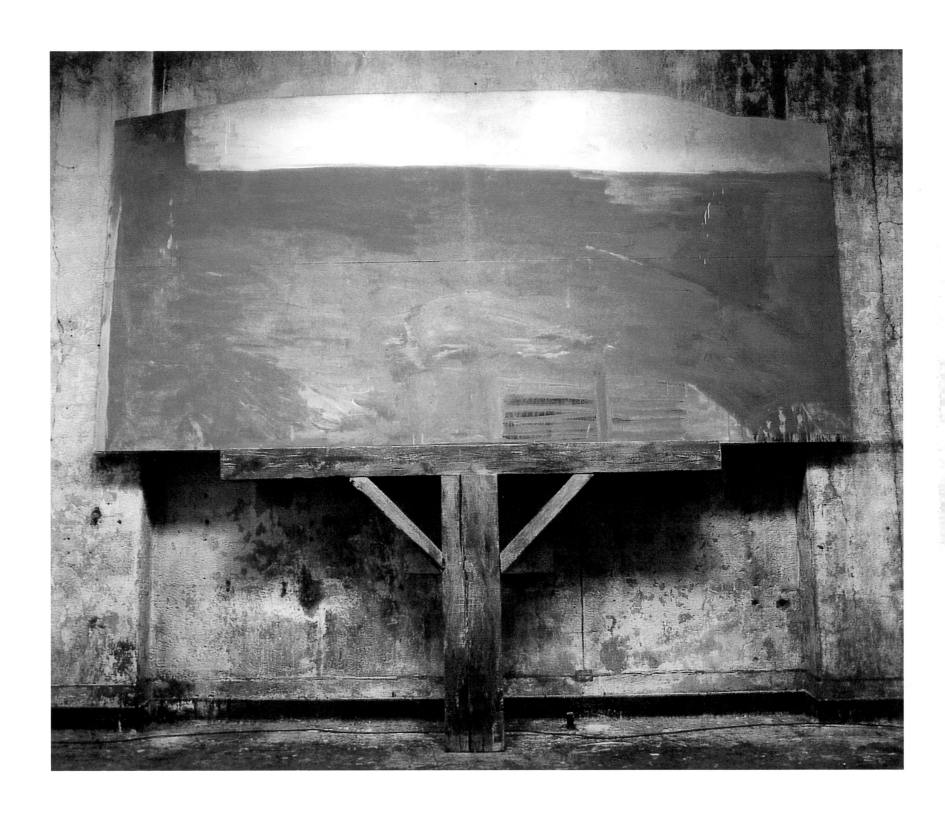

11 Rest, 1982

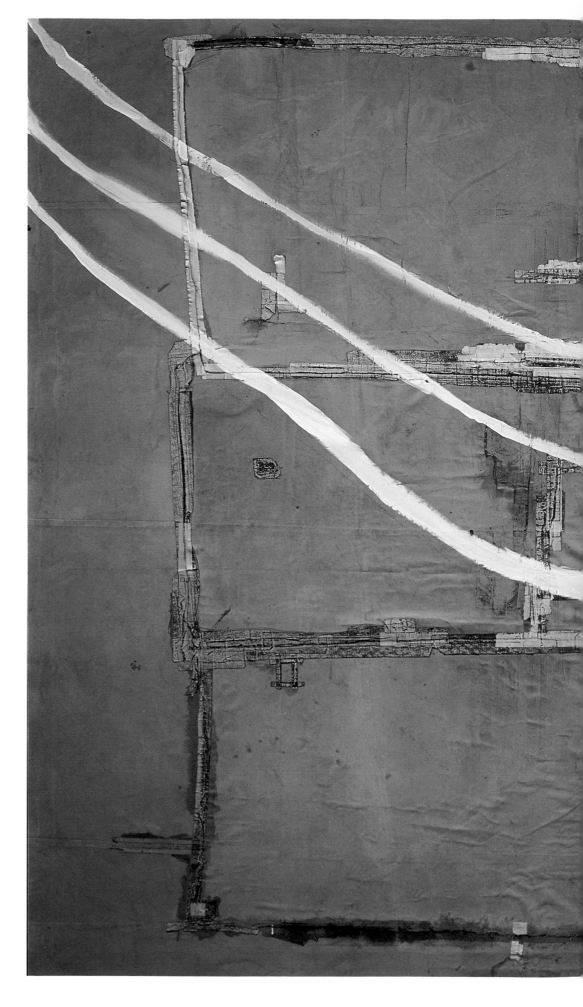

18 The Edge of Victory, 1987

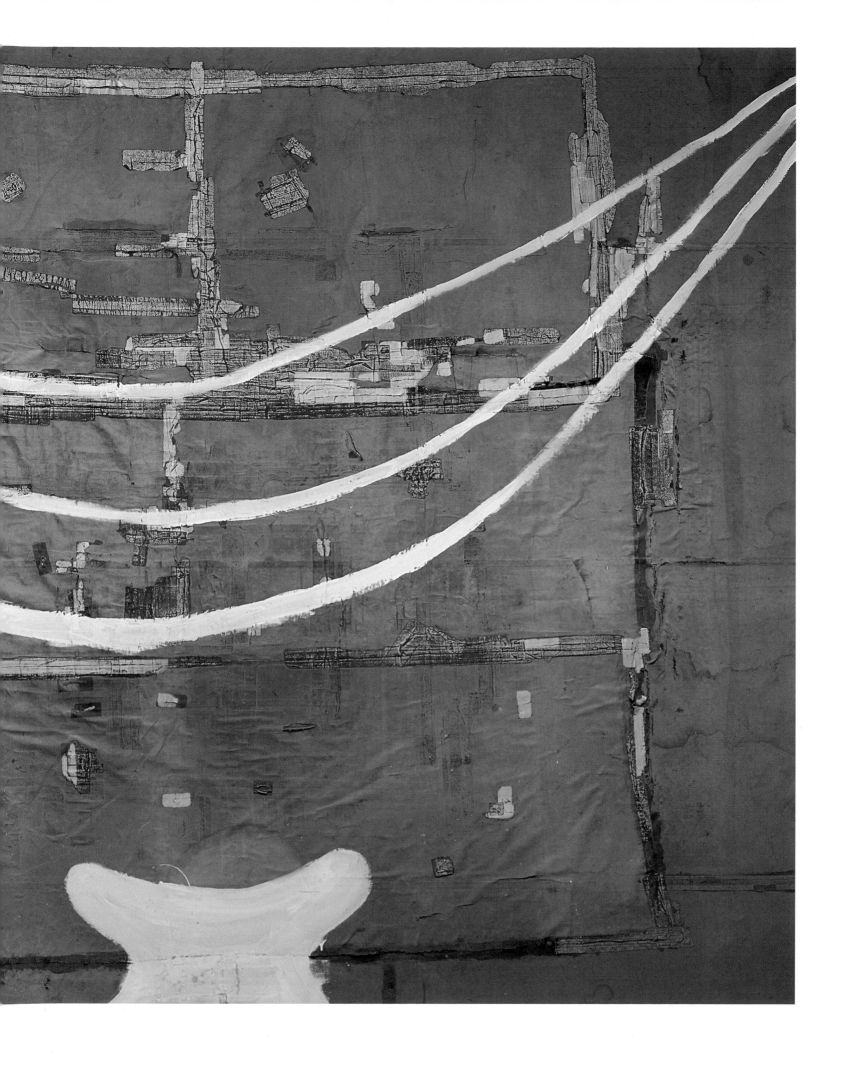

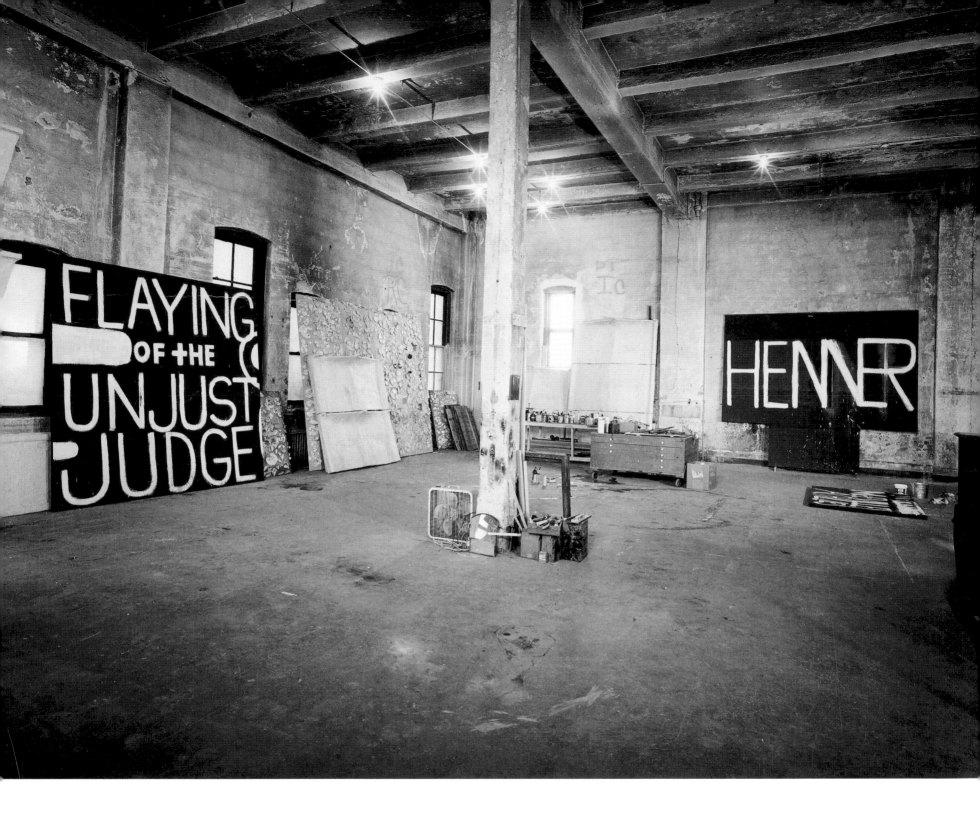

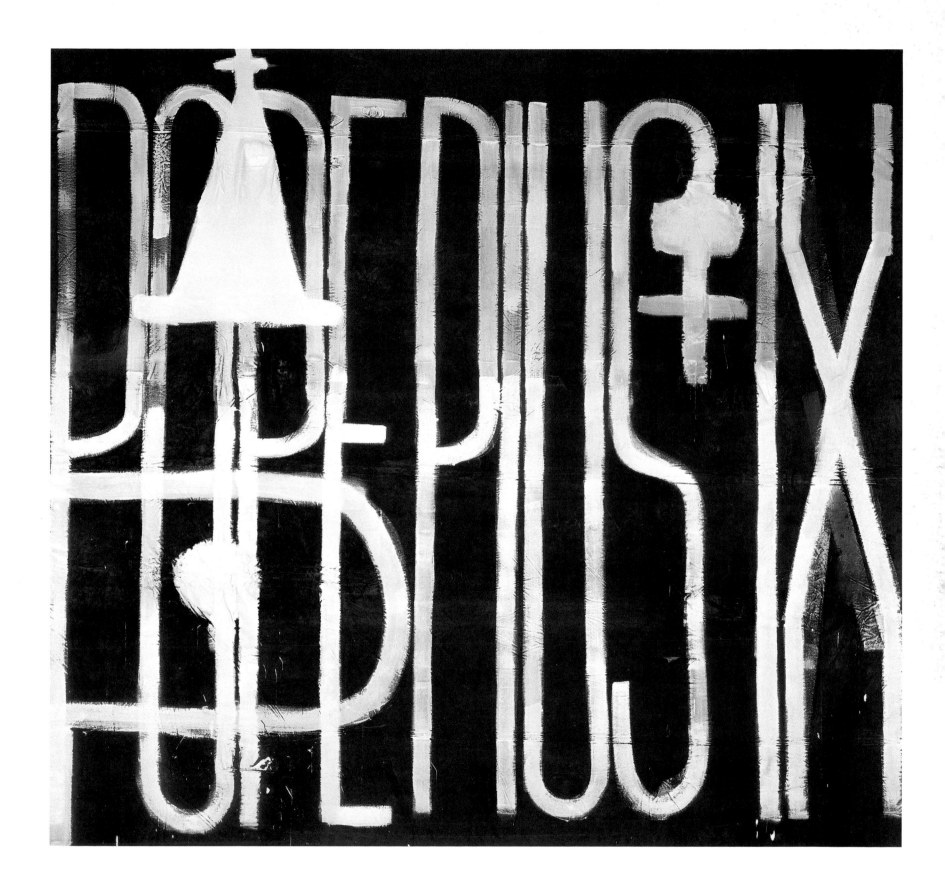

19 Pope Pius IX, 1987

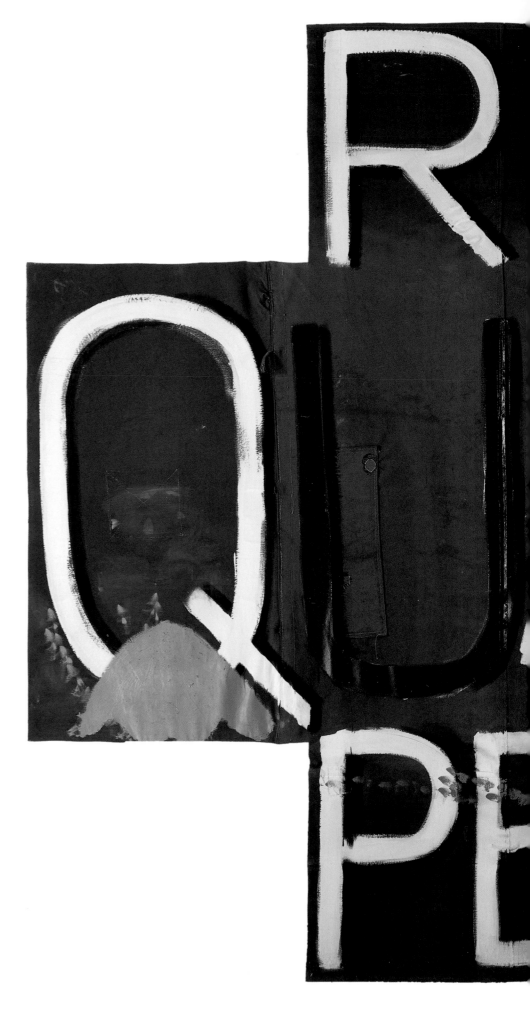

20 Ritu Quadrupedis, 1987

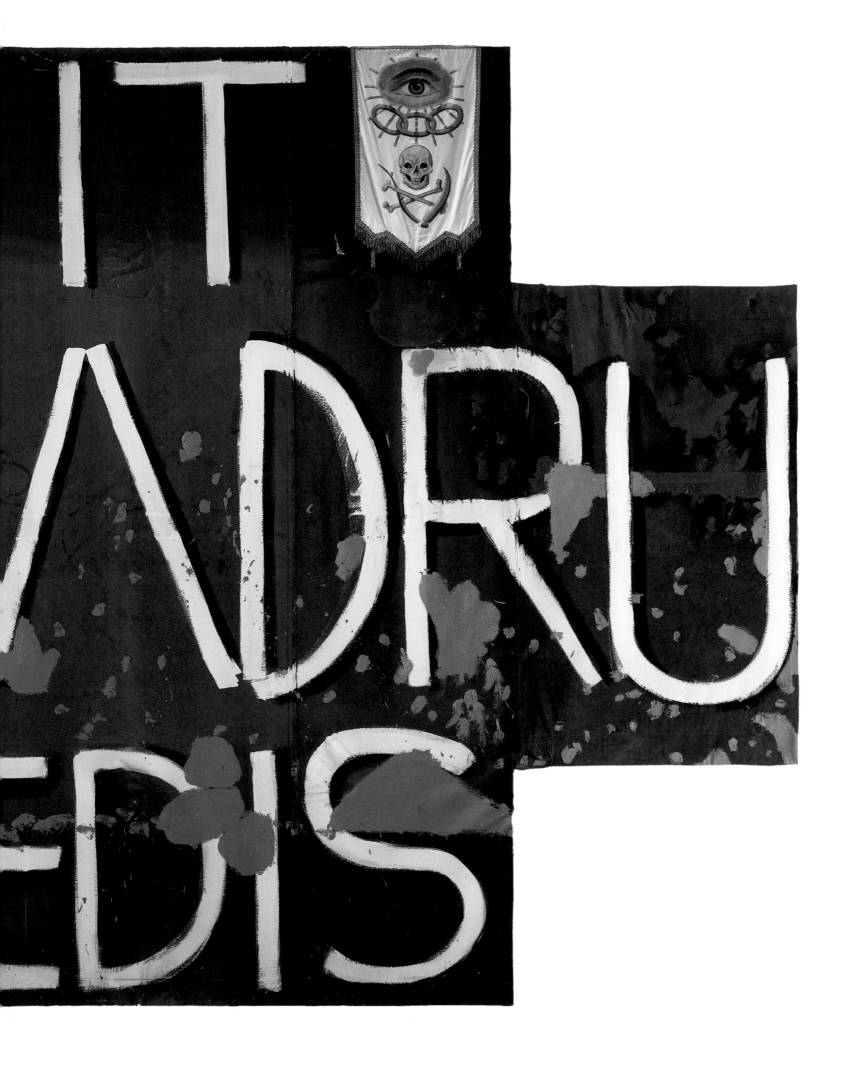

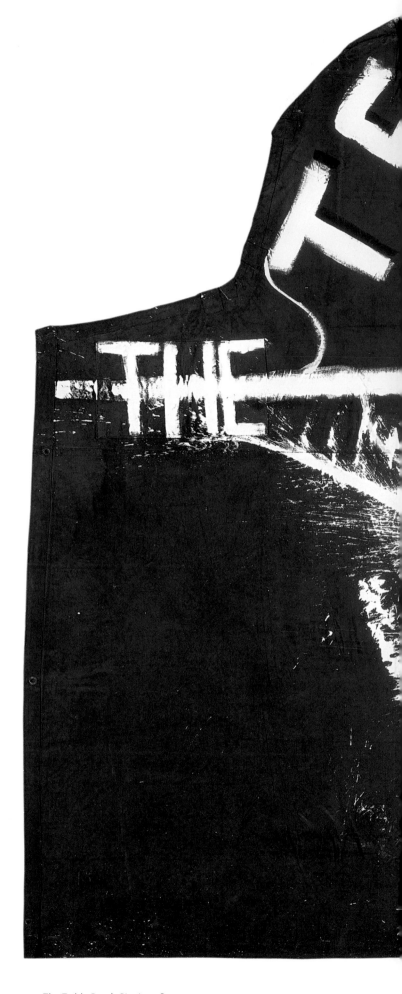

21 The Teddy Bear's Picnic, 1987

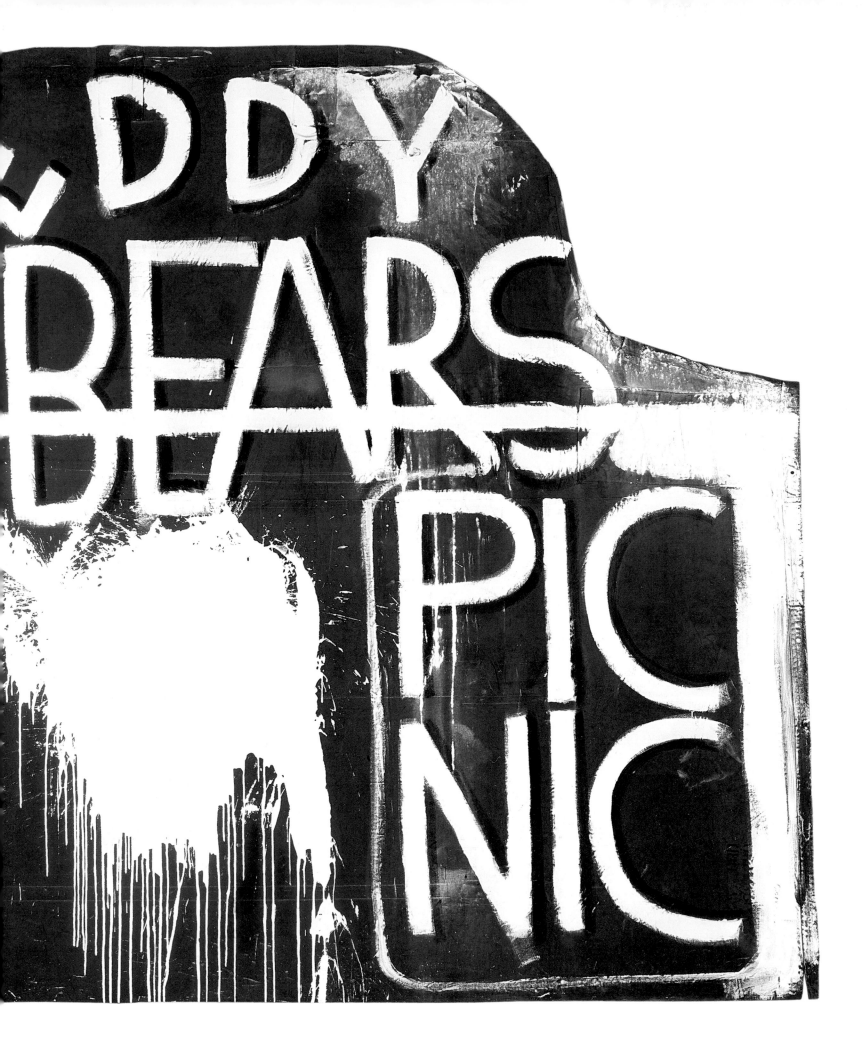

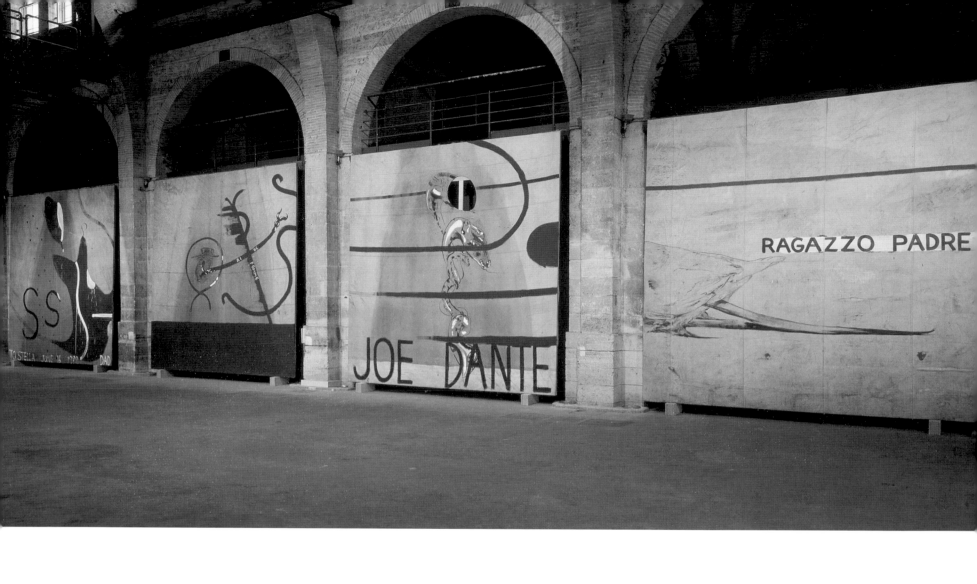

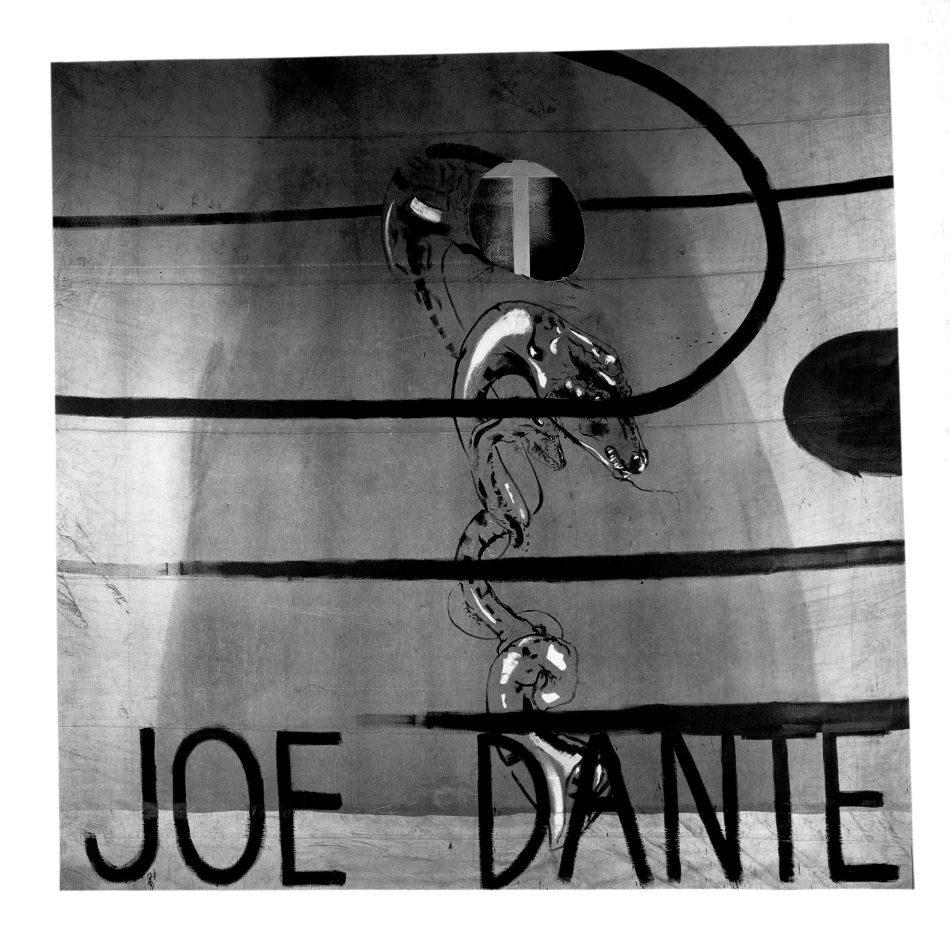

24 Joe Dante, 1988

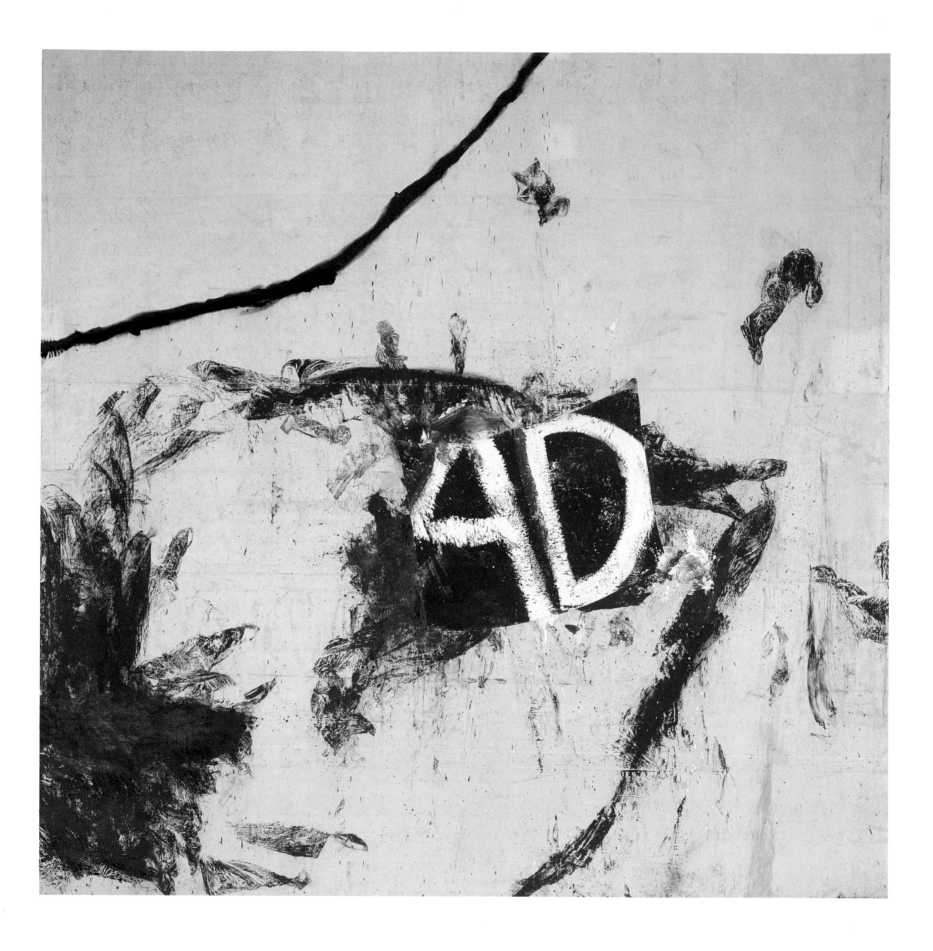

36 Anno Domini, 1990

37 El espontáneo (for Abelardo Martínez), 1990

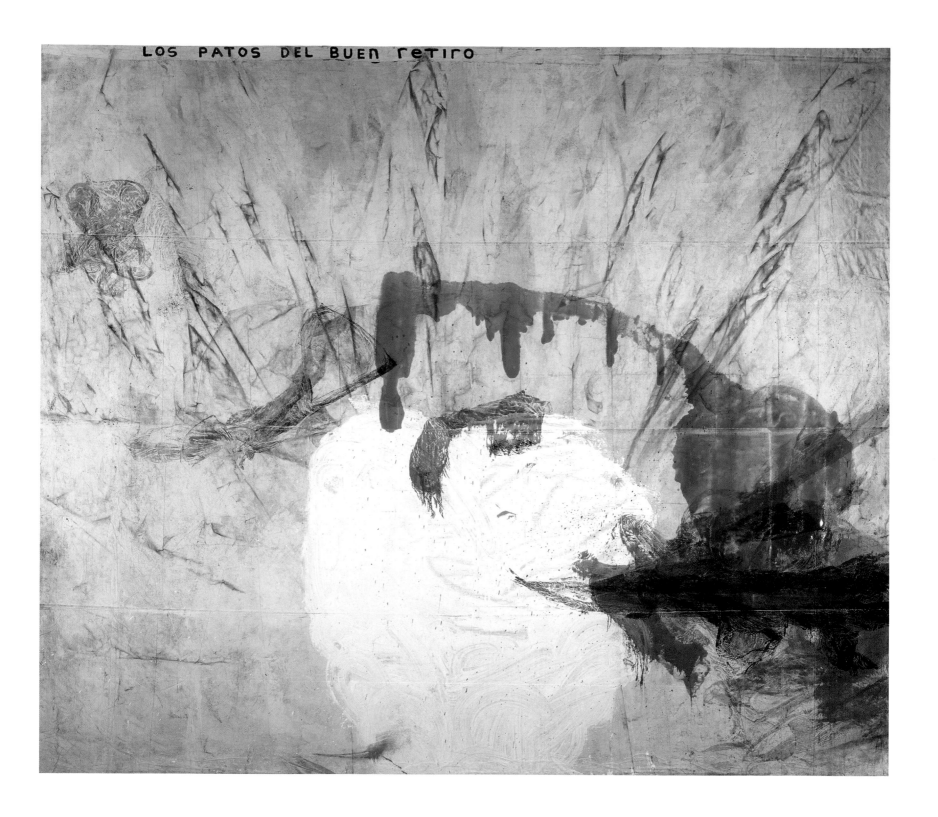

40 Untitled (Los patos del Buen Retiro) 1991

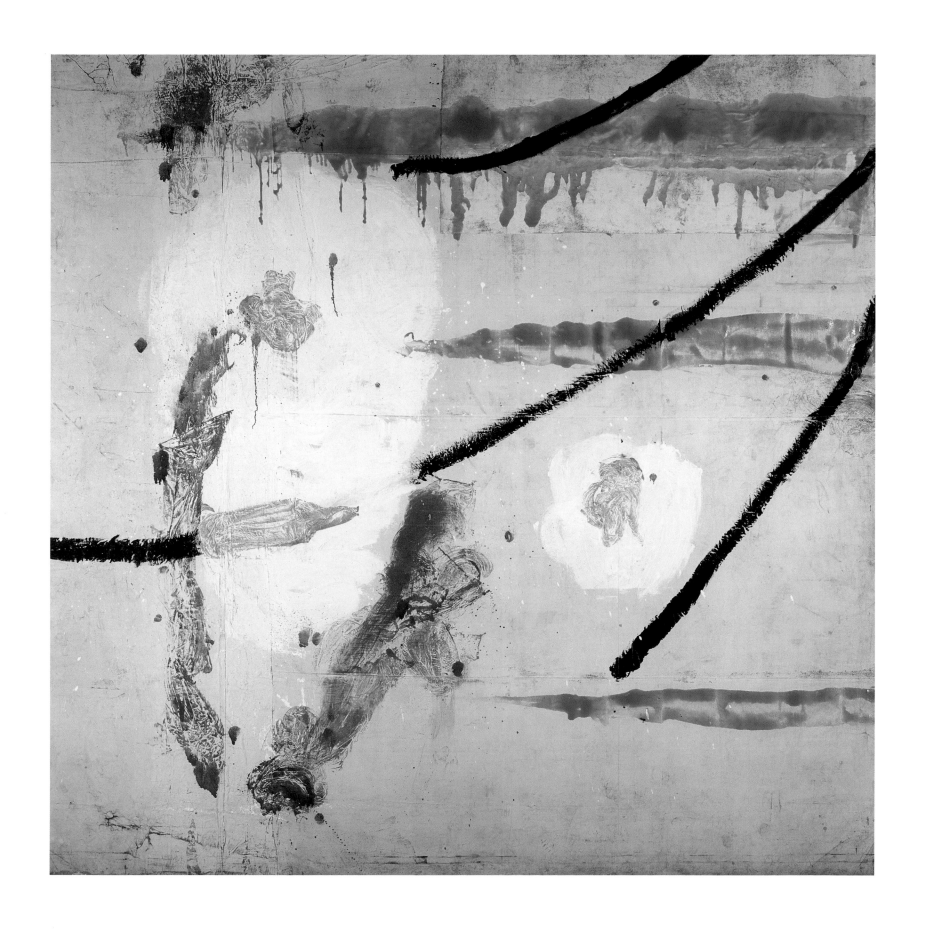

39 Untitled (Los patos del Buen Retiro), 1991

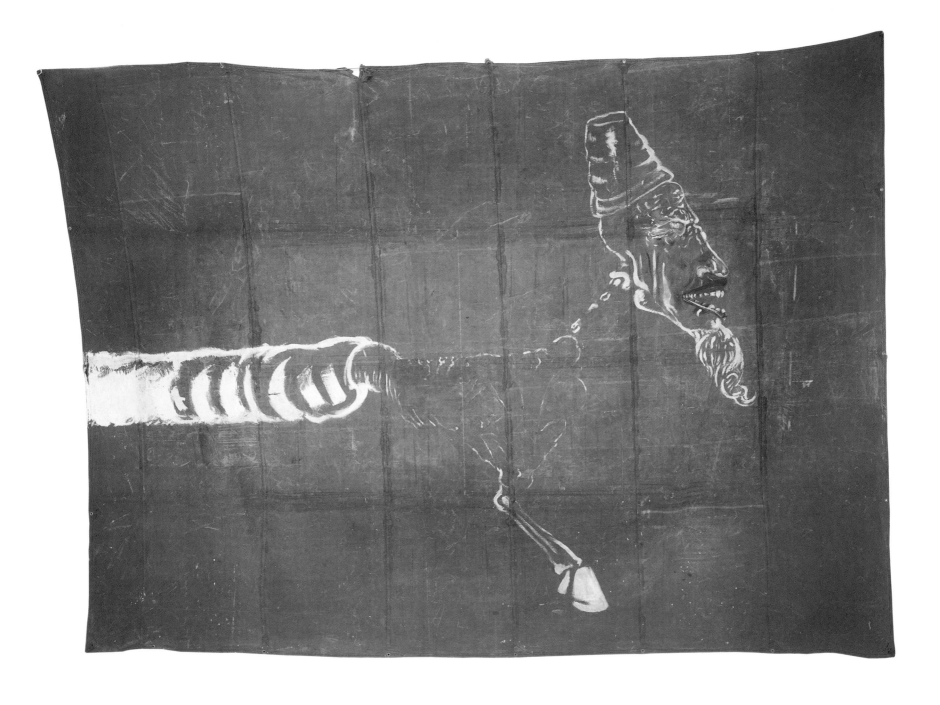

80 14 Apathy, 1986

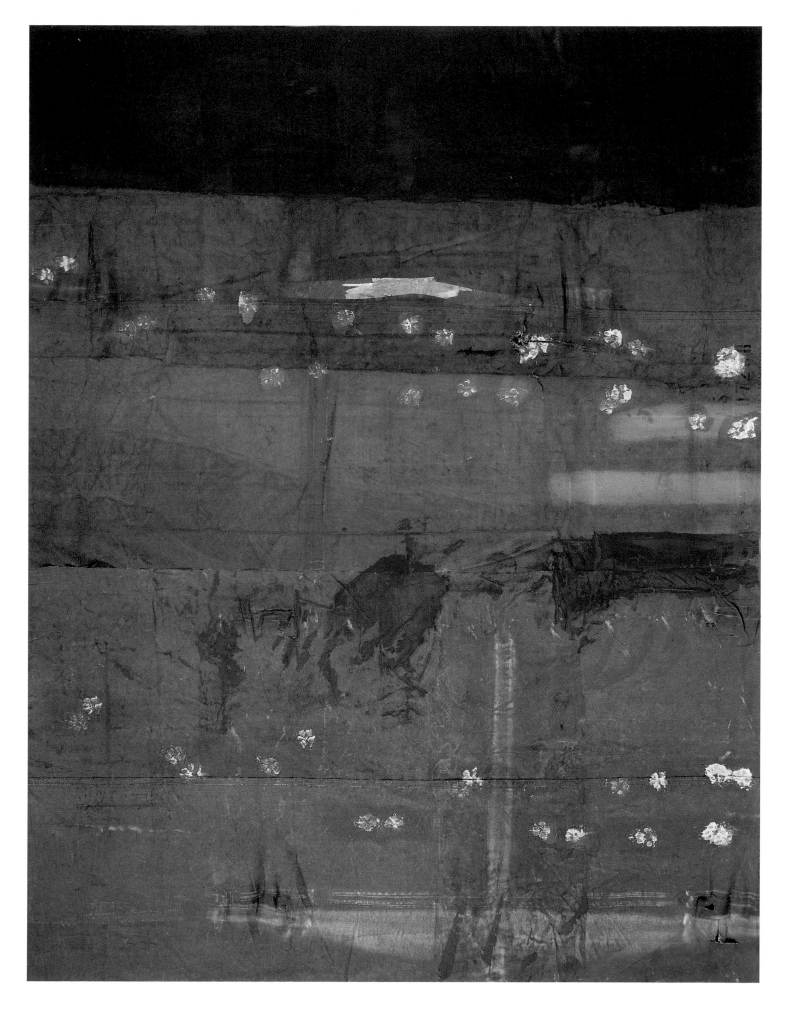

25 Untitled, 1989

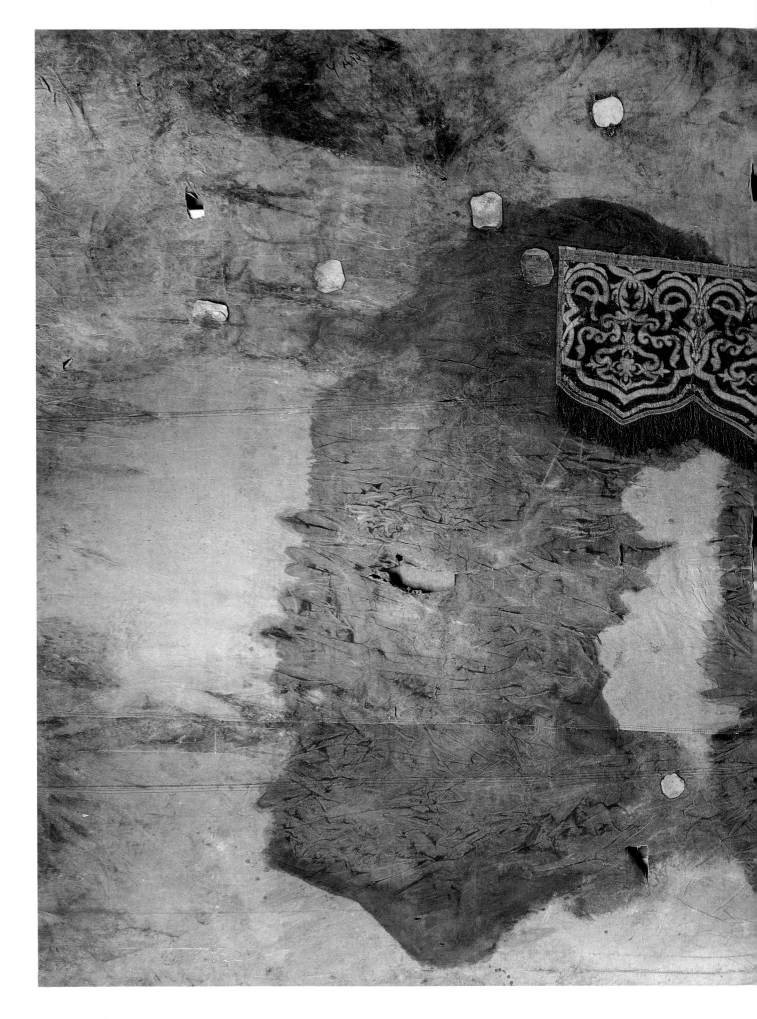

23 Cortes, 1988

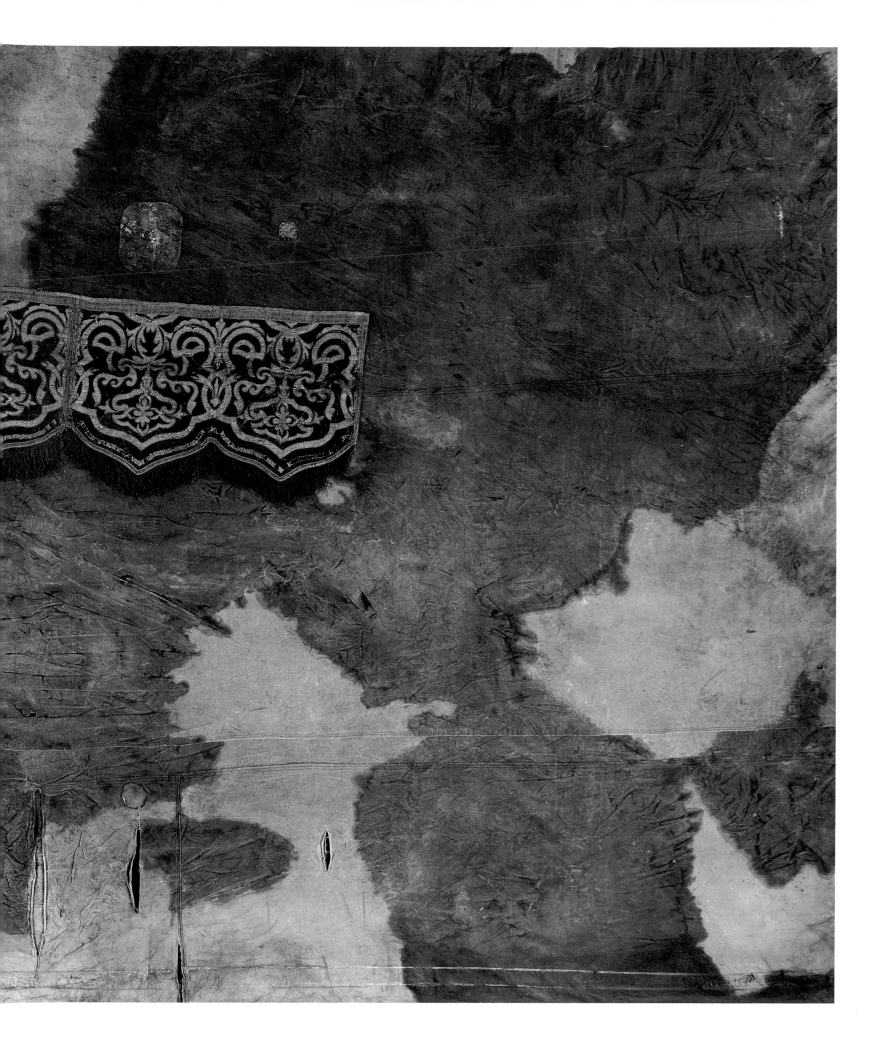

The Provocative Agonies of
Faded Heroism: Julian Schnabel
and William Gaddis

Die provozierenden Agonien eines
verblassten Heroismus:
Julian Schnabel und William Gaddis

"Agony has many faces: violent, passive, loud, or quiet, making possible readings that go forwards and backwards in time (marking a specific moment)."
JULIAN SCHNABEL.

"There's been a shift in the emphasis of art, a break with the American tradition of painting. That break will define the end of this century. It is an essential break with the basic role of the heroic."
JULIAN SCHNABEL.

»Agonie hat viele Gesichter: Sie ist brutal, passiv, laut oder leise. Sie lässt in die Zukunft und in die Vergangenheit gerichtete Interpretationen zu (und markiert einen besonderen Moment).« JULIAN SCHNABEL.

»Die Gewichtung in der Kunst hat sich gewandelt, es gab einen Bruch in der amerikanischen Malereitradition. Dieser Bruch wird das Ende dieses Jahrhunderts kennzeichnen. Es handelt sich um einen wesentlichen Bruch mit der grundlegenden Rolle des Heroischen.« JULIAN SCHNABEL.

Schnabel is a prototypal American, representing a girth of possibilities—generosity, scale of action, vulgarity, a ravenous borrowing, a capacity for risk, and a calculated blindness to the pitfalls of power. He is not an easy figure to deal with. He is part and parcel of the boom years of the market, the last bubble, or maybe not, of occidental super-prowess, but he is also a man who took on, inverted, and revised the myths of Modernism to create a more garrulous and free-wheeling Postmodernism, or at least one version of it that springs from a continuity with Modernism. He indisputably marks American painting of the eighties, even if so many critics have been loath to recognize it. Why? Because Schnabel works on a lavish roller-coaster scale, because he takes the existential *angoisse* of Pollock into a kind of punk, kitsch aesthetic that could only leave Greenberg trembling, even if his reading of kitsch has nothing to do with the kind Greenberg wrote of.

In this essay I want to look at the relationships between Schnabel and William Gaddis, the novelist, in order to suggest that both Schnabel's work and personality might be seen as 'figures' representative of Gaddis's understanding of the world. Schnabel's work, like that of Gaddis, is critical, affirming an inclusive and open stance towards reality. Both artists often create out of past art and current languages a separate standard for itself. Their work amounts to what Wyatt Gwyon, one of the characters in Gaddis's novel *The Recognitions*, defines as "disciplined recognitions." In the writer's essays these occur as patchworks of quotations, as scores for many voices that, as in his fictions, come from every class and

Schnabel ist ein prototypischer Amerikaner, der vielerlei Möglichkeiten in sich birgt: Er ist großzügig, umtriebig und vulgär, er plündert ungeniert fremde Vorlagen, scheut kein Risiko und hat eine kalkulierte Blindheit für die Fallstricke der Macht. Schnabel einzuordnen ist nicht leicht. Er war wesentlich am großen Boom des Kunstmarktes beteiligt und gleichzeitig hat er es mit den Mythen der Moderne aufgenommen, sie verkehrt und revidiert, um so einen wortreicheren und entspannteren Postmodernismus zu erschaffen, oder wenigstens eine Version davon, die aus der Kontinuität mit der Moderne entspringt. Es gibt in Schnabels Werk ein verschwenderisches Auf und Ab, er überführt die existenzielle Angst Pollocks in eine Ästhetik des Punk und Kitsch, die einzig Greenberg erzittern lassen könnte – auch wenn Schnabels Verständnis von Kitsch nichts mit dem Kitsch zu tun hat, über den Greenberg schrieb.

Gegenstand dieses Essays ist die Beziehung zwischen Julian Schnabel und dem Schriftsteller William Gaddis: Sowohl Schnabels Werk als auch seine Persönlichkeit können als »Gestalten« betrachtet werden, die für Gaddis' Verständnis von der Welt stehen. Schnabels Werk ist wie das von Gaddis kritisch; er nimmt eine umfassende und offene Haltung gegenüber der Realität ein. Im Rückgriff auf vergangene Kunst und gegenwärtige Sprachen erschaffen beide Künstler häufig einen eigenen Standard. Ihr Werk läuft auf das hinaus, was Wyatt Gwyon, einer der Charaktere in Gaddis Roman *Recognitions* (dt. *Die Fälschung der Welt*), als »diszipliniertes Wiedererkennen« bezeichnet. Dieses findet sich in den Essays des Schriftstellers als Flickwerk von Zitaten und

corner of American life. For example, the nonfiction project that overwhelms Jack Gibbs in *JR* is quarried from a book-length essay that Gaddis himself had worked on throughout the sixties: "A social history of mechanization and the arts" whose purpose is to bring insights from cybernetics and classical political theory to bear on the artist's marginal position in society and, in much the same way, Gaddis's final fiction, *Agapé Agape,* continues this critical engagement with technology in relation to the arts where the player-piano project serves as an encompassing metaphor for "a satirical celebration of the conquest of technology and of the place of art and the artist in a technological democracy."[1] Gaddis deliberately juxtaposes arguments, pushing them up against each other in a kind of collage confrontation as in *Carpenter's Gothic* where the argument between secular liberalism and Christian fundamentalism plays itself out in a devil's debate with McCandless defending his *roman à clef* against Lester's accusation that the book is mean and empty like everybody in it; or in *A Frolic of His Own* where Gaddis's lifelong obsession with the issues of copyright and plagiarism come to the fore in the legal hairsplitting over Oscar's play.

Collage has been one of the major languages of the last part of the twentieth century and corresponds to the way we experience, filter, and understand reality. We live amid a barrage of signs that we never fully comprehend and find ourselves strangely at ease amid such uncertainty. Schnabel's use of collage is more Modernist than Postmodernist in that he gives it a metonymic function but, at the time, he shows no hesitation in juxtaposing the disparate. He notes: "I think that many people even now when they make album covers, or even ideas about music, like sampling music and mixing it, or ideas about cybertext, those are just ideas about collage I think, in a way very dated, and not so modern as everybody thinks they are. I don't think simultaneity is captured in that. I just think that you've got a catalogue of things stuck together, and unfortunately the final form of all of it seems to be at the mercy of the design to put a lot of things together. That's a very different idea than trying to let a fragment of a larger world become the whole."[2]

Schnabel, of course, neither produces nor illustrates arguments, but he does collage ideas and densely charged frag-

zahlreichen Stimmen wieder, die – wie in seinen Romanen – aus allen Schichten und Winkeln des amerikanischen Lebens stammen. So ist das Sachbuch, mit dem sich Jack Gibbs in *JR* so sehr beschäftigt, aus einem buchlangen Essay entstanden, an dem Gaddis selbst in den sechziger Jahren gearbeitet hatte: »A Social History of Mechanization and the Arts«. Darin bezog er Erkenntnisse aus der Kybernetik und der klassischen politischen Theorie auf die marginale Position des Künstlers in der Gesellschaft. In die gleiche Richtung zielt auch Gaddis' letzter Roman, *Das mechanische Klavier,* in dem es wiederum um das kritische Engagement der Technik im Verhältnis zu den Künsten geht: Das Projekt des mechanischen Klaviers dient als umfassende Metapher für »ein satirisches Fest anlässlich der Eroberung durch die Technik und des Stellenwertes der Kunst und des Künstlers in einer technologischen Demokratie«.[1]

Gaddis konstruiert in einer collagenhaften Konfrontation bewusst eine Folge von Auseinandersetzungen, ähnlich wie in *Die Erlöser,* wo die Auseinandersetzung zwischen weltlichem Liberalismus und christlichem Fundamentalismus in einem Streitgespräch des Teufels mit McCandless stattfindet, der seinen Schlüsselroman gegen den Vorwurf Lesters verteidigt, das Buch sei genauso gewöhnlich und nichtssagend wie seine Gestalten. Das Gleiche gilt für den Roman *Letzte Instanz,* in dem Gaddis' lebenslängliche hartnäckige Auseinandersetzung mit Fragen des Copyrights und Plagiats in einer juristischen Haarspalterei über Oscars Stück zutage tritt.

Die Collage war eine der beherrschenden Sprachen des ausgehenden 20. Jahrhunderts. Sie steht für die Art und Weise, wie der Mensch die Realität erfährt, filtert und versteht. Wir leben inmitten eines Kreuzfeuers von Zeichen, die wir nicht vollständig begreifen können, und dennoch bleiben wir davon seltsam unberührt. Schnabel verwendet die Collage eher im Sinne der Moderne als im Sinne der Postmoderne, denn er verleiht ihr zwar eine metonymische Funktion, zögert aber gleichzeitig nicht, das Disparate nebeneinander zu stellen. Er merkt an: »Ich glaube, dass die Ideen, auf die die Menschen heute zurückgreifen, wenn sie Plattencover gestalten oder Musik sampeln und mischen oder Cybertexte entwickeln, eigentlich Ideen zu Collagen sind, im

ments in terms of materials, sources, and socio-cultural codes. His work is an inclusive space, and he, the artist, is the nexus through which ideas pass at a fast pace, both capricious and calculated. He constantly gives permission for disparate elements to brush up and live alongside each other, just as they do in life. In terms of materials, for example, *The Sea* of 1981 (pp. 46–47) mixes cheap Mexican ceramics and Bondo, and *Zum Solitaire* of 1988 (p. 28) oil paint with carpet. *The Sea* clearly refers Pollock's drip method onto the ceramic surface. It is an image signifier in itself rather than the bearer of an image. The ground of broken crockery stands as a metaphor of itself. Time is presented as an ocean of ruins that falls again and again from the past upon the present. It has no order of its own but is subject only to a constant random reordering. In other words, its order is that of chaos, and the sea is the ground swell of being. Schnabel insists that the modern, the industrial, and the mass-produced co-inhabit with shards from other cultures or with paint as the most classical expression of the medium. Everything is acceptable as long as it forms part of a high energy discharge. He wants the energy to be maintained from the point of emission to the point of reception. In *The Mud in Mudanza* of 1982 (pp. 48–49) he seems to slap everything together in a tension of comfortable coexistence because, in all probability, it comes from same experience. This work is an image of the nomadic, of the need, of the desire, of the cohesive chaos of human displacement, and of our inherent tendency to move from one place to another, from one person to another. The shards look like ancient ceramics, but they are really contemporary ceramic from stores, sometimes with the price tag still attached. Schnabel thus confronts us with the problems of the simulacrum, of the fusion of high and low culture so characteristic of much of contemporary life.

According to the novelist, the artist in a society of spectacle is a performer and Schnabel certainly is, but he is an emotive performer with a gargantuan appetite rather than a cynical player! Gaddis questions the role of the artist, documenting his rush to obsolescence but seeking the reasons for it in history, philosophy, and social theory. In *Agapé Agape*, his short essay from the early sixties, he proposed that "the frail human element" was being subordinated to program-

Prinzip also eher veraltet und gar nicht so modern, wie alle glauben. Simultaneität kann ich darin nicht entdecken. Ich bin vielmehr der Meinung, dass es sich um einen Katalog zusammengehörender Dinge handelt, und bedauerlicherweise scheint die endgültige Form des Ganzen davon abzuhängen, nach welchem Muster die Dinge zusammengefügt werden. Dahinter steckt ein vollkommen anderer Gedanke, als wenn man versucht, ein Fragment aus einer größeren Welt zum Ganzen werden zu lassen.«[2]

Natürlich produziert Schnabel weder Auseinandersetzungen noch illustriert er sie, sondern er erstellt Collagen aus Gedanken und Fragmenten, die durch Materialien, Quellen und sozio-kulturelle Kodes besetzt sind. Sein Werk ist ein umfassender Raum, und er als Künstler ist der Nexus, den die Ideen – ebenso kapriziös wie kalkuliert – in schnellem Tempo durchqueren. Beständig erlaubt er disparaten Elementen, sich – ganz wie im Leben – leicht zu berühren und nebeneinander zu bestehen. So verarbeitet er in seinem Werk *The Sea* von 1981 (S. 46/47) billige mexikanische Keramik und Füllmasse, in *Zum Solitaire* von 1988 (S. 28) Ölfarbe und Teppich. Mit *The Sea* wendet Schnabel Jackson Pollocks Drip-Methode auf einer keramischen Oberfläche an, die eher Bild-Zeiger denn Bild-Träger ist. Der Grund aus zerbrochenem Geschirr steht als Metapher für sich selbst. Die Zeit wird dargestellt als Ozean aus Ruinen, der immer und immer wieder aus der Vergangenheit auf die Gegenwart einstürzt. Sie hat keine eigene Ordnung, ist jedoch ständig Gegenstand einer zufälligen Neuordnung. Mit anderen Worten, ihre Ordnung ist das Chaos, und das Meer ist die Dünung des Seins. Für Schnabel findet das Medium seinen klassischen Ausdruck im Nebeneinander von Modernem, Industriellem und Massenprodukten mit Scherben anderer Kulturen oder mit Farbe. Alles ist akzeptabel, solange es Teil einer hohen Energieentladung ist. Sein Ziel ist es, die Energie von Anfang bis Ende zu erhalten. In *The Mud in Mudanza* von 1982 (S. 48/49) scheint er alles in einem Spannungsverhältnis von bequemer Koexistenz zusammenzupacken, da es aller Wahrscheinlichkeit nach derselben Erfahrung entstammt. Die Arbeit ist ein Bild für das Nomadische, für das Bedürfnis und die Sehnsucht des Menschen nach Ortswechsel und dem damit verbundenen Chaos. Die Scherben muten an wie antike Keramiken, doch es

matic management in every sphere of life. Writing for a public that had little time for his infinitely accurate and detailed representations, Gaddis understood the relative weakness of literary fiction in comparison with the state's collective imagination of itself. How does the State imagine? A disturbing question given the evidence of our times? Indeed one of Gaddis's great themes is that America is itself "a grand fiction," second only to religion, exacting a continuing faith in its own existence and a suspension of disbelief.

Schnabel proposes his own "grand fictions," virtually appropriating the whole of European culture and constantly referencing artists such as Pollaiuolo, Caravaggio, Beckmann, Goya, El Greco, Giotto, Courbet, and Ingres, to create an American art with a determinedly American cast: an operatic and funky grand luxe proposition. He wants to bring back the figure and find the face of our time. And finally he wants to communicate the feelings, new and profound, that correspond to his and our moment in history. It is here that he will find identity and history matters to him since it provides the chain of events from where he departs. His cultural borrowings are real anchors for actual emotions. They are both a place and a condition for living and usually come suffused with melancholy. The real subject is, as he says, meanings—meanings pulled out from the past, partial meanings that accumulate into new configurations in the present. His works are by no means exclusively about self-expression but also about ideas.

In Schnabel, Gaddis recognized a "frail human element" who would resist and force us to pay attention in a society where the attention span rarely has to go beyond a few seconds and where nervousness is confused with life: "painting on wood, on broken crockery, on the paint itself—demanding that we look and look again, that we move forward from the American tradition of seeing art as decoration, as the safe refuge promised by the New York Times section labeled 'Arts and Leisure,' equating one with the other and thus putting a fine spin on the oxymoron in fashionable use on all sides today. In his relentless search for authenticity, the Artist works to please himself in a constant process of Discovery through the very experience of making Art, and then seeking opportunities for it to prevail. Traveling abroad he may encounter

handelt sich um Kaufhausware, auf der noch das eine oder andere Preisschild klebt. So konfrontiert uns Schnabel mit dem Problem des Abbildes, mit der für unsere Gegenwart so charakteristischen Vermischung von hoher und niederer Kultur.

In einer vom Schauspiel beherrschten Gesellschaft sieht der Schriftsteller den Künstler als Darsteller, der Schnabel sicherlich ist. Aber er ist eher sensibel und von ungeheurem Appetit als ein zynischer Spieler. Gaddis hinterfragt die Rolle des Künstlers, indem er dessen Streben nach Vergangenem dokumentiert, wobei er die Gründe dafür in der Geschichte, Philosophie und Gesellschaftstheorie sucht. In einem kurzen Aufsatz aus den sechziger Jahren, der in seinem Werk Das mechanische Klavier enthalten ist, behauptete Gaddis, »das zerbrechliche menschliche Element« werde in allen Bereichen des Lebens dem programmatischen Management untergeordnet. Gaddis schrieb für eine Öffentlichkeit, die nur wenig Zeit für seine genauen und detaillierten Darstellungen hatte, und er erkannte die Schwäche der literarischen Fiktion gegenüber der kollektiven Vorstellung des Staates von sich selbst. Wie sieht die Vorstellungswelt des Staates aus? Ist das angesichts der Offensichtlichkeiten unserer Zeit eine beunruhigende Frage? Bei Gaddis ist ein wichtiges Thema Amerika als »große Fiktion«, die lediglich der Religion untergeordnet ist, einen beharrlichen Glauben an sich selbst erfordert und jede Form von Unglauben verbietet.

Schnabel hat seine eigenen »großen Fiktionen«. Im Grunde genommen macht er sich die gesamte europäische Kultur zu Eigen und bezieht sich permanent auf Künstler wie Pollaiuolo, Caravaggio, Beckmann, Goya, El Greco, Giotto, Courbet und Ingres, um eine amerikanische Kunst von eindeutig amerikanischem Charakter zu erschaffen: ein vom Aufwand her opernhaftes und schrilles Vorhaben. Er will unserer Zeit ihre Gestalt zurückgeben und ihr ein Gesicht verleihen. Darüber hinaus will Schnabel die – neuen und tiefen – Gefühle kommunizieren, die seinem und unserem Augenblick in der Geschichte entsprechen. Und hier findet er seine Identität, die Geschichte ist ihm ein wichtiges Anliegen, denn sie liefert ihm die Ereignisketten, von denen er ausgeht. Seine kulturellen Anleihen sind Anker für echte Emotionen. Sie sind gleichzeitig Ort und Bedingung für das Leben. Im Allgemeinen stecken sie voller Melancholie. Das eigentliche Thema,

other cultural versions of himself ... opening himself to a discovery in the past, in history, even in time itself."³

Gaddis became a friend of Schnabel and found things within him of intense value (and such care is a part of friendship): his desire to mash himself into history, the suffering self, his resistance to the abject drift into consumerism. Tabbi tells us: "He admired Schnabel, evidently, for much the same reason that he was fond of the boy *JR*—for his entrepreneurial spirit, his commitment (talent or none), and his determination to seek every opportunity for his enterprise to 'prevail.' 'Julian would be doing what he does no matter what,' Gaddis would say, 'He just gets so excited about things!'"⁴ "Gaddis praised Schnabel's work for compelling us to 'look and look again.' For it is here in the act of second order observation, that the viewer or reader participates in the artist's creative vision. Schnabel in 1987 assembled Gaddis's portrait, just as he would later do for his two daughters Stella and Lola (1996 [pp. 136, 137]), out of oil, broken plates, and Bondo on wood. Is Schnabel in turn being portrayed in the tribute as yet another Gaddis persona? Another of his proliferating doubles? And whose eye is it—Schnabel's or Gaddis's—doing the twinkling in that last line of ambiguous prose? Look again."⁵ Exactly! Both artists ask of us to look carefully, to unravel the layers of meanings, to sense the way experience, knowledge, sensibility, emotion, is an endless accumulation: a constant layering of thought and feeling; a series of fused stratifications.

There is a clear disposition in Schnabel's work to look back in time to find a common sense of identity and a respect for human difference. *Aborigine Painting* of 1980 (p. 31) is a push in this direction with its small squatting figure staring into the Australian desert is like a reference to dreamtime.

These details or snatches from the past are always intimate and charged, often carrying a concentrated libidinous power. *Ethnic Types No 15 and No 72* of 1984 (p. 25) seems borrowed from some reference source on ethnic differences, ironically presenting the classic stereotypes of the Moor and the African surrounded by other symbolic yet highly ambiguous figures. In this instance Schnabel seems to dig deeply into the subconscious of the individual, of history and the social structures of which we are all a part.

so sagt er, sind Bedeutungen – aus der Vergangenheit bezogene Bedeutungen, Teilbedeutungen, die sich in neuen Konfigurationen in der Gegenwart ansammeln. In Schnabels Arbeiten geht es keineswegs ausschließlich um den Ausdruck seiner eigenen Persönlichkeit, sondern auch um Ideen.

Gaddis erkannte in Schnabel ein »zerbrechliches menschliches Element«, das Widerstand leistet und uns zur Aufmerksamkeit zwingt in einer Gesellschaft, in der Aufmerksamkeit selten länger währt als ein paar Sekunden und in der man Unruhe mit Leben verwechselt: »Er malt auf Holz, auf zerbrochenem Geschirr, auf Farbe und fordert uns damit auf, wieder und wieder hinzusehen, uns von der amerikanischen Tradition zu lösen, die Kunst als schmückendes Beiwerk zu betrachten, als sicheres Refugium, das die *New York Times* in ihrem ›Kunst und Freizeit‹-Teil verspricht, indem er beides gleichsetzt und diesem Oxymoron, das heute in aller Munde ist, damit einen feinen Effekt verleiht. In seiner unermüdlichen Suche nach Authentizität durchlebt ein Künstler bei seiner Arbeit durch die bloße Erfahrung, Kunst zu machen, einen permanenten Entdeckungsprozess und sucht dann nach Gelegenheiten, die Kunst siegen zu lassen. Wenn er ins Ausland reist, trifft er möglicherweise auf andere kulturelle Versionen seiner selbst, oder er öffnet sich für eine Entdeckung in der Vergangenheit, in der Geschichte oder in der Zeit selbst.«³

Gaddis freundete sich mit Schnabel an und fand in ihm Dinge von immensem Wert (was einen Teil von Freundschaft ausmacht): sein Bestreben, in die Geschichte abzutauchen, das leidende Ich, seinen Widerstand gegen das Abdriften in den Konsum. Tabbi berichtet uns: »Er [Gaddis] bewunderte Schnabel ganz offensichtlich aus nahezu dem gleichen Grund, aus dem er den Jungen JR liebte – für seinen Unternehmergeist, sein Engagement (talentiert oder nicht) und seine Entschiedenheit, jede Gelegenheit zu nutzen, damit sein Vorhaben sich ›durchsetzt‹. ›Julian macht das, was er macht, ohne Einschränkung‹, sagte Gaddis. ›Er findet alles so aufregend!‹«⁴ »Gaddis gefiel an Schnabels Arbeit, dass sie uns zwingt, ›wieder und wieder hinzusehen‹. Durch den Akt der Beobachtung in zweiter Ordnung kann der Betrachter oder Leser den kreativen Blickwinkel des Künstlers einnehmen. 1987 porträtierte Schnabel Gaddis, es folgten Porträts

Gaddis in his short text on Schnabel—his final text that he was too ill to read—puts his finger on the pulse of the times, on the sites from where Schnabel comes with an inbuilt resistance: "We are living today in the market-driven Age of Imitation predicted by Walter Benjamin in which art is produced to be imitated and where frequently enough we remember who did it last rather than who did it first. . . . We are living today in an Age of Entertainment shaped and controlled by the media in which time is shattered with all the hype, speed, and moral delinquency needed to reduce anything to trivia . . ."[6] Schnabel stands out as a figure who is against all of this, a new kind of heroic figure—a jaded romantic, streetwise and playing for higher stakes than the circus of success whose rules he also knows can offer. He has been deeply moved by his encounter with history and bleeds. And this is precisely his American dimension: the scale of feeling and more precisely the scale of meaning. It is at this level that he is a prototypal American, but he is also anti-American: he suffers it, and he suffers it all the more because he is of it and knows its ways. He has been surrounded by the foam of fame (critics, curators, galleries) and, in all probability, still is. The hangers-on and the hangers-out! Nevertheless, his feelings are other, and this is where his works spring from. He fails, as we all fail, but he also triumphs as few of us do. So on what is such triumph based? Our heroes have been existential anti-hero, underground men. In a climate of cynicism Schnabel's bravour is excessive and all embracing. *Rest* of 1982 (p. 65) is like a massive insult, a wild combination of materials consisting of a giant wooden support with the work slung on top like an altarpiece. It is like an immense emptying, a rhetorically baroque exaggeration, a surge of religious intensity, but it is also an espousal of the fake. Are these mock heroics being turned into real? My dangerously swift answer might well be affirmative. What we certainly have is a lurid and sometimes overwhelming baring of the soul—a baring that paradoxically stands as an elegant, unchecked, and lyrical flowing of the self.

Gaddis is not concerned with winning, and "his work tries to discover what individual life can and should be in the midst of collective life and competing fictions."[7] And for Gaddis, Schnabel is a man and a character who would shout "yes"

seiner beiden Töchter Stella und Lola (1996 [S. 136, 137]), allesamt Arbeiten in Öl, mit zerbrochenen Tellern und Bondo auf Holz. Wird Schnabel nun seinerseits aus Anerkennung von Gaddis als eine seiner Gestalten porträtiert? Ein weiterer seiner sich beständig vermehrenden Doppelgänger? Und wessen Auge – Schabels oder Gaddis' – zwinkert in der letzten Zeile zweideutiger Prosa? Sehen Sie noch einmal hin!«[5] Und genau darum geht es: Beide Künstler nötigen uns, genau hinzusehen, die verschiedenen Bedeutungsebenen zu entwirren, zu spüren, wie Erfahrung, Wissen, Empfindsamkeit und Gefühl sich endlos anhäufen: eine beständige Überlagerung von Denken und Fühlen; miteinander verschmolzene Schichten.

Schnabel bevorzugt den Blick in die Vergangenheit, um einen allgemeingültigen Begriff von Identität und Respekt für die Verschiedenartigkeit der Menschen zu finden. In diese Richtung weist auch die Arbeit *Aborigine Painting* von 1980 (S. 31). Sie zeigt eine kleine, hockende Gestalt, die in die australische Wüste blickt und wie eine Referenz an die Traumzeit – die mythologische Vergangenheit der Aborigines – erscheint.

Die Details und Bruchstücke aus der Vergangenheit sind stets intim und belastet und nicht selten von einer konzentrierten triebhaften Kraft. Die Arbeit *Ethnic Types No. 15 and 17* von 1984 (S. 25) scheint Bezug zu nehmen auf eine Quelle zu ethnischen Unterschieden – auf ironische Weise sind die klassischen Stereotypen des Mauren und Afrikaners dargestellt, umgeben von weiteren, hochgradig zweideutigen Figuren. In diesem Fall scheint Schnabel sich tief in das Unbewusste des Individuums, der Geschichte und der gesellschaftlichen Strukturen, an denen wir alle teilhaben, zu graben.

In seinem kurzen Text über Schnabel – seinem letzten, den er nicht mehr selbst lesen konnte, weil er zu krank war – legt Gaddis den Finger an den Puls der Zeit und spricht mit Widerwillen von den Orten, von denen Schnabel kommt: »Wir leben heute in einem marktgelenkten Zeitalter der Imitation, wie es von Walter Benjamin vorausgesagt wurde. Kunst wird heute produziert, um imitiert zu werden, und wir erinnern uns häufig genug lediglich daran, wer sie zuletzt gemacht hat, und nicht, wer zuerst. [...] Wir leben heute in einem Zeitalter der durch die Medien gestalteten und kon-

even when drowning. Schnabel wishes to imbue even the commonplace with the energy of living. In his *Plate Paintings* the image seems to float on top as if struggling for a condition that somehow is known not to be there: "At that time I was thinking, What imagery is there to paint? In America everybody thought there were no more images in painting, that everything had been reduced out of it. Well, I wanted to use images that were charged—I wanted to put content back into painting. Content had been emptied out in an attempt to be more Modern, to just get to the formal nature of the construction of the painting, I wanted to reintroduce language into painting."[8] I have no problem with such an argument. It is slick, large, and passionate. It takes me back to the plates. They are, of course, surfaces, but they are also about cuts and pains. They are about aggression and also about unification. They refer back to the history of the plane in Modern art. Yet, even more significantly, they are about the fact that if you step forward and slip, you'll cut yourself and that's life! Pollock knew this, and Schnabel learnt it! Similarly his use of velvet, carpet, or fur extend the possibilities of surface. He may not be the inventor of painting on velvet, but he has left his indelible mark to create, as in *Geography Lesson* (1980), a shimmering surface that buzzes with activity.

Failure is, indeed, a wondrous dilemma and makes me think of the Austrian writer Thomas Bernhard who sharpens this same concept with acid splendor and a pared-down minimalism. Bernhard's novels *The Loser* and *Concrete* are, as far as Gaddis was concerned, plagiarism in advance "like my own ideas being stolen before I ever had them." Bernhard's subjects are those of Gaddis: musicology, a lashing-out against the state, and Glenn Gould as the 'hidden talent' who could do no more than his fellow students. Schnabel is more symphonic and his rampant imagination plunders whatever it can and whatever seems of use.

Music is a source of dangerous emotional and physical connections, dealing with sensations not easily defined. These are the mental communions that Gaddis searches for in *Agapé Agape* and that Schnabel heard when Cy Twombly played a few notes on his piano. Both artists are lavish enough to take on the miseries of the world: "Against all forgeries, simulations, and wastes of the world, this was the

trollierten Unterhaltung. Die Zeit wird zerschmettert mit dem Hype und Tempo und der moralischen Sorglosigkeit, die notwendig sind, um alles auf das Triviale zu reduzieren.«[6] Schnabel hebt sich ab als Mensch, der gegen all dies ist, er ist eine neue Art von Heldengestalt – ein erschöpfter Romantiker, clever und auf der Suche nach einem höheren Gewinn als ihn der Erfolgszirkus, dessen Regeln er auch kennt, bieten kann. Schnabel ist tief bewegt von seinem Zusammentreffen mit der Geschichte, und er blutet. Und genau das ist seine amerikanische Dimension: das Ausmaß an Gefühl und, um genauer zu sein, an Bedeutung. Auf dieser Ebene ist er ein prototypischer Amerikaner, doch gleichzeitig ist er auch Anti-Amerikaner: Er leidet daran, und dies umso mehr, als er aus Amerika kommt und sich da auskennt. Er wurde vom Ruhm umgarnt (Kritiker, Kuratoren, Galerien) und wird es vermutlich noch. Die, die mit dem Strom schwimmen, und die, die gegenanschwimmen! Doch sein Empfinden ist ein anderes, und daraus entspringen seine Arbeiten. Er scheitert, wie wir alle scheitern, doch er triumphiert auch, wie nur wenige von uns triumphieren. Und worauf begründet sich dieser Triumph? Unsere Helden waren existenzielle Anti-Helden, Männer im Untergrund. Im Klima des Zynismus ist Schnabels Meisterschaft exzessiv und allumfassend. *Rest* von 1982 (S. 65) ist eine fulminante Beleidigung, eine wilde Kombination aus Materialien. Oben an einem riesigen hölzernen Stützpfeiler ist das Werk, einem Altarbild gleich, festgezurrt. Es ist eine immense Entleerung, eine barocke rhetorische Übertreibung, eine Woge religiöser Intensität, gleichzeitig jedoch auch eine Parteinahme für die Nachahmung. Werden die spöttischen großen Worte nun Wirklichkeit? Meine gefährlich rasche Antwort könnte dies wohl nahe legen. Ganz sicher handelt es sich um eine gespenstische und mitunter überwältigende Entblößung der Seele, eine Entblößung, die paradoxerweise wie ein elegantes, ungehindertes und lyrisches Strömen des Ich anmutet.

Gaddis geht es nicht ums Gewinnen. »In seinem Werk versucht er zu entdecken, wie das individuelle Leben inmitten des kollektiven Lebens und angesichts konkurrierender Fiktionen sein kann und sollte.«[7] Für Gaddis ist Schnabel ein Mann und ein Charakter, der auch noch »Ja« rufen würde, während er untergeht. Schnabel will selbst das Gewöhnliche

one consolation that Gaddis held on to during the last stages of composition: that the life of the mind in collaboration with other minds, the fraternal love that he felt in his recollection of a friend no longer here, and the disciplined recognition of the achievements of past writers would give to his work a staying power beyond his own, finally human, powers of caring and invention."[9] Such disciplined recognition of the past links the work of Gaddis and Schnabel, not only at the level of desire but also as a methodology.

Schnabel feels himself almost as much a part of the European tradition as the American because the former links him directly to the humanist tradition to which he feels he belongs: of both continuity and change. His reading remains somewhat materialistically American. In other words, he is impressed by scale, but at the same time he finds partial truths and fragments that matter to him. Schnabel trusts the fragment rather than the whole, assembling them into his own glittering vision of intuitions, ideas, and emotions that all push towards a spiritual transcendency: "I think it is a dumb idea that to be Modern you had to stay in New York City. I went to Egypt, man. The scale of Luxor, it really blows away Greek and Roman sculpture. You can go see the fragments of Egypt, and it's daunting the scale that they were operating on. America has an *au courant* or myopic sense of time. . . . It's people that lose the sense of themselves in the idea of progress. . . . They lost the human element that gives them the possibility of being in a good room, giving you a longer life or a more calm life, or the ability to have a clearer and more personal view of the world."[10] What matters to Schnabel is going somewhere and feeling something. Admittedly, this is by no means an easy option in soap-box, reality-show America where the simulacrum rules. His tendency is to blow things up and to want everything all together at the same time. These are characteristically American emotions, as are his quests for primal energy and origin: "I don't make a separation between intellect and feelings, and that was the premise of my paintings, they were just one ball of experience."[11]

He occupies the slippery ground of the Postmodern hero, constantly questioning and even undermining what he is supposed to represent. Schnabel is not sure of this role, he

mit Lebensenergie ausfüllen. In seinen Teller-Gemälden scheint das Bild oben zu schwimmen, als kämpfe es um einen Zustand, von dem man irgendwie weiß, dass es ihn nicht gibt. »Damals dachte ich: Welche Bildsprache bleibt einem noch? In Amerika dachte jeder, es gäbe keine Bilder mehr in der Malerei, dass man sie gänzlich verbannt habe. Ich wollte Bilder verwenden, die belastet waren – ich wollte der Malerei wieder Inhalt verleihen. Man hatte ihr jeden Inhalt genommen in dem Versuch, moderner zu sein und den formalen Charakter einer Bildkonstruktion herauszuarbeiten. Ich wollte die Sprache wieder in die Malerei einbringen.«[8] Diese Argumentation ist gewandt, umfassend und leidenschaftlich und bringt mich wieder auf die Teller. Sie sind natürlich Oberfläche, doch bei ihnen geht es auch um Schnitte und Schmerzen, um Aggression und Vereinigung. Sie verweisen auf die Geschichte der ebenen Fläche in der modernen Kunst. Und sie zeigen sehr deutlich, dass man sich schneidet, wenn man einen Schritt vorwärts macht und ausrutscht – so ist das Leben! Pollock wusste das, und Schnabel hat es gelernt! Auch seine Verwendung von Samt, Teppich oder Pelz erweitert die Möglichkeiten der Oberfläche. Selbst wenn er nicht der Erste war, der auf Samt gemalt hat, so hat er dieser Technik dennoch unverkennbar seinen Stempel aufgedrückt, indem er Bildern wie *Geography Lesson* (1980) eine schimmernde, vor Geschäftigkeit flimmernde Oberfläche verliehen hat.

Scheitern ist in der Tat ein wundersames Dilemma und lässt mich an den Schriftsteller Thomas Bernhard denken, der genau dieses Konzept mit ätzender Brillanz und gedämpftem Minimalismus auf den Punkt gebracht hat. Bernhards Romane *Der Untergeher* und *Beton* waren in Gaddis' Augen vorauseilende Plagiate, »so wie meine eigenen Ideen bereits gestohlen wurden, bevor ich sie überhaupt hatte«. Bernhard hat dieselben Themen wie Gaddis: Musik, Auflehnung gegen den Staat und Glenn Gould als das »verborgene Talent«, das es nicht zu mehr gebracht hat als seine Studienkollegen. Schnabel ist ein Symphoniker, und seine überbordende Fantasie plündert alles, was sie kann und was von Nutzen zu sein scheint.

Musik ist ein Quell gefährlicher emotionaler und physischer Verbindungen, ihr Gegenstand sind schwer bestimmbare Sinnesempfindungen. Nach den mentalen Verbindun-

does not fully believe in it, but he continues to go along for the ride. Nevertheless, he is fascinated by a concept that has been essential to the mythic construction of American experience: "a heroic impulse? I don't even know what a heroic impulse is really, anymore. Maybe it's a heroic impulse just to stand up? I'm trying to be really honest about my role as I guess some people they see me as a hero. Some people see me as an asshole."[12] He knows something of the Modernist heroic impulse where the heroic self was presented as attaining the sublime and being dissolved within it, that is, the experience of Pollock. But he is, above all, the man at the crossroads where one view of history gives way to another, caught, as it were, in an even more fragmented angst. Schnabel himself notes: "We are all stained. More and more each day these stains configure into our personalities, become our character. Make us recognize and search for one another."[13] And, indeed, he works with these stains from the past and with what has been left behind in contemporary living: the canvas tops from American jeeps, tarps from trucks, backcloths from the theater, and boxing-ring canvases. These constitute the grounds for many of his works and they come full of stories. He notes: "In America I think we have kind of reduced everything to a panel of meaning. And for me I guess I was trying to make a surface or an object that sort of felt like it was already in the world."[14] He uses the worn and tattered because they themselves are critically emotional, intensely torn. He prefers things that already have a past life imbued in them. *Prehistory: Glory, Honor, Privilege, and Poverty* of 1981 (pp. 26–27), for example, with its use of antlers, fragmentary material, and paint on cowhide dribbles with life and mucous matter. The ambition and energy of these fragments is invariably grandiose. They literally seem to strive for something they know they cannot hold. It is a work that takes on the scale and mythic potential of classic Abstract Expressionism, a kind of filling out of Pollock, Gorky, and De Kooning, imbued with immediacy, with a rush of energy from the present, with a confusion of uncontrollable ideas and sensations that pour forth from one person. It is unchecked and holds together.

Schnabel deals with history at a time when history itself is being deconstructed as yet another fiction. History is the place where the work of art originates, where the present

gen suchte Gaddis in *Das mechanische Klavier*, und Schnabel vernahm sie, als Cy Twombly einige Noten auf seinem Klavier spielte. Beide Künstler sind überschwänglich genug, es mit dem Leid der Welt aufzunehmen: »Bei allen Fälschungen, Nachahmungen und Verschwendungen der Welt war dies der einzige Trost, der Gaddis in den letzten Phasen einer Komposition aufzurichten vermochte: dass das Leben des Geistes im Zusammenspiel mit dem Geist anderer, die brüderliche Liebe, die er für einen verblichenen Freund hegte, und das disziplinierte Wiedererkennen der Erfolge früherer Schriftsteller seinem Werk eine bleibende Kraft verleihen würden, die über seine eigenen – letztendlich menschlichen – Kräfte von Mühe und Erfindungsgabe hinausginge.«[9] Dieses disziplinierte Wiedererkennen der Vergangenheit verbindet die Werke von Gaddis und Schnabel nicht nur auf der Ebene der Sehnsucht, sondern auch als methodischer Ansatz.

Schnabel empfindet sich beinahe so sehr als Teil der europäischen wie als Teil der amerikanischen Tradition, denn erstere verbindet ihn unmittelbar mit der humanistischen Tradition, der er sich zugehörig fühlt, sowohl in der Beständigkeit als auch in der Veränderung. In seiner Wahrnehmung kann er seinen amerikanischen Materialismus nicht vollständig ablegen und lässt sich von Ausmaß und Umfang des Gesehenen beeindrucken, doch er findet auch partielle Wahrheiten und Fragmente, die ihn berühren. Schnabel traut eher den Fragmenten als dem Ganzen, und er ordnet sie zu seiner eigenen glitzernden Vision von Intuitionen, Gedanken und Gefühlen, die alle einer spirituellen Transzendenz zustreben: »Ich halte es für dumm zu denken, um modern zu sein, müsse man in New York bleiben. Ich war in Ägypten. Luxor ist so riesig, die griechische und die römische Bildhauerei sind nichts dagegen. Dort sieht man Ägypten in Fragmenten, und es macht einem richtig Angst, in welchem Maßstab man dort gearbeitet hat. Amerika hat ein sehr gegenwartsbezogenes oder kurzsichtiges Verständnis von Zeit. In Gedanken an den Fortschritt verlieren sie sich selbst aus dem Blick. Ihnen ist die menschliche Fähigkeit abhanden gekommen, sich ein angenehmes Umfeld zu schaffen, wo man ein langes und beschauliches Leben führen kann und von dem aus sie einen klareren und persönlicheren Blick auf die Welt werfen können.«[10] Schnabel geht es darum, sich zu entwickeln und et-

threatens to vanish and is about to become the past. His answer is to heroically personalize history, to assume it within himself. *The Edge of Victory* of 1997 (pp. 66–67) is a work of heroic dimensions, risking emptiness. It is a voiding but also a cleansing spiritual operation, as well as grandiloquent assertion of self. *Resurrection: Albert Finney Meets Malcom Lowry* of 1984 (p. 24) is equally heroical, with the volcano rising up behind painted almost in Romanesque forms. The theme of a bearer more mighty than the self had a grip on both Schnabel and Gaddis. The latter searched for models in history such as Gould and Tolstoy, or in the form of a character in one of his novels, such as Wyatt Gwyon in *The Recognitions*. Both show an obsessive need to speak with those no longer here: an endless turning to voices and fragments.

Schnabel, perhaps, moves towards the European camp because he can find no home in appropriation-based American Postmodernism. The bombast implicit within Schnabel's rhetoric has been grossly misread and has failed to situate the man in his work, to deal with a late flowering Romanticism that stems unchecked from Melville through Whitman to transcendental pantheistic poets such as William Everson or to the sheer inclusiveness of a poet such as Robert Duncan. Schnabel, however, looks for another home: "It was a time when people were painting a group of paintings: one was green, one was blue, but it was a similar method from one painting to the next. I would have one plate painting, one wax painting, and all together it was more like the way a sculptor would organize a room. Maybe it had more to do with the sensibility of Joseph Beuys, where Blinky Palermo and Polke came out of … At the same time when I was in Italy and I was painting these paintings, Panza saw them and he thought that they were the best paintings that he had ever seen, and that they were very American."[15] Panza, to my mind, was correct! Schnabel is not a flag carrier, but his grasp of the world is formed by the particularities of his experience. He is an American who wanted to bring the image back into painting: lavish images into lush painting.

Both are eclectic artists: "Gaddis would arrange snippets of dialogue, quotations and other narrative elements on pages laid out on a large table and pinned to the wall; then

was zu fühlen. Zugegebenermaßen ist das im Amerika der Soaps und Reality-Shows, in der Welt des Scheins, keinesfalls einfach. So neigt Schnabel dazu, die Dinge aufzubauschen und alles gleichzeitig zu machen. In diesem Punkt sind seine Emotionen typisch amerikanisch, und das gilt auch für seine Suche nach ursprünglicher Energie und den Anfängen: »Ich mache keinen Unterschied zwischen Intellekt und Gefühlen, und das war die Voraussetzung für meine Bilder, sie bestehen aus einem Klumpen Erfahrungen.«[11]

Als postmoderner Held bewegt er sich auf unsicherem Grund, und beständig hinterfragt er die Rolle, die er einnehmen soll, untergräbt sie sogar. Er ist sich ihrer nicht sicher, er glaubt nicht in aller Konsequenz an sie, und dennoch setzt er seinen Weg unbeirrt fort. Nichtsdestoweniger ist er fasziniert von dem Konzept, das entscheidend war für die mystische Konstruktion des amerikanischen Selbstverständnisses: »Ein heroischer Impuls? Ich weiß inzwischen gar nicht mehr, was das ist, ein heroischer Impuls. Vielleicht ist es ein heroischer Impuls, einfach nur für etwas einzutreten? Ich versuche wirklich, meine Rolle ernst zu nehmen, denn ich glaube, dass einige Menschen mich als Helden betrachten. Manche Menschen finden, ich bin ein Arschloch.«[12] Schnabel ist der modernistische heroische Impuls nicht fremd, das heroische Ich als etwas darzustellen, das Erhabenes erreicht und sich in ihm auflöst, das heißt er kennt die Erfahrung Pollocks. Doch er ist vor allem ein Mann an einer Kreuzung, an der ein Blick auf die Geschichte von einem anderen abgelöst wird, gleichsam gefangen in einer noch bruchstückhafteren Angst. Schnabel bemerkt dazu: »Wir sind alle befleckt. Und von Tag zu Tag werden die Flecken mehr zum Bestandteil unserer Persönlichkeit, zu unserem Charakter. Wir sollten uns gegenseitig erkennen und einander suchen.«[13] Und so arbeitet er tatsächlich mit den Flecken der Vergangenheit und dem, was der Mensch der Gegenwart zurücklässt. Er verwendet Abdeckplanen, Theaterfolie und Matten aus dem Boxring als Malgrund für seine Arbeiten, und sie erzählen zahlreiche Geschichten. Er bemerkt: »Ich glaube, in Amerika haben wir alles auf eine Bedeutungsebene reduziert. Ich wollte eine Oberfläche oder einen Gegenstand erschaffen, die irgendwie schon in der Welt waren.«[14] Er nimmt das Gebrauchte und Zerfetzte, denn es ist in entscheidendem Sinne emotional,

he would rearrange and rework the whole, trying for the right flow so that each page might go through six or eight revisions before he ever arrived at a 'first draft.'"[16] Schnabel is, of course, more impulsive, but he tends to work around themes and ideas that serve as magnetic fields capable of including whatever registers itself as a powerful presence. He is a magpie with images and materials: "I don't like collecting all this stuff, and I don't like building, I'm not a carpenter. I don't like constructions particularly and things like that, but placement and the kinds of psychological weight that different materials have is pretty interesting to me. What gold is about . . . you know? Or what fur is like. . . . I think I'm just as interested in finding an old drawing that I might have made, or a drawing that somebody else made or a photograph that might have a certain kind of location in it."[17]

Gaddis notes on scrap of paper for *Agapé Agape* that chaos theory might serve him as a means towards order. This project occupied him throughout his professional life and consisted of material cut from popular magazines and newspapers where even some of the high literature, art, or music quotes came from daily papers. "Composition, for Gaddis, was a distinctly material practice, involving a literal organization and arrangement of found materials, even as his narrator struggles to hold himself together. . . ."[18] Gaddis used his box of snippets to create a character who had an obsession identical to his own, whose lived experience and efforts at composition could dramatize both the possibilities and "the destructive element" within an emerging technological order. He uses all that is available in the world, anything can trigger him off. Schnabel is equally involved with the destructive element, with giving order to chaos, and risking the void of the world. The works sometimes have a kitsch glitz and there seems little point in denying it, but they are also deeply involved in high art. They show an American immediacy of reading but they open ways of bringing saturated painters, such as Rubens or Tintoretto, into the present. *Los patos del Buen Retiro* of 1991 (pp. 101–105) seems full of these extravagancies of gesture, of beautiful passages on dirt, and of imaginative flights.

Gaddis is not reader friendly, but Schnabel is slightly more garrulous and willingly espouses the beauties of failure, of aspiring without hope, of the flow that signals incom-

von heftiger Zerrissenheit. Es sind Dinge, die schon ein vergangenes Leben in sich tragen. Die Arbeit *Prehistory: Glory, Honor, Privilege, and Poverty* von 1981 (S. 26/27) beispielsweise, für die er Geweihe, fragmentarisches Material und Farbe auf Kuhfell verwendet, tropft vor lebender und schleimiger Materie. Der Ehrgeiz und die Energie dieser Fragmente sind ausnahmslos überwältigend. Sie scheinen buchstäblich nach etwas zu streben, von dem sie wissen, dass sie es nicht halten können. Das Werk hat die Größe und das mythische Potenzial des klassischen Abstrakten Expressionismus, es ist gewissermaßen die Weiterentwicklung von Pollock, Gorky und de Kooning, durchdrungen von Unmittelbarkeit, von Energie aus der Gegenwart, von einem Wirrwarr unkontrollierbarer Gedanken und Empfindungen, die allesamt von einer Person ausgehen. Es ist ungezügelt und hält zusammen.

Schnabel befasst sich zu einer Zeit mit Geschichte, als die Geschichte selbst als eine weitere Fiktion demontiert wird. Geschichte ist der Ort, an dem das Kunstwerk entspringt, an dem die Gegenwart zu verschwinden droht und im Begriff ist, zur Vergangenheit zu werden. Seine Antwort besteht darin, Geschichte heroisch zu personalisieren, sie zu einem Teil seiner selbst zu machen. *The Edge of Victory* von 1997 (S. 66/67) ist ein Werk von heroischen Dimensionen, das Leere riskiert. Es ist ein entleerender, aber auch reinigender Prozess, ebenso eine schwülstige Behauptung des Ich. *Resurrection: Albert Finney Meets Malcom Lowry* von 1984 (S. 24) mit dem in nahezu romanischen Formen aufsteigenden Vulkan im Hintergrund ist gleichfalls heroisch. Das Thema des Schöpfers, der mächtiger ist als das Ich, faszinierte sowohl Schnabel als auch Gaddis. Dieser suchte in der Geschichte nach Vorbildern wie Gould und Tolstoi oder in den Gestalten seiner Romane wie Wyatt Gwyon in *Die Fälschung der Welt*. Schnabel und Gaddis verspüren ein obsessives Bedürfnis, mit denen zu kommunizieren, die nicht mehr sind: eine endlose Hinwendung zu Stimmen und Fragmenten.

Möglicherweise wendet Schnabel sich Europa zu, weil er in der auf Aneignung begründeten amerikanischen Postmoderne keine Heimat findet. Der große Anteil des Impliziten in der Rhetorik Schnabels hat häufig zu Missverständnissen geführt und verhindert, dass der Künstler in sein Werk eingeordnet werden kann. Die Auseinandersetzung mit jener spät

pletion as condition. Gaddis taught a course on failure. He focused on "the importance of fictions" however tawdry in dealing with the ultimate nothing. Gaddis addressed the challenge that American fiction has centered upon from its beginning as "an inescapable predicament": "With no long history and no class system, with the tradition of a complete freedom to do and become what one wants to, we are confronted with essential human problems of what, exactly, is worth doing. . . . This is what I think produced our American philosophy of pragmatism, in which expediency becomes the goal in terms, too often, of the way 'things are,' rather than the way 'things should be.' And this in turn is the confrontation that much of our fiction tries to describe and redress."[19] On last page of *Agapé* he talks of discovering our hidden talent. What could be closer to Schnabel? His driven search for an acceptable body of meanings, of a black soil from which to emerge, of some fragment, signal, or sign of meaning and identity. His works are full of tatters that survive with a certain brilliance and they carry the pains of saturated recognitions and intuitive risks. We are in a limbo as an existential condition and art perhaps helps to imagine a sense of place and identity. Decomposition is in fact as much an aspect of art as composition or invention, and it is a process that is a natural site for the location of romantic feelings in a world such as ours. Ambiguity becomes for Schnabel a key for contradictory messages. In the late seventies he had been experimenting with reductive system of glyphs: Maltese crosses, shields, truncated figures, and a kind of carrot shape—an abstract shape that he could alter and move around. "It was just a line: I was looking for the multiplicity of uses and impulses that can come out of one shape, in the way a poet looks for the cumulative resonance in a single word. I was also looking for a multiplicity of signals that a shape could give off, the ambiguities of different shapes."[20] *Accattone* of 1978 (p. 30) stands as a simple reduction of this process.

In evolving his vocabulary Schnabel has stolen from the best and in the best sense, that is with the intelligent understanding of the difference between influence and the giving of license. He intuits that a great painting by somebody else can be a liberating experience that would allow him to take a risk that he might not have taken otherwise.

blühenden Romantik, die sich ungezügelt von Melville über Whitman zu transzendental-pantheistischen Dichtern wie William Everton und der reinen Einschließlichkeit eines Robert Duncan fortsetzt, hat nie stattgefunden. Wie dem auch sei, Schnabel sucht nach einer anderen Heimat: »Damals malten alle Bildgruppen: Eines war grün, eines war blau, doch die Methode blieb von einem Bild zum nächsten gleich. Ich hingegen hatte ein Teller-Bild, ein Wachs-Bild, und zusammen wirkte es, als hätte ein Bildhauer einen Raum gestaltet. Möglicherweise lag das daran, dass sie mehr mit der Empfindsamkeit von Joseph Beuys gemeinsam haben, die auch für Blinky Palermo und Polke zutraf. […] Doch als ich in Italien war und diese Bilder malte, sah Panza sie, und er sagte, dass er solche Bilder noch nie gesehen habe und dass sie sehr amerikanisch seien.«[15] Ich glaube, Panza hatte Recht! Schnabel hat kein besonderes Nationalbewusstsein, doch sein Weltverständnis ist geprägt von seinen spezifischen Erfahrungen. Er ist ein Amerikaner, der das Bild zurück in die Malerei bringen wollte: großzügige Bilder in eine üppige Malerei.

Schnabel und Gaddis sind eklektische Künstler: »Gaddis arrangierte Dialogschnipsel, Zitate und andere narrative Elemente auf Blättern, die er auf einem großen Tisch ausbreitete und an die Wand heftete. Immer wieder ordnete er alles neu und überarbeitete es. Er suchte nach dem richtigen Fluss. So kam es, dass er eine Seite sechs- bis siebenmal überarbeitete, bevor der ›erste‹ Entwurf fertig war.«[16]

Schnabel ist natürlich impulsiver, doch er arbeitet bevorzugt mit Themen und Gedanken, die alles, was über eine kraftvolle Präsenz verfügt, magnetisch anziehen. Wie besessen sammelt er Bilder und Materialien: »Ich sammele dieses ganze Zeug nicht gerne, und ich baue auch nicht gerne. Ich bin kein Schreiner. Ich bin kein Freund von Konstruktionen und dergleichen, doch ich interessiere mich sehr für die Anordnung und das psychologische Gewicht verschiedener Materialien. Was hat es mit Gold auf sich? Oder was ist mit Fell? Ich bin nur auf der Suche nach einer alten Zeichnung, die ich vielleicht selbst angefertigt habe oder auch jemand anders, oder nach einem Foto, das eine bestimmte Örtlichkeit zeigt.«[17] Gaddis notiert auf einem Stück Papier für *Das mechanische Klavier*, dass die Chaostheorie ihm als Mittel zur Ordnung dienen könnte. Dieses Projekt beschäftigte ihn sein

And in the case of Gaddis a compendium of forgeries, past and persisting, is the background to the multiple quests for truth in his first novel, *The Recognitions*. Once again we find the disposition towards ambiguity and uncertainty, to play rather than purity in the use of language. Schnabel in his series that appears as homage to this novel uses verbal elements taken from the text as a kind of formal structure for the paintings: a framing device. Gaddis's novel presents the kind of microcosm that Schnabel needed, a fascinating maze of fragments that could find new meanings within the military and the spiritual context in Seville (the Carmen had been both a monastery and a military barracks) where the paintings were shown. We are dealing then with affinities rather than specific influences. Both artists create patterns out of found materials; both are confessional. There is an intense outpouring of ideas and emotions: "In Gaddis imagination, character, meaning, and agency come not from some essential, core self but from the languages and systems that circulate through many selves in a social collectivity—including the "self that could do no more," a potential, creative agency that emerges only in the work, and in the act of recognizing answering patterns in the work of others."[21] Schnabel is similarly a nexus point within his work, the locus through whom ideas and emotions pass, permitting and provoking their rushing together to fuse into a new possibility.

Near the end of *Agapé* Gaddis offers his own version of the "self who could no more" and of a mind devouring itself in endless self-reflection: "It's fifteenth, sixteenth-century Italian poetry, who nearer to me or more mighty, yes more mighty than I. Tore me away from myself. Tore me away!"[22] Here specifically is the turning to the past as a way of continuing that are obsessively central to the work of both artists. Gaddis continues "everything depends on the language, on the living author's struggle with a past artist's word and on the future reader's ability to hold in mind two opposed meanings—O Dio and odium, heaven and repugnance. A capacity for imaginative projection into the lifeworld, thought, and language of another person, whether living or dead, through music literature, the visual arts or conversation—this is the ethical burden of *Agapé* in the

ganzes kreatives Leben lang: Er sammelte Material aus Magazinen und Zeitungen, und einige bedeutende Zitate zu Literatur, Kunst oder Musik stammten aus der Tagespresse. »Die Komposition war für Gaddis ein eindeutig physischer Vorgang, der das buchstäbliche Organisieren und Arrangieren der gefundenen Materialien miteinschloss, auch wenn sein Erzähler sich kaum selbst zusammenhalten kann.«[18] Gaddis verwendete seinen Zettelkasten, um einen Charakter zu erschaffen, der die gleiche Obsession hat wie er, dessen Erlebnisse und Anstrengungen bei der Komposition sowohl die Möglichkeiten als auch »das destruktive Element« der zu Tage tretenden technischen Ordnung verschärfen könnten. Er verwendet alles, was die Welt ihm bietet, alles kann seine Aufmerksamkeit wecken. Auch Schnabel beschäftigt sich mit dem destruktiven Element, er will Ordnung in das Chaos bringen und riskiert damit die Leere der Welt. Einige seiner Arbeiten sind zweifellos unglaublich kitschig, doch gleichzeitig sind sie der Hochkunst zuzuordnen. In ihrer Lesart sind sie von amerikanischer Unmittelbarkeit, doch gleichzeitig vermögen sie vergangene Künstler wie Rubens oder Tintoretto in die Gegenwart zu transportieren. *Los patos del Buen Retiro* von 1991 (S. 101–105) strotzt vor Extravaganzen in der Gestik, vor wunderschönen Passagen auf Dreck und vor Flügen der Fantasie.

Gaddis ist nicht leserfreundlich, Schnabel hingegen ist ein wenig mitteilsamer und tritt bereitwillig ein für die Schönheiten des Scheiterns, des Ehrgeizes ohne Hoffnung, des Flusses, der Lückenhaftigkeit zum Zustand macht. Gaddis lehrt eine Lektion des Scheiterns. Er konzentrierte sich auf »die Bedeutung von Fiktionen«, so billig sie auch sein mögen, im Umgang mit dem ultimativen Nichts. Gaddis befand die Herausforderung, die im Mittelpunkt der amerikanischen Fiktion seit ihren Anfängen stand, als »unausweichliche Zwangslage«: »Wir haben keine lange Geschichte und kein Klassensystem, außerdem traditionell die uneingeschränkte Freiheit, zu tun und zu werden, was wir wollen. So werden wir mit dem grundlegenden Problem der Menschheit konfrontiert, nämlich dem, was sich zu tun lohnt. Und in der Fiktion nimmt diese (Herausforderung) die Form von ›so wie die Dinge sein sollten‹ im Gegensatz zu ›so wie die Dinge sind‹ an. Dies hat in meinen Augen unsere amerikanische

arts."[23] Schnabel's *Saint Sebastian* of 1979 (p. 15), a torso scarred with red slashes, creates the impression not only of the immediacy of the paint but also of a whole past life under the work.

For Schnabel work is a revolt, a kind of constant state of rebellion against the transitory nature of life. *The Patients and the Doctors* of 1978 (p. 45), the first of the *Plate Paintings,* seems to yearn for life to be crushed and wallowing within it. The works are wounds, as I have said, and there is a constant building up of emotion, and they make primal forms into content. They talk of disease, death, and illness but also of the power of love. They may often shout brashly but this is not inappropriate for these times. They convey the tragic spirit and melancholy that are the very essence of the cathartic function of art.

Surface is a key figure but Schnabel's work offers a glimpse of hidden realities of the kind that Gaddis himself aspired to. The fragmentation and concomitant reshaping of the picture surface is a methodology for opening up new realities. We find ourselves face to face with theatrical grandeur, emotional crisis, the will to statement, and a determined retention of mystery. Schnabel rejects closed and finished forms as if a final form could only confuse the complexity and contradictory nature of emotion. In subjectivizing culture, Schnabel emotionalizes everything. He wants emotion and experience before it is fully formed, in the lava state or as organism.

Schnabel is, then, a plunderer of the modern world, a collector of the abandoned, a writer of grandiose decay, large scale, large script, and large range. We think of Bruce Sterling's *Dead Media* project initiated on the Internet or, as I have been trying to suggest, to Gaddis's ongoing and unfinished *Agapé* that has been my focus through this essay and similarly deals with built-in obsolescence, material culture. One cannot help wondering if Schnabel, apart from being a friend of Gaddis, is not also a massive and mighty character in one of his texts. What I believe is certain is that if such were the case it is a role that he can fully occupy!

Philosophie des Pragmatismus begründet, in der die Zweckmäßigkeit zu häufig im Sinne von ›wie die Dinge sind‹ anstatt ›wie die Dinge sein sollten‹ zum Ziel wird. Und dies nun wiederum ist die Konfrontation, die ein großer Teil unserer Fiktion zu beschreiben und zu beseitigen sucht.«[19] Auf der letzten Seite von *Das mechanische Klavier* spricht er von der Entdeckung unseres verborgenen Talents. Dort ist er Schnabel so nah wie nie in seiner rastlosen Suche nach einem akzeptablen Bedeutungskorpus, nach einem Nährboden, aus dem – aus irgendeinem Fragment – ein Signal, ein Anzeichen von Bedeutung und Identität hervorgehen möge. Sein Werk ist voller Fetzen, die in einem gewissen Glanz überleben und in sich die Schmerzen saturierter Wiedererkennungen und intuitiver Risiken tragen. Das Leben in der Vorhölle ist ein existenzieller Zustand, und die Kunst kann uns helfen, uns einen Begriff von Ort und Identität zu erschaffen. Die Dekomposition ist genauso ein Bestandteil der Kunst wie die Komposition oder die Invention, und es handelt sich dabei um einen Prozess, in den romantische Gefühle in einer Welt wie der unseren naturgemäß verortet werden. Die Vieldeutigkeit wird für Schnabel zum Schlüssel für widersprüchliche Botschaften. In den späten siebziger Jahren experimentierte er mit reduzierten Zeichensystemen: mit Malteserkreuzen, Wappenschilden, gestutzten Figuren und einer Linie wie eine Möhre – einer abstrakten Form, die er verändern und vielseitig einsetzen konnte. Zunächst war es eine italienische Pappel, dann eine Mitra und ein halber Torso: »Es war einfach nur eine Linie: Ich suchte nach möglichst vielfältigen Einsatzmöglichkeiten und Impulsen, die aus einer Form erwuchsen, so wie der Dichter nach einem kumulativen Widerhall in einem Wort sucht. Genauso suchte ich nach einer Vielzahl von Signalen, die von einer Form ausgehen können, nach den Vieldeutigkeiten verschiedener Formen.«[20] *Accattone* von 1978 (S. 30) steht für eine einfache Reduzierung dieses Prozesses.

Bei der Entwicklung seines Vokabulars hat Schnabel nur das Beste und nur im besten Sinne gestohlen, das heißt er hält stets die Waage zwischen Beeinflussung und Plagiat. Er begreift intuitiv, dass das gelungene Gemälde eines anderen ihm die Freiheit geben kann, ein Risiko einzugehen, das er sonst vielleicht nicht eingegangen wäre. Was Gaddis angeht,

1 Joseph Tabbi, introduction to *The Rush for Second Place*, by William Gaddis (New York, 2002), p. ix.

2 Ibid.

3 William Gaddis, "Julian Schnabel," in *The Rush for Second Place* (New York, 2002), p. 138.

4 William Gaddis, "A Note of Gratitude Introducing a William Gaddis Tribute," in *Conjunctions* 33 (New York, 1999), p. 83. (Schnabel's 1987 portrait of Gaddis is reproduced in this same issue on p. 148.)

5 Joseph Tabbi, in Gaddis 2002 (see note 1), p. xxi.

6 William Gaddis, "Julian Schnabel," in Gaddis 2002 (see note 3), p. 138.

7 Joseph Tabbi, in Gaddis 2002 (see note 1), p. xi.

8 Julian Schnabel, interview by Carter Ratcliff, October 6, 1994, in *Julian Schnabel* (Barcelona, 1995), p. 103.

9 Ibid., p. 112.

10 Ibid., p. 104.

11 Ibid.

12 Ibid., p. 105.

13 Julian Schnabel, *CVJ: Nicknames of Maitre D's and Other Excerpts from Life* (New York, 1987), p. 32.

14 Julian Schnabel, interview by Carter Ratcliff (see note 8), p. 103.

15 Ibid., p. 106.

16 Joseph Tabbi, in Gaddis 2002 (see note 1), p. xiii.

17 Julian Schnabel, quoted in Carter Ratcliff, *Interview Magazine* 10/10 (October 1980), p. 55.

18 Joseph Tabbi, afterword to *Agapé Agape*, by William Gaddis (New York, 2002), p. 100.

19 Joseph Tabbi, in Gaddis 2002 (see note 1), p. 39.

20 Schnabel 1987, p. 113.

21 Joseph Tabbi, in Gaddis 2002 (see note 1), p. xviii.

22 William Gaddis, *Agapé Agape* (New York, 2002), p. 94.

23 Ibid., p. 109.

so ist ein Kompendium vergangener und bestehender Fälschungen in seinem ersten Roman *Die Fälschung der Welt* Hintergrund für die zahlreichen Versuche, die Wahrheit zu finden. Wieder kann man seine Neigung zu Vieldeutigkeit und Ungewissheit, zum Spiel, beobachten, in seiner Sprache strebt er nicht nach Reinheit. In Schnabels Bildreihe, die als Hommage zu dem Roman erscheint, verleihen verbale Elemente aus dem Text den Gemälden eine Art formale Struktur und geben ihnen damit einen Rahmen. Gaddis' Roman ist genau der Mikrokosmos, den Schnabel braucht, ein faszinierendes Gewirr von Fragmenten, das im militärischen und spirituellen Kontext von Sevilla, wo seine Bilder gezeigt wurden (El Carmen war sowohl ein Kloster als auch eine Kaserne), neue Bedeutungen erhalten konnte. In diesem Fall haben wir es eher mit Affinitäten als mit besonderen Einflüssen zu tun. Beide Künstler erschaffen Muster aus Fundstücken, beide wagen ein Bekenntnis. Es gibt ein intensives Fließen von Gedanken und Gefühlen. »In Gaddis' Vorstellungswelt entspringen Charakter, Bedeutung und Kraft nicht irgendeinem wesentlichen Kern-Ich, sondern den Sprachen und Systemen, die durch zahlreiche Individuen einer Gesellschaft zirkulieren – einschließlich des ›Ich, das nicht mehr tun konnte‹ –, einer potenziellen, kreativen Kraft, die nur innerhalb des Werkes und im Akt des Wiedererkennens von Antwortmustern in den Werken anderer auftritt.«[21] Entsprechend ist Schnabel ein Nexus innerhalb seiner Arbeit, der Ort, den Gedanken und Gefühle durchqueren, der Ort, der ihr Zusammentreffen, ihr Verschmelzen zu einer neuen Möglichkeit zusammenführt.

Am Ende von *Das mechanische Klavier* offenbart Gaddis seine eigene Version des »Ich, das nicht mehr konnte« und eines Geistes, der sich selbst in endlosen Selbst-Reflexionen zerfleischt: »...nein, so dämlich klingt das in Wirklichkeit nicht, ist 15., 16. Jahrhundert und geht in Richtung Dichtung. Wer näher mir war oder stärker, genau, stärker als ich, entriss mich mir selbst. Mir selbst oder meiner selbst.«[22] Genau dies ist die Hinwendung zur Vergangenheit als Möglichkeit für eine Zukunft, die so zentral ist im Werk der beiden Künstler. Gaddis fährt fort, dass »alles von der Sprache abhängt, vom Kampf des lebenden Autors mit den Worten eines vergangenen, von der Fähigkeit des zukünftigen Lesers, zwei gegen-

sätzliche Bedeutungen im Sinn zu behalten – O Dio und Odium, Himmel und Hölle. Die Fähigkeit, mittels Musik, Literatur, bildender Kunst oder Konversation Erdachtes in die Lebenswelt, Gedanken und Sprache einer anderen Person zu projizieren, sei sie lebendig oder tot, darin besteht die ethische Last von *Das mechanische Klavier* in den Künsten.«[23] Bei Schnabels Werk *San Sebastian* von 1979 (S. 15), einem mit roten Striemen übersäten Torso, hat man nicht nur einen unmittelbaren Eindruck von Farbe, sondern auch von einem ganzen vergangenen Leben unter dem Werk.

Für Schnabel ist seine Arbeit Revolte, ein unablässiges Aufbegehren gegen die Vergänglichkeit des Lebens. *The Patients and the Doctors* von 1978 (S. 45), das erste der Tellergemälde, scheint sich nach dem Leben zu sehnen, damit es in ihm zerdrückt werde und sich in ihm wälze. Die Werke sind Wunden, es werden beständig Emotionen aufgebaut, die dem Inhalt erste Formen geben. Sie sprechen vom Leiden, von Tod und von Krankheit, aber auch von der Kraft der Liebe. Sie übermitteln den tragischen Geist und die Melancholie, aus denen das reine Wesen der kathartischen Funktion von Kunst besteht. Man erinnere sich daran, dass die klassische Kunstgeschichte oftmals mit griechischen Vasen beginnt und sich über die Renaissance-Malerei in die Gegenwart vorarbeitet. Schnabels Werk ahmt diesen Prozess nach, eint ihn in einem Raum. Er schafft ihm einen fiktiven Ursprung von appellativem Charakter mit Landschaften aus Niedergang, Schmerz und existenzieller Angst. Auch wenn die Oberfläche eine zentrale Rolle einnimmt, gewähren Schnabels Arbeiten dennoch einen flüchtigen Blick auf die versteckten Realitäten, nach denen auch Gaddis strebte. Die Fragmentierung und gleichzeitige Neugestaltung der Oberfläche ist eine Methode zur Schaffung neuer Realitäten. Wir werden konfrontiert mit dramatischer Pracht und emotionaler Krise, mit dem Willen zum Statement und einer entschiedenen Bewahrung des Mysteriums. Schnabel lehnt in sich geschlossene und vollendete Formen ab, als könnten diese die komplexe und widersprüchliche Natur des Gefühls nur durcheinander bringen. In der Subjektivierung der Kultur emotionalisiert er alles. Er will das Gefühl und die Erfahrung in einem lavaartigen Zustand oder als Organismus erfassen, bevor sie vollständig ausgeformt sind.

In diesem Sinne ist Schnabel ein Plünderer der modernen Welt, ein Sammler des Verlassenen, ein Chronist des großen Zerfalls, in großem Maßstab, in großen Lettern und in großem Stil. Ich verweise auf Bruce Sterlings *Dead-Media*-Projekt im Internet oder auf Gaddis' fortlaufendes und nie vollendetes Werk *Das mechanische Klavier*, das sich mit der eingeplanten Veralterung, der Kultur des Materiellen beschäftigt. Man kommt nicht umhin zu fragen, ob Schnabel nicht nur ein Freund von Gaddis war, sondern auch einer der gewaltigen und mächtigen Charaktere aus seinen Texten. Eins ist sicher: Sollte dies der Fall sein, so wird er seiner Rolle vollkommen gerecht.

1 Joseph Tabbi, in: William Gaddis, *The Rush for Second Place*, New York 2002, S. ix.

2 Ebd.

3 William Gaddis, »Julian Schnabel«, in: *Rush for Second Place*, New York 2002, S. 138

4 Zit. nach »A Note of Gratitude Introducing a William Gaddis Tribute«, in: *Conjunctions*, 33, New York 1999, S. 83. (Das Porträt, das Schnabel 1987 von Gaddis anfertigte, findet sich in derselben Ausgabe auf Seite 148.)

5 Tabbi (s. Anm. 1), S. xxi

6 Gaddis (s. Anm. 2), S. 138

7 Tabbi (s. Anm. 1), S. xi

8 Schnabel in: »Carter Ratcliff Interviews Julian Schnabel, 6. Oktober 1994«, in: *Julian Schnabel*, Ausst.-Kat. Fundació Joan Miró, Barcelona, 1995, S. 103.

9 Ebd., S. 112.

10 Ebd., S. 104.

11 Ebd.

12 Ebd., S. 105.

13 Julian Schnabel, *C V J. Nicknames of Maitre D's and other Excerpts from Life*, New York 1987, S. 32

14 Schnabel, Interview mit Carter Ratcliff (s. Anm. 8), S. 103.

15 Ebd., S. 106.

16 Tabbi (s. Anm. 1), S. xiii.

17 Schnabel, zit. nach: Carter Ratcliff, *Interview Magazine*, 10/10, Oktober 1980, S. 55.

18 Joseph Tabbi, »Nachwort« in: William Gaddis, *Das mechanische Klavier*, München 2003, S. 100.

19 Tabbi, *Rush for Second Place*, S. 39.

20 Schnabel, *C V J* (s. Anm. 13), S. 113.

21 Tabbi (s. Anm. 1), S. pxviii.

22 Gaddis, *Das mechanische Klavier* (s. Anm. 1), S. 122.

23 William Gaddis, *Agapé Agape*, New York 2002, S. 109.

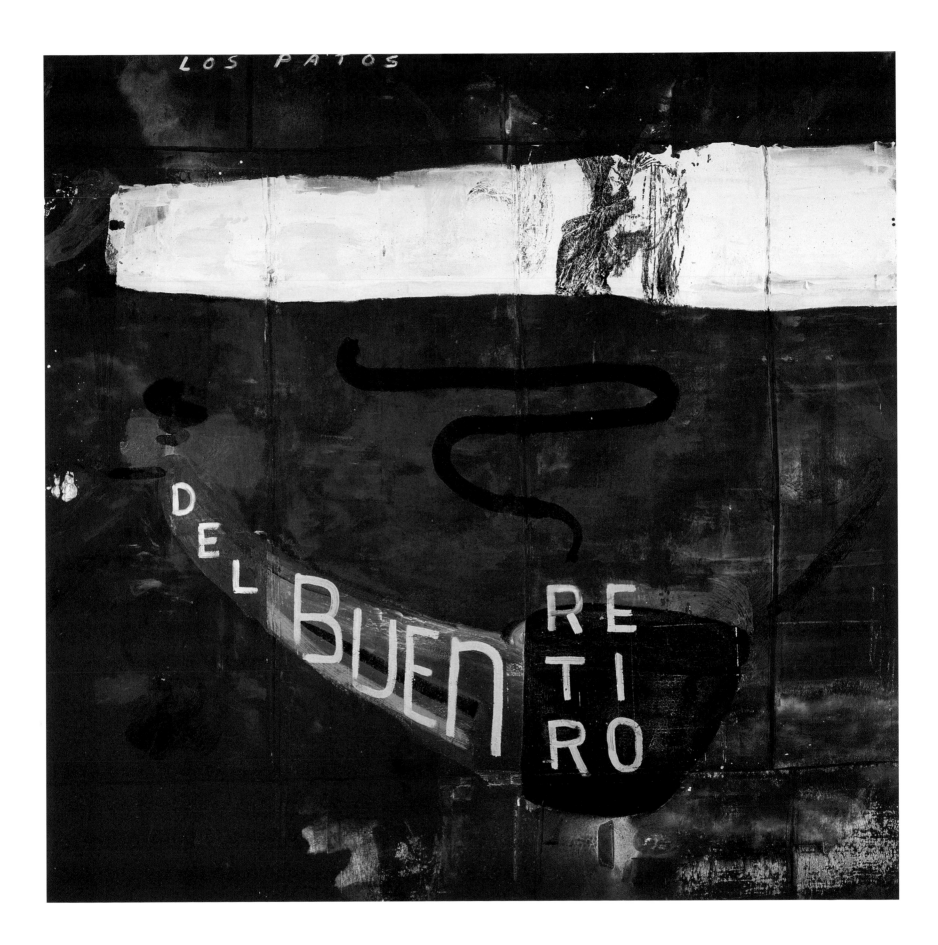

43 Untitled (Los Patos del Buen Retiro), 1991

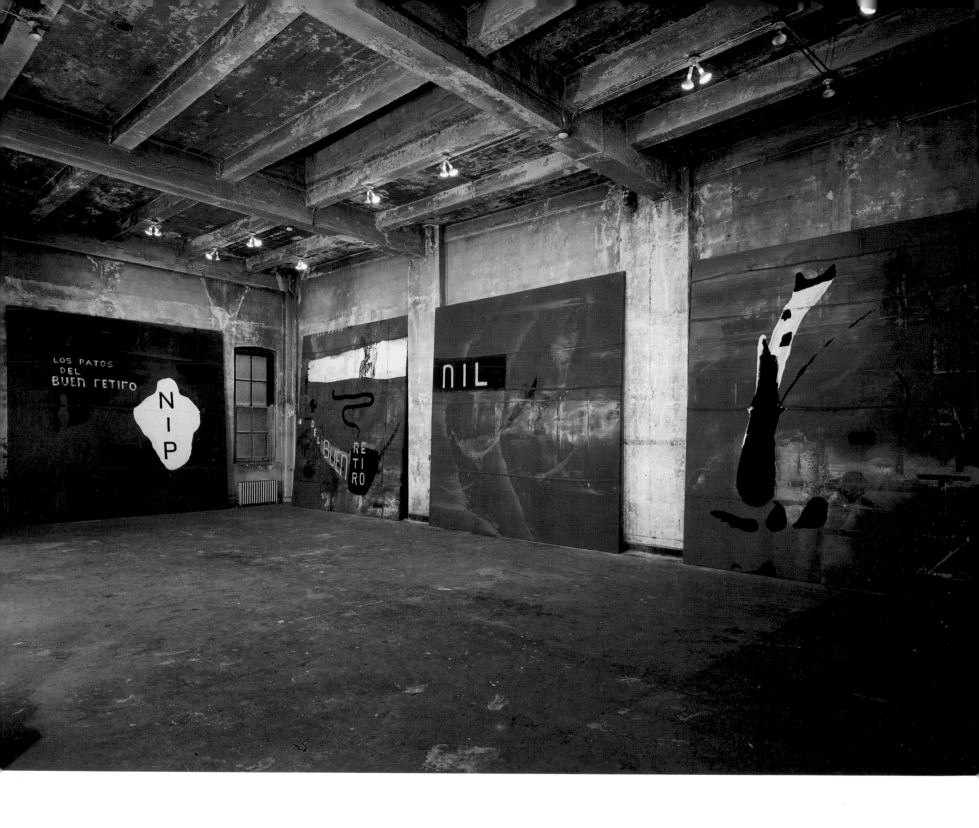

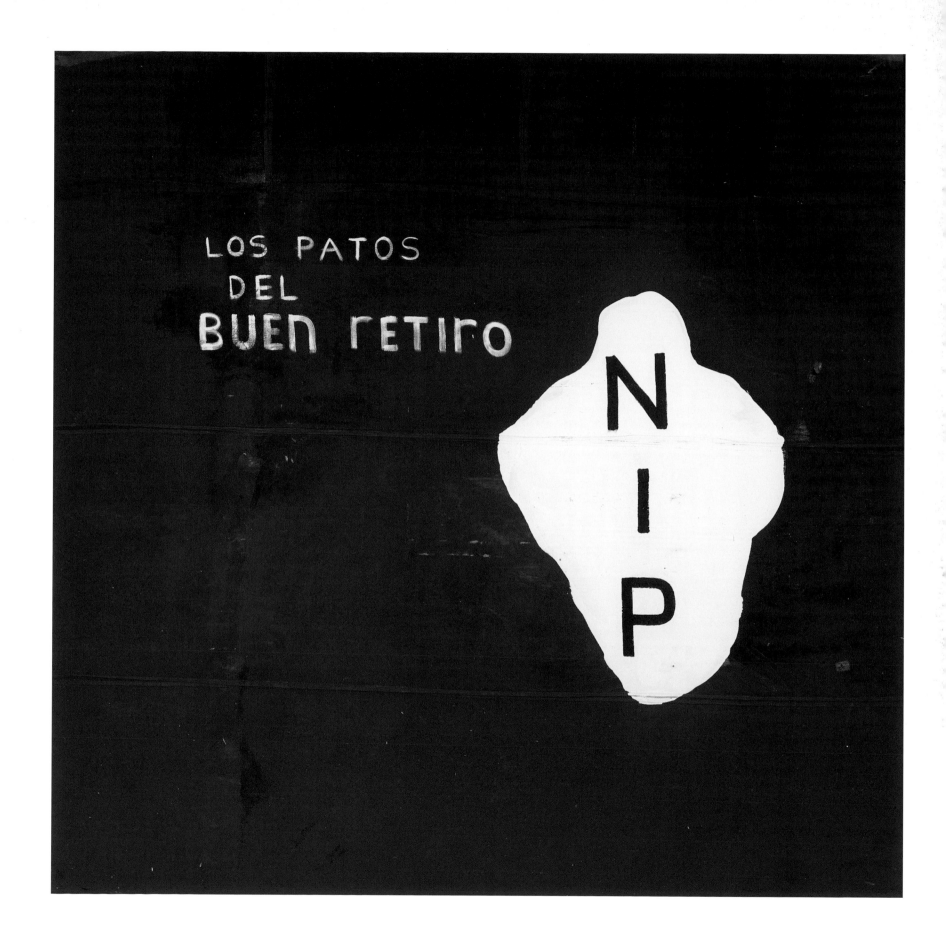

41 Untitled (Los patos del Buen Retiro), 1991

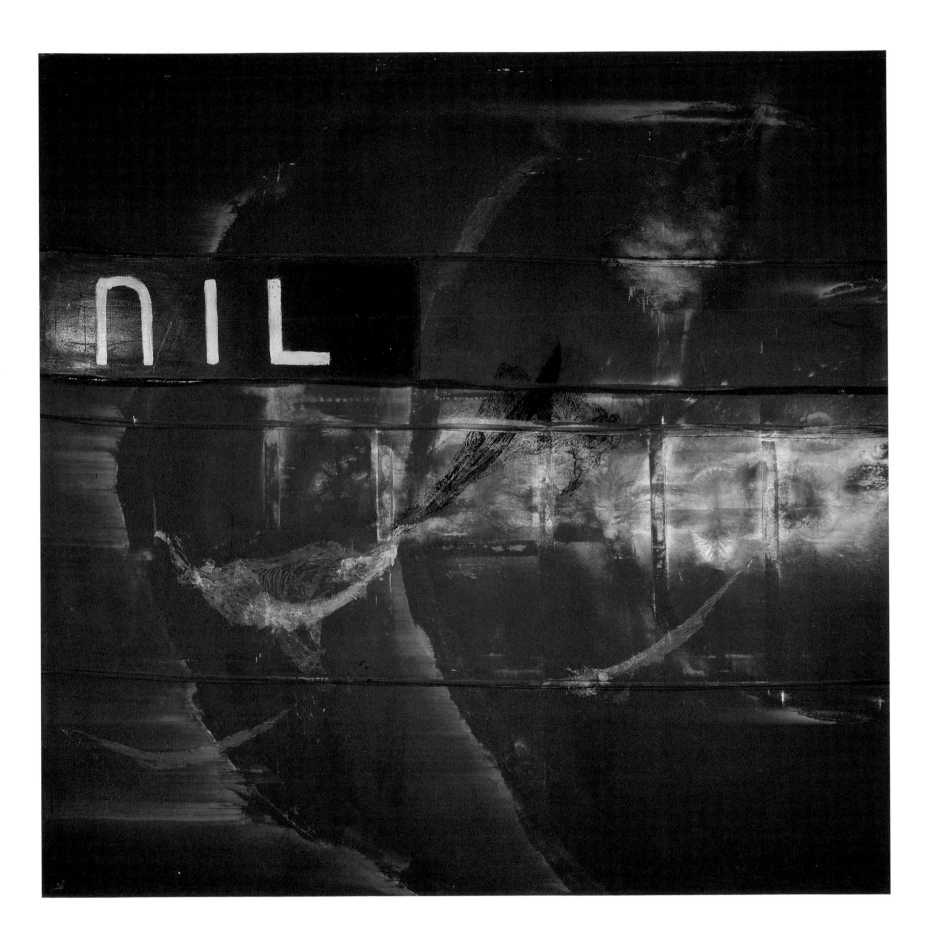

44 Untitled (Los patos del Buen Retiro), 1991

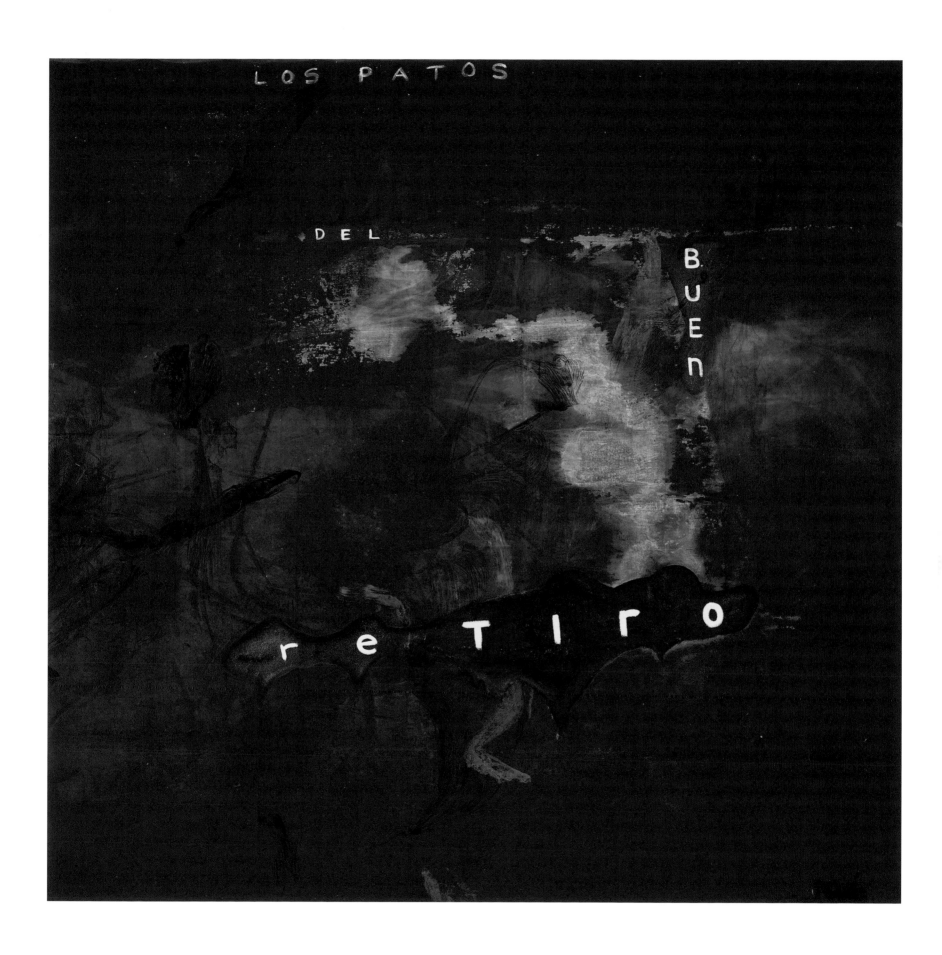

42 Untitled (Los patos del Buen Retiro), 1991

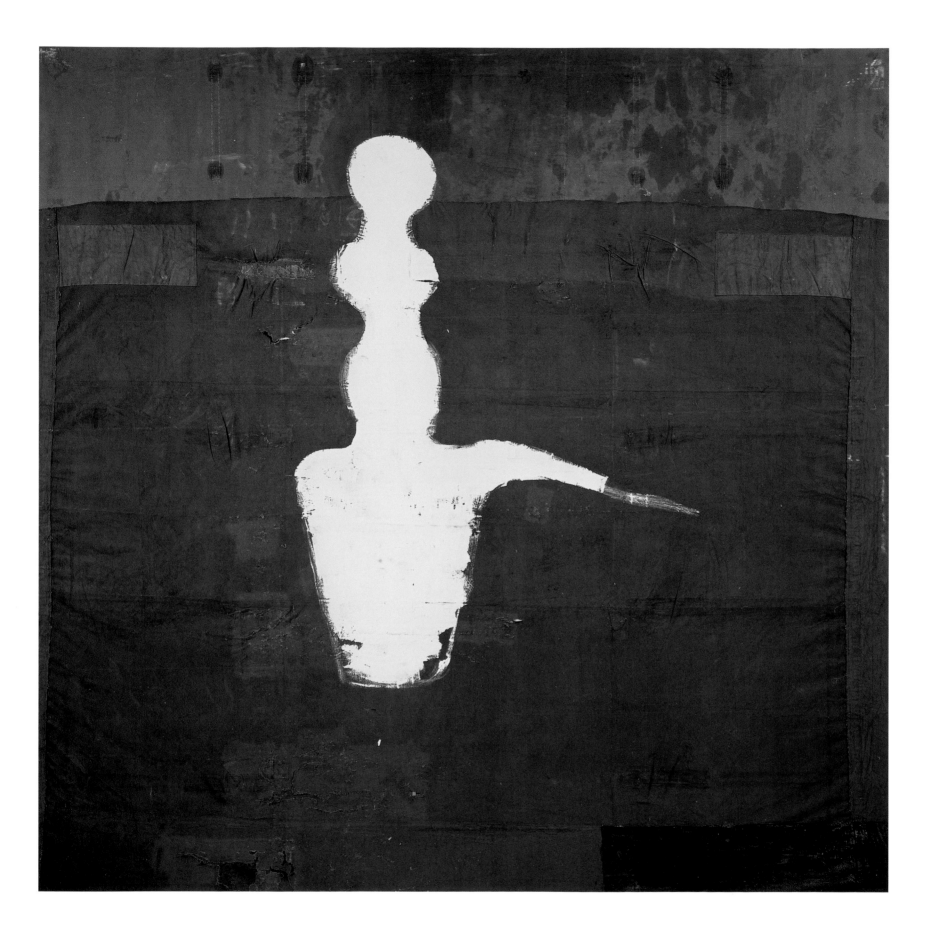

26 Untitled (Treatise on Melancholia), 1989

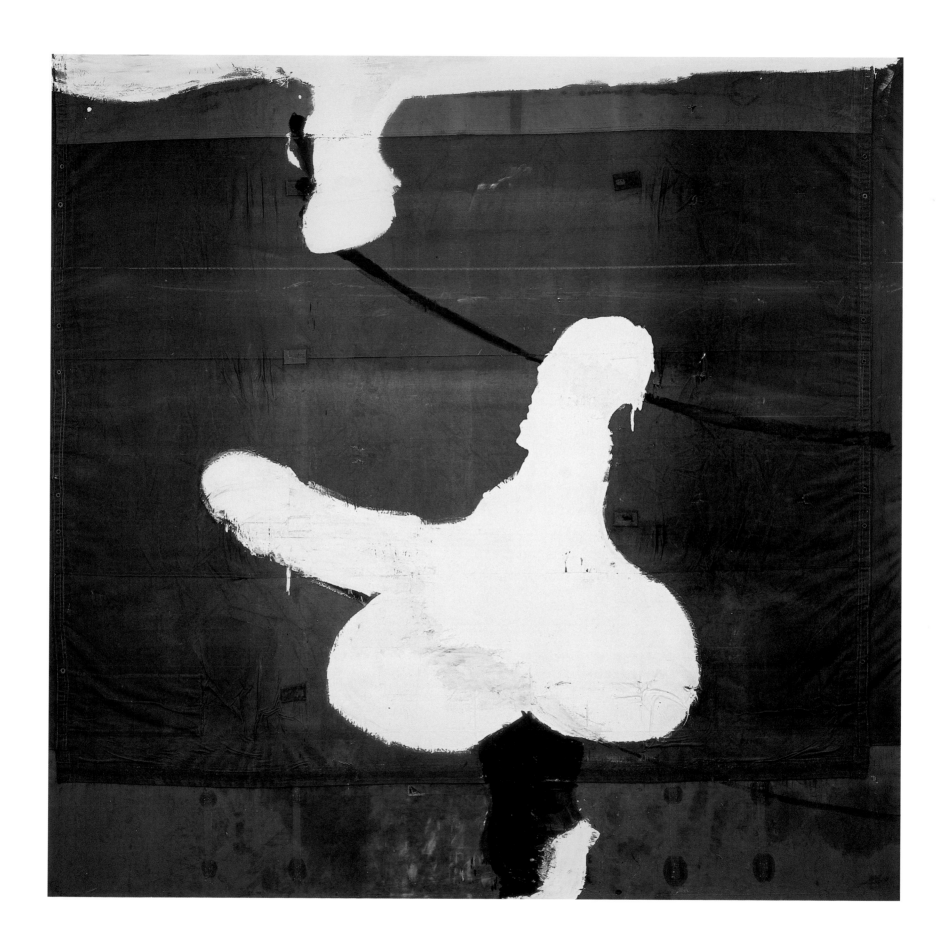

27 Untitled (Treatise on Melancholia), 1989

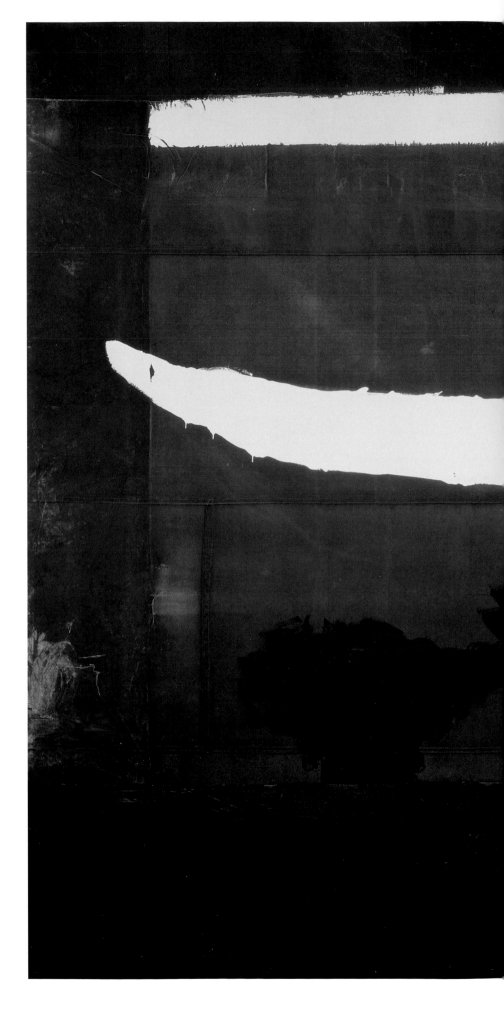

29 Untitled (Treatise on Melancholia), 1989

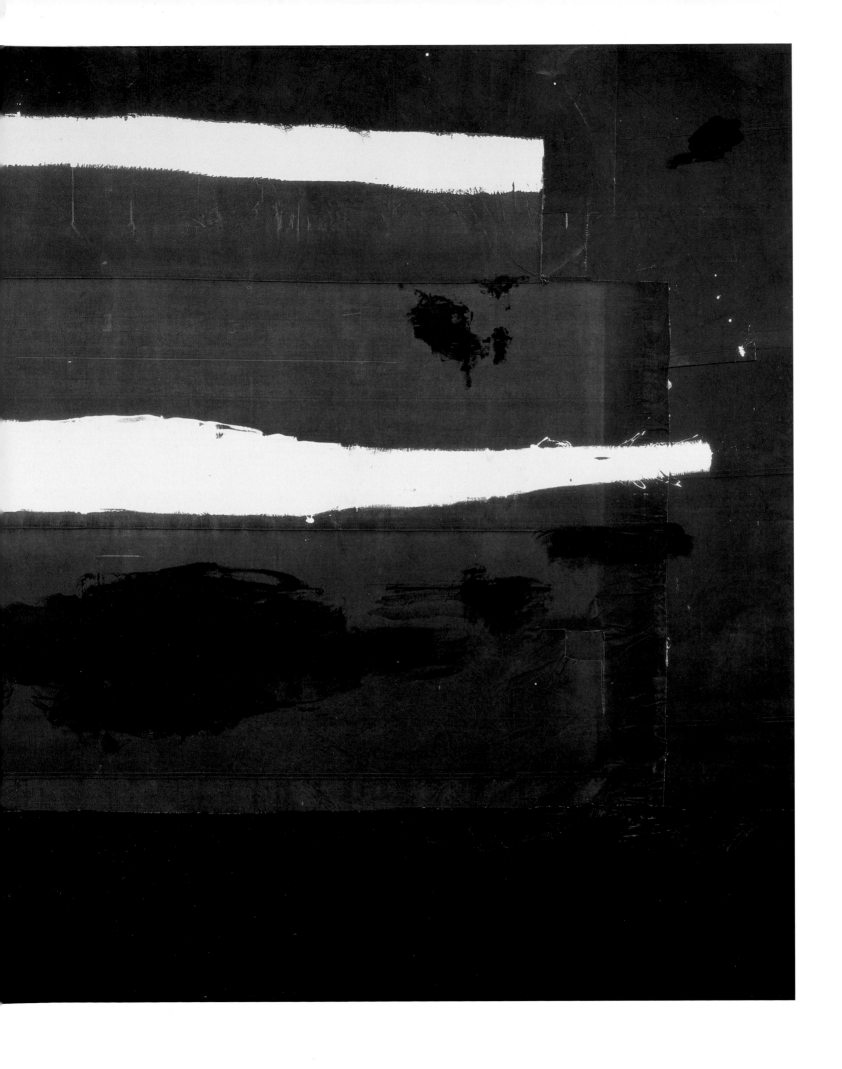

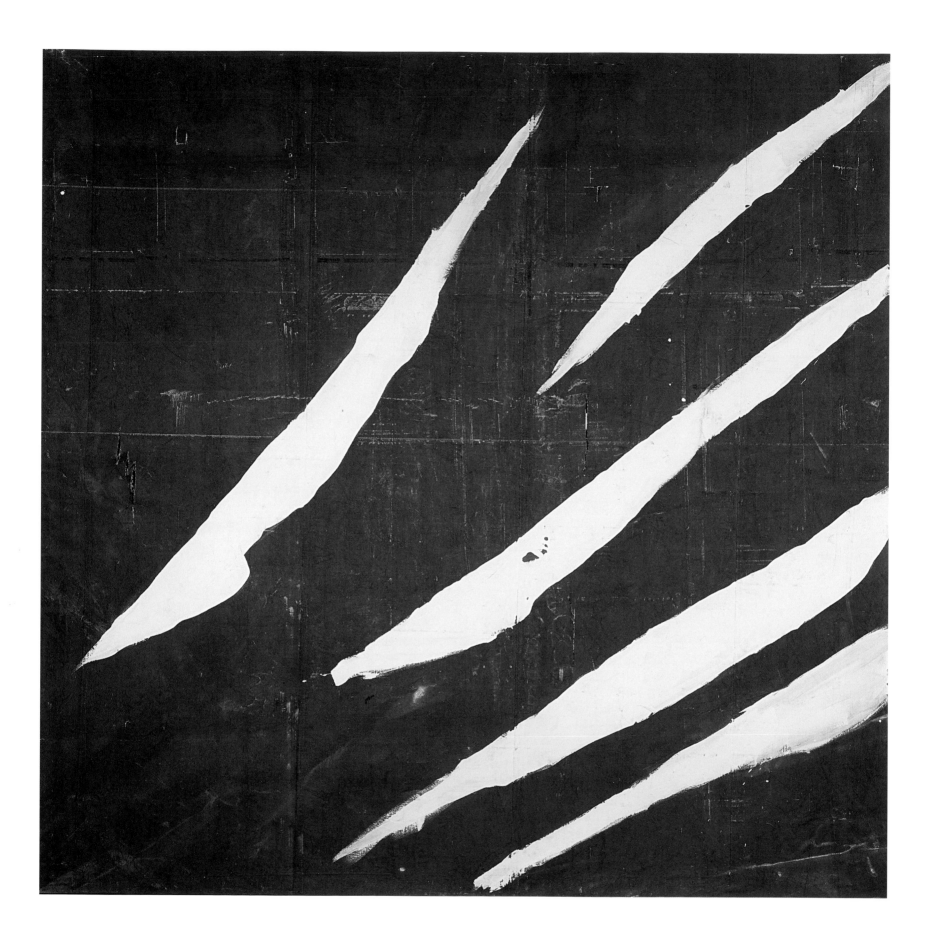

110 30 Untitled (Treatise on Melancholia), 1989

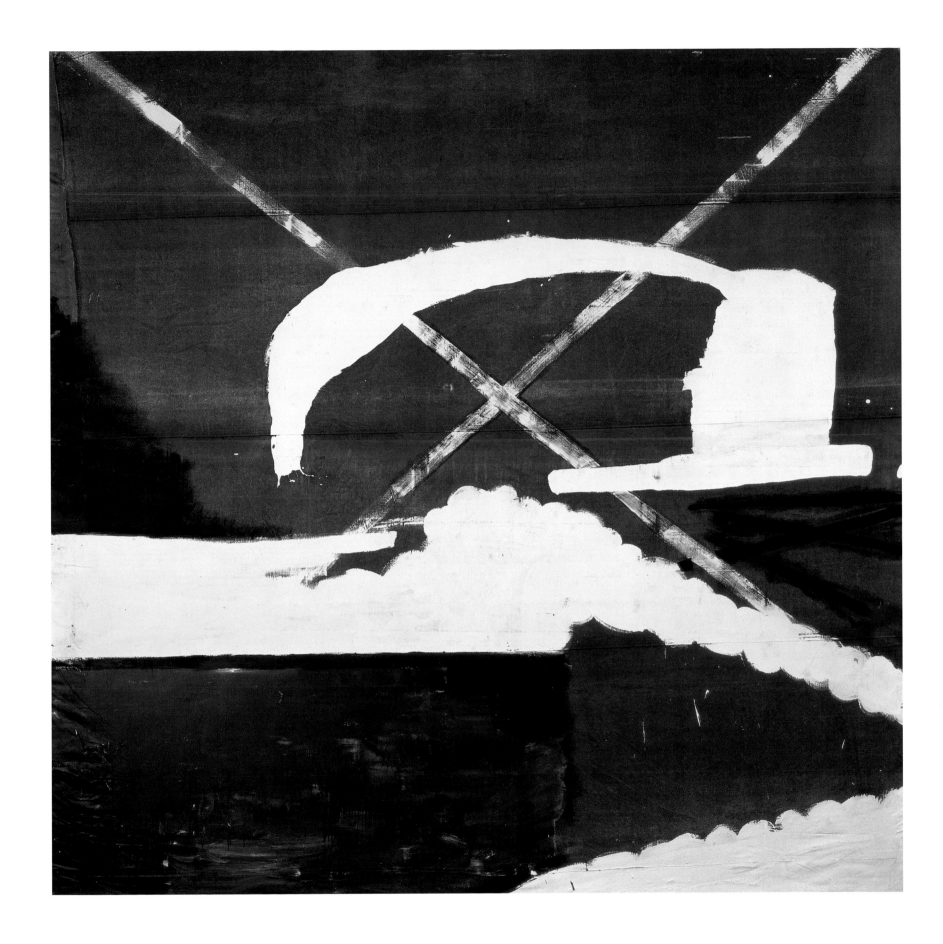

28 Untitled (Treatise on Melancholia), 1989

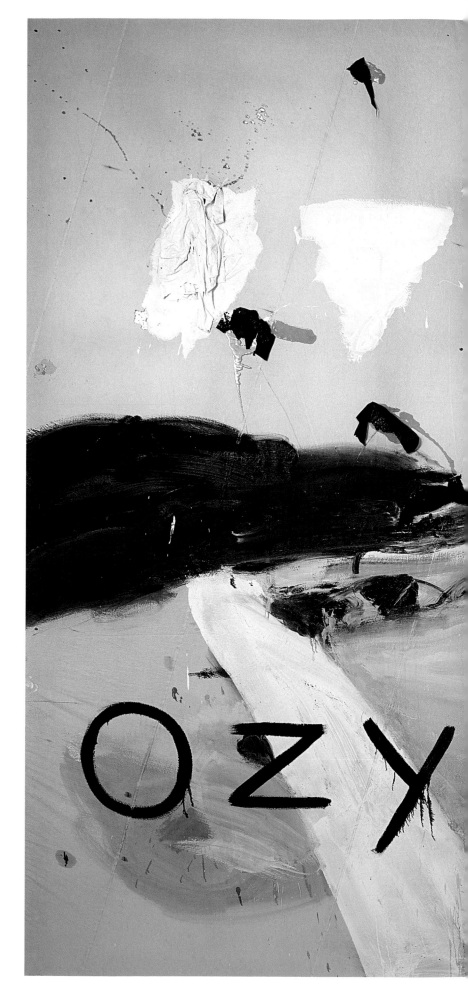

32 Ozymandias, 1990

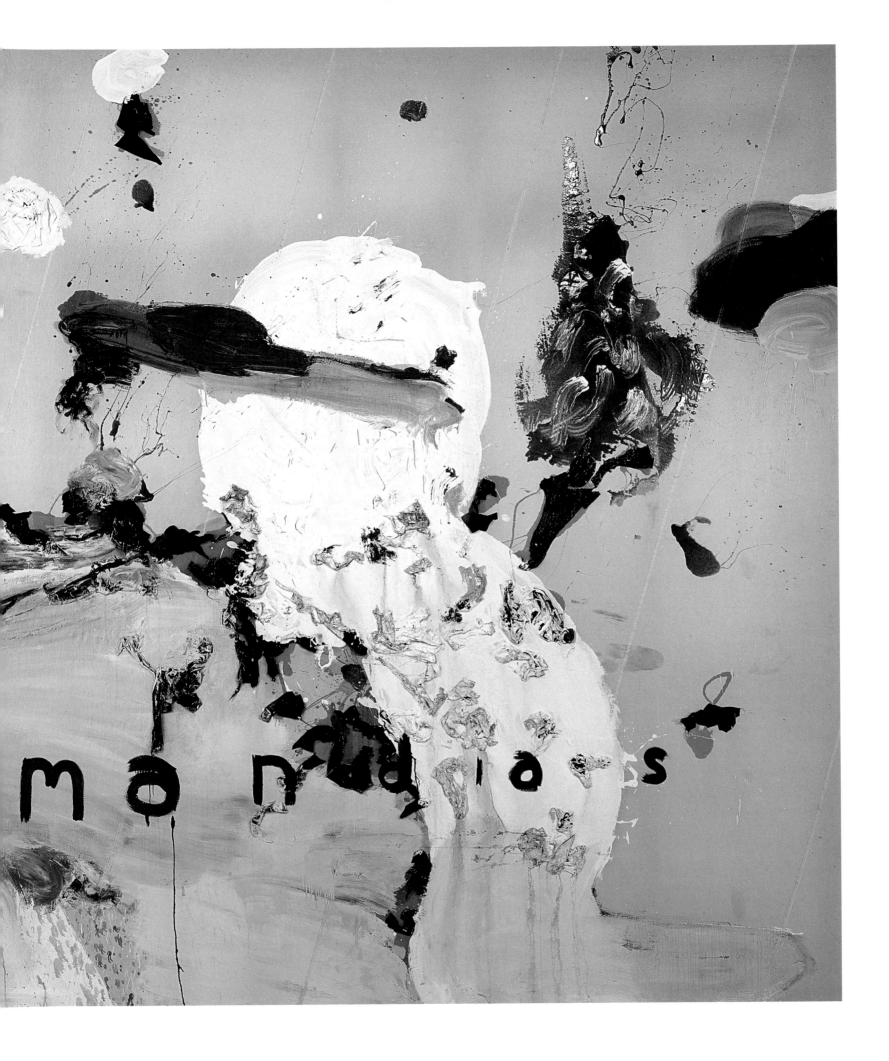

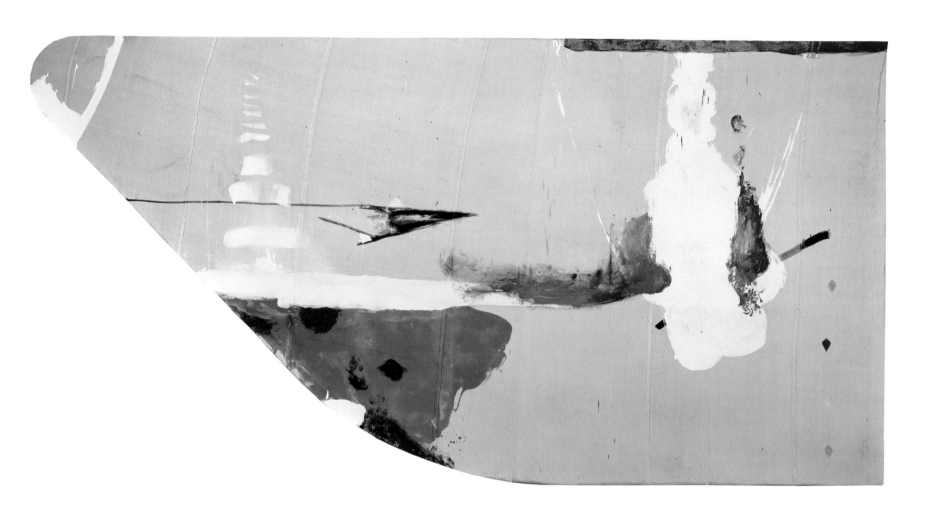

34 Jane Birkin #3 (Vito), 1990

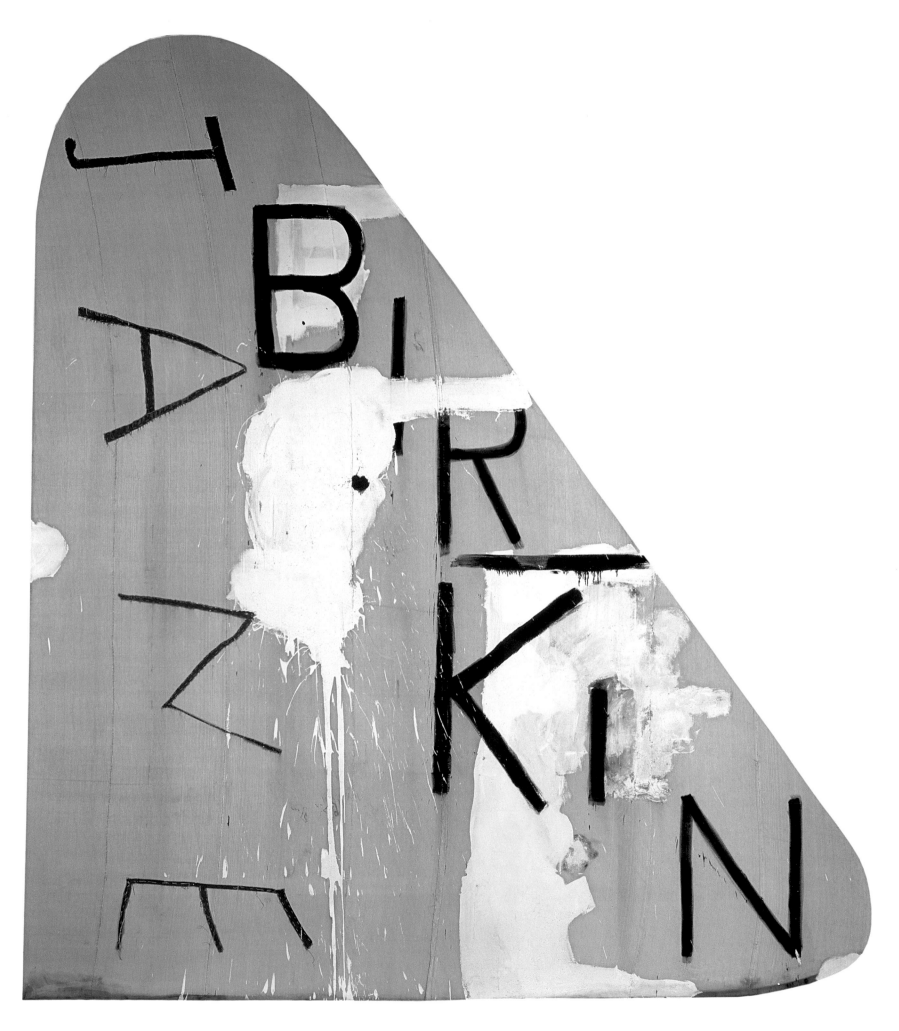

33 Jane Birkin, 1990

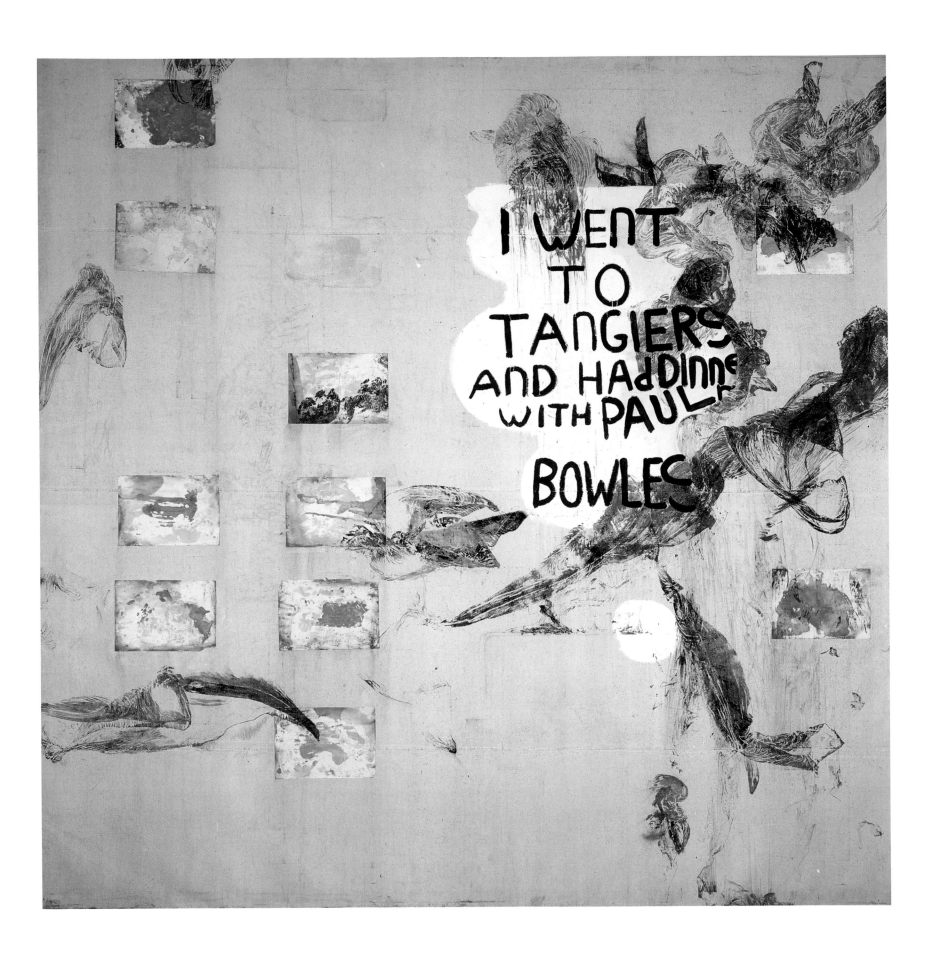

35 I Went to Tangiers and Had Dinner with Paul Bowles, 1990

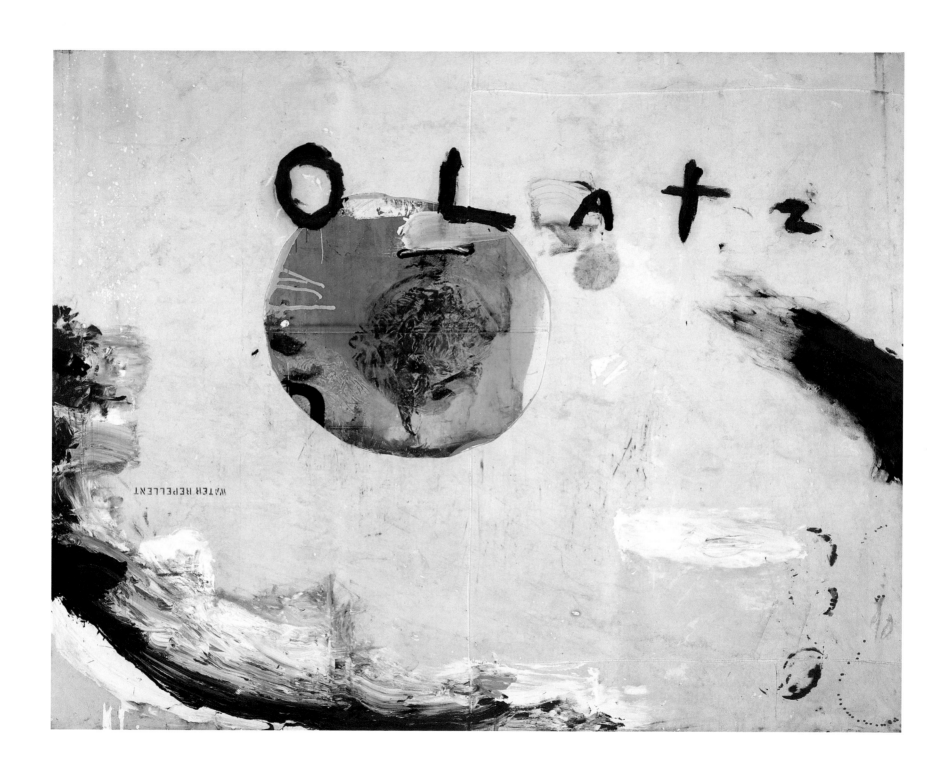

38 Olatz 1, 1991

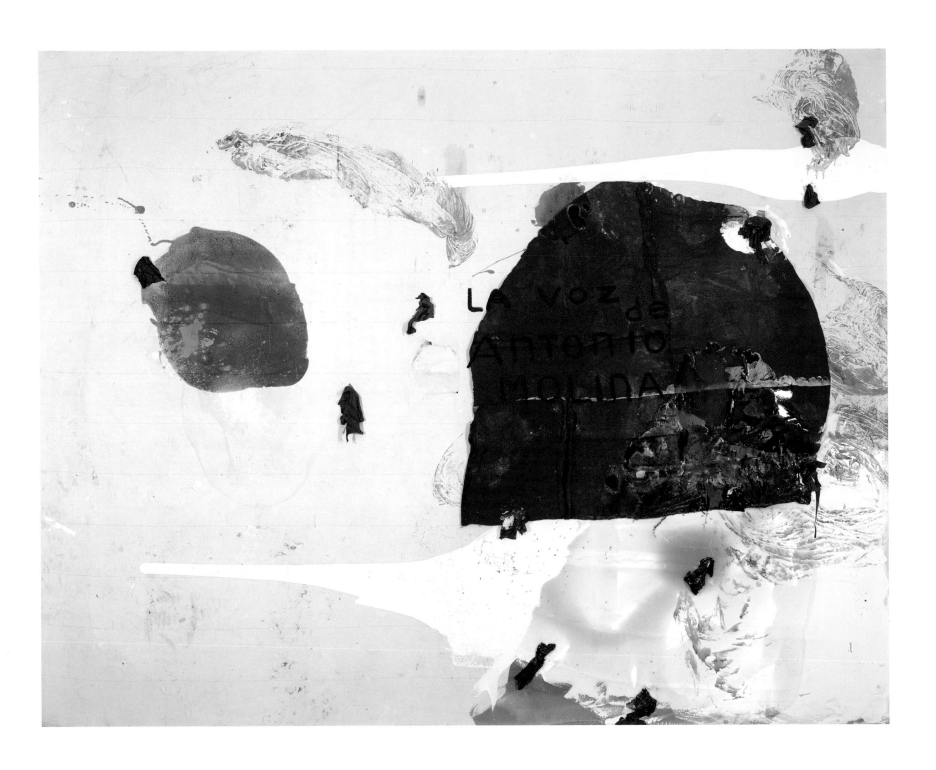

45 Untitled (La voz de Antonio Molina), 1991

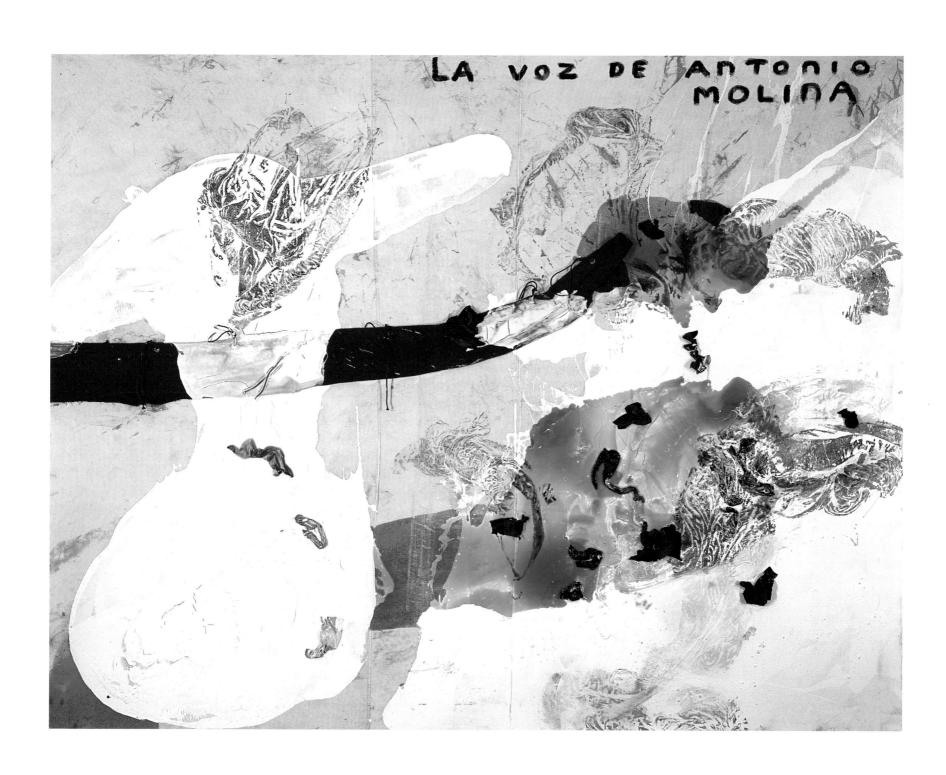

46 Untitled (La voz de Antonio Molina), 1991

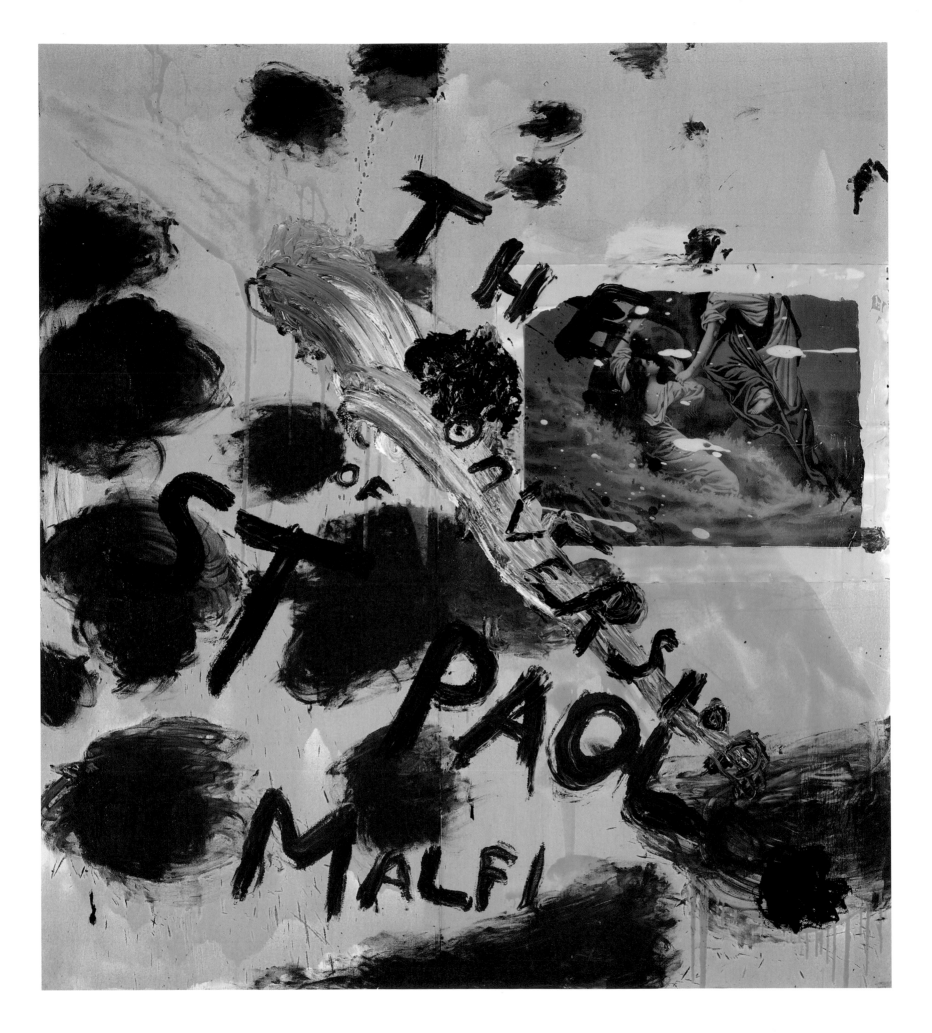

56 The Conversion of St. Paolo Malfi, 1995

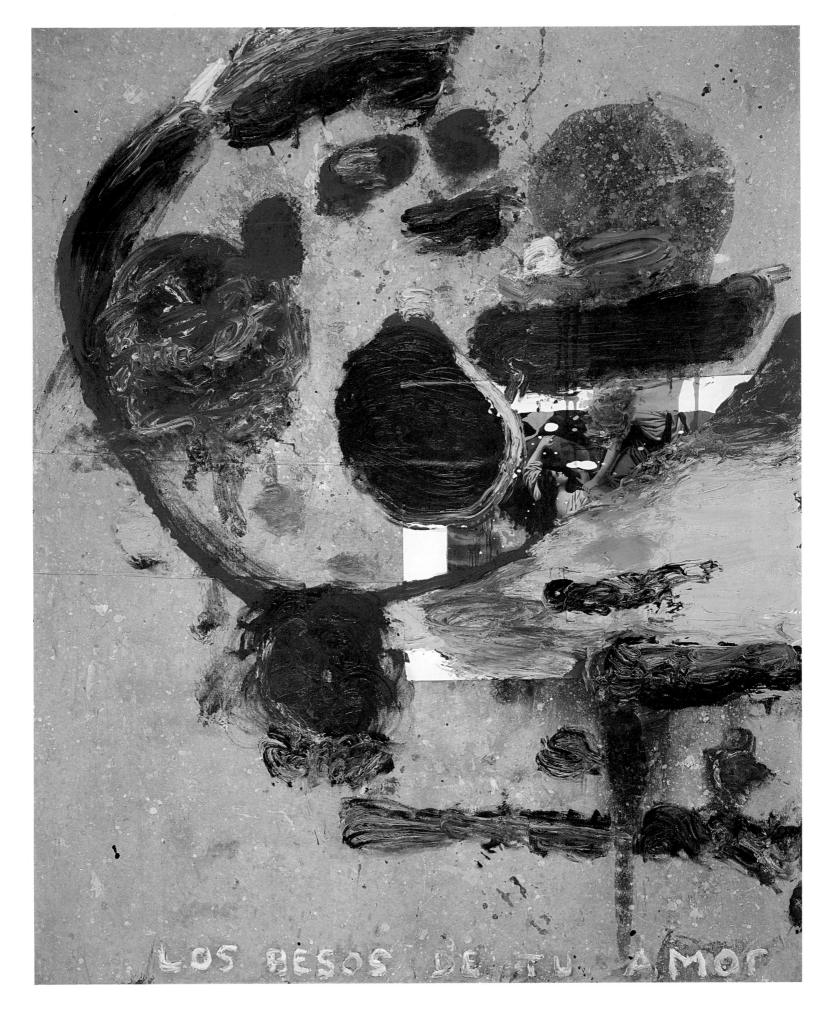

50 Untitled (Los besos de tu amor), 1992

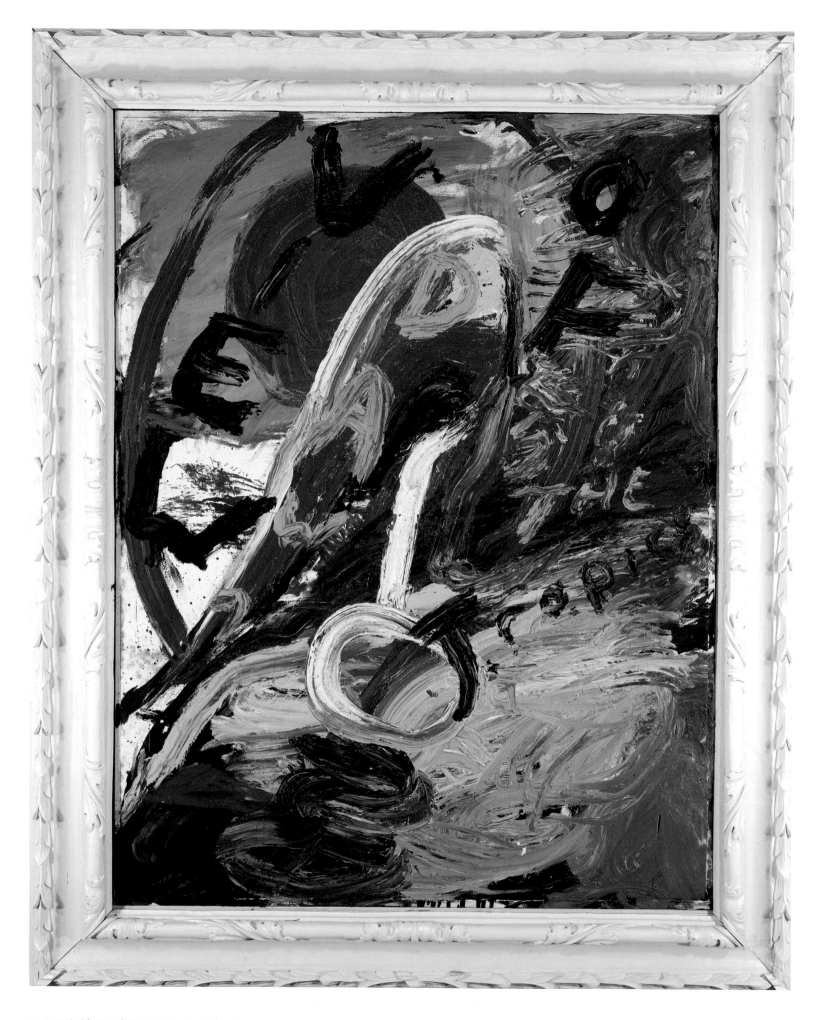

53 Untitled (View of Dawn in the Tropics), 1993

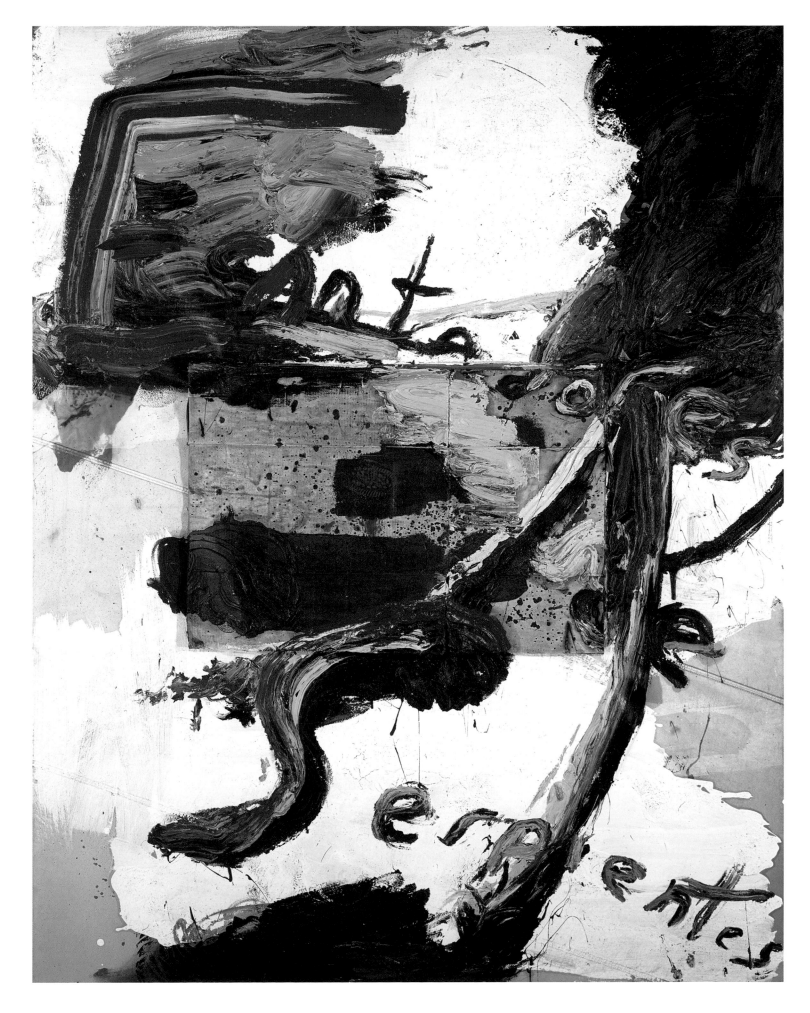

51 Encantadores de serpientes, 1993

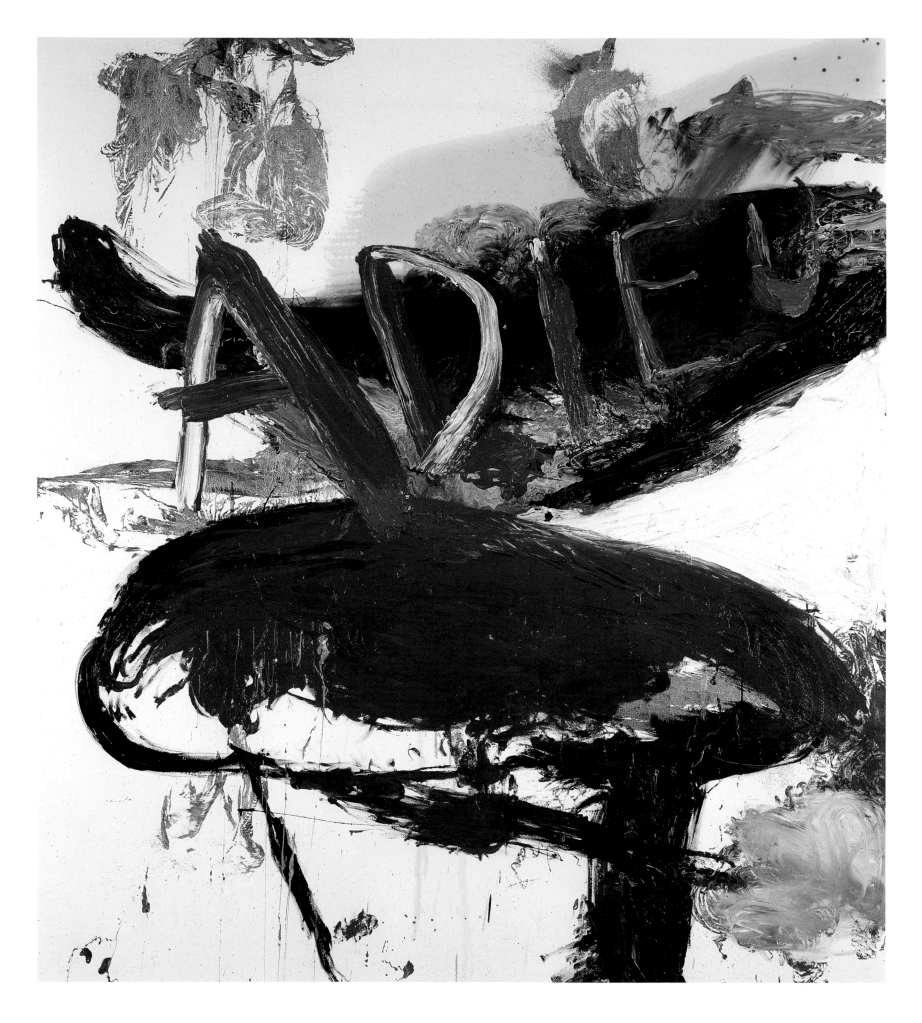

57 Adieu, 1995

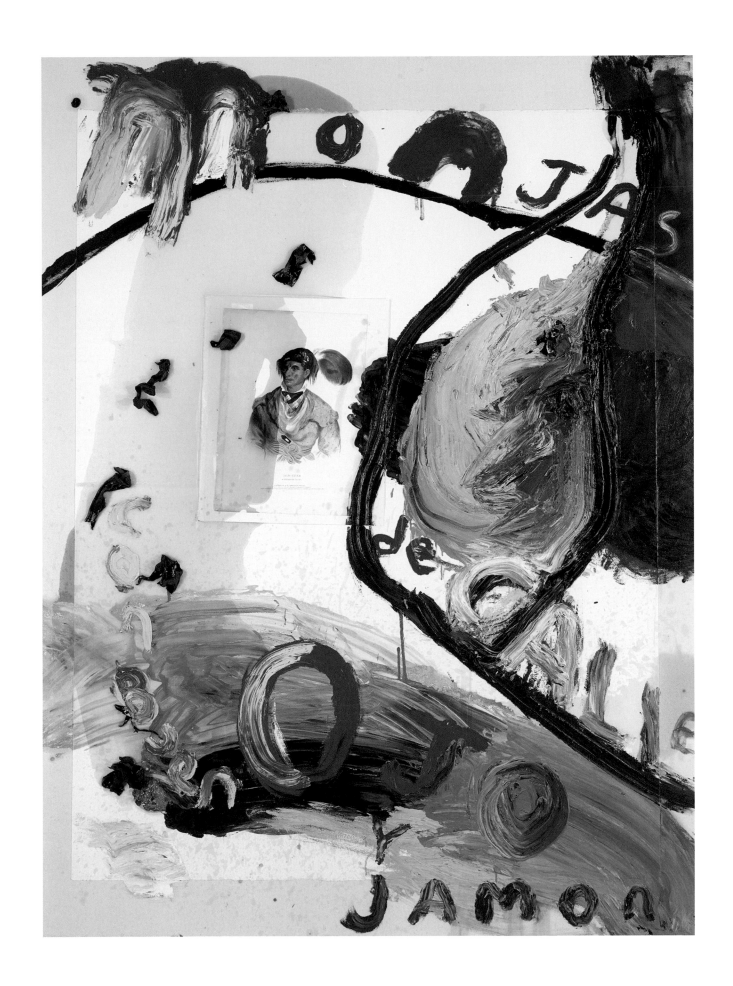

54 Untitled (Monjas de calle con buen ojo y jamon), 1993

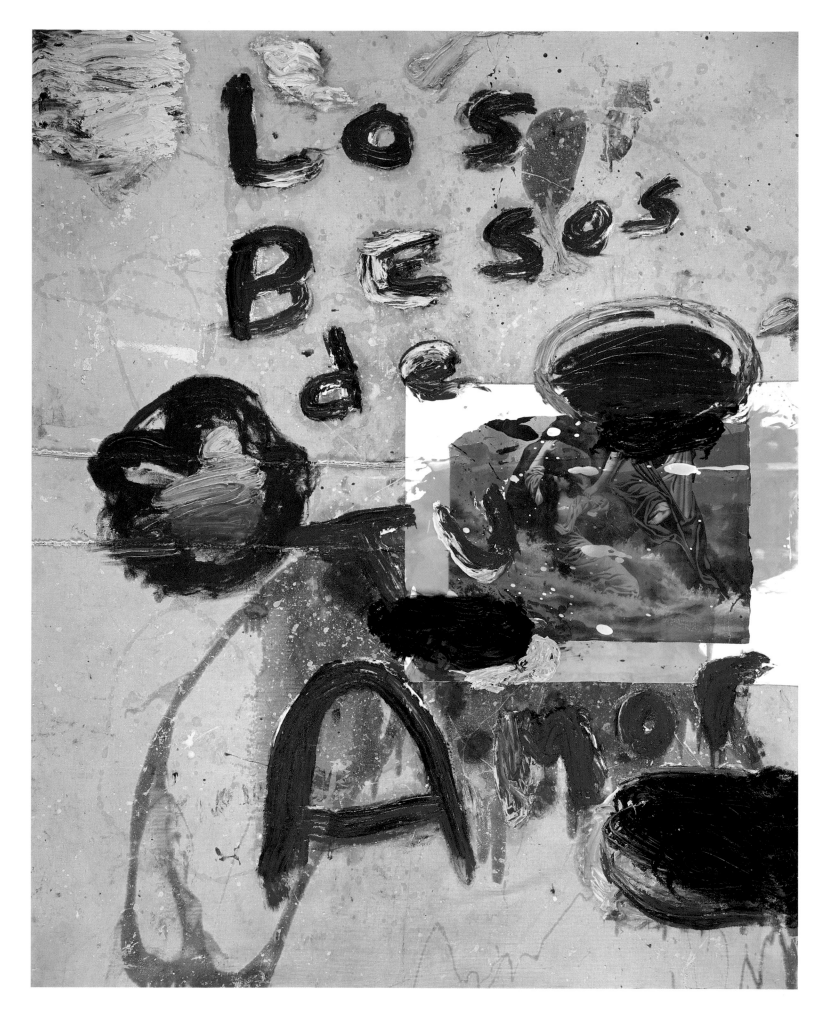

49 Untitled (Los besos de tu amor), 1992

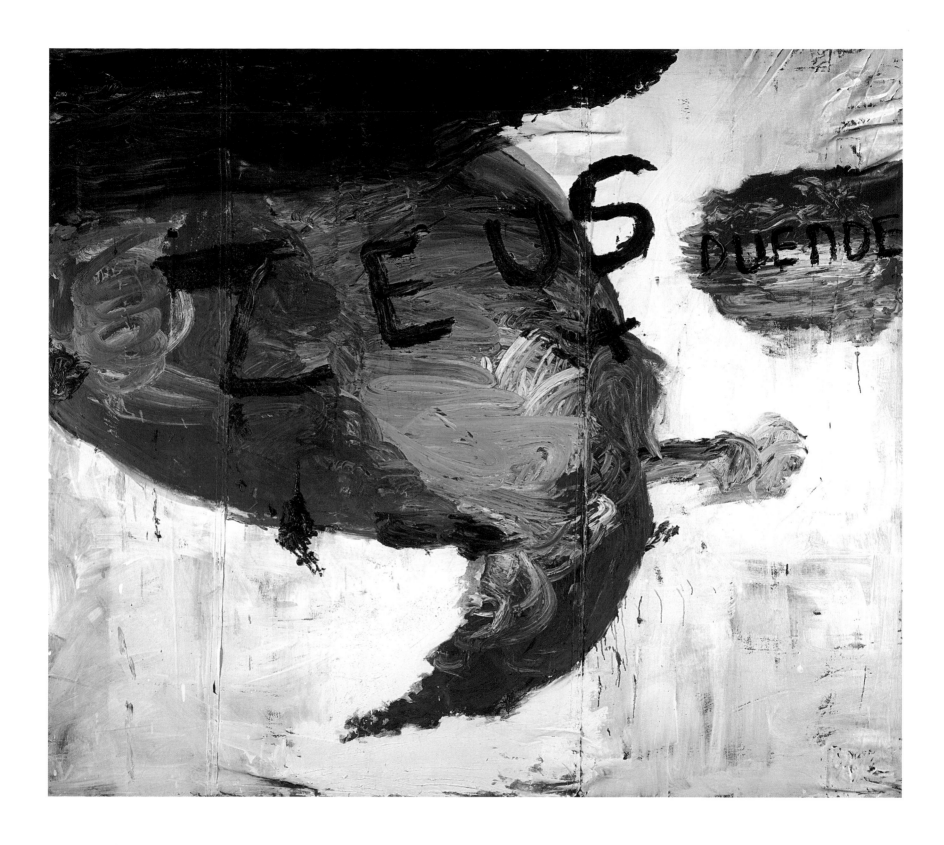

48 Untitled (Zeus and Duende), 1992

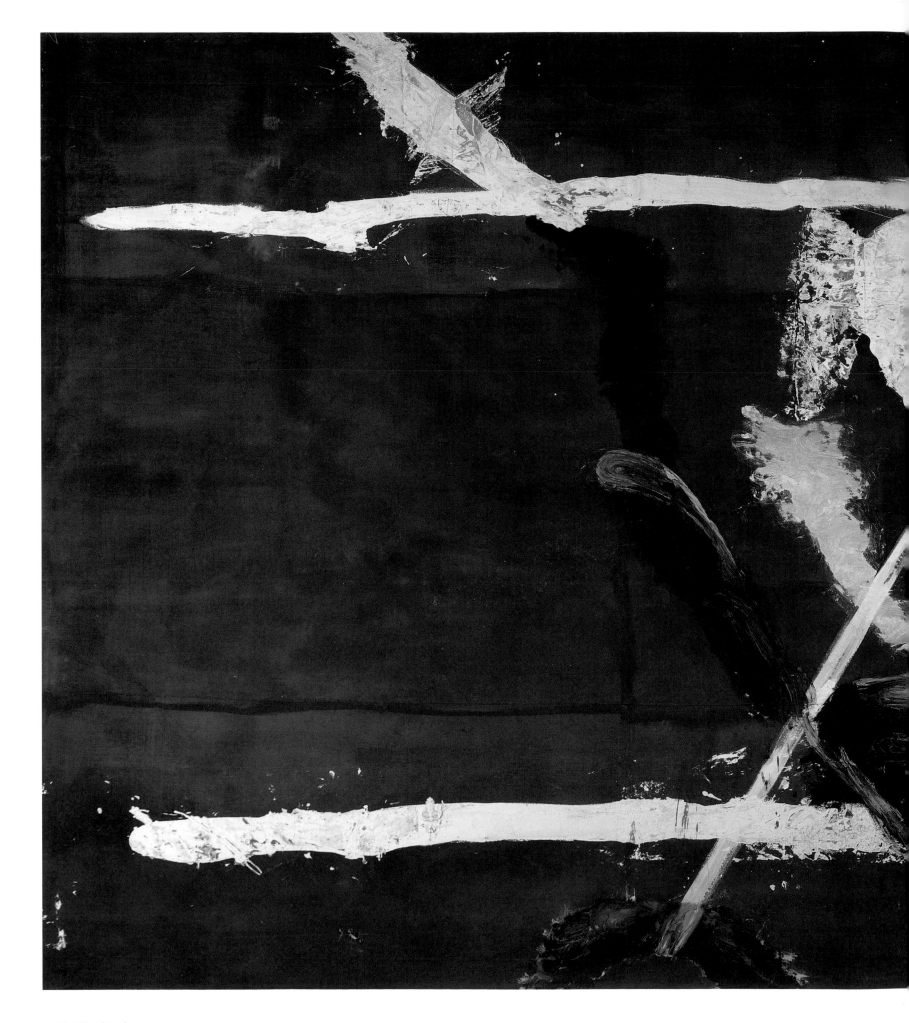

47 Untitled (Zeus), 1992

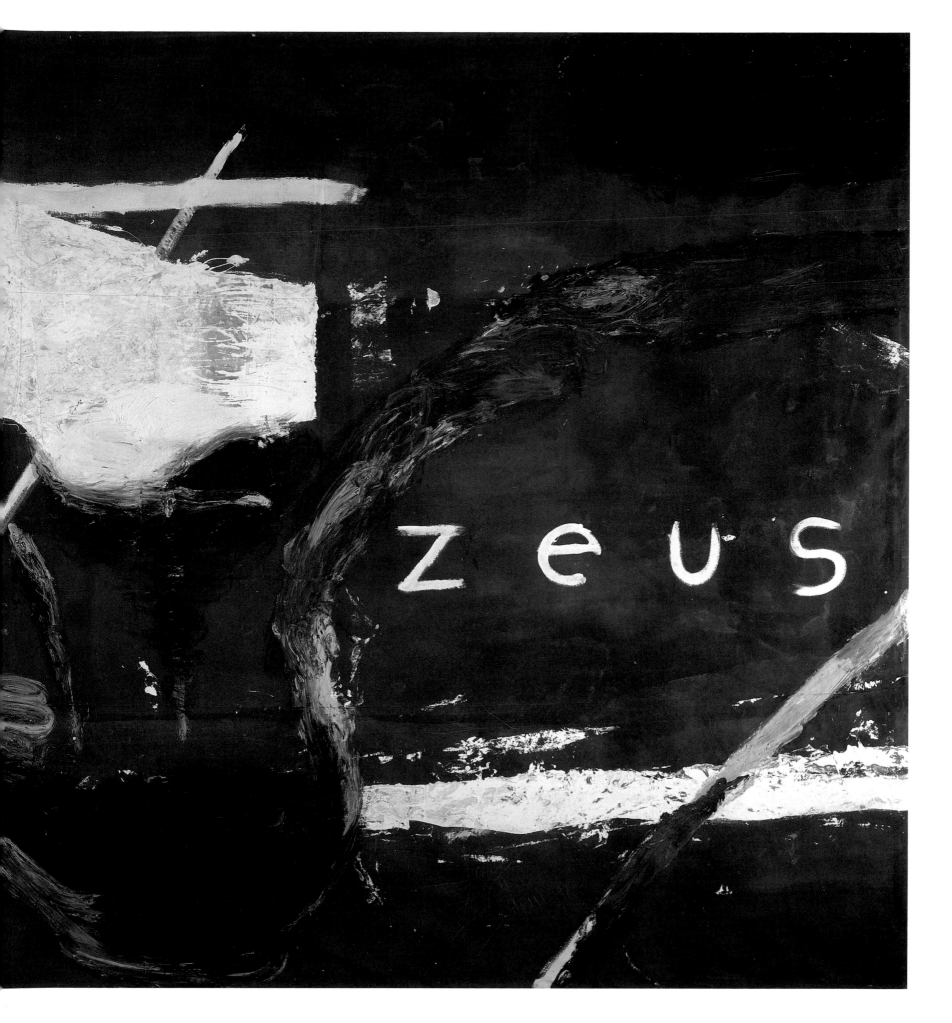

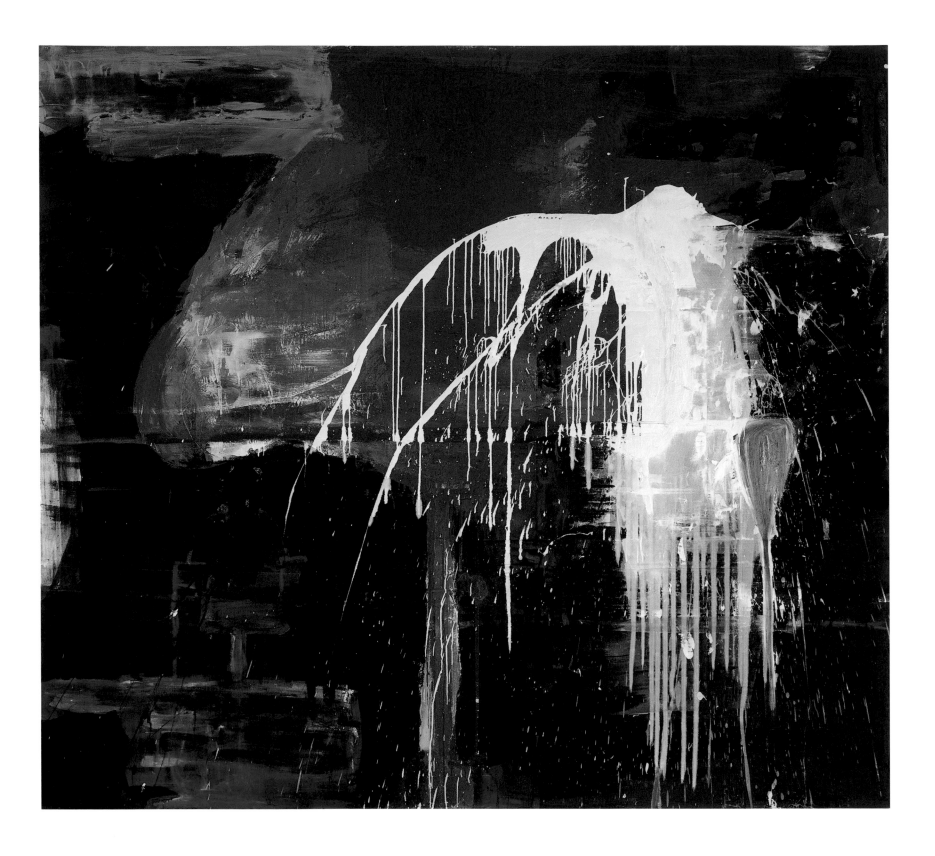

7 Maria Callas II, 1982

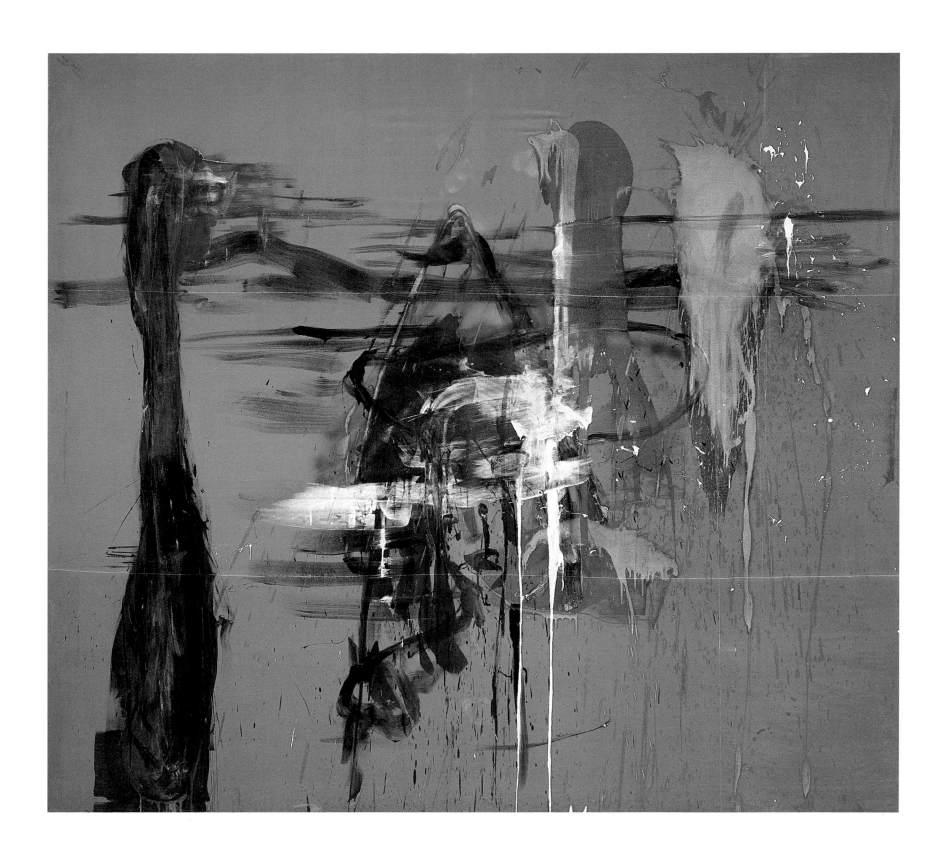

10 Maria Callas III, 1982

31 Adieu, 1989

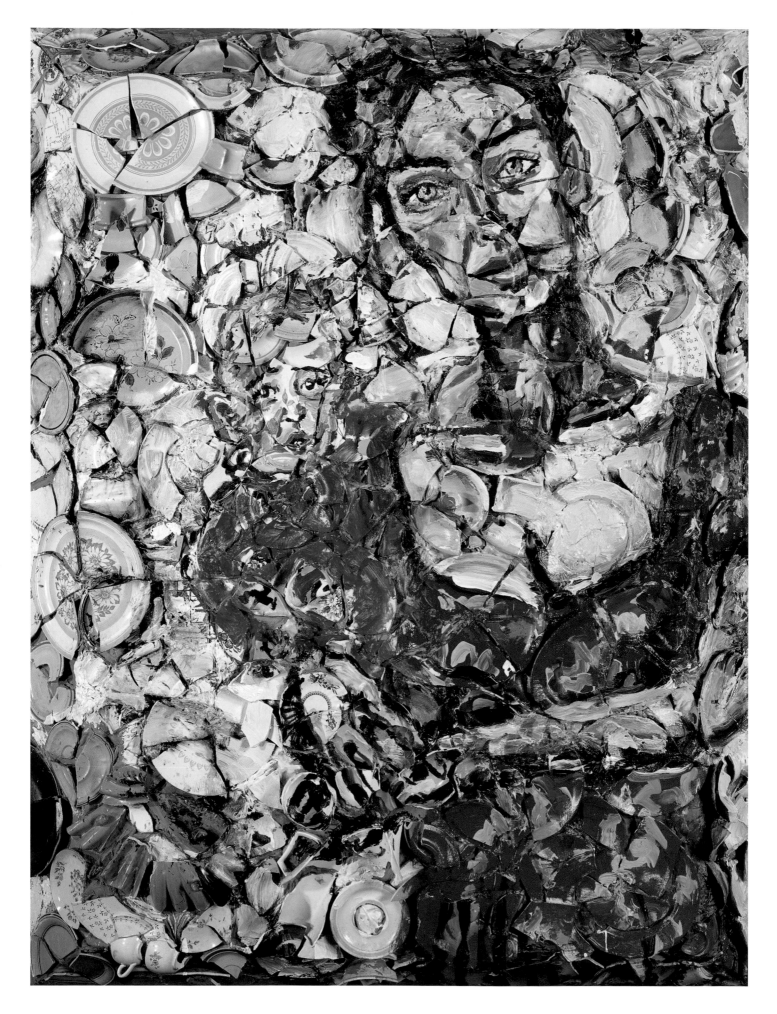

55 Portrait of Olatz with Cy, 1994

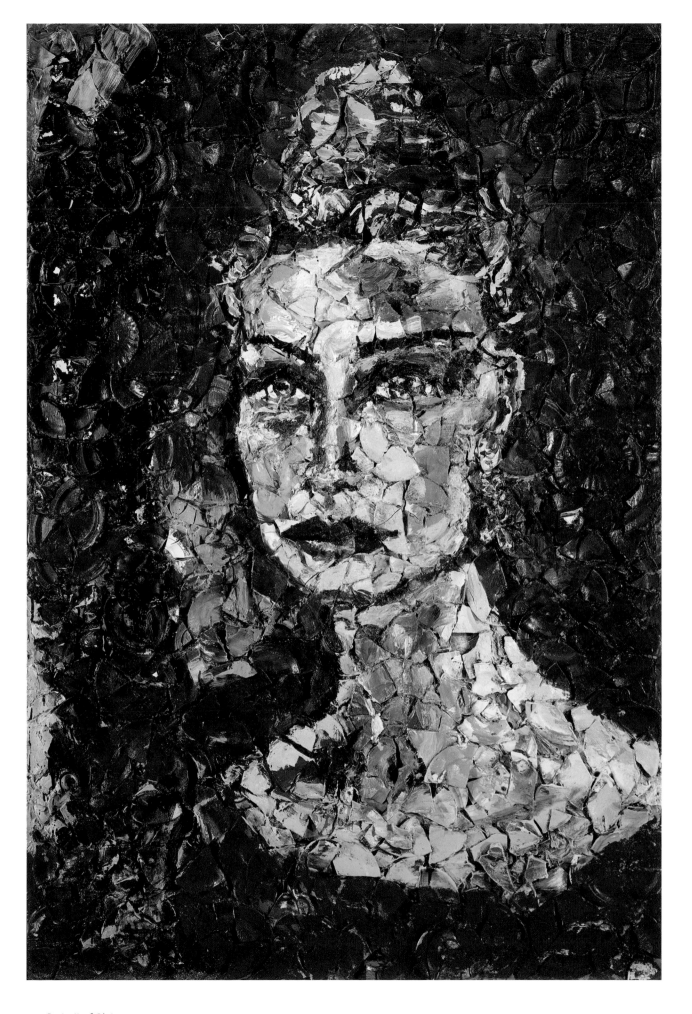

52 Portrait of Olatz, 1993

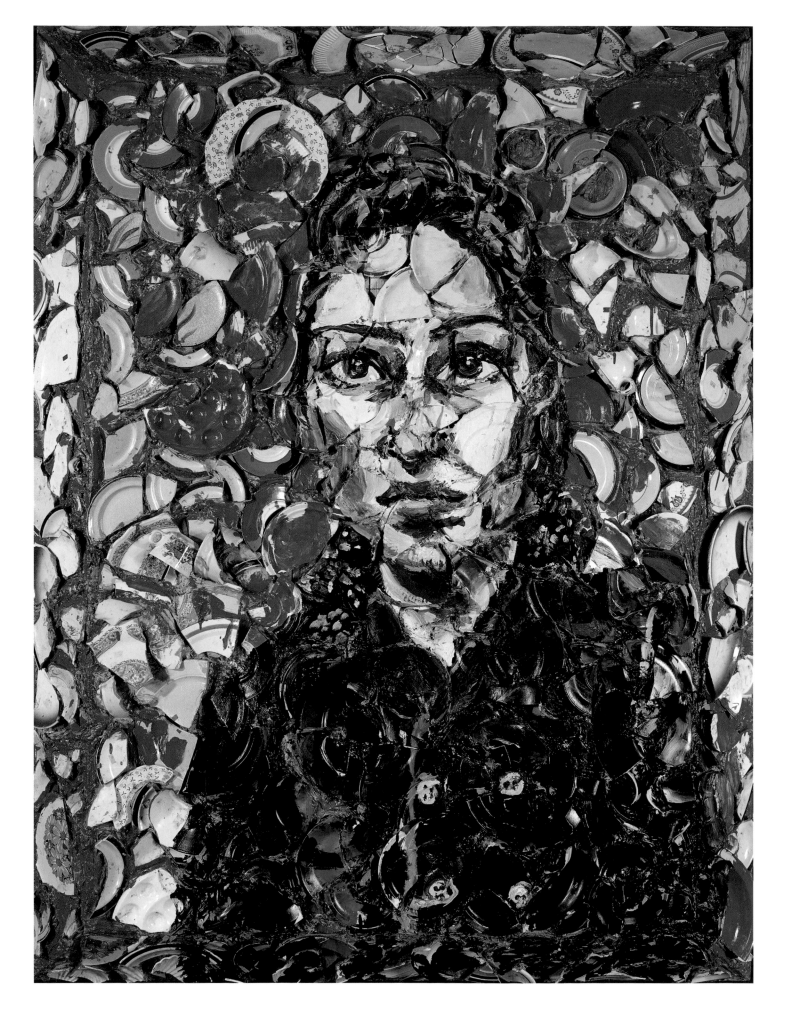

58 Portrait of Stella, 1996

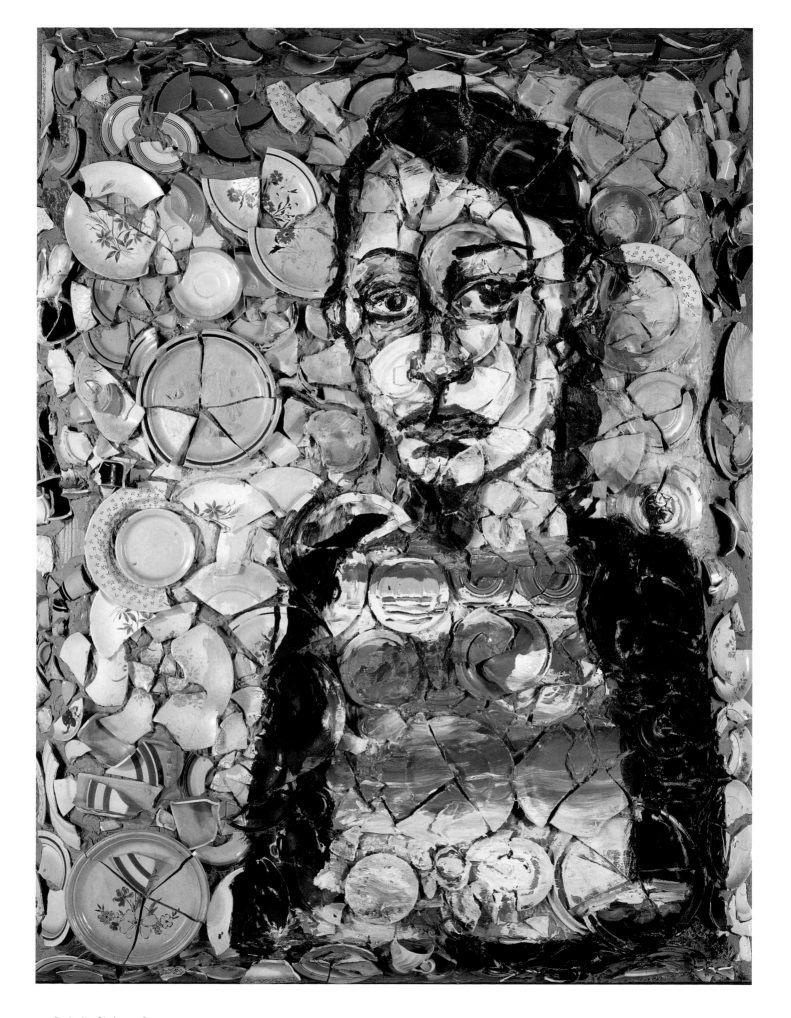

59 Portrait of Lola, 1996

Painting and Seduction

Malerei und Verführung

Julian Schnabel has always been thought of as a European artist in the U.S., most likely because of the way he turns his thoughts to the past and uses them as a source of creative inspiration. In the eyes of Europeans, however, Julian is most definitely North American, not only because of the huge size of the majority of his works but also because nostalgia is not a sentiment that seems to have a place either in Schnabel's work or in his life. For him, everything can be constantly addressed without time constraints or any hierarchy of present and past coming into play at all.

"No other artist is so challenging, no other artist tears his viewers back and forth with such impact and immerses them in ever new perspectives, no other artist commands such immediacy in confronting his viewers with the creative process."[1] Jean Christophe Ammann's words sum up to perfection my own first impressions on seeing Schnabel's works at the Venice "Aperto" in 1980. I would add that his paintings seduced me at the time, firstly because of the opposition between fiction and reality and between concept and perception and, secondly, because of the way the genuine form of the pictorial vocabulary used was called into question. That means you take a good look at the history of painting and go beyond it, to the possibilities of free expression not just for the artist but for painting itself.

Sometime in the late seventies, Julian Schnabel started to use pieces of broken plates stuck to his artistic medium as the background to his paintings. It has always been said that the idea of making a mosaic first came up during a visit Schnabel paid to Barcelona to see Gaudí's architecture. The artist has never denied that version of the source of his inspiration, but he has openly talked about his interest in getting rid of the two-dimensional nature of the canvas and in his interview with Carter Ratcliff he remarked: "When I started to work on the plate pictures, not only did I want to see how many different types of forms and permutations of the structure I could use as a medium but, on top of that, how many different types of images I could paint, how many different types of drawing I could include in those pictures."[2] And a little earlier, he said "What I'm really interested in is taking things that are already there, like fragments of the world, and reorganizing those fragments."[3]

In den Vereinigten Staaten hat man Julian Schnabel immer als einen europäischen Künstler gesehen, was an seiner Art liegen mag, sich mit der Vergangenheit auseinander zu setzen und sie zum Ausgangspunkt seines Schaffens zu machen. Auf Europäer dagegen wirkt Julian durch und durch nordamerikanisch, nicht allein wegen der riesigen Formate der meisten seiner Werke, sondern auch, weil Schnabel weder als Künstler noch als Mensch nostalgische Gefühle zu kennen scheint, da, ungeachtet zeitlicher Kategorien oder Hierarchien von Gegenwart und Vergangenheit, stets alles thematisiert werden kann.

»Von keinem Künstler wird man derart gefordert wie von ihm, von keinem derart hin- und hergerissen und in immer neue Perspektiven getaucht, von keinem wird man derart unmittelbar mit dem schöpferischen Prozess konfrontiert.«[1] Diese Worte von Jean-Christophe Ammann beschreiben sehr genau meine ersten Eindrücke von Schnabels Arbeiten auf dem *Aperto* der Biennale in Venedig 1980; und ich würde hinzufügen, dass mich seine Bilder damals verführt haben, und zwar in erster Linie wegen ihres Kontrasts zwischen Fiktion und Realität, zwischen Konzeption und Perzeption, aber auch wegen der Art, wie er sich mit der authentischen Form seines malerischen Vokabulars auseinander setzt, will sagen: einen minutiösen Blick auf die Geschichte der Malerei und über sie hinaus wirft, auf die Möglichkeiten des freien Ausdrucks nicht nur des Künstlers, sondern der Malerei als solcher.

Gegen Ende der siebziger Jahre begann Schnabel Tellerscherben auf Leinwände zu kleben und als Hintergrund für seine Bilder zu benutzen; es wurde immer behauptet, dass diese Idee einer Mosaikstruktur auf eine Begegnung mit der Architektur von Gaudí in Barcelona zurückginge, so als wären die Gemälde unmittelbar aus den auf dieser Reise gesammelten Erfahrungen und Erinnerungen hervorgegangen. Der Künstler hat diese Inspirationsquelle nie bestritten, allerdings betont, dass es ihm wichtig gewesen sei, die Zweidimensionalität der Leinwand aufzuheben; in einem Interview mit Carter Ratcliff erklärt er: »Als ich mit der Arbeit an den *Tellerbildern* anfing, wollte ich nicht nur wissen, wie viele verschiedene Arten struktualer Formen und Permutationen sich für den Untergrund verwenden ließen, sondern auch, wie viele verschiedene Arten Bilder ich malen, wie viele

Whatever the case, with these works, Schnabel manages to break through the dividing line between painting and sculpture; the *Plate Paintings* are part and parcel of an aesthetic idea that tries to bridge the gap between reality and the conventional illusionist trick played by painting as well as span the divide between art and real life.

The artist does not merely appropriate and use the materials. He goes further than that. He integrates all of the elements he collects into his paintings, confirming the fragment as the paradigm of the work and creates images that are crafted with a new degree of complexity, density, determination, and ambition. By manipulating their scale, color, material, and positioning, the images are freed from what they are there to represent.

In his paintings from the early eighties, Julian experiments with a highly diverse array of materials—pottery, antlers, metal objects—on equally varied media—canvas, animal skins, velvet, curtains, tarpaulins—which invest the picture with a truly original materiality. But what really interests me is that nothing gives the impression of being fixed or closed off. Instead, all of the elements seem to be in a permanent state of flux and one's perception of them is so arbitrary that all interpretations end up being equally valid.

Indeed, these paintings are a festive delight for the eyes and, ultimately, they do not place any great analytical demands on the viewer who is simply allowed to drink in and enjoy the eloquent, romantic, and embellished landscape of the imagination that Schnabel spreads out before us. At the same time, they reflect the multifarious sides of the nature of life and the simultaneity of experience.

In 1988, Julian Schnabel held an exhibition in Seville in the fourteenth-century monastery El Carmen which had been used as a military barracks between 1835 and 1978. In this exhibition, called "The Recognitions Paintings" as a tribute to William Gaddis, author of a famous publication with the same title, Schnabel put on show nineteen works created on tarpaulin. The former monastery was in a dreadful state of neglect with no doors, paneless windows, graffiti-covered walls, piles of rubble lying around, and rooms in imminent danger of collapse. Nevertheless, Julian hung his works there, took over the building and its history, and created a new

verschiedene Arten von Zeichnungen ich in diese Gemälde integrieren konnte.«[2] Und kurz vorher sagt er: »Mich reizt es, bestimmte, schon vorhandene Dinge zu nehmen, als Fragmente der Welt, und diese Fragmente neu anzuordnen.«[3]

Jedenfalls durchbricht Schnabel mit diesen Werken die Grenze zwischen Malerei und Skulptur; die *Tellerbilder* sind Teil einer Ästhetik, die als Brücke zwischen der Realität und dem konventionellen Illusionismus der Malerei sowie zwischen der Kunst und dem wirklichen Leben dienen will.

Der Künstler beschränkt sich nicht nur auf die Aneignung und Verwendung von Materialien, vielmehr integrieren seine Gemälde die zusammengetragenen Elemente. Damit erhebt er das Fragment zum Paradigma des Kunstwerks und erschafft Bilder, die einen neuen Grad von Komplexität, Dichte, Bestimmtheit und Anspruch verraten; Bilder, denen es gelingt, sich von dem zu lösen, was sie darstellen, weil der Künstler ihren Maßstab, ihre Farbe, ihr Material und ihre Anordnung manipuliert.

In seinen Gemälden aus den frühen Achtzigern experimentiert Julian Schnabel sowohl mit den unterschiedlichsten Materialien – Keramik, Hirschgeweihe, Metallgegenstände – als auch Untergründen – Leinwand, Tierhäute, Samt, Vorhänge, Wachstuch –, die dem Bild eine wahrhaft originelle Materialität verleihen; noch interessanter aber scheint mir, dass nichts statisch oder abgeschlossen wirkt. Vielmehr sind alle Elemente permanent im Fluss, und ihre Wahrnehmung erweist sich als so arbiträr, dass alle Interpretationen gleichermaßen gültig sind.

Diese Bilder sind tatsächlich ein visuelles Fest, für deren nachträgliche Analyse der Betrachter so lange keine großen analytischen Fähigkeiten benötigt, wie er in der Lage ist, die eloquente, romantische und überbordende Landschaft der Imagination zu genießen, die Schnabel vor uns entfaltet. Zugleich spiegeln seine Arbeiten das facettenreiche Wesen des Lebens und die Simultaneität der Erfahrung wider.

1988 fand in Sevilla eine Schnabel-Ausstellung in dem alten Kloster El Carmen aus dem 14. Jahrhundert statt, das zwischen 1835 und 1878 als Kaserne diente. In dieser »Recognitions« (»Dank«) überschriebenen Ausstellung – der Titel ist eine Hommage an William Gaddis, den Autor des berühmten gleichnamigen Romans[4] –, präsentierte Schnabel 19 Arbeiten

space in which the viewer was invited to project his or her own feelings and emotions.

The works—including *Ignatius of Loyola, Blessed Clara, Pope Pius IX* (p. 69), *La Macule, Spinoza, Cortés, Ritu Quadrupedis* (pp. 70–71), *Diaspora*—were an accumulation of impulses, sensations, and elements underpinned by a cultural memory and embodied in a repertoire of words, gestures, and subject matters. They are paintings that look at each other in their memory, as Matisse would say. They are signs, fragments of history, and bits of their own history which are jumbled up on the canvas without a thought for hierarchy. Nor is any distinction made on the basis of what they are or where they come from, and yet at the same time they represent a commitment to painting as a sensual, touch-sensitive experience in which your hands are needed as much as your eyes and brain.

On going round the spaces recreated by Schnabel's pictures and admiring the way in which he had integrated the works as if they had always been there, that sentence Miró wrote in a letter to S. P. Ràfols in 1918 came to mind: "When I work with a canvas, I fall in love with it, with a love that grows out of a slow understanding."

Between 1989 and 1991, Julian painted three of his most beautiful, sensual, and enigmatic series of paintings: *Treatise on Melancholia* (pp. 106–111), *Las pinturas de Nîmes,* and *Los patos del Buen Retiro* (pp.101–105). All of them are huge works in which the artist constantly plays with the idea of excess but where he is always in full command of the surface, color, texture, and composition. The art he makes lies beyond the constraints of painting, thus creating an emotional, meaningful relationship between viewer and object.

In the same interview with Ratcliff, Schnabel told us: "For me, the pictures are made to a given scale because it is part of their function, part of their content. It is what makes the viewer connect with them at a physical, emotional, and psychological level. If a given picture is large in size it is so that it can communicate the image of something. When you get into it, in a way it is as if you were getting into a screen."[4]

In these series, Schnabel uses language as an instrument of transition, the passage from one work to another, from one style to another, and it is a transition that allows him to

auf Wachstuch. Das alte Kloster befand sich in einem verwahrlosten Zustand, es gab keine Türen, in den Fenstern fehlten die Scheiben, die Wände waren mit Graffitis bedeckt, überall Schutt und einsturzgefährdete Räume; aber Schnabel hängte hier seine Bilder auf, machte sich das Gebäude, seine Geschichte zueigen, erschuf einen neuen Raum, auf den die Besucher ihre eigenen Empfindungen und Gefühle übertragen sollten.

Die Werke – *Ignatius of Loyola, Blessed Clara, Pope Pius IX.* (S. 69), *La Macule, Spinoza, Cortés, Ritu Quadrupedis* (S. 70/71), *Diáspora*..... – sind Verdichtungen von Impulsen, von Empfindungen, von Elementen, die getragen werden von einem kulturellen Gedächtnis und verkörpert von einem Inventar aus Worten, Gesten und Materialien. Es sind Bilder, die man in der Erinnerung betrachtet, wie Matisse sagen würde. Es sind Zeichen, Fragmente der Geschichte und seiner Geschichte, die unhierarchisch und ungeachtet ihres verschiedenartigen Materials und Ursprungs auf der Leinwand zusammenfinden, die gleichzeitig hindeuten auf eine Hingabe an die Malerei als eine sinnliche, taktile Erfahrung, die Hände, Augen und Verstand einschließt.

Während man durch die Räume lief, die Schnabels Bilder neu erschaffen hatten, und die Art bewunderte, wie er seine Werke komponiert, fühlte man sich an einen Satz von Miró aus einem Brief an S. P. Ràfols erinnert: »Wenn ich an einer Leinwand arbeite, verliebe ich mich in sie, und diese Liebe entspringt einem allmählichen Verstehen.«

Zwischen 1989 und 1991 vollendete Schnabel drei seiner schönsten, sinnlichsten und geheimnisvollsten Zyklen: *Treatise on Melancholia* (S. 106–111), *Las pinturas de Nîmes* und *Los patos del Buen Retiro* (S. 101–105) – monumentale Werke, in denen der Künstler unablässig mit der Maßlosigkeit spielt, aber stets die vollkommene Kontrolle über Oberfläche, Farbe, Textur und Komposition behält. Es entsteht eine Kunst, die über die Malerei hinausgeht und eine affektive und transzendente Beziehung zwischen Betrachter und Gegenstand erzeugt.

In dem oben zitierten Interview mit Ratcliff sagt Schnabel auch: »Die Bilder sind meines Erachtens in einer bestimmten Größe entstanden, weil das zu ihrer Funktion, ihrem Inhalt gehört. Hierdurch stellt der Besucher eine

move in different directions without contradicting himself. The paintings *Ozymandias* (pp. 112–113) and *La voz de Antonio Molina* (pp. 118–119) draw on the subjective unconscious of the artist for their inspiration; what characterizes them is their thousand and one possibilities ranging from the abstract to the figurative, from the dazzling idea to the sweet thickness of the subject matter and everything crosses over and flows in perfect harmony. The sheer physicality of his brush strokes and the brave intensity of his colors achieve a synthesis of stroke-work and background that turns it into something tangible. The works envelop the viewer with their vibrant splashes of color and their tactile and gesticulative lines, creating an image of visual plenitude and a surface of great baroque lushness.

Portraits (pp. 134–137) have always been part of Schnabel's artistic track record. Most of them are taken from life and put on a background of smashed plates. "I liked the idea of painting from life and not from a photograph, the fact that I painted from life was actually what made the picture into a picture and not simply a description of something I could see."[5]

By painting on top of plates—even though there is a marked likeness between his models and their representation in the picture—you have the feeling that Schnabel was trying to get rid of any legible subject and that through the painting process painting takes on a new meaning that is brimming with contradictory responses.

In 2001, Schnabel painted a series of portraits entitled *Girl with No Eyes* (pp. 153, 154). Some of them were absolutely huge, measuring almost four yards in height and width, and for the first time he did not use a live model. Instead, he used a small oil painting of a young girl with fair hair and wearing a blue outfit with a huge white trimmed collar that he found in a bric-a-brac shop in Houston in 1987. He painted four purple marks on it, one of which covered her eyes. Fourteen years later Schnabel used this portrait, purple marks and all, as a model for his large-scale paintings. He blotted out her eyes with extremely violent thick brushstrokes. The result of that change in the picture's scale means you no longer see her as a young girl or even as a portrait because you can't look her in the eye any more. In these works, I would venture to say that his energetic pictorial expression is subtly reduced so

physische, emotionale und psychische Verbindung zu ihnen her. Wenn ein Gemälde groß ist, dann deshalb, weil es ein Bild von etwas vermitteln soll. Wenn wir darin eintauchen, dann in gewissem Sinne so wie in eine Filmleinwand.«[5]

In diesen Zyklen benutzt Schnabel die Sprache als eine Brücke und ein Mittel des Übergangs von einem Werk zum anderen, von einem Stil zum anderen – eine Brücke, die es ihm erlaubt, sich in verschiedene Richtungen zu bewegen, ohne sich zu widersprechen.

Die Arbeiten *Ozymandias* (S. 112/113) und *La voz de Antonio Molina* (S. 1118/119) beziehen ihre Inspiration aus dem Unterbewusstsein des Künstlers; sie sind gekennzeichnet durch die breite Palette ihrer Möglichkeiten, von abstrakter bis figürlicher Darstellung, vom grellen Einfall bis zur zarten Pastosität des Materials, und alles durchdringt sich und fließt im Gleichklang. Die große Körperlichkeit seines Pinselstrichs und die Intensität seiner Farben erzeugen eine Synthese von Zeichnung und Hintergrund, die förmlich greifbar wird. Die Bilder umschlingen den Betrachter mit ihren vibrierenden Tupfern und ihren taktilen und gestischen Linien, aus denen ein Bild visueller Opulenz und eine Oberfläche von barocker Üppigkeit entsteht.

Porträts (S. 134–137) hat Schnabel während seiner ganzen Laufbahn immer wieder gemalt, die meisten von ihnen nach der Natur und auf Scherbenhintergrund. »Mir gefiel die Vorstellung, nach der Natur, nicht nach einer Fotografie zu malen; tatsächlich war es das Malen nach der Natur, wodurch ein Gemälde ein Gemälde wurde und nicht eine bloße Beschreibung von etwas, das ich sah.«[6]

Wenn er auf Tellern malt, können wir trotz der großen Ähnlichkeit seiner Modelle mit der Darstellung auf dem Gemälde den Eindruck gewinnen, als versuchte Schnabel, jedes lesbare Subjekt zu eliminieren, und als würde durch den Prozess des Malens dieses Malen zu einer neuen, in sich widersprüchlichen Bedeutung finden.

2001 vollendet Schnabel den Zyklus *Girl with No Eyes* (S. 153, 154). Einige der Gemälde sind mit circa vier mal vier Metern sehr großformatig, und zum ersten Mal ist seine Vorlage kein lebendes Modell, sondern ein kleines Ölgemälde, das ein Mädchen mit blondem Haar, blauem Kleid und einem großen, paspelierten Kragen darstellt; er hatte das Bild 1987

that he channels and concentrates his considerable creative intensity into an evocative poetic construction.

Schnabel slips into all of his pictorial works mythical, religious, and private images and symbols tied up with his own individual history but also with the history of art and culture which I generally see as a celebration, as a way of embracing a culture rather than a quest for any sense of identity. His works swing in extraordinary fashion between abstraction and representational art, between all-over and definition of space, between painted landscapes that are quite frenzied and others that are so serene, between concealment and visibility.

Schnabel represents a new subjectivity, bringing together the conceptual impetus with the pleasure of a manual task as he makes use of all the instruments of expression and all the possible languages.

in einem Trödelladen in Houston gefunden. Darauf malte er vier violette Flecken, von denen einer ihre Augen bedeckte. 14 Jahre später nahm Schnabel dieses Bild mit seinen violetten Flecken und allem als Vorlage für seine großformatigen Gemälden. Er strich die Augen des Mädchens mit einem überaus brutalen Pinselstrich aus. Die Veränderung der Größenverhältnisse bewirkt, dass wir es nicht mehr als Mädchen wahrnehmen, und auch nicht als Porträt, weil wir ihm nicht in die Augen schauen können. Ich würde behaupten, dass es in diesen Arbeiten insofern eine leichte Verringerung seines energischen malerischen Ausdrucks gibt, als er seine beträchtliche kreative Kraft auf eine evokative, poetische Konstruktion hin kanalisiert und konzentriert.

In seine Malerei lässt Schnabel stets mythische, religiöse und private Bilder und Zeichen einfließen, die mit seiner eigenen Geschichte, aber auch mit der Kunst- und Kulturgeschichte im Zusammenhang stehen und die ich zumeist als ein Fest empfinde, als eine Art, eine Kultur zu umarmen, und weniger als eine Suche nach irgendeiner Art von Identität. Seine Werke bestechen durch dieses außergewöhnliche Oszillieren zwischen Abstraktion und Figuration, zwischen Grenzenlosigkeit und Begrenztheit des Raums, zwischen phasenweise frenetischer Malerei und eher gelassenen Passagen, zwischen Undurchsichtigkeit und Sichtbarkeit.

Schnabel repräsentiert eine neue Subjektivität, in der der konzeptualistische Antrieb und die Lust an manueller Tätigkeit eine Verbindung eingehen und sich dabei alle erdenklichen Ausdrucksmittel und Sprachen zunutze machen.

1 Jean-Christophe Ammann, "For Julian Schnabel," in *Julian Schnabel—Reconocimientos,* exh. cat. Cuartel del Carmen Monastery, Seville (Seville, 1988), p. 14.

2 Carter Ratcliff, "Interview with Julian Schnabel," in *Julian Schnabel,* exh. cat. Fundació Joan Miró, Barcelona (Barcelona, 1995), p. 93.

3 Ibid., p. 93.

4 Ibid., p. 94.

5 Ibid., p. 92.

1 Jean-Chistophe Ammann, »Für Julian Schnabel«, in: *Julian Schnabel – Reconocimientos/Die »Recognitions«-Bilder,* Ausst.-Kat./exh. cat. Kunsthalle Basel, 1989, S. 14.

2 Carter Ratcliff, »Intverview with Julian Schnabel«, in: *Julian Schnabel,* Ausst.-Kat. Fundació Joan Miró, Barcelona, 1995, S. 93.

3 Ebd.

4 William Gaddis, *The Recognitions* (1955), dt. *Die Fälschung der Welt* (1998).

5 Ratcliff 1995 (s. Anm. 2), S. 94.

6 Ebd., S. 92.

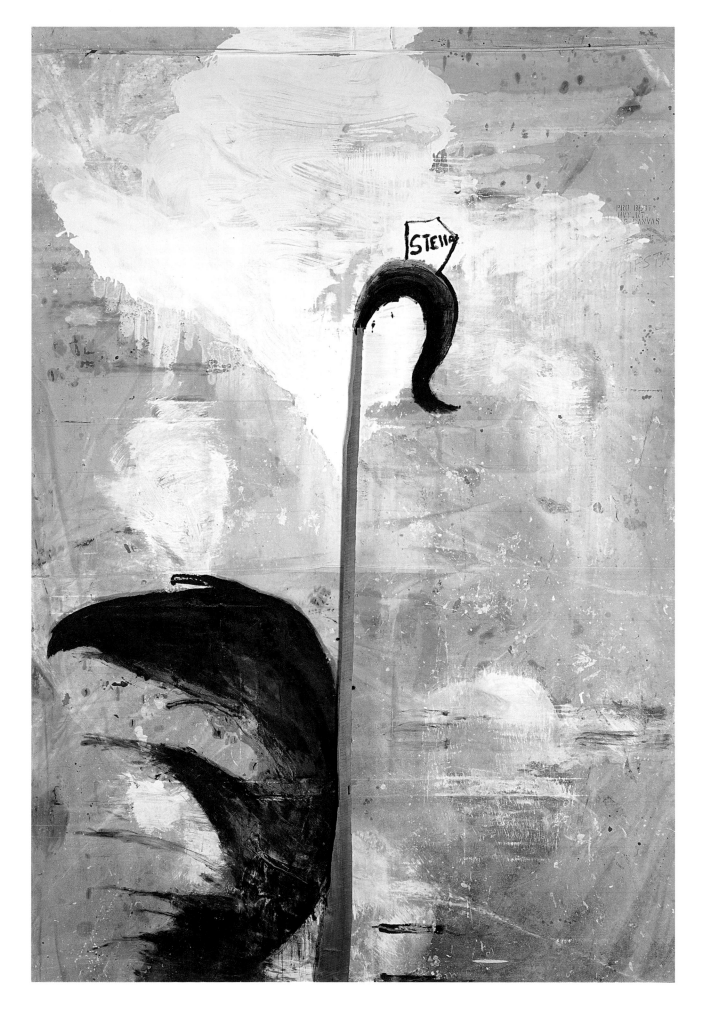

63 And the Ugly Duckling Turned into a Beautiful Swan, 2002

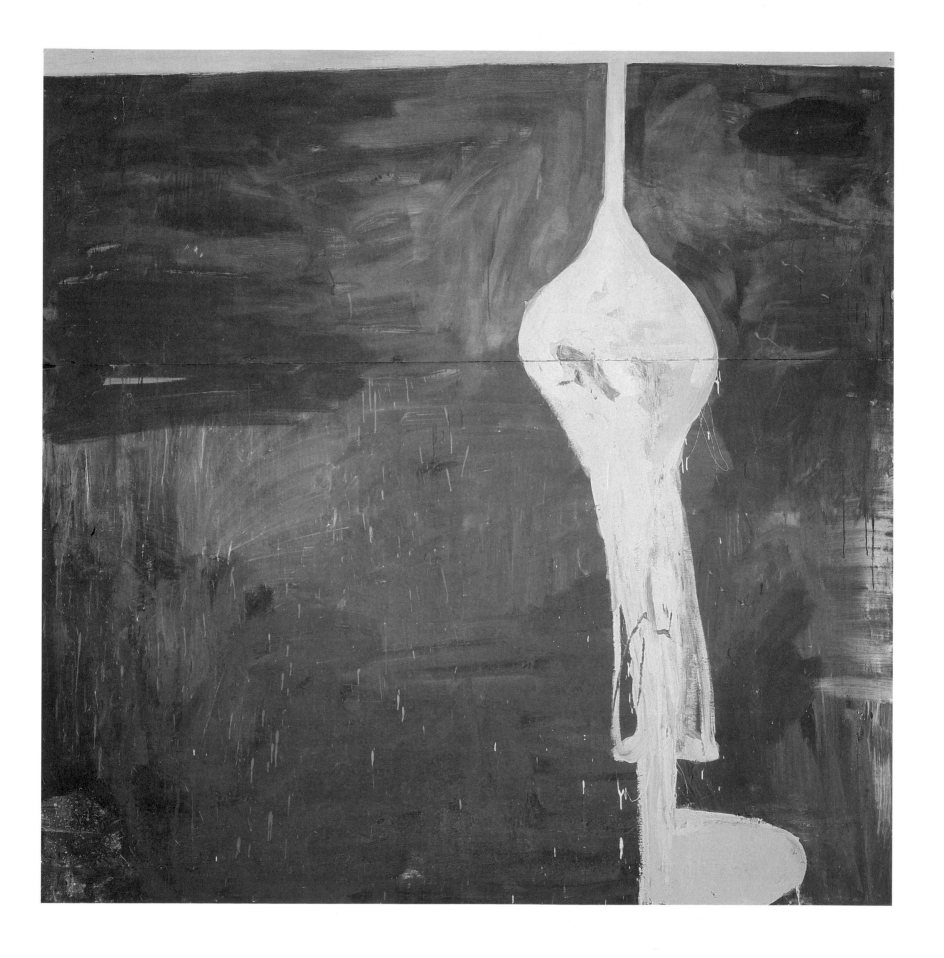

8 Milton, 1982

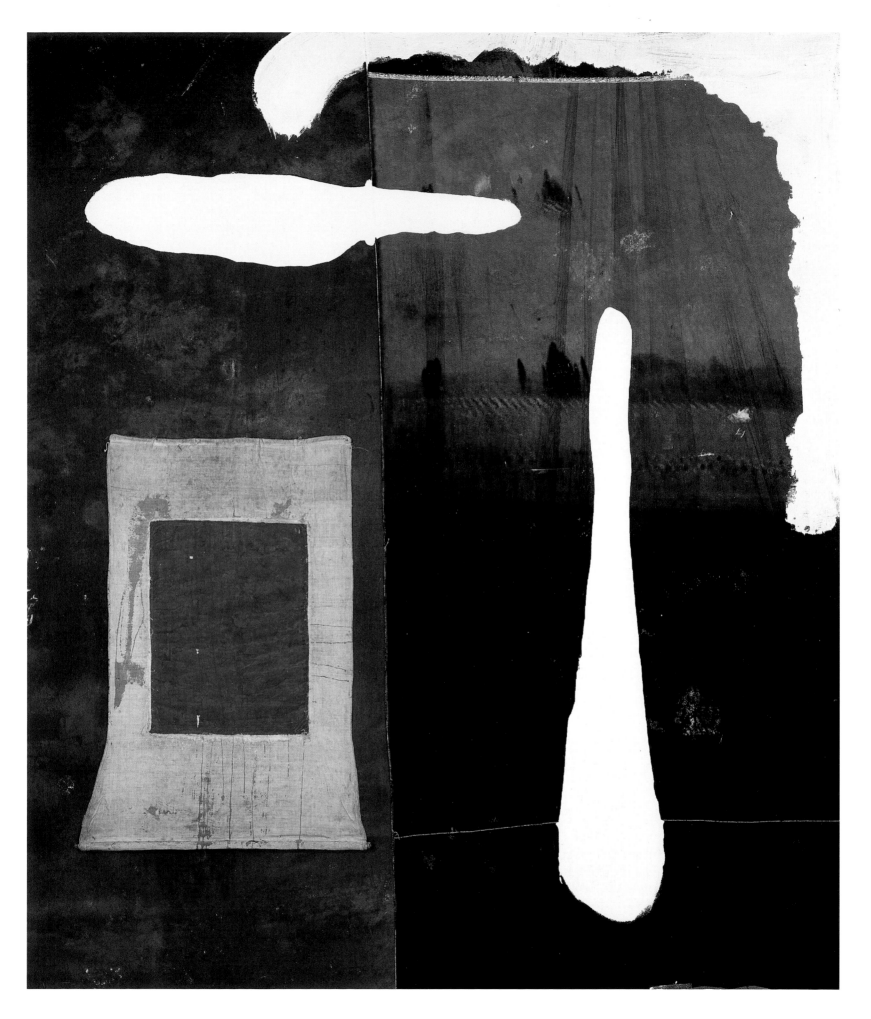

17 The Migration of the Duck-Billed Platypus to Australia, 1986

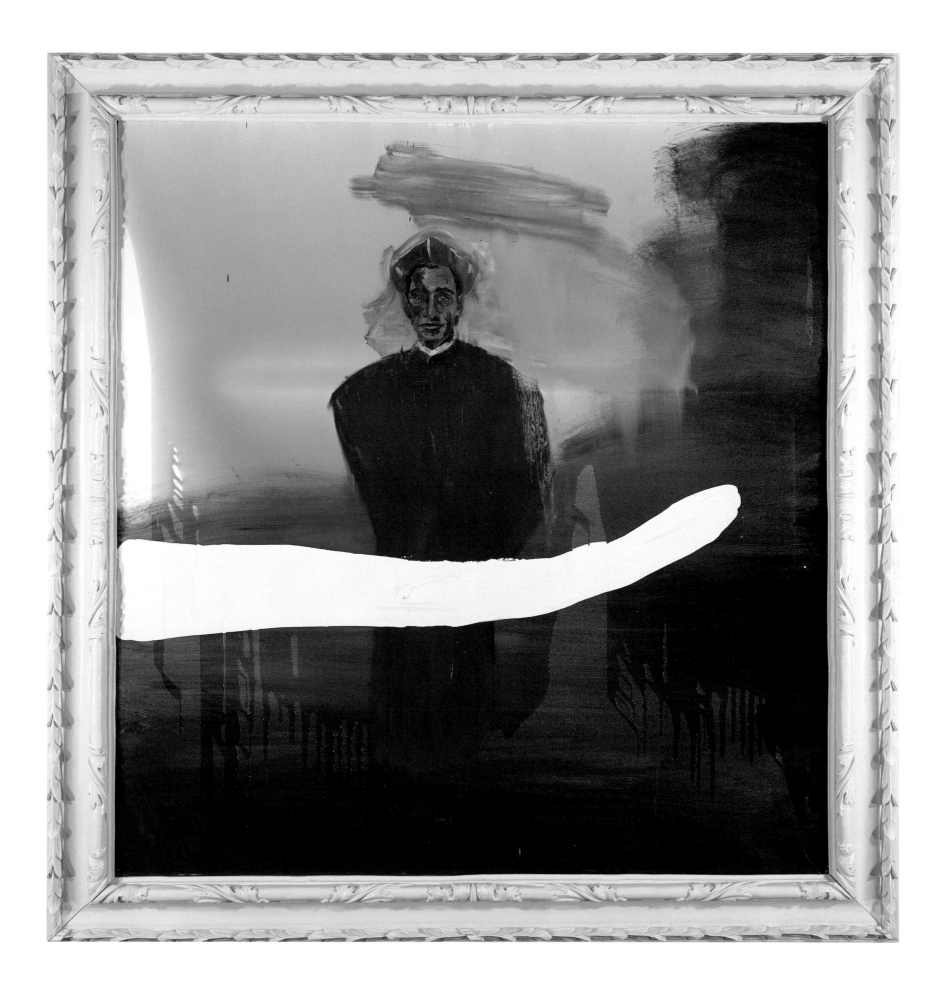

60 Portrait of Victor Hugo Demo, 1997

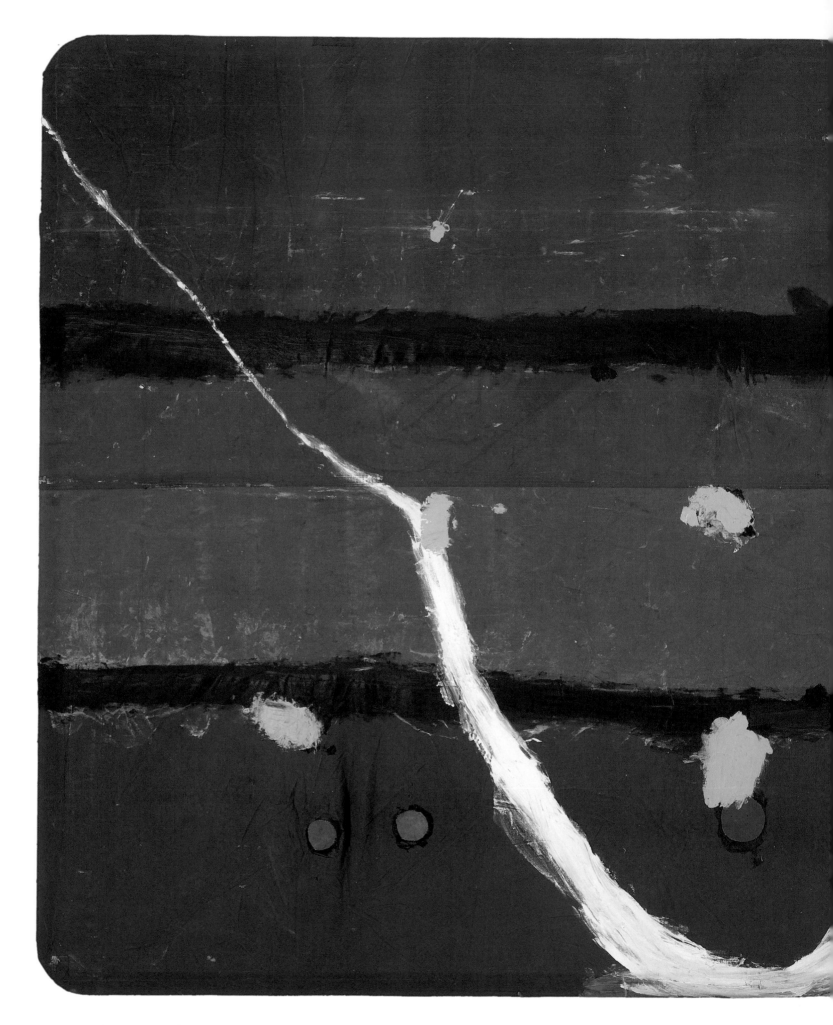

65 Untitled (Chinese Painting), 2003

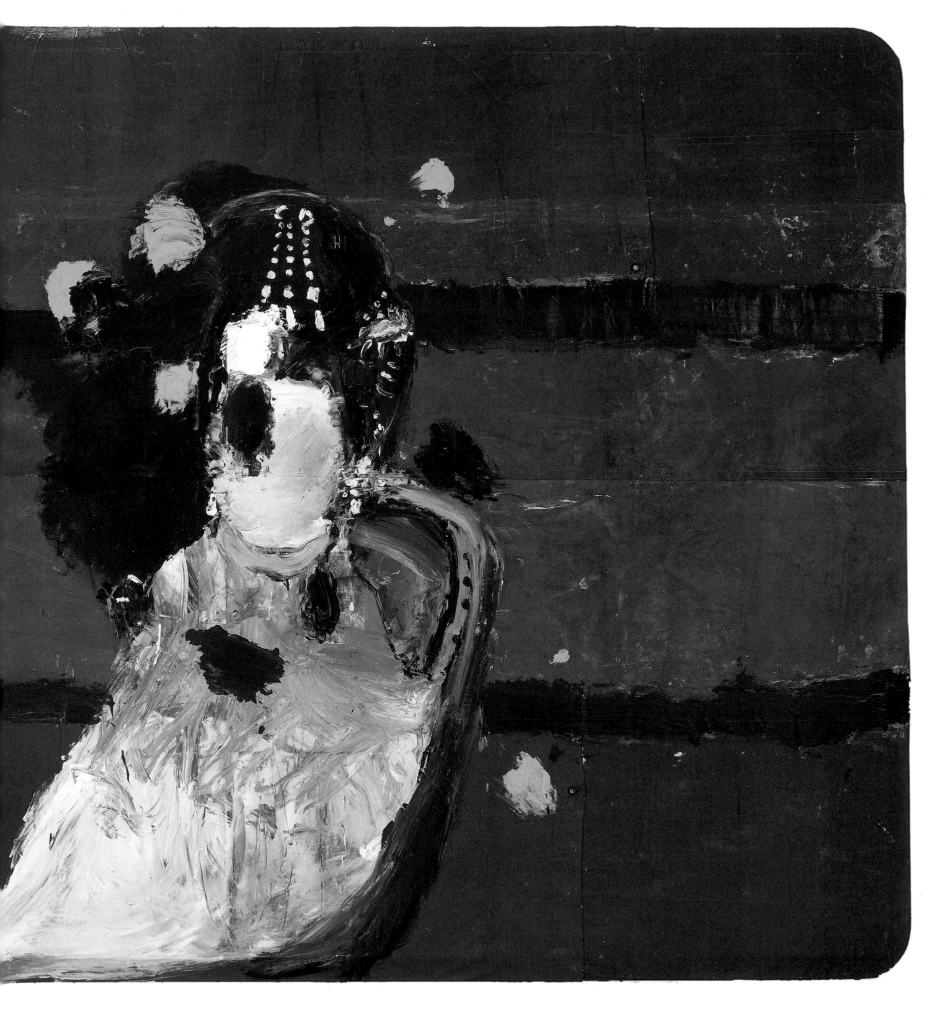

64 Untitled (Chinese Painting), 2003

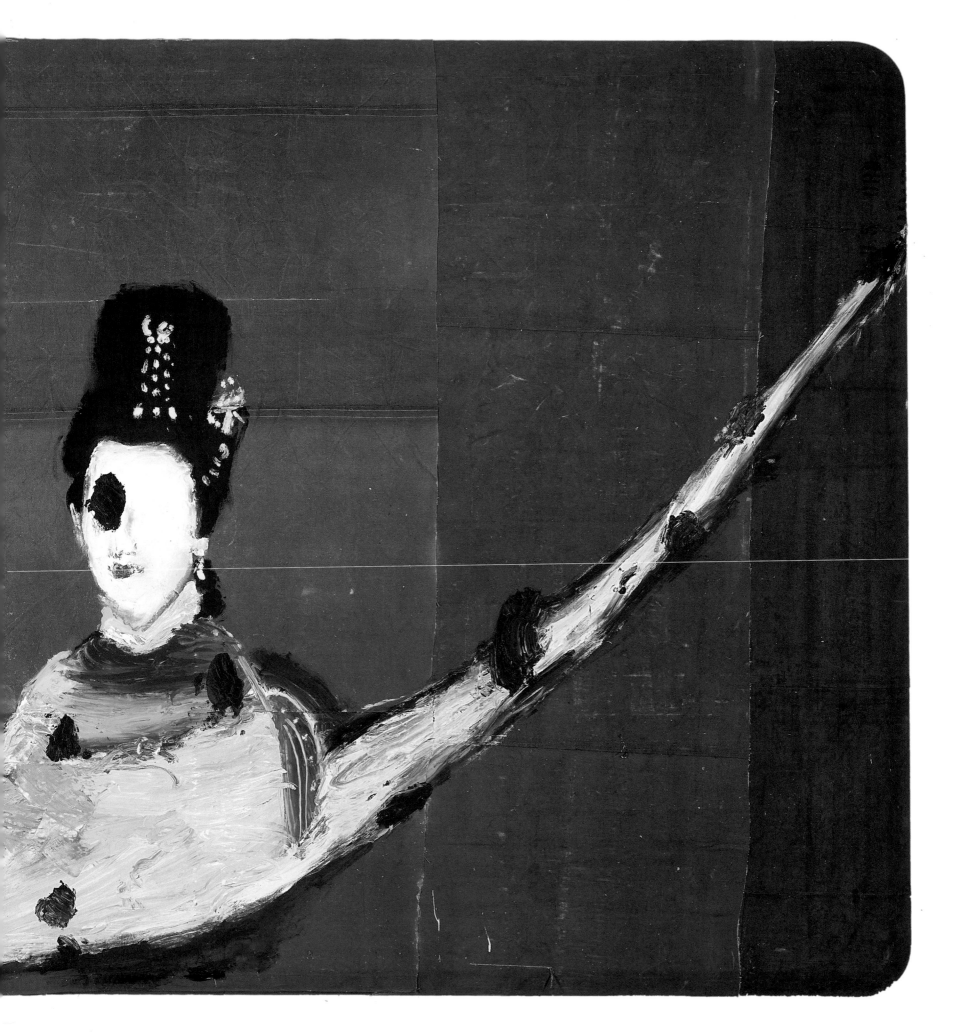

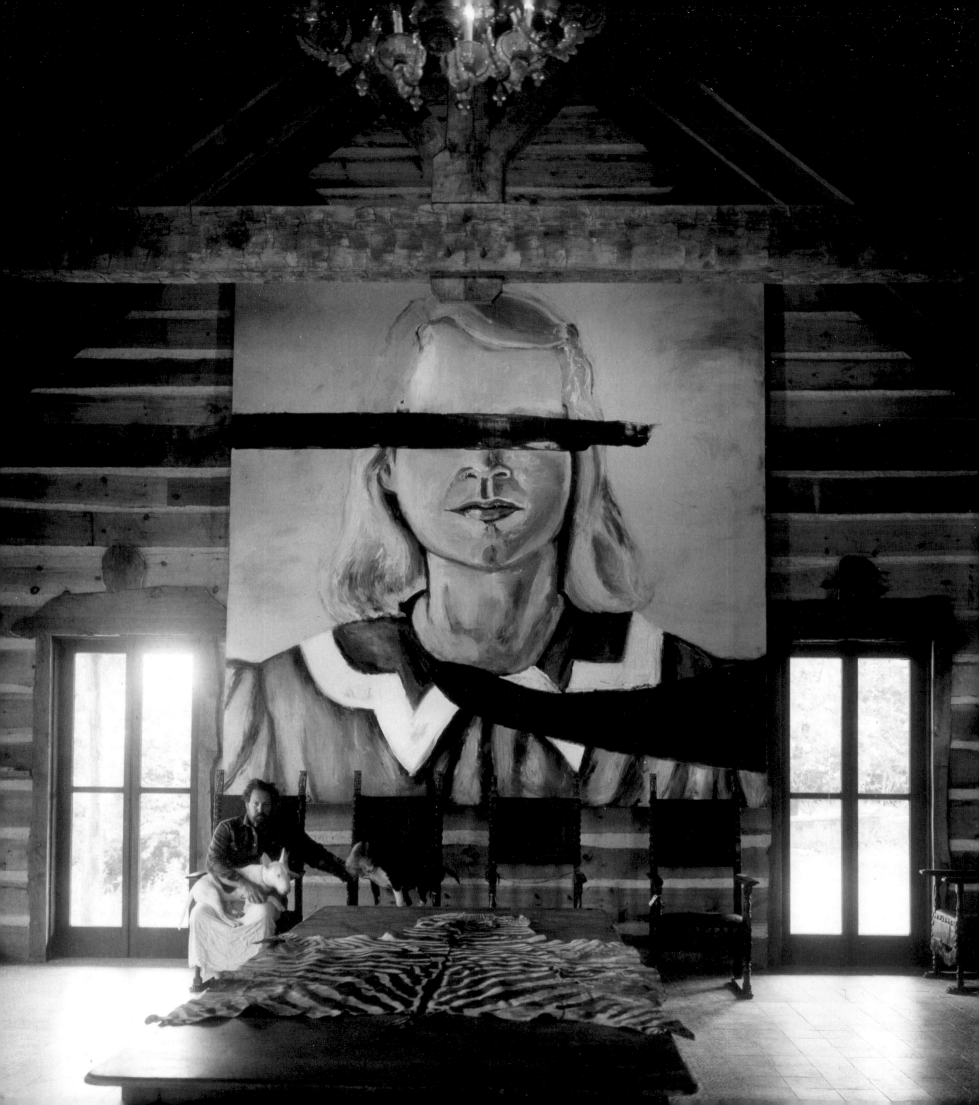

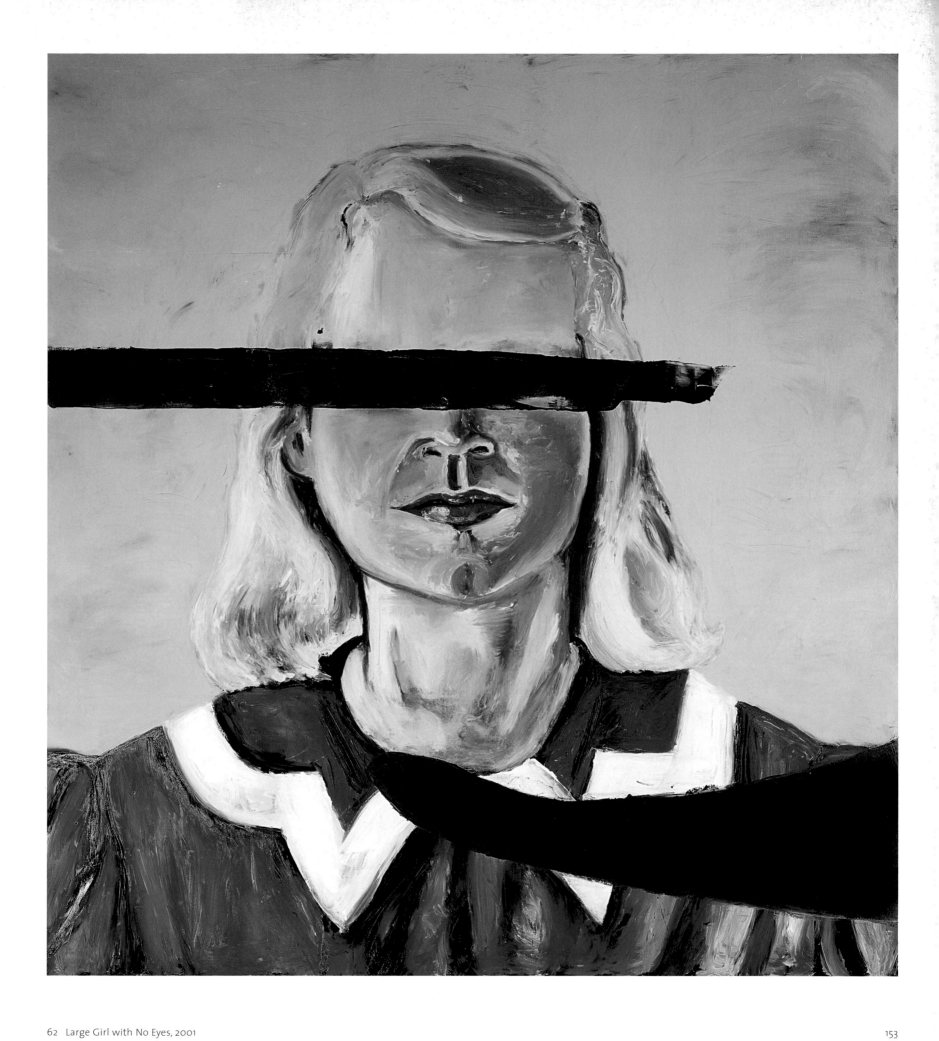

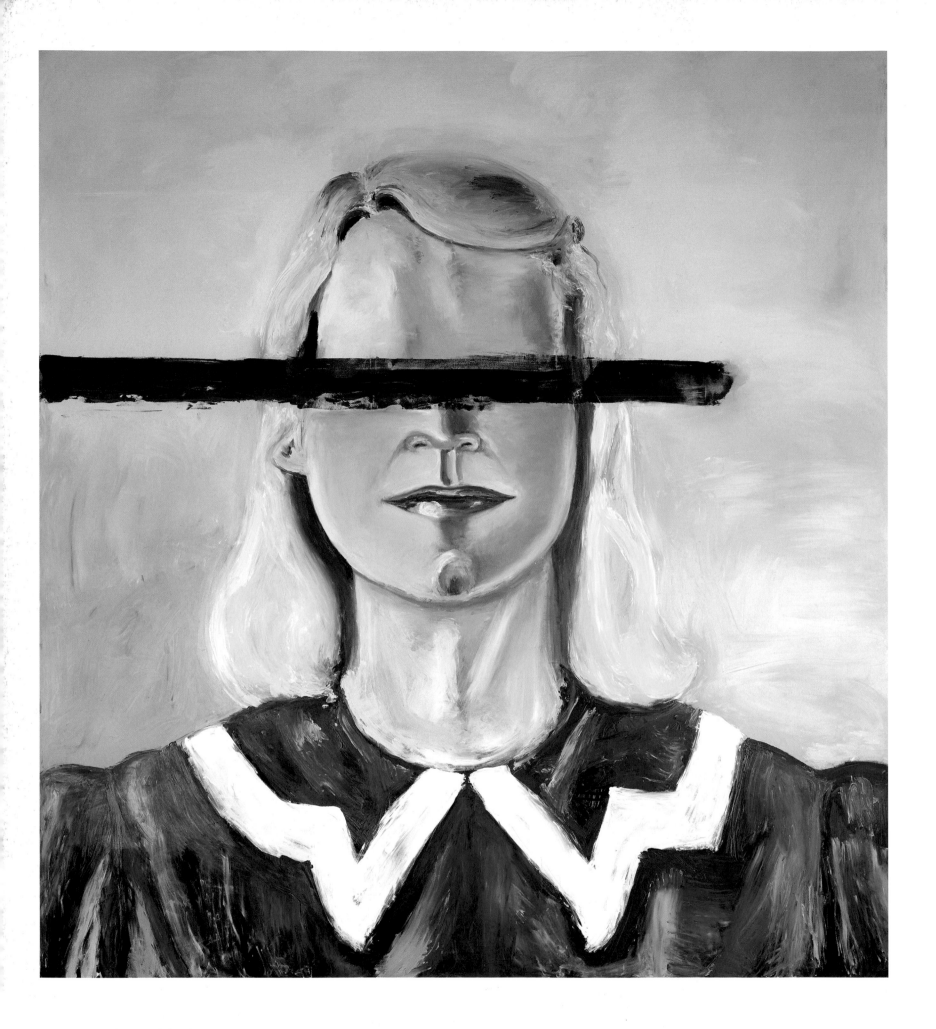

61 Large Girl with No Eyes, 2001

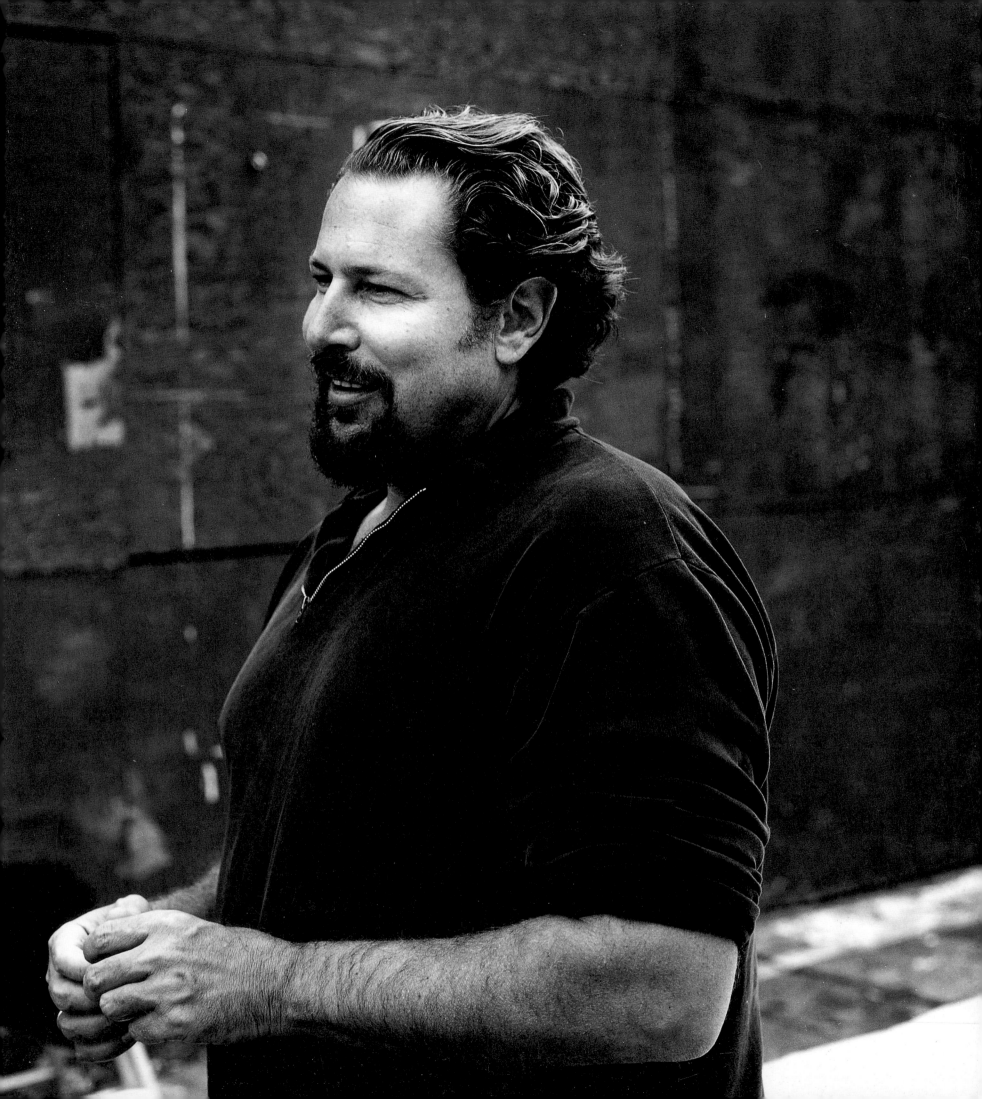

Julian Schnabel – Biography and Quotes

Julian Schnabel – Kommentierte Biografie

"I believe that paintings are physical things that need to be seen in person." (*Artforum*, April 2003, p. 59)

»Ich glaube, dass Bilder physische Dinge sind, die man sich persönlich ansehen muss.« (*Artforum*, April 2003, S. 59)

1951

JS is born on October 26 in Brooklyn, New York, to parents Jack Schnabel, originally from Prague, and Esther Schnabel from New York.

1951

JS wird am 26. Oktober in Brooklyn, New York, geboren als Sohn von Jack Schnabel, ursprünglich aus Prag, und seiner Frau Esther aus New York.

1965

The family moves to Brownsville, Texas, a small town near the Mexican border with a population of 36,000. On the job-training notes of his 1987 book *C V J*, JS later describes his extreme experiences in this environment, where everyday life is dominated by violence, weapons, and drugs.

"I am both an urban dweller and a small-town delinquent. My understanding of things is informed both by the insulation of the ethnic European community and cultural conditioning of the New York Jew in Brooklyn, and my role as a witness and participant in an inventory of small-town tragedies." (*C V J*, 1987, p. 54)

1965

Umzug der Familie nach Brownsville, Texas, einer Kleinstadt mit 36.000 Einwohnern nahe der mexikanischen Grenze. In seinem Buch *C V J*, berichtet JS, als er über seine Berufsausbildung schreibt, von den extremen Erfahrungen in dieser Umgebung, deren Alltag dominiert wird von Gewalt, Waffen und Drogen.

»Ich bin sowohl ein Großstadtbewohner wie auch ein Kleinstadtrowdy. Meine Sicht der Dinge ist von der Geborgenheit der einzelnen europäischen Gemeinden geprägt und von den kulturellen Bedingungen eines New Yorker Juden in Brooklyn sowie von meiner Rolle als Zeuge und Teilnehmer der üblichen Kleinstadttragödien.« (*C V J*, 1987, S. 54)

1969–1973

Studies at the University of Houston and earns the degree of Bachelor of Fine Arts.

He says about this period that he had nice teachers but learned nothing interesting about art.

1969–1973

Studium an der University of Houston mit Abschluss des Bachelor of Fine Arts. Er sagt über diese Zeit, dass seine Lehrer nett gewesen seien, er aber nichts Interessantes über Kunst gelernt habe.

1973

After being accepted to the Whitney Independent Study Program, JS moves to New York in the summer. For his application, he places slides of his paintings between slices of bread and sends them to New York as a sandwich in a paper bag.

"I wanted to be sure that they'd look at my slides." (*C V J*, 1987, p. 15)

The sculptor Joel Shapiro provides him space in his loft in exchange for painting the walls and ceiling. Shortly thereafter, the Whitney Program provides JS with his own studio, where he also lives although this is forbidden. He sells sunglasses and drives a taxi to earn a living.

An after-hours meeting at David Diao's studio with the artist Brice Marden ends in a brawl.

1973

JS zieht im Sommer nach New York, nachdem er in das Whitney Independent Study Program aufgenommen worden ist. Für seine Bewerbung steckt er Dias von seinen Bildern zwischen Brotscheiben und schickt diese in einer Papiertüte als Sandwich nach New York.

»Ich wollte sicher sein, dass sie meine Dias auch anschauen.« (*C V J*, 1987, S. 15)

Der Bildhauer Joel Shapiro überlässt JS Räume in seinem Loft als Gegenleistung dafür, dass er die Wände und Decken streicht. Kurze Zeit später erhält JS über das Whitney-Programm ein eigenes Studio, in dem er auch wohnt, obwohl das nicht erlaubt ist. Um seinen Lebensunterhalt zu finanzieren, arbeitet JS zeitweise als Sonnenbrillenverkäufer und Taxifahrer.

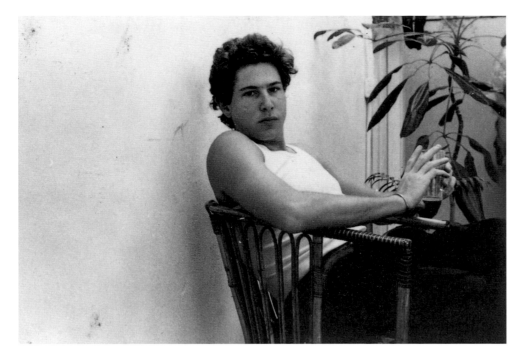

Julian Schnabel in New York, 1973–74

At Max's Kansas City, a famous artists' bar on 18th Street and Park Avenue, JS meets Ernst Mitzka, the young art and psychology professor from Hamburg, who introduces JS to the German artists Sigmar Polke and Blinky Palermo. JS drives with them to Philadelphia to see Marcel Duchamp's *Large Glass* at the Philadelphia Museum of Art.

A discussion with Blinky Palermo, whom JS describes as the most interesting artist since Barnett Newman, involves abstract and figurative art, the apparent contradiction of which is a non-issue for JS:

"I had no hierarchical notions of images and materials that could be or should be paintings. I still don't. Actually, there are no abstract paintings even if there are no figures in them. A painting can have an abstract image, but that doesn't make a painting abstract. Paintings are utilitarian." (*C V J*, 1987, pp. 30 and 32)

1975

Returns to Texas for eight months. JS begins using joint compound mixed with plaster and wax.

He will later paint over or destroy many paintings created in the mid-1970s.

1976

First solo exhibition at the Contemporary Arts Museum in Houston, Texas. JS works as a part-time cook at Mickey Ruskin's Ocean Club in New York, turning out approximately two hundred dinners per day.

JS travels through Europe for several months. In Italy, he is especially interested in the works of Fra Angelico, Giotto, and Caravaggio.

Ein Zusammentreffen mit dem Künstler Brice Marden in David Diaos Atelier endet in einer Prügelei.

Bei Max's Kansas City, einer berühmten Künstlerbar an der 18th Street und Park Avenue, trifft JS den jungen Hamburger Kunst- und Psychologieprofessor Ernst Mitzka, der ihn mit den deutschen Künstlern Sigmar Polke und Blinky Palermo bekannt macht. JS fährt mit ihnen im Auto nach Philadelphia, um im Philadelphia Museum of Art Marcel Duchamps *Großes Glas* anzusehen.

In einer Diskussion mit Blinky Palermo, den JS als den interessantesten Künstler seit Barnett Newman bezeichnet, geht es um abstrakte und gegenständliche Kunst, ein Gegensatz, der für JS keiner ist:

»Ich hatte keine hierarchische Vorstellung von Bildern und von Materialien, die Gemälde werden könnten oder sein sollten. Ich habe es noch immer nicht. […] Tatsächlich gibt es keine abstrakten Bilder, auch wenn nichts Gegenständliches darin vorkommt. Ein Gemälde kann ein abstraktes Bild zeigen, aber das macht nicht das Gemälde abstrakt. Gemälde sind zweckgebunden.« (*C V J*, 1987, S. 30 und 32)

1975

Für acht Monate Rückkehr nach Texas. JS beginnt mit Spachtelmasse, vermischt mit Gips und Wachs, zu arbeiten. Er wird später viele Bilder übermalen oder zerstören, die Mitte der 1970er Jahre entstanden sind.

1976

Erste Einzelausstellung im Contemporary Arts Museum, Houston, Texas.

Im Sommer arbeitet JS als Aushilfskoch im Ocean Club von Mickey Ruskin in New York. JS hat hier täglich ungefähr 200 Essen zuzubereiten.

Für mehrere Monate Reise nach Europa. In Italien setzt er sich besonders intensiv mit Werken von Fra Angelico, Giotto und Caravaggio auseinander.

»Ich habe eine Art Affinität zur alten italienischen Malerei und interessiere mich dafür […]. Es gibt da eine Ebene der Synästhesie, auf der all die verschiedenen Sinne vermischt werden, wodurch man etwas erlebt, was ich auch in meinen eigenen Bildern finden möchte.« (*Flash Art International*, Okt./Nov. 1986, S. 53)

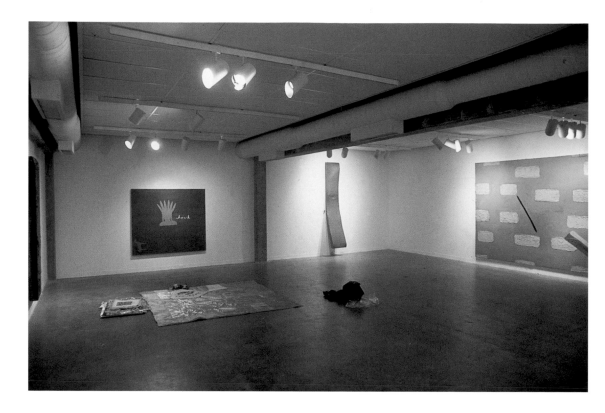

First solo exhibition at the Contemporary Arts
Museum in Houston, Texas, March–April 1976
**Erste Einzelausstellung im Contemporary Arts
Museum in Houston, Texas, März–April 1976**

"I have felt a kind of affinity and an interest in old Italian painting . . .
There is a level of synesthesia where all the different senses are
mixed together that gives you an experience that I'm interested in
finding in my own paintings." (*Flash Art International,* October/November 1986, p. 53)

1977

Participation in a group exhibition in Holly Solomon's gallery
in New York. JS also exhibits *Jack the Bellboy (A Season in Hell)*
here, a painting that will later achieve the status of "first realized painting."

1978

In Gerald Just's Galerie Dezember in Düsseldorf, JS exhibits
five paintings using the wax technique and first sees the studio of Sigmar Polke, who comes to the opening with Imi
Knoebel. JS values (as he puts it) the "subversive quality" of
Polke's pieces and, upon returning to New York, shows a catalogue of the works to gallery owner Holly Solomon. She rejects the idea of an exhibition with the comment that the
pieces are "too German." Some years later she shows the
work.
From Germany, JS travels to Italy again with his painterfriend Ross Bleckner, as well as visiting Barcelona for the first
time, where he is especially interested in the work of the architect Antonio Gaudí.
First works using the new "plate painting" technique.

1977

Teilnahme an einer Gruppenausstellung in der Galerie von
Holly Solomon in New York. JS stellt darin auch *Jack the Bellboy (A Season in Hell)* aus, ein Bild, das später den Status des
»ersten realisierten Bildes« erhält.

1978

In der Galerie Dezember von Gerald Just in Düsseldorf zeigt
JS fünf Gemälde in Wachstechnik und besucht bei dieser Gelegenheit das Atelier von Sigmar Polke, der zusammen mit
Imi Knoebel zur Eröffnung kommt. JS schätzt die, wie er es
nennt, »subversive Qualität« von Polkes Arbeiten und zeigt
nach seiner Rückkehr nach New York einen Katalog mit dessen Arbeiten der Galeristin Holly Solomon. Diese lehnt eine
Ausstellung mit der Bemerkung ab, sie seien »zu deutsch«.
Einige Jahre später zeigt sie schließlich doch seine Arbeiten.
Von Deutschland aus reist JS zusammen mit dem Malerfreund Ross Bleckner erneut nach Italien sowie erstmals
nach Barcelona, wo er sich besonders mit dem Werk des Architekten Antonio Gaudí auseinander setzt.
Erste Arbeiten in der neuen Technik der »Tellerbilder« (»plate
paintings«).
**»Die Teller-Bilder machte ich, weil ich die Bildoberfläche aufbrechen
wollte, und weil ich mich die Dissonanz zwischen der Helligkeit der
Teller und den anderen Teilen des Bildes interessierte.«** (Galerie Daniel
Blau, München, 1991)
Eine Reihe von Arbeiten mit archäologischen oder antiken Zitaten sowie Statuen oder Säulen entstehen. Beginn der Me-

"When I did the plate paintings I wanted to break the surface of the painting and I liked the dissonance between the brightness of the plates and the other parts of the picture." (Galerie Daniel Blau, Munich 1991)

A series of works is created featuring archaeological and classical references, as well as statues and columns. Beginning of the fragmentation method, which will be a recurring theme in JS's work as well as the elimination of the foreground and background. Other elements of his iconography include pagan, Christian, and Jewish symbols, for instance in *Saint Sebastian*, a kind of self-portrait.

1979

In February and October, JS has two solo exhibitions in Mary Boone's gallery, located in the same building as the galleries of Leo Castelli, Ileana Sonnabend, Andre Emmerich, and John Weber. Boone's gallery benefits from this neighborhood and attracts many visitors.

JS exhibits wax paintings in the first exhibition along with plate paintings in the second, including The *Death of Fashion*. Critics celebrate JS's work as "the return of painting." A broad discussion of the aims and future of painting is initiated, in which JS's pieces, among others, are at the center of heated debates. Numerous articles on painting appear in the next two years, including "The End of Painting" *(October)* and "Last Exit: Painting" *(Artforum)*.

"I thought that if painting is dead, then it's a nice time to start painting. People have been talking about the death of painting for so many years that most of those people are dead now." (*Artforum*, April 2003, p. 59)

First outdoor works. JS adds bronze sculptural elements to his plate paintings.

1980

April exhibition at Mary Boone's gallery, this time together with the painters Ross Bleckner and David Salle. In his review in *Arts Magazine*, Robert Pincus-Witten dubs the three artists "Boonies."

First exhibition at Galerie Bruno Bischofberger in Zurich.

JS participates in the Venice Biennale, as does Francesco Clemente, with whom he becomes friends. Other artists par-

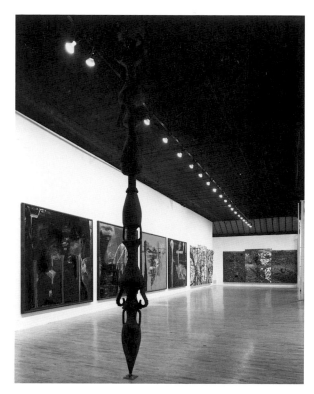

Solo exhibition at the Leo Castelli Gallery, New York, 1983
Einzelausstellung in der Leo Castelli Gallery, New York, 1983

thode der Fragmentierung, die sich wie ein roter Faden in JS's Werk fortsetzt, wie auch die Eliminierung von Vorder- und Hintergrund. Weitere Elemente seiner Ikonografie werden heidnische, christliche und jüdische Symbole, zum Beispiel bei *St. Sebastian*, einer Art Selbstporträt.

1979

Im Februar und im Oktober hat JS zwei Einzelausstellungen in der Galerie von Mary Boone, die sich im selben Gebäude befindet wie die Galerien von Leo Castelli, Ileana Sonnabend, Andre Emmerich und John Weber. Boones Galerie profitiert von dieser Nachbarschaft und zieht viele Besucher an.

JS stellt Wachsbilder und in der zweiten Ausstellung erstmals auch Tellerbilder aus, darunter *Death of Fashion*. Die Kritiker feiern JS Werk als »Wiederkehr der Malerei«. Eine breite Diskussion über Ziel und Zukunft der Malerei wird eröffnet, bei der unter anderem die Arbeiten von JS im Zentrum hitziger Debatten stehen. In den nächsten beiden Jahren erscheinen zahlreiche Artikel über die Malerei wie »The End of Painting« *(October)* oder »Last Exit: Painting« *(Artforum)*.

»Ich dachte, wenn Malerei tot ist, dann ist es gerade recht, mit dem Malen zu beginnen. Die Leute haben so lange über den Tod der Malerei geredet, nun sind die meisten von denen selbst tot.« (*Artforum*, April 2003, S. 59)

Erste Arbeiten im Außenraum. JS fügt skulpturale Elemente aus Bronze in seine Tellerbilder ein.

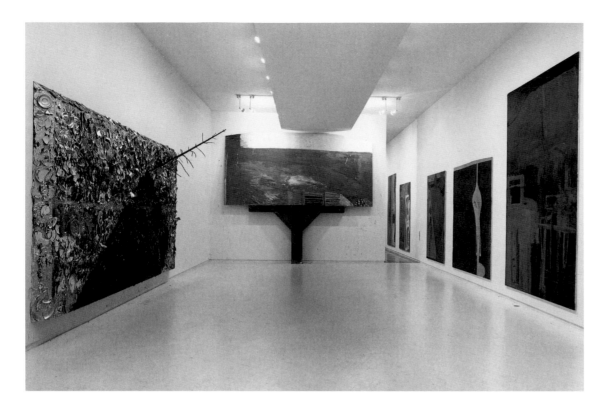

Solo exhibition at the Mary Boone Gallery,
New York, 1982
Einzelausstellung in der Mary Boone
Gallery, New York, 1982

ticipating in the Biennale include Anselm Kiefer and Georg Baselitz. Relatively new trends in European and American painting are linked with each other for the first time.

Marriage to Jacqueline Beaurang.

Shortly after the first plate paintings, works are also created using other unusual materials (such as deer antlers), including *Prehistory: Glory, Honor, Privilege, and Poverty* (1981), which is painted on cow hide.

The materialism of the paintings and everything that's inside them makes me look at something that's invisible, that's just outside of the painting . . . I don't know if that's spirit, or God, or just . . . confusion." (*Flash Art International*, October/November 1986, p. 48)

The treatment of different historic sources in the painting of Julian Schnabel, Francesco Clemente, and David Salle is denoted "cultural cannibalism" by the American critic Thomas Lawson ("Last Exit: Painting," in *Artforum*, October 1981, p. 42). Jean-Christophe Ammann organizes a solo exhibition for Julian Schnabel in the Kunsthalle Basel, as well as a group exhibition together with Robert Moskowitz and Susan Rothenberg entitled "Three New York Artists," which travels to the Frankfurter Kunstverein in 1981.

1981

In April, JS has parallel shows at Mary Boone's and Leo Castelli's galleries, exhibiting a total of fourteen paintings and nine drawings. He is the first new artist in Castelli's gallery program since 1971. Like Schnabel's first exhibition at Mary

1980

Im April Ausstellung bei Mary Boone, diesmal zusammen mit dem Malern Ross Bleckner und David Salle: In seiner Kritik im *Arts Magazine* nennt Robert Pincus-Witten die drei Künstler »Boonies«.

Erste Ausstellung in der Galerie Bruno Bischofberger in Zürich.

JS nimmt an der Biennale in Venedig teil wie auch Francesco Clemente, mit dem er seither befreundet ist. An der Biennale beteiligt sind unter anderem auch Anselm Kiefer und Georg Baselitz. Zum ersten Mal werden neuere Tendenzen in der europäischen und amerikanischen Malerei zueinander in Beziehung gesetzt.

Heirat mit Jacqueline Beaurang.

Kurz nach den ersten »Tellerbildern« entstehen auch Arbeiten mit weiteren ungewöhnlichen Materialien wie beispielsweise Hirschgeweihen, darunter *Prehistory: Glory, Honor, Privilege and Poverty* (1981), das auf einem Kuhfell gemalt ist.

»Die Materialität der Gemälde und alles, was darin ist, bringt mich dazu, etwas zu sehen, das unsichtbar ist, das nur außerhalb des Bildes ist [...]. Ich weiß nicht, ob es Geist ist oder Gott oder nur ... Verwirrung.« (*Flash Art International*, Okt./Nov. 1986, S. 48)

Die Verarbeitung von unterschiedlichsten historischen Quellen in der Malerei von Julian Schnabel, Francesco Clemente und David Salle wird von dem amerikanischen Kritiker Thomas Lawson als »erweiterter kultureller Kannibalismus« bezeichnet. (»Last Exit: Painting«, in: *Artforum*, Oktober 1981, S. 42)

Boone's gallery two years earlier, all pieces are already sold before the opening.

"I don't know what success is, I've had the privilege to do my work. I think it has to do with my paintings. I think it has to do what's in the paintings." (*Flash Art International*, October 1986, p. 45)

An article by René Ricard, "Not about Julian Schnabel," appears in *Artforum* in May, in which he attacks the business practices of the New York gallery owners.

"Wild," gestural painting becomes an important element in JS's work, leading some critics to describe his art as "Neo-Expressionist."

"Painting your guts out has never been an interesting idea or made an interesting painting. Feeling cannot be separated from intellect. In that sense, Neo-Expressionism doesn't exist; it never has." (*C V J*, 1987, p. 205)

In the summer, JS paints in Amagansett on Long Island, where he finds faded pieces of wood that he includes in paintings and sculptures. The concept of integrating found, used, weather-beaten, and historical objects in his painting will become a core element of his work.

"Using already existing materials establishes a level of ethnographicness in the work; I mean it brings a real place and time into the aesthetic reality." (Prato 1990, p. 32)

Jean-Christophe Ammann organisiert in der **Kunsthalle Basel** eine Einzelausstellung mit JS sowie eine Gruppenausstellung zusammen mit Robert Moskowitz und Susan Rothenberg unter dem Titel *Three New York Artists*, die 1981 in den Frankfurter Kunstverein wandert.

1981

Im April stellt JS parallel bei Mary Boone und Leo Castelli 14 Gemälde und 9 Zeichnungen aus. Er ist der erste neue Künstler in Castellis Galerieprogramm seit 1971. Wie bei Schnabels erster Ausstellung bei Mary Boone zwei Jahre zuvor sind alle Arbeiten noch vor der Eröffnung verkauft.

»Ich weiß nicht, was Erfolg ist, ich habe das Privileg, einfach arbeiten zu können. Ich denke, das hat mit meinen Bildern zu tun. Ich denke, es hat etwas damit zu tun, was in den Bildern ist.« (*Flash Art International*, Okt./Nov. 1986, S. 45)

Im Mai erscheint im *Artforum* ein Artikel von René Ricard: »Not about Julian Schnabel«, in dem er die Geschäftspraktiken der New Yorker Galeristen angreift.

»Wilde«, gestische Malerei wird ein wichtiges Element in JS's Arbeiten, was manche Kritiker dazu veranlasst, sein Werk als »neo-expressionistisch« zu bezeichnen.

»Mit dem Malen das Innere nach außen kehren zu wollen, war nie eine spannende Sache oder machte gar ein Bild spannend. Gefühle können nicht vom Kopf getrennt werden. In diesem Sinne gab es keinen Neo-Expressionismus, hat es nie gegeben.« (*C V J*, 1987, S. 205)

JS malt im Sommer in Amagansett auf Long Island, wo er ausgewaschene Hölzer findet, die er in Gemälde und Skulpturen einfügt. Das Konzept, gefundene, benutzte, verwitterte und historisch besetzte Gegenstände in seine Malerei zu integrieren, wird zu einem zentralen Moment seiner Arbeit.

»Bereits existierende Materialien zu verwenden bringt etwas Ethnographisches in die Arbeit; ich meine, damit werden ein realer Ort und eine reale Zeit in der ästhetischen Wirklichkeit angesiedelt« (Ausst.-Kat. Prato, 1990, S. 32)

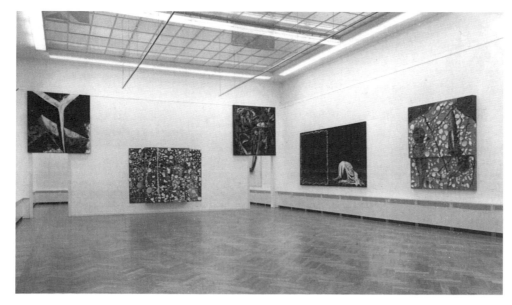

Exhibition at the Kunsthalle Basel, 1981 Ausstellung in der Kunsthalle Basel, 1981

Participation in the "Westkunst" exhibition in Cologne and in the Whitney Biennial in New York, as well as in the large group exhibition "A New Spirit in Painting" at the Royal Academy of Arts in London, which includes pieces from both "classic" painters such as Willem de Kooning, Andy Warhol, Francis Bacon, Cy Twombly, Robert Ryman, and Frank Stella, and relatively young European and American artists such as Gerhard Richter, A.R. Penck, Sigmar Polke, Markus Lüpertz, and Brice Marden. JS is the youngest painter in the exhibition.
Birth of daughter Lola Montes.

1982

Participation in the Venice Biennale and the "Zeitgeist" exhibition in Berlin.

First bronze sculptures are created. As with his paintings, JS performs this work without sketches.

"I see myself as painter even if I make sculptures." (Matthew Marks Gallery New York, 1992, p. 45)

Participation in a group exhibition at Anthony d'Offay's gallery in London, together with the Italian Transavanguardia painters Sandro Chia and Francesco Clemente, as well as Anselm Kiefer and David Salle.

The fact that against all expectations, curator Rudi Fuchs does not invite JS to "documenta 7" causes a stir in the art world. According to his own statement, Fuchs wants to "free art from the various constraints and distortions in which it is currently mired," thus reacting less to JS's artistic significance and more to his success in the art market.

1983

The American art critic Clement Greenberg visits an exhibition of JS and criticizes exactly those aspects of his paintings that JS considers especially integral.

"I overwhelmingly understood from this that some people just don't want to see anything that they don't expect to see. Rather than being stimulated by a new experience, they want to remove any annoyance that disturbs their preconception of what they think art is." (*C V J*, 1987, p. 142)

Exhibition of thirty paintings in the Stedelijk Museum Amsterdam, another exhibition at the Tate Gallery London. JS participates again in the Whitney Biennial in New York. Partici-

Teilnahme an der Ausstellung *Westkunst* in Köln und an der *Whitney Biennial*, New York, sowie an der großen Gruppenausstellung *A New Spirit in Painting* in der Royal Academy of Arts in London, in der sowohl Arbeiten von »Klassikern« wie Willem de Kooning, Andy Warhol, Francis Bacon, Cy Twombly, Robert Ryman und Frank Stella zu sehen sind wie auch jüngere europäische und amerikanische Künstler wie Gerhard Richter, A.R. Penck, Sigmar Polke, Markus Lüpertz und Brice Marden. JS ist der jüngste Maler in der Ausstellung.
Geburt der Tochter Lola Montes.

1982

Teilnahme an der Biennale in Venedig und an der Ausstellung *Zeitgeist* in Berlin.

Erste Bronze-Skulpturen entstehen. Wie bei den Gemälden arbeitet JS auch hier ohne Vorzeichnungen.

»Ich sehe mich als Maler, selbst wenn ich Skulpturen mache.« (Matthew Marks Gallery, New York, 1992, S. 45)

Teilnahme an einer Gruppenausstellung bei Anthony d'Offay in London zusammen mit den italienischen »Transavanguardia«-Malern Sandro Chia und Francesco Clemente sowie Anselm Kiefer und David Salle.

Dass JS entgegen allen Erwartungen nicht zu der von Rudi Fuchs kuratierten *documenta* 7 eingeladen wird, erregt in der Kunstszene viel Aufsehen. Fuchs will laut eigener Aussage »die Kunst von den unterschiedlichen Zwängen und Verdrehungen befreien, in die sie verstrickt ist«, und reagiert damit weniger auf den künstlerischen Stellenwert von JS als auf seinen Erfolg auf dem Kunstmarkt.

1983

Der amerikanische Kunstkritiker Clement Greenberg besucht eine Ausstellung von JS und kritisiert genau jene Aspekte in dessen Bildern, die JS für besonders wesentlich hält.

»Mir wurde dadurch sehr deutlich, dass einige Leute einfach nicht sehen wollen, was sie nicht zu sehen erwarten. Sie wollen lieber jede Störung entfernen, die ihrer vorgefassten Meinung von dem, was sie für Kunst halten, zuwiderläuft, als durch eine neue Erfahrung Anregungen zu erhalten.« (*C V J*, 1987, S. 142)

Ausstellung von 30 Gemälden im Stedelijk Museum Amsterdam, eine weitere in der Tate Gallery London. Erneute Teil-

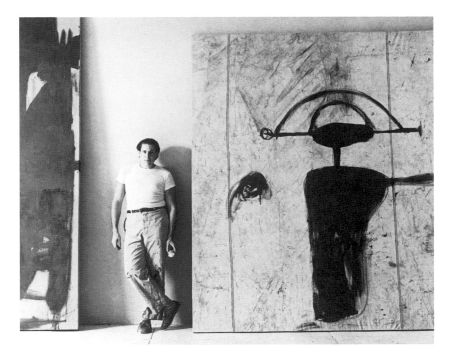

Julian Schnabel, 1982

pation in the group exhibition "New York Now" at the Kunsthalle Düsseldorf and "New Tendencies in New York" at Palacio Velazquez in Madrid, curated by Carmen Gimenez.

A relatively long statement from JS appears in the Amsterdam exhibition catalogue on the American painter Willem de Kooning:

"The materiality of a work of art is just parts of a desire, only important as a quality of being, a feeling, a meaning, a recognition which is described by and describes the time it has been made in; something human." (*Artforum*, February 1984, p. 57)

Birth of daughter Stella Madrid.

1984

Begins collaborating with Arne Glimcher and the Pace Gallery in New York.

1985

In Mexico, JS begins painting on tarpaulin, an olive-green waterproof material made of heavy cotton with vinyl paint, used especially in the army.

"The three Mexican paintings from '85 are the first paintings I did on tarpaulins, this material that the army uses to cover things. I felt like I was really painting Mexico when I did them, and that the blood of this tradition of cruelty was coming up through my feet and was coming out in the paintings." (Prato 1990, p. 22)

JS travels to Australia and begins collecting wood sculptures from Papua New Guinea, off the northern coast of Australia.

nahme an der *Whitney Biennial* in New York. Beteiligung an den Gruppenausstellungen *New York Now* in der Kunsthalle Düsseldorf und *New Tendencies in New York* im Palacio Velazquez in Madrid, kuratiert von Carmen Gimenez.

Im Amsterdamer Ausstellungskatalog zum amerikanischen Maler Willem de Kooning erscheint ein längeres Statement von JS:

»Die Materialität eines Werke ist nur Teil einer Sehnsucht, nur wichtig als eine Qualität des Seins, eines Gefühls, eines Wiedererkennens, das durch die Zeit beschrieben wird und das die Zeit beschreibt, in der es gemacht ist; etwas Menschliches.« (*Artforum*, Feb. 1984, S. 57)

Geburt der Tochter Stella Madrid.

1984

Beginn der Zusammenarbeit mit Arne Glimcher und der Pace Gallery in New York.

1985

JS malt in Mexiko erstmals auf Persenning (»tarpaulin«), einem olivgrünen, wasserfesten Material aus schwerer Baumwolle mit Vinylschicht, das vor allem in der Armee eingesetzt wird.

»Die drei mexikanischen Bilder von 1985 sind die ersten Bilder, die ich auf Tarpaulin gemacht habe, dieses Material, das die Armee zum Abdecken benutzt. Ich hatte das Gefühl, hier Mexiko selber zu malen, als ich es tat, und das Blut dieser Tradition der Grausamkeit kam hoch durch meine Füße und heraus in meine Bilder.« (Ausst.-Kat. Prato, 1990, S. 22)

JS reist nach Australien und beginnt, Holzskulpturen aus Papua-Neuguinea vor der nordaustralischen Küste zu sammeln.

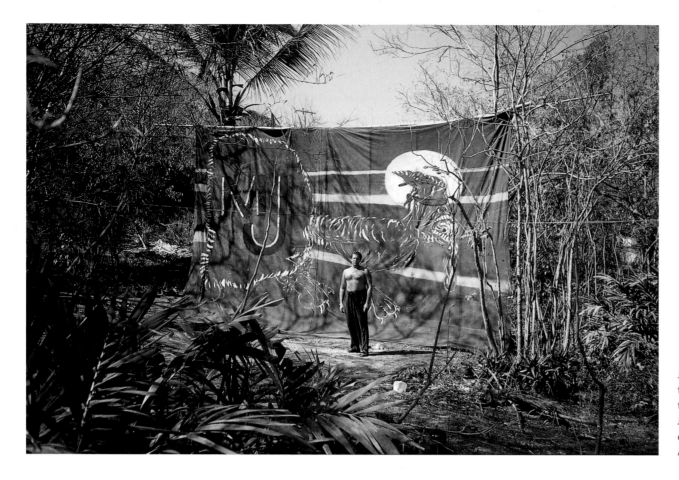

Julian Schnabel in Mexico with one of his three *Mexican Paintings,* painted on tarpaulin for army trucks, 1986
Julian Schnabel in Mexiko mit einem der drei *Mexican Paintings*, gemalt auf Abdeckplanen von Armeelastwagen, 1986

1986

To commemorate the death of Joseph Beuys, JS creates the sculpture *Tomb for Joseph Beuys*. Participation in the exhibition "Beuys zu Ehren" in the Lenbachhaus in Munich.
JS uses canvases from the Japanese Kabuki theater as a background for his paintings, and exhibits these works in 1988/89 in museums in Osaka and Tokyo.
Birth of son Vito.

1987

For certain paintings, including *The Edge of Victory*, JS uses the former floor covering of a boxing ring, which bears the traces of numerous boxing matches. Like tarpaulin, he again uses a material "with a history," the traces of its use lending the work an unmistakably unique character.
JS creates the *Recognitions* series of paintings, exhibiting them in the ruins of the Cuartel del Carmen in Seville and subsequently in the Kunsthalle Basel. The title of the work refers to William Gaddis's 1983 novel of the same name. In the large-format paintings on dark tarpaulin and often irregular contours, the linear white writing becomes the single pictorial element, defining the space. The use of language and writing, an important element in JS's pieces of art since early 1970s, reaches a climax.

1986

Anlässlich des Todes von Joseph Beuys entsteht die Skulptur *Grab für Joseph Beuys*. Teilnahme an der Ausstellung *Beuys zu Ehren* im Lenbachhaus in München.
JS benutzt Leinwände des japanischen Kabuki-Theaters als Hintergrund für seine Gemälde und stellt diese Arbeiten 1988/89 in Museen in Osaka und Tokio aus.
Geburt des Sohnes Vito.

1987

Für einige Bilder, darunter *The Edge of Victory*, benutzt JS den ehemaligen Fußbodenbelag eines Boxrings, der die Spuren zahlreicher Boxkämpfe trägt. Wie bei der Persenning setzt er wieder ein Material »mit Geschichte« ein, dessen Benutzungsspuren dem Werk einen eigenen, unverwechselbaren Charakter verleihen sollen.
Die Serie der *Recognitions*-Bilder entsteht und wird in der Ruine des Cuartel del Carmen in Sevilla und anschließend in der Kunsthalle Basel ausgestellt. Der Titel der Arbeiten bezieht sich auf den 1983 erschienenen gleichnamigen Roman von William Gaddis. In den großformatigen Gemälden auf dunkler Persenning und mit oft unregelmäßigem Umriss wird die weiße Linienschrift zum einzigen und die Fläche ausfüllen-

"Letters are real. For me they're pictorial elements that also have a sociological connotation and a historical, temporal connotation." (Prato 1990, p. 21)

JS's book *C V J: Nicknames of Maître D's & Other Excerpts from Life* is published.
Large retrospective exhibitions of JS's painting in Europe: Whitechapel Art Gallery, London, curated by Nicholas Serota; Centre Pompidou, Paris, curated by Dominique Bozo; and Kunsthalle Düsseldorf.

1988

The retrospective is exhibited in the United States at the Whitney Museum of American Art in New York, the San Francisco Museum of Modern Art, and the Museum of Fine Arts in Houston. A critic describes JS's style as "romantic, manneristic-minimalist . . . like an American hybrid of Arte Povera," which is another try labeling his style. (*Flash Art International* 140, p. 73)

den Bildelement. Der Einsatz von Sprache und Schrift, ein wichtiges Element in JS's Arbeiten seit den frühen 1970ern, erlebt einen Höhepunkt.

»Buchstaben sind wirklich. Für mich sind sie Bildelemente, die auch eine soziologische sowie eine historische, zeitliche Bedeutung haben.« (Ausst.-Kat. Prato, 1990, S. 21)

Das von JS verfasste Buch *C V J, Nicknames of Maître D's & other Excerpts from Life* erscheint.

Große Retrospektive der Malerei in Europa: Whitechapel Art Gallery, London, kuratiert von Nicholas Serota, Centre Pompidou, Paris, kuratiert von Dominique Bozo, sowie Kunsthalle Düsseldorf.

1988

Die Retrospektive wird in den USA im Whitney Museum of American Art in New York, dem San Francisco Museum of Modern Art und dem Museum of Fine Arts in Houston gezeigt. Ein Kritiker beschreibt JS's Stil als »romantisch, manie-

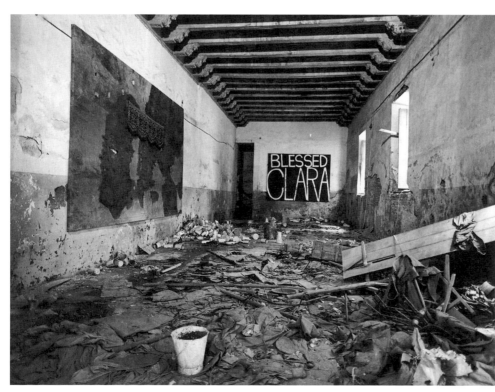

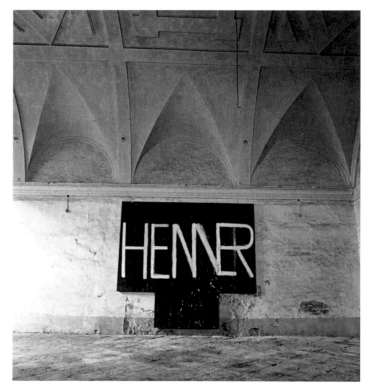

Exhibition of the *Recognitions* paintings in the ruins of the Cuartel del Carmen in Seville, 1987 Ausstellung der *Recognitions*-Bilder in der Ruine des Cuartel del Carmen in Sevilla, 1987

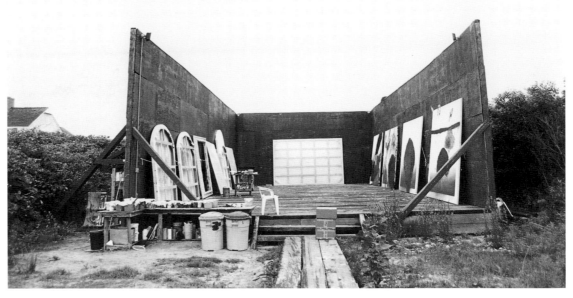

Julian Schnabel's open-air studio in Montauk at the Estate of Andy Warhol, 1994

Julian Schnabels Freiluftatelier in Montauk beim Andy Warhol Estate, 1994

"I don't want to have a logo and I have not found a signature that represents me." (JS, New York 2003)

Travels to Egypt.

First summer in Montauk, Long Island with outside studio. JS paints works measuring 16 by 16 feet for the show at CAPC in Bordeaux.

1989

Large retrospective of works on paper with stops in Basel, Nîmes, Munich, Brussels, Edinburgh, and Chicago. Participation in the exhibition "Bilderstreit" in Cologne.

Exhibition of paintings, sculpture, and works on paper in the Museo d'Arte Contemporanea in Prato, Italy. Joint exhibition with works by Jean-Michel Basquiat in the Rooseum in Malmö, Sweden.

1990

The largest pieces in JS's oeuvre are created: an untitled series of paintings, measuring 22 by 22 feet surpasses the size of pieces such as *Joe Dante* from 1988 (16 by 16 feet). These room-filling pieces of art are installed for five years in a former Roman temple, the Maison Carrée, in Nîmes.

"They are large because that's a necessary part of the content of the paintings. The scale and size of the painting has a physical reality that affects its meaning . . . When the paintings are large, the interior of the painting seems to deconstruct itself, I like that, and I like what happens to me, when I feel like I'm watching the painting deconstruct itself." (*Flash Art International*, October/November 1986, p. 51)

First exhibition of sculptures in the Pace Gallery, New York. Sixteen bronze sculptures are installed on a mountain top in St. Moritz, Switzerland, organized by the Galerie Bruno Bischofberger

1991

A large series on Olatz Lopez Garmendia, his wife-to-be, is created.

"The *Olatz* paintings are Mediterranean and open like her. They are about different times of day, different locations. They are not land-

ristisch-minimalistisch [...] wie ein amerikanischer Hybride der Arte Povera«. (*Flash Art International*, Nr. 140, S. 73)

»Ich will kein Logo, und ich habe auch noch keine Handschrift gefunden, die mich repräsentiert.« (JS, New York 2003)

Reise nach Ägypten.

Erster Sommer in Montauk, Long Island, im Freiluftatelier. JS malt 490 x 490 cm große Bilder für eine Ausstellung im Museum CAPC in Bordeaux.

1989

Große Retrospektive der Arbeiten auf Papier mit Stationen in Basel, Nîmes, München, Brüssel, Edinburgh und Chicago. Teilnahme an der Ausstellung *Bilderstreit* in Köln.

Ausstellung von Gemälden, Skulpturen und Arbeiten auf Papier im Museo d'Arte Contemporanea in Prato. Gemeinschaftsausstellung mit Arbeiten von Jean-Michel Basquiat im Rooseum in Malmö.

1990

Die bisher größten Arbeiten in JS's Œuvre entstehen: Eine unbetitelte Serie von Gemälden mit den Maßen 670 x 670 cm übertrifft Werke wie *Joe Dante* von 1988 mit einer Größe von 488 x 488 cm. Diese raumfüllenden Arbeiten werden für fünf Jahre in einem ehemaligen römischen Tempel, dem Maison Carrée, in Nîmes installiert.

»Sie sind groß, weil das für den Inhalt der Bilder notwendig ist. Maße und Größe der Bilder haben eine physische Realität, die ihre Bedeutung beeinflusst. [...] Wenn die Bilder groß sind, scheint das Innere der Bilder sich selbst auseinander zu nehmen, ich mag das, und ich mag,

scapes, but places that exist in my mind. I exist in those places."
(Pace Gallery, New York, 1992)

Participates again in the Whitney Biennial in New York.
On large expanses of dark-red velvet, JS paints the series *Los patos del Buen Retiro*, in which he again addresses the history and aesthetics of Spanish culture.

1992

JS now also uses photographs as picture elements in his works on paper.

"I think I use photographs in my drawings almost as if there were a mirror. I use them as a non-image . . . They are like a blind spot."
(Matthew Marks Gallery, New York, 1992, p. 46)

JS creates a group of works dealing with the word Zeus. Some of these describe a love story between Zeus and Duende, a synonym for the magical and unsayable which comes from poems by the Spanish author Federico García Lorca.

1993

Marriage to Olatz Lopez Garmendia.
Participation in the group exhibition "American Art in the 20th Century" at Martin-Gropius-Bau, Berlin, and at the Royal Academy of Arts, London.
Birth of twin sons Olmo Luis und Cy Juan.

1994

Retrospective in the Museum of Monterrey and The Tamayo Museum in Mexico City.

1995

Exhibition in the Fundació Joan Miró in Barcelona.
JS writes the screenplay for and directs the film *Basquiat*, with Jeffrey Wright as Basquiat, David Bowie in the role of Andy Warhol, and Dennis Hopper as Bruno Bischofberger. The film is based on the life of the young painter and shooting star of the New York art scene, who died of a drug overdose at the age of twenty-seven.

1996

Basquiat is selected for the competition at the Venice Film Festival.

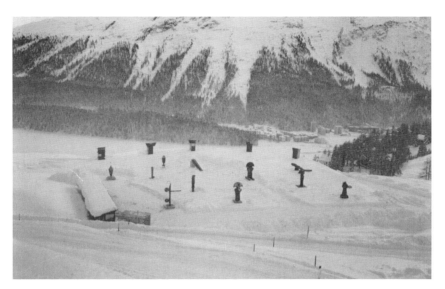

Exhibition of 16 sculptures at Chantarella in the Swiss Alps, 1990 Ausstellung von 16 Skulpturen in Chantarella in den Schweizer Alpen, 1990

was mit mir passiert, wenn ich das Gefühl habe, ich beobachte das Bild, wie es sich selbst auseinander nimmt.« (*Flash Art International*, Okt./Nov. 1986, S. 51)
Erste Ausstellung mit Skulpturen in der Pace Gallery, New York.
16 Bronze-Skulpturen werden auf einem Berggipfel in St. Moritz in der Schweiz installiert, organisiert von der Galerie Bruno Bischofberger

1991

Eine große Serie zu Olatz Lopez Garmendia, seiner späteren Frau, entsteht.

»Die Olatz-Bilder sind sehr mediterran und so offen wie sie. Sie handeln von verschiedenen Tageszeiten, verschiedenen Orten. Sie sind keine Landschaften, aber Orte, die in meinem Kopf existieren. Ich existiere an solche Orten.« (Pace Gallery, New York, 1992)
Erneute Teilnahme an der *Whitney Biennial* in New York.
Auf große Flächen von dunkelrotem Samt als Untergrund malt JS die Serie *Los patos del Buen Retiro*, in der er erneut die Geschichte und Ästhetik der spanischen Kultur aufgreift und verarbeitet.

1992

JS setzt in seinen Arbeiten auf Papier jetzt auch Fotografien als Bildelement ein.

»Ich verwende Fotografien in meinen Zeichnungen, als ob sie Spiegel wären. Ich verwende sie als Nicht-Bilder... Sie sind blinde Flecken.« (Matthew Marks Gallery, New York, 1992, S. 46)
Eine Gruppe von Arbeiten entsteht, in denen sich JS unter anderem mit dem Wort Zeus auseinander setzt. Einige be-

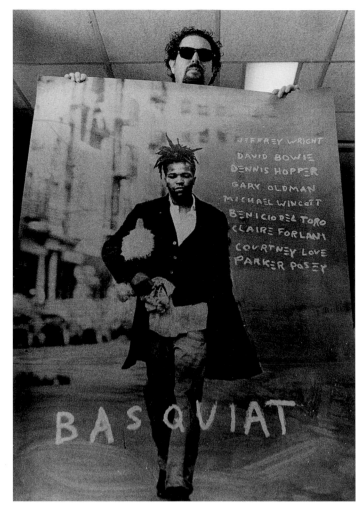

Julian Schnabel on the occasion of his lecture at the Cuban National Film
School, with poster for his film *Basquiat* during the Havana Film Festival, 1996
**Julian Schnabel anlässlich seiner Vorlesung an der kubanischen Filmakademie
mit Plakat zu seinem Film Basquiat während des Havanna Filmfestivals, 1996**

Twelve pictures entitled *The Conversion of St. Paolo Malfi* and
Adieu are created, addressing the tragic death of an Italian
artist friend. This is not the first time that JS has created
works related to the death of friends or admired artists
(Beuys, Basquiat).
Retrospective in the Galleria d'Arte Moderna in Bologna. Co-
operation with the fashion designer Azzedine Alaïa for an art
and fashion exhibition in Florence.

1997
A portrait series with a smooth resin surface is created and
exhibited for the first time a year later at the Guggenheim
Museum in Bilbao and then later in New York.

1999
JS shoots his second film, *Before Night Falls*, based on the life of
the late exiled Cuban novelist Reinaldo Arenas. Actors include
Johnny Depp, Olatz Schnabel, and other family members.

schreiben eine Liebesgeschichte zwischen Zeus und Duende,
das ein Synonym für das Magische und Unaussprechbare ist
und aus den Gedichten des spanischen Poeten Federico
García Lorca stammt.

1993
Heirat mit Olatz Lopez Garmendia.
Teilnahme an der Gruppenausstellung *Amerikanische Kunst
im 20. Jahrhundert* im Martin-Gropius-Bau, Berlin, und in der
Royal Academy of Arts, London.
Geburt der Zwillingssöhne Olmo Luis und Cy Juan.

1994
Retrospektive im Museum von Monterrey und dem Tamayo
Museum in Mexiko-Stadt.

1995
Ausstellung in der Fundació Joan Miró in Barcelona.
JS schreibt das Drehbuch für *Basquiat*, ein Film, bei dem er
auch Regie führt, mit Jeffrey Wright als Basquiat, David Bowie
als Andy Warhol und Dennis Hopper als Bruno Bischofberger.
Darin wird das Leben des mit 27 Jahren an Drogen gestorbe-
nen jungen Malers und Shootingstars der New Yorker Kunst-
szene nachgezeichnet.

1996
Basquiat wird auf dem Filmfestival in Venedig im Wettbe-
werb gezeigt.
12 Bilder mit den Titeln *The Conversion of St. Paolo Malfi* und
Adieu entstehen, die den tragischen Tod eines mit JS befreun-
deten italienischen Künstlers zum Thema haben. Auch in frü-
heren Werke (Beuys, Basquiat) hat er auf den Tod von be-
freundeten oder bewunderten Künstlern Bezug genommen.
Retrospektive in der Galleria d'Arte Moderna in Bologna. Zu-
sammenarbeit mit dem Modedesigner Azzedine Alaïa für
eine Kunst- und Modeausstellung in Florenz.

1997
Eine Porträtserie mit glatter Harzoberfläche entsteht und
wird ein Jahr später erstmals im Guggenheim Museum Bil-
bao und dann in New York ausgestellt.

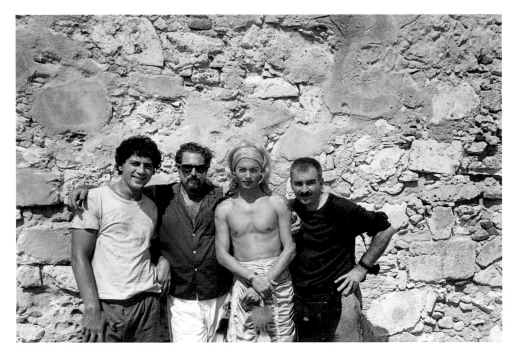

On the set of *Before Night Falls* in Mexico, 1999. From left to right: leading man Javier Bardem, Julian Schnabel, Johnny Depp, and Eniac Martinez

Während der Filmarbeiten an *Before Night Falls* in Mexiko, 1999. V.l.n.r. Hauptdarsteller Javier Bardem, Julian Schnabel, Johnny Depp und Eniac Martinez

2000

Before Night Falls wins both the Grand Jury Prize and the Colpa Volpi for best actor Javier Bardem at the Venice Film Festival 2000. Javier Bardem is nominated for Best Actor at both the Golden Globe Awards and the Academy Awards.

2002

JS starts the *Big Girl* series. Exhibition at the Gagosian Galleries in New York and Los Angeles. Begins painting a group of works on pieces of historical wallpaper laminated on canvas. First surfboard sculptures.

2003

JS uses a Polaroid that is the size of a large room to photograph his two dogs.
He builds painted sculptures with an acrylic cement of characters from the children's versions of the *Iliad*.
Abrams publishes a monograph.
Completion of the screenplay for filming Patrick Süskind's novel *Perfume*. Exhibition of paintings, sculptures, and photographs in Edinburgh. A polemic critic writes in the *Guardian* that the paintings are "a waste of good colours."

2004

JS lives and works in New York, as well as in Montauk, Long Island, and in San Sebastián, Spain.

1999

JS macht seinen zweiten Film *Before Night Falls*, der auf den Memoiren des verstorbenen Exilkubaners und Schriftstellers Reinaldo Arenas beruht. Darsteller sind unter anderem Johnny Depp, Olatz Schnabel und andere Familienmitglieder.

2000

Der Film erhält bei den Filmfestspielen in Venedig den Jurypreis, und der Hauptdarsteller Javier Bardem wird als bester Schauspieler mit dem Colpa Volpi ausgezeichnet. Außerdem wird Javier Bardem sowohl für den Golden Globe wie auch für den Academy Awards als bester Schauspieler nominiert.

2001

Beginn der Serie der *Big Girl*-Bilder. Ausstellung in den Gagosian Galleries in New York und Los Angeles. Beginn einer Werkgruppe mit Malerei auf historischen Tapeten, die auf Leinwand kaschiert sind. Erste Surfbrettskulpturen.

2003

JS verwendet eine Polaroidkamera von der Größe eines Raumes, um seine beiden Hunde zu fotografieren.
Er stellt bemalte Skulpturen aus künstlichem Zement her, die auf Charakteren aus der Kinderversion der *Illias* basieren.
Bei Abrams erscheint eine Monografie.
Fertigstellung des Drehbuchs für die Verfilmung von Patrick Süskinds *Das Parfum*. Ausstellung von Gemälden, Skulpturen und Fotografien in Edinburgh. Ein Kritiker schreibt im *Guardian* sehr polemisch, es sei bei den Gemälden schade um die gute Farbe.

2004

JS lebt und arbeitet in New York sowie zeitweise in Montauk auf Long Island und in San Sebastián, Spanien.

Liste der ausgestellten Werke List of Works in the Exhibition

* nur/only Schirn Kunsthalle Frankfurt
** nur/only Museo Nacional Centro de Arte Reina Sofia, Madrid

1 **Accattone,** 1978
Öl auf Leinwand/Oil on canvas
213,4 x 182,9 cm/84 x 72 in.
Privatsammlung/Private collection
S./p. 30

2 **The Patients and the Doctors,** 1978
Öl, Teller, Füllmasse auf Holz/Oil, plates,
Bondo on wood
243,8 x 274,3 x 305 cm/96 x 109 x 12 in.
Privatsammlung/Private collection
S./p. 45

3 **St. Sebastian,** 1979
Öl auf Leinwand/Oil on canvas
281,9 x 167,6 cm/111 x 66 in.
Privatsammlung/Private collection
S./p. 15

4 * **Aborigine Painting,** 1980
Öl, Teller, Füllmasse auf Holz und Leinwand/
Oil, plates, Bondo on wood and canvas
243,8 x 218,4 cm/96 x 86 in.
Jacqueline Schnabel, New York
S./p. 31

5 **The Sea,** 1981
Öl, mexikanische Teller, Füllmasse auf
Holz/Oil, Mexican pots, Bondo on wood
274,3 x 396,2 cm/108 x 132 in.
Courtesy The Brant Foundation, Greenwich,
CT, USA
S./pp. 46 – 47

6 * **Prehistory: Glory, Honor, Privilege and
Poverty,** 1981
Öl, Kuhhaut, Geweihe auf Holz/Oil,
cowhide, antlers on wood
335,3 x 457,2 cm/132 x 180 in.
Sammlung/Collection Bruno Bischofberger,
Zürich
S./pp. 26 – 27

7 **Maria Callas II,** 1982
Öl auf Samt/Oil on velvet
274,3 x 304,8 cm/108 x 120 in.
Privatsammlung/Private collection
S./p. 130

8 **Milton,** 1982
Öl auf Holz/Oil on wood
251,2 x 247,5 cm/100 x 99 in.
Privatsammlung/Private collection
S./p. 144

9 **The Mud in Mudanza,** 1982
Öl, Teller, Füllmasse, Metall auf Holz/Oil,
plates, Bondo, metal on wood
292,1 x 579,1 cm/115 x 228 in.
Privatsammlung/Private collection
S./pp. 50 – 51

10 **Maria Callas III,** 1982
Oil, Modelliermasse auf Samt/Oil, modeling
paste on velvet
274,3 X 304,8 cm/108 x 120 in.
Privatsammlung/Private collection
S./p. 131

11 ** **Rest,** 1982
Öl auf Holz, von Balken getragen/Oil
on wood with beam
426,7 x 487,7 cm/168 x 192 in.
Privatsammlung/Private collection
S./p. 65

12 * **Ethnic Types No. 15 and No. 72,** 1984
Öl, Tierfell, Modelliermasse auf Samt/Oil,
hide, modeling paste on velvet
274,3 x 304,8 cm/108 x 120 in.
Courtesy The Brant Foundation, Greenwich,
CT, USA
S./p. 25

13 **Resurrection: Albert Finney Meets
Malcolm Lowry,** 1984
Oil, Spritzlack, Modelliermasse auf Samt/
Oil, spray paint, modeling paste on velvet
304,8 x 274,3 cm/120 x 108 in.
Privatsammlung/Private collection
S./p. 24

14 * **Apathy,** 1986
Vinyl auf Tarpaulin/Vinyl paint on tarpaulin
563,9 x 792,5 cm/222 x 312 in.
Privatsammlung/Private collection
S./p. 80

15 **Eulalio Epiclantos after Seeing St. Jean
Vianney on the Plains of the Cure d'Ars,** 1986
Öl, Tempera auf Musselin/Oil, tempera
on muslin
345,4 x 447 cm/136 x 176 in.
Privatsammlung/Private collection
S./pp. 22 – 23

16 ** **Mimi,** 1986
Öl, Linoleum mit Kuhhörnern/Oil, linoleum
with cow horns
363,2 x 273,1 cm/143 x 107^{1}/$_{2}$ in.
Privatsammlung/Private collection
S./p. 29

17 **The Migration of the Duck-Billed
Platypus to Australia,** 1986
Acryl, Fahne auf Cordsamt/Acrylic, banner
on corduroy
304,8 x 243,8 cm/120 x 96 in.
Privatsammlung/Private collection,
New York
S./p. 147

18 **The Edge of Victory,** 1987
Gips, Klebeband auf Tarpaulin/Gesso,
tape on tarpaulin
345,4 x 487,7 cm/136 x 192 in.
Privatsammlung/Private collection
S./pp. 66 – 67

19 * **Pope Pius IX,** 1987
Öl auf Leinwand und Tarpaulin/ Oil on
canvas and tarpaulin
345,4 x 365,8 cm/136 x 144 in.
Courtesy The Brant Foundation, Greenwich,
CT, USA
S./p. 69

20 **Ritu Quadrupedis,** 1987
Öl, Gips, Lackfarbe auf Tarpaulin mit Fahne/
Oil, gesso, spray enamel on tarpaulin with
banner
335,3 x 457,2 cm/132 x 180 in.
Privatsammlung/Private collection
S./pp. 70 – 71

21 **The Teddy Bear's Picnic,** 1987
Gips, Öl auf Tarpaulin/Gesso, oil on
tarpaulin
345,2 x 428,5 cm/136 x 169 in.
Privatsammlung/Private collection
S./pp. 72 – 73

22 ** **Zum Solitaire,** 1988
Öl auf Teppich/Oil on carpet
350,5 x 264,2 cm/138 x 104 in.
Privatsammlung/Private collection
S./p. 28

23 **Cortes,** 1988
Öl, Samt auf Tarpaulin/Oil, velvet on
tarpaulin
335,3 x 579,1 cm/132 x 228 in.
Privatsammlung/Private collection
S./pp. 82 – 83

24 * **Joe Dante,** 1988
Öl auf grünem Tarpaulin/Oil on green
tarpaulin
487,7 x 487,7 cm/192 x 192 in.
Privatsammlung/Private collection
S./p. 75

25 * **Untitled,** 1989
Öl auf Tarpaulin/Oil on tarpaulin
322.6 x 243.8 cm/127 x 96 in.
Privatsammlung/Private collection
S./p. 81

26 * **Untitled (Treatise on Melancholia),**
1989
Gips auf Tarpaulin/Gesso on tarpaulin
457,2 x 457,2 cm/180 x 180 in.
Privatsammlung/Private collection
S./p. 106

27 * **Untitled (Treatise on Melancholia),**
1989
Öl, Gips auf Tarpaulin/Oil, gesso on tarpaulin
457,2 x 457,2 cm/120 x 120 in.
Privatsammlung/Private collection
S./p. 107

28 * **Untitled (Treatise on Melancholia),**
1989
Öl, Gips auf Tarpaulin/Oil, gesso on tarpaulin
457,2 x 457,2 cm/120 x 120 in.
Privatsammlung/Private collection
S./p. 111

29 * **Untitled (Treatise on Melancholia),**
1989
Öl, Gips auf Tarpaulin/Oil, gesso on tarpaulin
457,2 x 609,6 cm/120 x 240 in.
Privatsammlung/Private collection
S./pp. 108 – 109

30 * **Untitled (Treatise on Melancholia),**
1989
Gips auf Tarpaulin/Gesso on tarpaulin
457,2 x 457,2 cm/120 x 120 in.
Privatsammlung/Private collection
S./p. 110

31 **Adieu,** 1989
Öl, Gips auf Tarpaulin/Oil, gesso on
tarpaulin
305 x 487 cm/120 x 192 in.
Privatsammlung/Private collection,
courtesy Caratsch, de Pury & Luxembourg
S./pp. 132 – 133

32 **Ozymandias,** 1990
Öl, Harz, Gips, Wildleder auf Dacron-Segel/
Oil, resin, gesso, suede on dacron sail
396,2 x 548,6 cm/132 x 216 in.
Sammlung/Collection Bruno Bischofberger,
Zürich
S./pp. 112 – 113

33 ** **Jane Birkin,** 1990
Öl, Gips auf Segeltuch/Oil, gesso on sailcloth
472,4 x 416,6 cm/186 x 164 in.
Privatsammlung/Private collection
S./p. 115

34 **Jane Birkin #3 (Vito),** 1990
Öl, Harz, Gips auf Segeltuch/Oil, resin,
gesso on sailcloth
326,4 x 630 cm/128^1/$_2$ x 248 in.
Privatsammlung/Private collection
S./p. 114

35 * **I Went to Tangiers and Had Dinner
with Paul Bowles,** 1990
Öl, Gips auf weißem Tarpaulin/Oil, gesso
on white tarpaulin
487,7 x 487,7 cm/192 x 192 in.
Privatsammlung/Private collection
S./p. 116

36 ** **Anno Domini,** 1990
Öl auf weißem Tarpaulin/Oil, gesso on
white tarpaulin
670,6 x 670,6 cm/264 x 264 in.
Privatsammlung/Private collection
S./p. 76

37 ** **El espontáneo
(for Abelardo Martínez),** 1990
Öl, Fahne auf weißem Tarpaulin/ Oil,
banner on white tarpaulin
670,6 x 670,6 cm/264 x 264 in.
Privatsammlung/Private collection
S./p. 77

38 **Olatz 1,** 1991
Öl, Gips, Harz, Applikation auf Staubdecke/
Oil, gesso, resin, appliqué on drop cloth
243,8 x 304,8 cm/96 x 120 in.
Privatsammlung/Private collection
S./p. 117

39 ** **Untitled (Los patos del Buen Retiro),**
1991
Öl, Gips, Harz auf weißem Tarpaulin/Oil,
gesso, resin on white tarpaulin
472,4 x 472,4 cm/186 x 186 in.
Museo Nacional Centro de Arte Reina Sofia,
Madrid
S./p. 79

40 ** **Untitled (Los patos del Buen Retiro)**
1991
Öl, Gips, Harz auf weißem Tarpaulin/Oil,
gesso, resin on white tarpaulin
472,4 x 549,9 cm/186 x 216^1/$_2$ in.
Museo Nacional Centro de Arte Reina Sofia,
Madrid
S./p. 78

41 **Untitled (Los patos del Buen Retiro),**
1991
Öl, Gips auf Samt/Oil, gesso on velvet
457,2 x 457,2 cm/180 x 180 in.
Privatsammlung/Private collection
S./p. 103

42 **Untitled (Los patos del Buen Retiro),**
1991
Öl, Gips auf Samt/Oil, gesso on velvet
457,2 x 457,2 cm/180 x 180 in.
Privatsammlung/Private collection
S./p. 105

43 * **Untitled (Los patos del Buen Retiro),**
1991
Öl, Gips auf Samt/Oil, gesso on velvet
457,2 x 457,2 cm/180 x 180 in.
Privatsammlung/Private collection
S./p. 101

44 * **Untitled (Los patos del Buen Retiro),**
1991
Öl, Gips auf Samt/Oil, gesso on velvet
457,2 x 457,2 cm/180 x 180 in.
Privatsammlung/Private collection
S./p. 104

45 **Untitled (La voz de Antonio Molina),**
1991
Öl, Gips, Harz, Samt, Leder auf Staubdecke/
Oil, gesso, resin, velvet, leather on drop cloth
243,8 x 304,8 cm/96 x 120 in.
Privatsammlung/Private collection
S./p. 118

46 **Untitled (La voz de Antonio Molina),**
1991
Öl, Gips, Harz, Samt, Leder auf Staubdecke/
Oil, gesso, resin, velvet, leather on drop cloth
243,8 x 304,8 cm/96 x 120 in.
Privatsammlung/Private collection
S./p. 119

47 **Untitled (Zeus),** 1992
Öl auf Tarpaulin/Oil on tarpaulin
365,8 x 670,6 cm/144 x 264 in.
Privatsammlung/Private collection
S./pp. 128 –129

48 **Untitled (Zeus and Duende),** 1992
Öl auf Tarpaulin/Oil on tarpaulin
243,8 x 274,3 cm/96 x 108 in.
Privatsammlung/Private collection
S./p. 127

49 **Untitled (Los besos de tu amor),** 1992
Öl, Druck, Harz auf Staubdecke/Oil, print,
resin on drop cloth
304,8 x 243,8 cm/120 x 96 in.
Gian Enzo Sperone, New York
S./p. 126

50 ** **Untitled (Los besos de tu amor),** 1992
Öl, Druck, Harz auf Staubdecke/Oil, print,
resin on drop cloth
304,8 x 243,8 cm/120 x 96 in.
Privatsammlung/Private collection
S./p. 121

51 * **Encantadores de serpientes,** 1993
Öl, Gips, Pappe auf Dacron-Segeltuch/Oil,
gesso, cardboard on dacron sailcloth
274,3 x 213,4 cm/108 x 84 in.
Sammlung/Collection Bruno Bischofberger,
Zürich
S./p. 123

52 **Portrait of Olatz,** 1993
Öl auf Teller auf Holz/Oil on plates
mounted on wood
213,4 x 139,7 cm/84 x 55 in.
Privatsammlung/Private collection
S./p. 135

53 * **Untitled (View of Dawn in the Tropics),**
1993
Öl auf Papier auf Leinwand/Oil on paper
mounted on canvas
205,7 x 154,9 cm/81 x 61 in.
Privatsammlung/Private collection
S./p. 122

54 **Untitled (Monjas de calle con buen ojo
y jamon),** 1993
Öl, Acryl, Harz, Lithografie auf Papier auf
Leinwand/Oil, acrylic resin, litho on paper
mounted on canvas
243,8 x 182,8 cm/96 x 72 in.
Gian Enzo Sperone, New York
S./p. 125

55 * **Portrait of Olatz with Cy,** 1994
Öl, Teller, Füllmasse auf Holz/Oil, plates,
Bondo on wood
203,2 x 152,4 cm/80 x 60 in.
Privatsammlung/Private collection
S./p. 134

56 * **The Conversion of St. Paolo Malfi,** 1995
Öl, Harz, Druck auf Leinwand/Oil, resin,
print on canvas
274,3 x 243,8 cm/108 x 96 in.
Privatsammlung/Private collection
S./p. 120

57 * **Adieu,** 1995
Öl, Harz auf Leinwand/Oil, resin on canvas
274,3 x 243,8 cm/108 x 96 in.
Gian Enzo Sperone, New York
S./p. 124

58 **Portrait of Stella,** 1996
Öl, Teller, Füllmasse auf Holz/Oil, plates,
Bondo on wood
203,2 x 152,4 cm/80 x 60 in.
Privatsammlung/Private collection
S./p. 136

59 **Portrait of Lola,** 1996
Öl, Teller, Füllmasse auf Holz/Oil, plates,
Bondo on wood
203,2 x 152,4 cm/80 x 60 in.
Lola Schnabel, New York
S./p. 137

60 **Portrait of Victor Hugo Demo,** 1997
Öl, Harz, Lackfarbe auf Leinwand/Oil, resin,
enamel on canvas
274,3 x 259,1 cm/108 x 102 in.
Privatsammlung/Private collection
S./p. 145

61 **Large Girl with No Eyes,** 2001
Wachs, Öl auf Leinwand/Wax, oil on canvas
411,5 x 376 cm/162 x 148 in.
Privatsammlung/Private collection
S./p. 154

62 ** **Large Girl with No Eyes,** 2001
Wachs, Öl auf Leinwand/Wax, oil on canvas
414,5 x 378 cm/163 x 149 in.
Courtesy The Brant Foundation, Greenwich,
CT, USA
S./p. 153

63 ** **And the Ugly Duckling Turned into a
Beautiful Swan,** 2002
Öl, Wachs auf Tarpaulin und Holz/Oil,
wax on tarpaulin and wood
426,7 x 304 cm/168 x 240 in.
Privatsammlung/Private collection
S./p. 143

64 **Untitled (Chinese Painting),** 2003
Öl, Wachs auf Tarpaulin/Oil, wax on tarpaulin
274,3 x 485,1 cm/108 x 191 in.
Sammlung/Collection of Laurence Graff
S./pp. 150 –151

65 **Untitled (Chinese Painting),** 2003
Öl, Wachs auf Tarpaulin/Oil, wax on tarpaulin
274,3 x 485,1 cm/108 x 191 in.
Privatsammlung/Private collection
S./pp. 148 –149

Ausgewählte Bibliografie Selected Bibliography

Einzelausstellungen und Monografien Solo Exhibitions and Books

Julian Schnabel, Ausst.-Kat./exh. cat. Kunsthalle Basel, Frankfurter Kunstverein, 1981.

Julian Schnabel, Ausst.-Kat./exh. cat. Stedelijk Museum, Amsterdam, 1982.

Julian Schnabel, Ausst.-Kat./exh. cat. Tate Gallery London, London, 1982.

Julian Schnabel, Ausst.-Kat./exh. cat. Waddington Galleries, London, 1983.

Julian Schnabel, Drawings, Ausst.-Kat./exh. cat. Akira Ikeda Gallery, Nagoya, 1983.

Julian Schnabel, Ausst.-Kat./exh. cat. The Pace Gallery, New York, 1984.

Julian Schnabel, The Aluminium Paintings, Ausst.-Kat./exh. cat. Akira Ikeda Gallery, Nagoya, 1984.

Julian Schnabel, Printed on Velvet, Ausst.-Kat./exh. cat. Akira Ikeda Gallery, Nagoya, 1984.

Julian Schnabel, Ausst.-Kat./exh. cat. Waddington Galleries, London, 1985.

Julian Schnabel, Angelo d'oro, Ausst.-Kat./exh. cat. Galleria Gian Enzo Sperone, Rom/Rome, 1985.

Julian Schnabel, New Etchings, Pace Editions, New York, 1985.

Julian Schnabel, The Kabuki Paintings, Ausst.-Kat./exh. cat. The Pace Gallery, New York, 1986.

Current 10 – Julian Schnabel, Ausst.-Kat./exh. cat. Milwaukee Art Museum, Milwaukee, 1987.

Julian Schnabel – Plate Paintings, Ausst.-Kat./exh. cat. Akira Ikeda Gallery, Nagoya, 1987.

Julian Schnabel – œuvres 1975–1986, Ausst.-Kat./exh. cat. Musée nationale d'art moderne, Centre Georges Pompidou, Paris, 1987.

Julian Schnabel – Bilder 1975–1986, Ausst.-Kat./exh. cat. Städtische Kunsthalle, Düsseldorf, 1987.

Julian Schnabel – Paintings 1975–1987, Ausst.-Kat./exh. cat. Whitechapel Art Gallery, London, 1987.

Julian Schnabel, Ausst.-Kat./exh. cat. Waddington Galleries, London, 1988.

Julian Schnabel, Ausst.-Kat./exh. cat. The Israel Museum, Jerusalem, 1988.

Julian Schnabel – Crows Flying the Black Flag of Themselves, Ausst.-Kat./exh. cat. Sarah Campbell Blaffer Gallery, University of Houston, Houston, 1988.

Julian Schnabel – The Kabuki Paintings, Ausst.-Kat./exh. cat. Setagaya Art Museum, Tokio/Tokyo, 1988.

Julian Schnabel – Reconocimientos Pinturas, El Carmen/The Recognition Paintings, Ausst.-Kat./exh. cat. Cuartel del Carmen, Sevilla/Seville, 1988.

Julian Schnabel – Reconocimientos/Die »Recognitions«-Bilder, Ausst.-Kat./exh. cat. Kunsthalle Basel, 1989.

Julian Schnabel – Arbeiten auf Papier 1975–1988/Julian Schnabel – Works on Paper 1975–1988, hrsg. von/ed. Jörg Zutter, Ausst.-Kat./exh. cat. Museum für Gegenwartskunst Basel, München/Munich 1989.

Julian Schnabel – Kabuki Paintings. Ausst.-Kat./exh. cat. The National Museum of Art, Osaka, 1989.

Julian Schnabel – Œuvres Nouvelles, hrsg. von/ed. Sylvie Couderc, Ausst.-Kat./exh. cat. CAPC Musee d'art contemporain, Bordeaux, 1989.

Julian Schnabel – Fox Farm Paintings, Ausst.-Kat./exh. cat. The Pace Gallery, New York, 1989.

Jean-Michel Basquiat and Julian Schnabel, Ausst.-Kat./exh. cat. Rooseum, Malmö, 1989.

Julian Schnabel – New Drawings, Akira Ikeda Gallery, Nagoya, 1989.

Julian Schnabel, Ausst.-Kat./exh. cat. Centro per l'Arte Contemporanea Luigi Pecci, Museo d'Arte Contemporanea, Prato, 1990.

Julian Schnabel – Paintings, Duson Gallery, Seoul, 1990.

Julian Schnabel – Sculpture. Ausst.-Kat./exh. cat. The Pace Gallery, New York, 1990.

Lola and Julian Schnabel (*Art Random Series*, 27), Kyoto 1990.

Julian Schnabel – Tati Paintings. Ausst.-Kat./exh. cat. Galerie Yvon Lambert, Paris, 1990.

Julian Schnabel Graphische Arbeiten 1983–1991, Ausst.-Kat./exh. cat. Galerie Daniel Blau, München/Munich, 1991.

Julian Schnabel – Mito y magia en America, Ausst.-Kat./exh. cat. Los Ochenta, Museo de Arte Contemporaneo de Monterrey, Monterrey (Mexiko/Mexico), 1991.

Julian Schnabel – Virginia de lujo, Ausst.-Kat./exh. cat. Galeria Soledad Lorenzo, Madrid, 1991.

Julian Schnabel. Olatz/The End of the Summer/Hurricane Bob, Ausst.-Kat./exh. cat. The Pace Gallery, New York, 1992.

Julian Schnabel – Sculpture, Waddington Galleries, London, 1992.

Julian Schnabel – Works on Paper 1976–1992, Ausst.-Kat./exh. cat. Matthew Marks Gallery, New York, 1993.

Julian Schnabel – Pinturas del invierno de 1993 para Olatz, Ausst.-Kat./exh. cat. Galeria Soledad Lorenzo, Madrid, 1993.

Julian Schnabel – Opere recenti, Ausst.-Kat./exh. cat. Galleria Gian Ferrari Arte Contemporanea, Mailand/Milan, 1994.

Julian Schnabel – Boni Lux. Ausst.-Kat./exh. cat. The Pace Gallery, New York, 1994.

Julian Schnabel – Retrospectiva, Ausst.-Kat./exh. cat. Museo de Monterrey, Monterrey (Mexiko/Mexico) 1994.

Julian Schnabel, Ausst.-Kat./exh. cat. Fundació Joan Miró, Barcelona, 1995.

Julián Schnabel – pinturas, Ausst.-Kat./exh. cat. Palacio Revillagigedo, Centro Internacional de Arte, Gijón, 1995.

Julian Schnabel – New Paintings, Ausst.-Kat./exh. cat. Herning Kunstmuseum, Herning (Dänemark/Denmark) 1995.

Julian Schnabel – Paintings, Ausst.-Kat./exh. cat. Galería Ramis Barquet, Mexiko-Stadt/Mexico City 1995.

Julian Schnabel – The Conversion of St. Paolo Malfi/The Pink Blouse that I Like the

Most/Pink Paintings, Ausst.-Kat./exh. cat. Jablonka Galerie, Köln/Cologne 1995.

Julian Schnabel, Ausst.-Kat./exh. cat. Sala de Exposiciones Rekalde, Guggenheim Museum Bilbao 1995.

Julian Schnabel, Waddington Galleries, London 1996.

Julian Schnabel – The Conversion of St. Paolo Malfi, Ausst.-Kat./exh. cat. Pace Wildenstein, New York 1996.

Julian Schnabel – Ego y la iluvia, Ausst.-Kat./exh. cat. Galería Soledad Lorenzo, Madrid, 1996.

Julian Schnabel – The Conversion of St. Paolo Malfi, Ausst.-Kat./exh. cat. Galerie Kyoko Chirathivat, Bangkok, 1996.

Julian Schnabel, hrsg. von/ed. Danilo Eccher, Ausst.-Kat./exh. cat. Galleria d'arte moderna di Bologna, Turin 1996.

Julian Schnabel – Portrait Paintings, Ausst.-Kat./exh. cat. Pace Wildenstein, New York, 1997.

Julian Schnabel – Neue Bilder, Ausst.-Kat./exh. cat. Galerie Thaddaeus Ropac, Salzburg–Paris, 1999.

Julian Schnabel – Plate Paintings 1978–1997, Ausst.-Kat./exh. cat. Pace Wildenstein, New York, 1999.

Julian Schnabel – Obra recente, Ausst.-Kat./exh. cat. Galeria Fernando Santos, Porto, 2000.

Julian Schnabel, Galeria Cardi, Mailand/Milan, Gallery Gian Enzo Sperone, New York, 2001.

Julian Schnabel – Sculptures 1982–1998, Ausst.-Kat./exh. cat. Galerie Bischofberger, Zürich/Zurich, 2001.

Julian Schnabel – Big Girl Paintings, Ausst.-Kat./exh. cat. Gagosian Gallery, New York–Los Angeles, 2002.

Julian Schnabel – Paintings, Sculpture & Photographs, Ausst.-Kat./exh. cat. Inverleith House, Royal Botanic Garden, Edinburgh, 2003.

Julian Schnabel, New York (Abrams) 2003.

Gruppenausstellungen Group Exhibitions

Visionary Images, Renaissance Society, University of Chicago, 1979.

A New Spirit in Painting, hrsg. von/ed. Christos M. Joachimides et al., Royal Academy of Arts, London 1981.

Westkunst. Zeitgenössische Kunst seit 1939, Ausst.-Kat./exh. cat. Museen der Stadt Köln/Cologne, Köln/Cologne 1981.

Zeitgeist, hrsg. von/ed. Christos M. Joachimides, Norman Rosenthal Ausst.-Kat./exh. cat. Martin-Gropius-Bau, Berlin, Berlin 1982.

Five Painters – Chia, Clemente, Kiefer, Salle, Schnabel, Ausst.-Kat./exh. cat. Anthony d'Offay, London, 1982.

Avanguardia Transavanguardia, hrsg. von/ed. Achille Bonito Oliva, Ausst.-Kat./exh. cat. Mura Aureliane Rom, Mailand/Milan 1982.

New York Now, hrsg. von/ed. Carl Haenlein, Ausst.-Kat./exh. cat. Kunstverein für die Rheinlande und Westfalen, Düsseldorf, et al., 1983.

The Fifth Biennale of Sydney – Private Symbol: Social Metaphor, Ausst.-Kat./exh. cat. The Gallery of New South Wales, Sydney, 1984.

Painting Now – Jean Michel Basquiat, Sandro Chia, Francesco Clemente, Enzo Cucchi, David Salle, Salome, Julian Schnabel, Ausst.-Kat./exh. cat. Akira Ikeda Gallery, Nagoya, 1984.

Art of Our Time – the Saatchi Collection, London 1984.

In Tandem – the Painter-Sculptor in the 20th Century, hrsg. von/ed. Nicholas Serota, Rachel Kirby, Ausst.-Kat./exh. cat. Whitechapel Art Gallery, London 1986.

1988 The World of Art Today, Ausst.-Kat./exh. cat. Milwaukee Art Museum, Milwaukee, 1988.

Art of the 1980s – Artists from the Eli Broad Family Foundation Collection, Ausst.-Kat./exh. cat. Kresge Art Museum, Michigan State University, East Lansing, 1988.

Miquel Barcelo, George Condo, Julian Schnabel, Ausst.-Kat./exh. cat. Galeria de arte Soledad Lorenzo, Madrid, 1988.

Carnegie International, Ausst.-Kat./exh. cat. Carnegie Museum of Art, Pittsburgh, 1988.

Contemporary Art from New York, Ausst.-Kat./exh. cat. Ho-Am Art Hall, Seoul, 1988.

Three Decades – The Oliver-Hoffmann Collection, Ausst.-Kat./exh. cat. The Museum of Contemporary Art, Chicago, 1988.

Bilderstreit – Widerspruch, Einheit, Fragment, hrsg. von/ed. Siegfried Gohr, Ausst.-Kat./exh. cat. Museum Ludwig, Köln/Cologne, 1989.

Seibu Corporation Collection, Ausst.-Kat./exh. cat. Seibu Corporation, New York, Tokio/Tokyo, 1990.

The Refco Collection, Refco Group, Chicago 1990.

Artist's Sketchbooks, Ausst.-Kat./exh. cat. Matthew Marks Gallery, New York, 1991.

El Sueno de Egipto – La Influencia del Arte Egipcio en el Arte Contemporaneo, Ausst.-Kat./exh. cat. Centro Cultural Arte Contemporaneo, Mexiko-Stadt/Mexico City, 1991.

Robert Gober, On Kawara, Mike Kelley, Martin Kippenberger, Jeff Koons, Albert Oehlen, Julian Schnabel, Cindy Sherman, Thomas Struth, Philip Taaffe, Christopher Wool, Max Hetzler/Thomas Borgmann, Köln/Cologne, 1992.

Le Portrait dans L'art contemporain, Ausst.-Kat./exh. cat. Musée d'art moderne et d'art contemporain, Nizza/Nice, Nizza/Nice1992.

Amerikanische Kunst im 20. Jahrhundert. Malerei und Skulptur 1913–1993, hrsg. von/ed. Christos M. Joachimides, Norman Rosenthal, Ausst.-Kat./exh. cat. Martin-Gropius-Bau, Berlin, München/Munich 1993.

American Art in the Twentieth Century – Painting and Sculpture 1913–1993, hrsg. von/ed. Christos M. Joachimides, Norman Rosenthal, Ausst.-Kat./exh. cat. Royal Academy of Arts, London, München/Munich 1993.

The Portrait Now, Ausst.-Kat./exh. cat. National Portrait Gallery, London, 1993.

The Present Time of Arts, Ausst.-Kat./exh. cat. Mitsukoshi Museum, Tokio/Tokyo, 1993.

Family Values. Amerikanische Kunst der achtziger und neunziger Jahre – Die Sammlung Scharpff in der Hamburger Kunsthalle/American Art in the Eighties and Nineties – The Scharpff Collection at the Hamburg Kunsthalle, hrsg. von/ed. Uwe M. Schneede, Ausst.-Kat./exh. cat. Hamburger Kunsthalle, Hamburg, Ostfildern-Ruit 1996.

The Guggenheim Museums and the Art of This Century, Guggenheim Museum, Bilbao 1997.

Aufsätze Articles

Edit DeAk, »Julian Schnabel«, in: *Art Rite Magazine*, 9, Frühling/spring 1975.

Ross Bleckner, »Transcendent Anti-Fetishism«, in: *Artforum*, 17, März/March 1979, S./p. 50.

Valentin Tatransky, »Julian Schnabel«, in: *Artforum*, 17, Mai/May 1979, S./p. 36.

Carrie Ricky, »Julian Schnabel«, in: *Artforum*, 17, Mai/May 1979, S./p. 59.

Rene Ricard, »Julian Schnabel's Plate Paintings at Mary Boone«, in: *Art in America*, November 1979, S./pp. 125–126.

Carter Ratcliff, »Art to Art: Julian Schnabel«, in: *Interview Magazine*, Oktober/October 1980, S./pp. 55–57.

Robert Pincus-Witten, »Entries: If Even in Fractions«, in: *Arts Magazine*, September 1980, S./pp. 116–119.

Craig Crimp, »The End of Painting«, in: *October*, Februar/February 1981.

Stuart Morgan, »A New Spirit in Painting«, in: *Artforum*, 19, April 1981, S./p. 47.

William Feaver, »A New Spirit – or Just a Tired Ghost?«, in: *Artnews*, Mai/May 1981, S./pp. 114–118.

René Ricard, »Not about Julian Schnabel«, in: *Artforum*, 19, Sommer/summer 1981, S./pp. 74–80.

Nina Sundell, »Julian Schnabel «, in: *Flash Art International*, 103, 1981, S./p. 32.

Thomas Lawson, »Last Exit: Painting«, in: *Artforum*, 20, Oktober/October 1981, S./pp. 40–47.

Robert Pincus-Witten, »Julian Schnabel: Blind Faith«, in: *Arts Magazine*, Februar/February 1982, S./pp. 152–155.

Mel Gooding, »Julian Schnabel«, in: *Arts Review*, 16, Juli/July 1982.

Stuart Morgan, »Misunderstanding Schnabel«, in: *Artscribe International*, 36, August 1982, S./p. 56.

Dorian Mohr, »Julian Schnabel Another Look«, in: *Studio International*, 196, 1983, S./pp. 8f.

»Julian Schnabel: The Patients and the Doctors«, in: *Artforum*, 22, Februar/February 1984, S./pp. 54–59.

Donald Kuspit, »The Rhetoric of Rawness: Its Effects on Meaning in Julian Schnabel's Paintings«, in: *Arts Magazine*, März/March 1985, S./pp. 126–130.

Gerald Marzorati, »Julian Schnabel Plate It as It Lays«, in: *ARTnews*, April 1985, S./pp. 62–69.

Donald Kuspit, »Julian Schnabel. Die Rückeroberung des Primitiven«, in: *Wolkenkratzer*, 10, 1985–86, S./pp. 44–54.

Stuart Morgan, »Letters to a Wound«, in: *Artscribe International*, 55, 1985–86, S./pp. 32–37.

»Julian Schnabel interviewed by Matthew Collings«, in: *Artscribe International*, 59, 1986, S./pp. 26–28.

Giancarlo Politi, »Julian Schnabel«, in: *Flash Art International*, 130, 1986, S./pp. 45–53.

Peter Fuller, »Julian Schnabel, Paintings 1975–1986«, in: *Burlington Magazine*, November 1986.

Frank Huser, »Gargantua et le vaste monde«, in: *Le Nouvel Observateur*, 6.–12. Februar/February 6–12, 1987, S./p. 64.

Lisa Liebmann, »About Julian Schnabel«, in: *Flash Art International*, 140, 1988, S./pp. 71–73.

Brooks Adams, »Ich hasse denken – Julian Schnabels neue Bilder«, in: *Parkett*, 18, 1988, S./pp. 116–122.

Eric Gibson, »Julian Schnabel at Pace Wildenstein«, in: *ARTnews*, Mai/May 1996, S./p. 134.

Roberta Smith, »Julian Schnabel at Pace Wildenstein«, in: *New York Times*, 31. Oktober/October 31, 2003.

Autobiografie Autobiography

Julian Schnabel, *C V J. Nicknames of Maitre D's & Other Excerpts from Life*, New York—Toronto 1987.

Interwiews

»Interview with Julian Schnabel by Carter Ratcliff«, in: *Julian Schnabel*, Ausst.-Kat./exh. cat. Kunsthalle Basel, 1981.

»Expressionism Today: An Artists' Symposium, Interview with Hayden Herrera«, in: *Art in America*, 11, Dezember/December 1982, S./pp. 58–75, 139, 141.

»Julian Schnabel Interviewed by Stuart Morgan«, in: *Artscribe International*, 44, 1983, S./pp. 15–21.

» Julian Schnabel Interviewed by Giancarlo Politi«, in: *Flash Art International*, 130, 1986, S./pp. 45–53.

»Julian Schnabel Interviewed by Frank Owen«, in: *I-D Magazine*, November 1986.

»Julian Schnabel im Gespräch mit Matthew Collings«, in: *Julian Schnabel: Bilder 1975–1986*, Ausst.-Kat./exh. cat. Städtische Kunsthalle Düsseldorf, Düsseldorf 1987, S./pp. 93–97.

Donald Kuspit, »Julian Schnabel«, in: *Art Talk, the Early 80s*, hrsg. von/ed. Jeanne Siegel, New York 1988, S./pp. 152–158.

»Graphische Arbeiten 1983–1991. Daniel Blau Interviews Julian Schnabel (Galerie Blau, München/Munich 1991)«, in: *Julian Schnabel – New Paintings*, Ausst.-Kat./exh. cat. Herning Kunstmuseum, Herning (Dänemark/Denmark) 1995, S./pp. 43f.

»Works on Paper 1976–1992. Francesco Clemente Interviews Julian Schnabel (New York 1992)«, in: *Julian Schnabel – New Paintings*, Ausst.-Kat./exh. cat. Herning Kunstmuseum, Herning (Dänemark/Denmark) 1995, S./pp. 45–48.

»Carter Ratcliff Interviews Julian Schnabel, 6. Oktober/October 6, 1994«, in: *Julian Schnabel*, Ausst.-Kat./exh. cat. Fundació Joan Miró, Barcelona 1995.

»La Tradizione dei Principi – Intervista a Julian Schnabel di Rene Ricard/The Princely Tradition – Interview between Julian Schnabel and Rene Ricard (1996)«, in: *Julian Schnabel*, Ausst.-Kat./exh. cat. Galleria d'Arte Moderna di Bologna, Bologna 1996/97, S./pp. 192–198.

»Julian Schnabel Talks to Max Hollein«, in: *Artforum*, 41, April 2003, S./p. 59.

Abbildungen Illustrations

Fotonachweis Photo Credits

Mauricio Alanis S./p. 166
Pamela Barkentin S./p. 164
Dan Chavkin S./p. 155
Ken Cohen S./p. 102
Jean Kallina S./p. 165
Rita K. Katz S./pp. 44, 49
Alan Kleinberg S./pp. 14, 64
Hans Namuth S./p. 163
Beth Phillips S./p. 68
Phillips/Schwab S./p. 74
Pedro P. Portales S./p. 168
Laura Reesen S./p. 11
Julian Schnabel S./pp. 1–6, 152
Zindman / Fremont S./pp. 159, 160

Umschlagabbildungen / Cover illustrations
Vorderseite / Front: Julian Schnabel, *Untitled
(Los patos de Buen Retiro)*, 1991
Rückseite / Back: Julian Schnabel, *Ritu
Quadrupedis*, 1987

Bildlegenden der Schwarzweißfotografien/ Captions of the black-and-white photographs

S./pp. 1–6
Ansichten von Haus und Atelier des
Künstlers in New York, fotografiert von Julian
Schnabel 2002 / Views of the artist's house
and studio in New York, photographed by
Julian Schnabel

S./p. 8
Julian Schnabel mit seinem Hund Milton,
Montauk, Sommer 2002 / Julian Schnabel
and his dog Milton, Montauk, summer 2002

S./p. 14
Julian Schnabel in seinem Atelier 24 East
20th Street in New York, 1979 / Julian
Schnabel in his studio at 24 East 20th Street
in New York, 1979

S./p. 44
Julian Schnabel mit / with Bruno
Bischofberger in Amagansett, NY, 1981

S./p. 48
Freilichtatelier in Bridgehampton, NY, 1981 /
Open air studio in Bridgehampton, NY, 1981

S./p. 49
Julian Schnabel in Amagansett, NY, 1981

S./p. 64
Julian Schnabel (r.) und Brian Kelly beim
Aufbau der Einzelausstellung in der Mary
Boone Gallery, New York, 1982 / Julian
Schnabel (right) and Brain Kelly working on
the installation of the solo exhibition at the
Mary Boone Gallery, New York, 1982

S./p. 68
Julian Schnabels Atelier in New York, 1987 /
Julian Schnabel's studio in New York, 1987

S./p. 74
Installationsansicht im Musée d'Art
Contemporain in Bordeaux, 1989 /
Installation view in the Musée d'Art
Contemporain in Bordeaux, 1989

S./p. 102
Julian Schnabels Atelier in New York, 1991 /
Julian Schnabel's studio in New York, 1991

S./p. 152
Julian Schnabel in seinem Haus und Atelier
in Montauk, Long Island, 2002 / Julian
Schnabel in his house and studio in
Montauk, Long Island, 2002

Diese Publikation erscheint anlässlich der Ausstellung *Julian Schnabel – Malerei 1978–2003 /*
This catalogue is published on the occasion of the exhibition *Julian Schnabel—Paintings 1978–2003.*
Schirn Kunsthalle Frankfurt 29. Januar – 25. April 2004 / January 29 – April 25, 2004
Museo Nacional Centro de Arte Reina Sofia Madrid 3. Juni – 13. September 2004 / June 3 – September 13, 2004
Mostra d'Oltramare, Neapel/Naples Oktober 2004 – Januar 2005 / October 2004 – January 2005

Katalog / Catalogue

Herausgeber / Editor
Max Hollein

Redaktion / Coeditor
Ingrid Pfeiffer

Redaktionsassistenz / Editing Assistance
Carla Orthen

Verlagslektorat / Copyediting
Karin Osbahr (Deutsch / German)
Tas Skorupa (Englisch / English)

Übersetzungen / Translations
Polisemia, S.L., John Southard,
Textworker Bernd Wilczek

**Grafische Gestaltung und Herstellung /
Graphic Design and Production**
Andreas Platzgummer

Satz / Typesetting
Weyhing digital, Ostfildern-Ruit

Reproduktion / Reproduction
Pallino Media Integration, Ostfildern-Ruit

Gesamtherstellung / Printed by
Dr. Cantz'sche Druckerei, Ostfildern-Ruit

© 2004 Hatje Cantz Verlag, Ostfildern-Ruit,
Schirn Kunsthalle Frankfurt,
Julian Schnabel und Autoren / and authors

Erschienen im / Published by
Hatje Cantz Verlag
Senefelderstraße 12
73760 Ostfildern-Ruit
Deutschland / Germany
Tel. +49 / 7 11 / 4 40 50
Fax +49 / 7 11 / 4 40 52 20
www.hatjecantz.de

**Hatje Cantz books are available internation-
ally at selected bookstores and from the fol-
lowing distribution partners:**
USA/North America – D.A.P., Distributed Art
Publishers, New York, www.artbook.com
France – Interart, Paris,
interart.paris@wanadoo.fr
UK – Art Books International, London,
sales@art-bks.com
Belgium – Exhibitions International, Leuven,
www.exhibitionsinternational.be
Australia – Towerbooks, French Forest (Sydney),
towerbks@zipworld.com.au
For Asia, Japan, South America, and Africa, as
well as for general questions, please contact
Hatje Cantz directly at sales@hatjecantz.de,
or visit our homepage www.hatjecantz.com
for further information.

ISBN 3-7757-1386-7

Printed in Germany